TRADITIONS

CONTEMPORARY ART | IN ASIA

TENSIONS

D0927254

INDIA

INDONESIA

PHILIPPINES

SOUTH KOREA

THAILAND

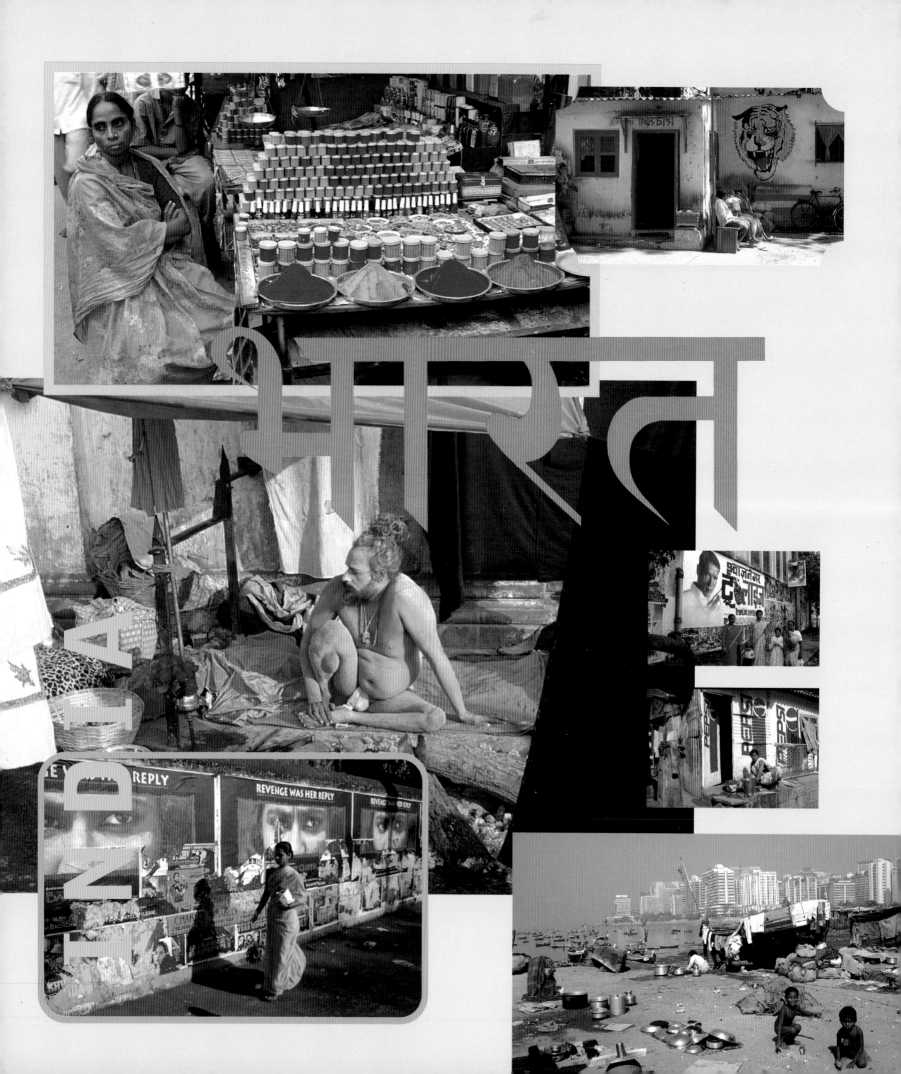

भारत

INDIA

REVENGE WAS HER REPLY

Indonesia

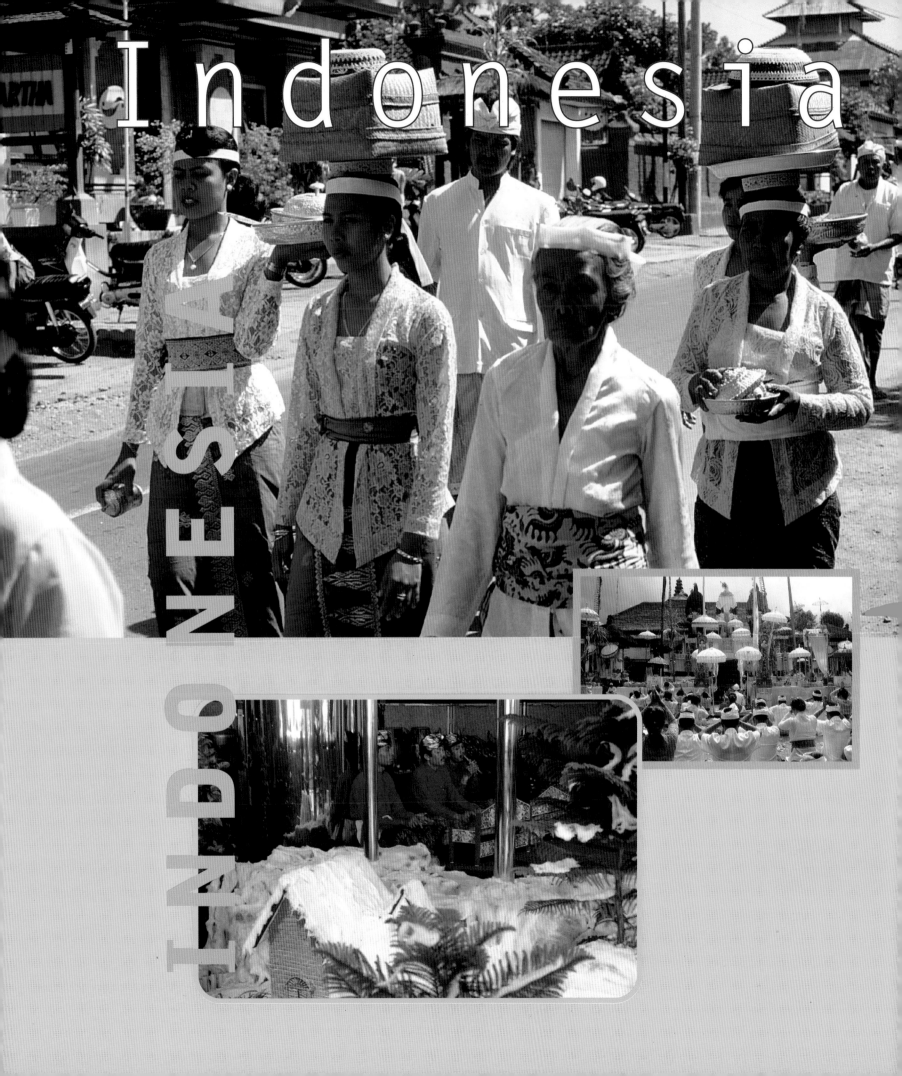

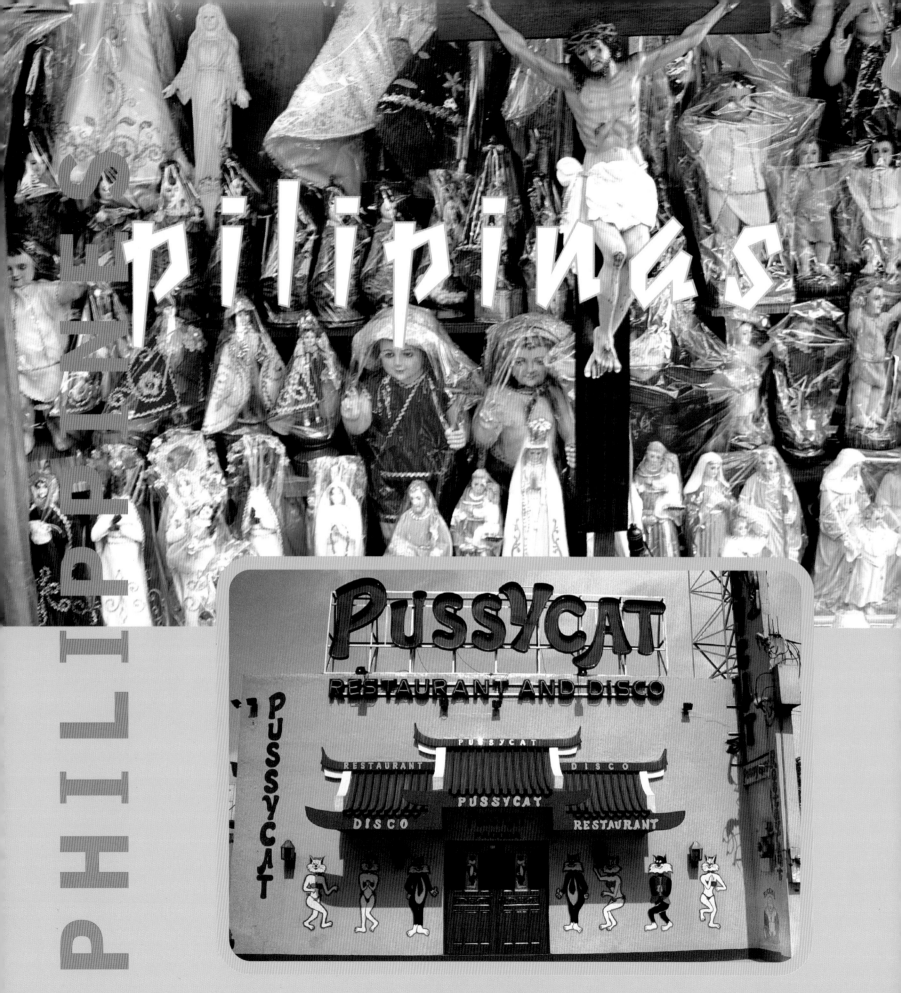

pilipinas

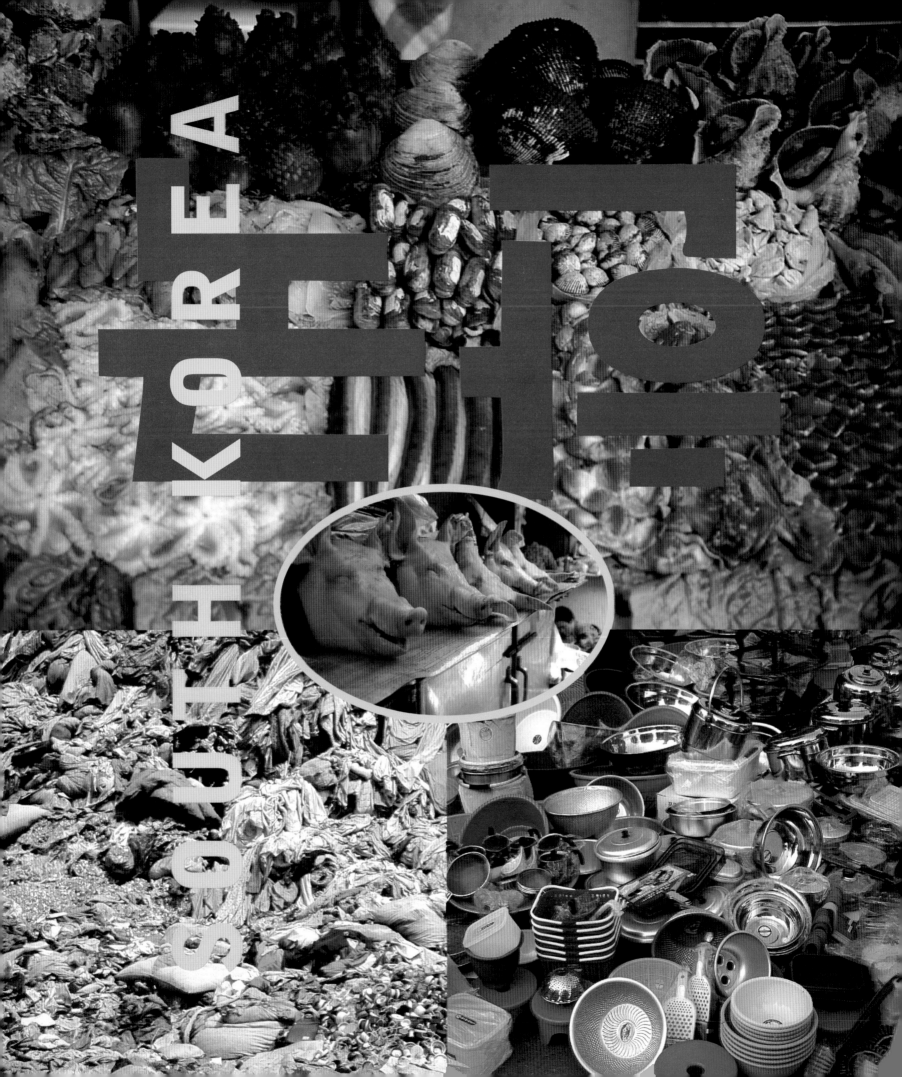

THAILAND ประเทศไทย

INDIA

Sheela Gowda

Bhupen Khakhar

Nalini Malani

Ravinder G. Reddy

N. N. Rimzon

Arpita Singh

TRADITIONS

CONTEMPORARY ART IN ASIA

TENSIONS

INDONESIA

Nindityo Adipurnomo

Arahmaiani

I Wayan Bendi

Dadang Christanto

Heri Dono

FX Harsono

PHILIPPINES

Agnes Arellano

Imelda Cajipe-Endaya

Reamillo & Juliet

Sanggawa Group

SOUTH KOREA

Cho *Duck Hyun*

Choi *Jeong-Hwa*

Kim *Ho-Suk*

Soo-Ja Kim

Yun *Suknam*

THAILAND

Montien Boonma

Kamol Phaosavasdi

Chatchai Puipia

Araya Rasdjarmrearnsook

Navin Rawanchaikul

Jakapan Vilasineekul

TRADITIONS

CONTEMPORARY ART · IN ASIA

TENSIONS

GUEST CURATOR

Apinan Poshyananda

ESSAYS BY

Apinan Poshyananda

Thomas McEvilley

Geeta Kapur

Jim Supangkat

Marian Pastor Roces

Jae-Ryung Roe

ASIA SOCIETY GALLERIES, NEW YORK

Published in conjunction with the exhibition
Contemporary Art in Asia: Traditions/Tensions
organized by the Asia Society Galleries, New York.

Contemporary Art in Asia: Traditions/Tensions is organized by the Asia Society. The international presentation of the exhibition is supported by funders including AT&T, Lippo-bank of Indonesia, the National Endowment for the Arts, The Andy Warhol Foundation for the Visual Arts, Agnes Gund and Daniel Shapiro, and the W.L.S. Spencer Foundation. Additional support for the exhibition and Asia Society Galleries education programs is provided by the Friends of the Asia Society Galleries, The Starr Foundation, The Armand G. Erpf Fund, and the Arthur Ross Foundation.

Special thanks to *ART AsiaPacific* magazine, Asiana Airlines, and the Indian Council for Cultural Relations.

Published by the Asia Society Galleries, New York.
Copublished in Australia and Asia by G+B Arts International.
Distributed in the Americas and Europe by
Harry N. Abrams, Inc.

Asia Society Galleries
725 Park Avenue
New York, NY 10021
USA

G+B Arts International
Distributed by Craftsman House
Level 1, 20 Barcoo Street
Roseville 2069 NSW
Australia

Harry N. Abrams, Inc.
100 Fifth Avenue
New York, NY 10011
USA

Library of Congress Catalog Card Number: 96-085888

ISBN: 0-87848-083-8 (Asia Society Galleries, paperback)
ISBN: 90-5704-09-13 (G+B)
ISBN: 01-8109-6331-0 (Abrams)

Front cover, page 8: **Chatchai** Puipia, *Siamese Smile* (detail), 1995, oil on canvas, 240 × 220 cm (94½ × 86⅜ in.), private collection. See page 181.

Photographs on pages 2–4, 6 are by Apinan Poshyananda, and photographs on page 5 are courtesy of Choi Jeong-Hwa.

Notes to the Reader

The preferred name order of each artist and author has been respected: in title type, given names are shown in italics, as in ***Soo-Ja* Kim** and **Kim *Ho-Suk***, in both of which **Kim** is the family name.

The exhibition will be reconfigured for each venue. A checklist is available upon request.

Contents

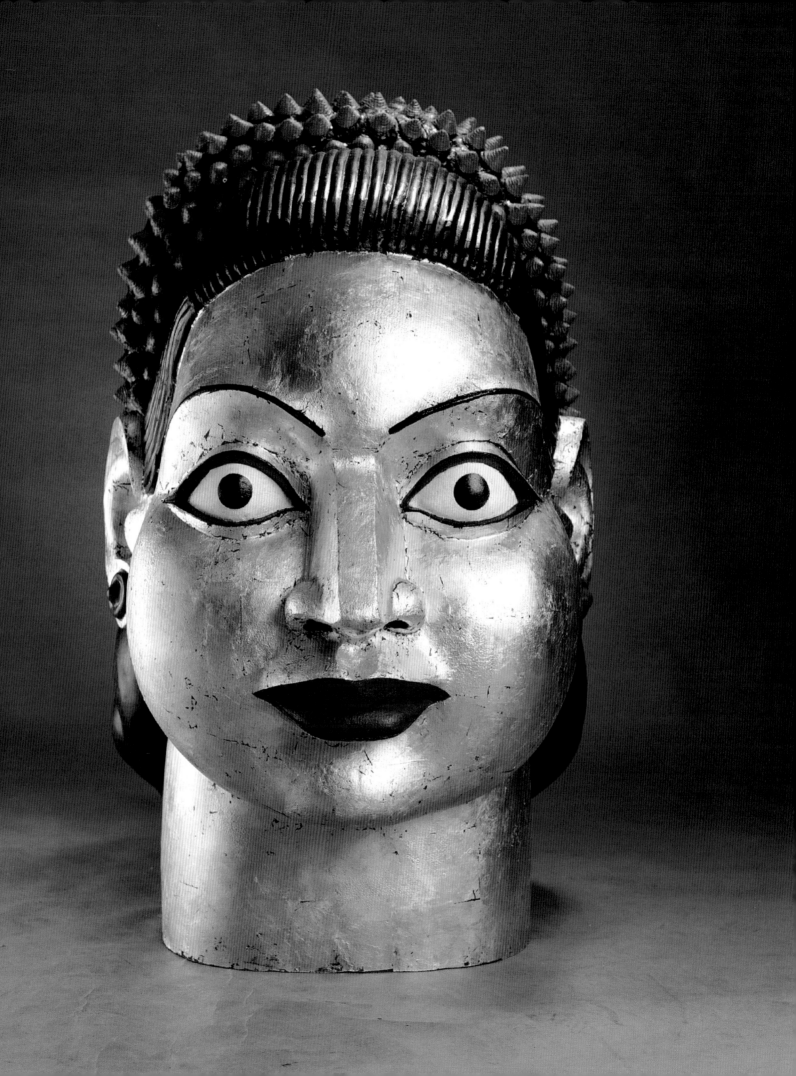

Foreword

Even a casual visitor to most countries in Asia is struck by the vivid juxtaposition of traditional elements and ultramodern forms. In India, saris woven by ancient techniques can be seen alongside mass-produced synthetic fibers; in Japan, elaborate Shinto rituals for weddings are performed with Western-style receptions; and in the Philippines, young artists pay as much attention to MTV Asia as they do to the indigenous music of the remote islands of their country. Artisans who practice age-old skills in making fine ceramics or bronze images are designated as "living treasures" in Japan or "master craftsmen" in India while urban contemporary artists tackle the latest video technology or construct elaborate installations. If, at times, this cheek-by-jowl occurrence of jarringly contrasting forms seems utterly incongruous, at other times, these highly dissimilar elements stimulate startling new expressions. The fact is this clash between traditional Asian culture and modern Western influences has been an integral part of Asian life for most of this century. This makes the phenomenon both familiar and central to the very fabric of life in many Asian societies.

Cultural hybridity—the mixing or juxtaposition of outside elements with indigenous forms and techniques—has been a key part of modern Asian art. In the Asia-Pacific region itself, there is a general awareness and understanding of this complex phenomenon, but in North America, this fundamental reality of the twentieth-century Asian experience is routinely misunderstood. In fact, in the study of Asian art history in most Western countries, twentieth-century art is not even considered. Rather, as anthropologist James Clifford points out, there is a privileging of the premodern, "traditional" past of Asia; this is defined as the only "authentic" artistic and cultural expression of the region.

It is always challenging to understand art made in and for a culture that is different from one's own. But, curiously, it is even more difficult to do this when the work looks deceptively similar to the forms one knows best. In the case of urbanized contemporary art from Asia, this paradox is exacerbated by the fact that its forms often challenge long-held Western perceptions about what makes it "Asian." The supposed "Asianness" observed by outside viewers generally turns out to be

simply that which contrasts with what is familiar to Western eyes rather than that which responds to it. As we approach the end of this century and prepare for the next, it is imperative that we go beyond such critical prejudices and begin to explore seriously the complex artistic realities that have long been part of Asian culture.

"Contemporary Art in Asia: Traditions/Tensions" has been organized as a key element in the New York–based Asia Society's relatively recent commitment to present all forms of the arts in Asia, including the most contemporary. The Asia Society has been known for its efforts to present the finest in historical Asian art but, in the past, contemporary art was not part of this program. And it is fortunate in some ways that "Traditions/Tensions" was not organized earlier. Past exhibitions of contemporary art from Asia have tended to highlight work from individual Asian countries; none really tried to address the contradictions or to encompass the extraordinary vitality of modern-day Asia. This exhibition, then, is part of a deliberate effort by the Asia Society to revise North American notions of Asian culture, contemporary as well as traditional.

"Contemporary Art in Asia: Traditions/Tensions" might be seen as a paradigmatic project for the postcolonial, postmodern age we live in. The exhibition consists of works selected from five Asian countries: India, Indonesia, the Philippines, South Korea, and Thailand. Most of the art has been created in the last five years or so, and is evidence of the cultural and economic upheavals in all of these countries. The slash in the title between the terms "traditions" and "tensions" is intended to suggest the dynamic forces at work. As curator Apinan Poshyananda aptly notes, words like "tradition" and "tension" become slippery as soon as you try to pin them down. In this case, the ambiguity is intentional. As with the fluidity of those terms, the aim of this exhibition is not to define in some fixed way, to classify the developments of contemporary Asian art into neat compartments. Rather, its goal is to suggest the current realities in Asia that make conventional antinomies such as "East/West" or "traditional/modern" somewhat outmoded. Works are organized neither by country nor by theme, but are juxtaposed in ways that can suggest

Ravinder G. Reddy
Head IV, 1995
Gilded and painted
polyester-resin fiberglass
120 × 74 × 103 cm
(47¼ × 29⅛ × 40½ in.)
Courtesy of the artist

visual and conceptual relationships that transcend national boundaries. Presumably, this will also demonstrate the range of local, national, and international issues influencing each individual artist.

The exhibition does not claim to provide an overview of all contemporary art forms in Asia: it presents instead twenty-seven artists and about sixty works, and looks at the ways these artists deal with their own sense of the past and attempt to move beyond a narrow version of traditional culture. Viewers hoping to discover a continuity of traditional Asian forms with no contemporary intervention will be disappointed. On the other hand, if these works are judged simply by the standards of the international contemporary art scene, something else will be missed. Certainly there are artists in this show who could be perceived as part of the Western neo–avant-garde; they make installations and use the latest theories. But the culturally specific references in their works are so potent that if these elements are not understood the works lose their basic power.

Among the current preoccupations of artists in Asia are changing attitudes toward indigenous cultural traditions, critiques of political and social conditions, comments on the place of religion in society, and reconsiderations of the role of women in historically patriarchal cultures. Such issues are addressed by the artists in this exhibition in various ways, depending on their individual preferences, their national preoccupations, and their historical circumstances. Thus, Montien Boonma, a Thai artist, can evoke the contemplative power of religion and the yearning for it, while the Indian artist N. N. Rimzon can use the transcendental form of an Indian icon to create a sense of dynamic tension, commenting on contemporary religion and politics. In different ways, they both provide powerful testimony to the pervasive influence of religion in contemporary Thailand and India, a situation that forms a striking contrast to North American attitudes toward religion.

This exhibition is being organized by the Asia Society as it celebrates its fortieth anniversary. In 1956, when the Society was established, its mission was to educate Americans about all aspects of Asian societies, from contemporary political systems to arts and culture. Although the Society offered forums that dealt with contemporary political, economic, and social realities, its programs in the arts and culture emphasized traditional, premodern Asian culture. Since 1990, however, the Asia Society has emphasized the need for

understanding and presenting the arts of our own time. Toward this end, the Society held a roundtable discussion in New York in 1992 and one in Bombay in 1994, bringing together scholars and critics from Asia, Europe, and North America to try to help us shape a new direction in presenting the art of living Asian and Asian American artists. "Traditions/Tensions" and several other exhibitions of contemporary art that are scheduled over the next four years are a direct result of such conversations with our colleagues. It is our hope that these efforts will have a catalytic effect on the North American art scene, and that artists from Asia will begin to be included routinely in other international ventures. One would hope that such exhibitions would be seen at more museums of modern and contemporary art as well. However, a special feature of presenting this exhibition to Americans at the Asia Society Galleries is that contemporary Asian art will be shown in a broad cultural context, making juxtapositions with historical artworks that the Society is uniquely suited to show.

As an educational institution dedicated to fostering understanding between Asia and America, the Asia Society has an obligation to play a part in redefining the field of Asian art history and cultural studies. One aspect of our mission is to help our audiences to better understand the complexities and contradictions of contemporary Asian art. We hope that "Contemporary Art in Asia: Traditions/Tensions" will help foster a change in Western perceptions of Asian art.

After opening in New York—at the Asia Society Galleries, the Grey Art Gallery and Study Center at New York University, and the Queens Museum of Art—the exhibition will travel to Vancouver, B.C., and then to Asia. Clearly, reactions will be different in each place. If New York and Vancouver audiences may learn about the dynamic vitality of contemporary Asian arts for the first time, in Bombay, Singapore, or Seoul visitors may gain a perspective on their neighbors not readily available in the region. It is hoped that the exhibition, through its tour, will not only open new vistas for American audiences but also will begin a new chapter in our understanding of a local/national/global discourse through the language of art.

Vishakha N. Desai
Vice President for Cultural Programs
Director of the Galleries
Asia Society

Preface

As the millennium draws to a close, the whirlwinds of political, economic, and cultural change have shifted direction ferociously. Artistic centers in the West, which once claimed to be the hubs of a powerful international art scene, have recently been challenged by decentered megacities in distant corners of the globe. Swiftly, attention has switched to places previously considered to be disconnected zones of silence located on the periphery. One major force behind these changes in world cultural politics has been the abrupt shift from a traditional East-West defense axis to a North-South trade axis. In this context, globalization is often seen as either a cultural gain or a challenge to traditional values.

In the posthegemonic era of Cold Trade War tensions, Asia has emerged as a region of great richness and prosperity; it provides a significant counterweight to the economic and cultural dominance of Europe and America. Moreover, Asia's cultural heritage and traditions have contributed to multifaceted Western fantasies through the invention of various Others and through the construction of degrees of self-consciousness and nationness. In Asia, however, highly revered traditions are often regarded as old treasures under threat from modernization, transformation, and materialism.

For museums and other cultural institutions, in particular, the idea of tradition promotes an exaggerated desire to protect the past from the impact of disruptive contemporary changes. More often than not, displays of tradition in these institutions reflect a form of cultural containment exercised through specific preconceptions and fixed terms. On the one hand, these collections tend to reinforce fictive imaginings of ancestry, nostalgic inheritance, cultural roots, heritage, and nationhood. On the other hand, they reflect the capacity of a dominant power to subjugate, plunder, and triumph over vulnerable subordinates. The collection of artifacts from other peoples' cultures and traditions has contributed to the perception that power often gives license to exploit, abuse, and ravage.

Since its founding in 1956, the Asia Society has been regarded with veneration as the place to display the treasures of Asian art. Classical and premodern traditions from Asia are spectacles that visitors and friends of the Asia Society expect to revere as they step inside the polished granite facade at 725 Park Avenue. There, they enter a cultural space where "Asia and America meet." Public programs encourage a mutual cultural awareness that might serve to deepen understanding between Asians and Americans. Through imaginative constructions of distant societies and cultures, specific visions of Asia are made available for audiences in New York. With its emphasis on highly venerated art of the past, however, the aura of Asiana emanating from the Asia Society is that of the nostalgic, heritage-conserving exhibitions of "great" collections.

For the first time in forty years, contemporary art from Asia is now being shown at the Asia Society in the exhibition "Contemporary Art in Asia: Traditions/Tensions." A key point of this project is to demonstrate that tradition should not be interpreted as the opposite of contemporaneity. In fact, in contemporary Asia, tradition extends across such vast heterogeneities and cultural differences that it has become essential for individuals to assimilate, adapt, and resist. Some artists regard the traditional as an inheritance that offers inspiration for their creative imagination. Others redefine and renegotiate tradition through cultural and regional identity in ways that can be challenging, innovative, and provocative. In either case, the Asia Society offers a grandiloquent backdrop for living Asian artists to display their creations in the context of extraordinary traditional objects. Moreover, as a cultural arena, the Asia Society is an ideal place for artists to intervene and arbitrate the fixity of such simplistic dichotomies as East versus West, Orient versus Occident, Asia versus America, us versus them, history versus modernity, tradition versus contemporaneity.

From the initial discussions in 1992 to the present moment, in mid-1996, "Traditions/Tensions" has swelled considerably. The exhibition has grown to three New York sites: in addition to the Asia Society, works will be shown at the Queens Museum and the Grey Art Gallery. From New York, the exhibition travels to venues in North America and Asia. The organization and preparation of "Traditions/Tensions" was also vast; I was compelled to meet artists and study their work at widely

dispersed nodal points throughout Asia: Bangkok, New Delhi, Jakarta, Seoul, Manila, Bombay, Bali, Baguio, Bangalore, Baroda, Banahaw, Calcutta, Fukuoka, Singapore, Bandung, Osaka, Sapporo, Chiang Mai, Tokyo, Yogyakarta, and Kwangju. I also crossed many time zones to see contemporary Asian art shown in "foreign" spaces, such as London, New York, Havana, Johannesburg, Venice, Copenhagen, Istanbul, Sydney, and Brisbane. Attending various exhibitions, seminars, and talk shops allowed me to learn not only the perceptions that Westerners hold of contemporary Asian art but also how Asian artists view themselves.

The thematic sinews of "Contemporary Art in Asia: Traditions/Tensions" are by no means confined to only five countries—India, Indonesia, the Philippines, South Korea, and Thailand. Rather, these particular countries are meant to serve as an elaborate backdrop of long Asian traditions which are now experiencing stages of intense transition owing to the impact of continually increasing globalization and rapid industrialization. "Traditions/Tensions" does not intend to tell the "whole" of the Other story. Rather, it attempts to bring a whiff of contemporaneity from living Asia. This may comprise the sweet fragrance of jasmine and an aroma of herbs or, at times, it may be mixed with the sharp fumes of gasoline or the stench of stale KFC fried chicken covered with slimy sauce.

Shifting polarities of traditions and tensions result in antinomies and contradictions of fixed perceptions of Asian exotica and cultural heritage. Some of the themes that emerge in this exhibition have been made more complex and intricate by the rapid and dynamic change rocketing through Asian societies. The dislocations in Asia today have resulted in anxiety, disorientation, and cultural dysfunction in capitals and megacities where cultural heritage and tradition are under threat. The body has become a symbol of both the self and the masses, anxiety and relief, sacredness and profanity, violator and victim. The preservation of traditional national, regional, ethnic, and religious allegiances has become a way for artists to express nostalgia or resistance to the "poisonous" West. Conversely, some artists react negatively to the stereotypical notion that their work must hark back to the old, highly exalted traditional values. Such a burden has been a source of inspiration for them to work against the cultural grain. Still, their choice of indigenous materials as means to subvert as well as to reinterpret tradition has resulted in

works that can be accepted as sacred and sensuous in one context and sacrilegious and distasteful in another.

Issues related to cultural difference and multiculturalism are central to this exhibition. Layers of hybridity, crossing, and intermixing of different ethnic, racial, religious groups, and classes are explored by artists in various ways. Ethnic groups, religious sects, postcolonialism, and patriarchal dominance are subjects that are deeply embedded in many of these artworks; through these issues, artists mirror the complexities of the contemporary in Asia. Marginalization and hierarchization, for instance, relate to the problems of appropriation and authenticity. A standard of excellence as a form of discrimination is raised by several artists who challenge Western preconceptions of contemporary Asian art as weak and derivative. At the same time, this exhibition poses the problem of defining excellence and how it is determined in different art infrastructures. For instance, oil painting, as a medium closely associated with Western art techniques, has been adapted as a way to critique postcolonial displacements and religious infatuation.

The voice of the suppressed raises questions of speech and silence, visibility and invisibility. Many artworks in this exhibition demonstrate the artist's reactions against authoritarian control and the deprivation of human and civil rights. Mental and physical violence also appear in many layers. Violence as a form of power wielded by individuals and groups is contrasted or compared to domestic and sexual violence. Forced labor and migration through the sex industry are expressed overtly by artists whose work focuses on issues of femininity.

As global powers are forced to deal with such shifting paradigms in politics, economics, religions, and cultures, it is hoped that "Contemporary Art in Asia: Traditions/Tensions" will contribute to different and challenging perspectives in the new world disorder. This exhibition of contemporary art from Asia aspires to change stereotypes and fixities. As if mixing paints from a color chart, "Traditions/Tensions" tries to blend a variety of tints and hues, from peril yellow to friendly copper and from sunburnt pink to pale white. In dealing with these numerous shades, there is a desire to attenuate and diminish the potency of the R- and X-ratings that, in this context, stand for racism and xenophobia.

Apinan Poshyananda
Guest curator

Acknowledgments

Presenting an exhibition is not unlike making a film. The initial idea may come from one person, but to turn that idea into a compelling reality takes the genius and dedication of many gifted people, most of whom work behind the scenes. When the exhibition opens to the public—if all of the parts have functioned well—it appears seamless to visitors. From the time that "Contemporary Art in Asia: Traditions/Tensions" was first conceived in 1992, a large group of people, both within the Asia Society and outside of it, have worked hard to make the exhibition an exciting reality.

When I first came to the Asia Society in 1990, I made it clear that arts of the twentieth century by Asian and Asian American artists should be an important part of the Galleries' exhibition program. Recognizing the hesitation of some of the senior members on the Galleries' advisory committee and being aware of the need to get a better grasp of the contemporary art world in many of the thriving cities in Asia, we decided that it would be best to develop our contemporary exhibition program slowly and deliberately. We began by organizing roundtable discussions among curators, critics, and scholars of contemporary arts in Asia as well as a select group from the U.S., Canada, and the U.K. The first roundtable discussion in New York, in November 1992, was closed to the general public but was both intense and illuminating. It was at that meeting that some of the parameters of this exhibition were first articulated. There was a general feeling that the exhibition should have a clear curatorial vision, with one person at the helm (contrary to the common practice in organizing shows of non-Western art of having different curators representing the individual countries). He or she could draw on the expertise of advisors, but the final selection would be up to the curator in charge.

From the start, it was clear that Apinan Poshyananda, with his training in the West (Cornell and Edinburgh), his keen mind and critical eye, and his commitment to put contemporary arts in Asia on the world map, was the ideal choice. This exhibition reflects his vision and his astute understanding of the art trends and critical issues in Asia at the end of the twentieth century. During the gestation period of the exhibition, Apinan became a father, and one of the most prominent curators of contemporary Asian art, while continuing his duties as an assistant professor and associate dean at Chulalongkorn University. All of these responsibilities have often made it difficult to keep track of Apinan, who has become a true globetrotter. The fact that he gave his primary commitment to the Asia Society show and fielded innumerable requests from our team with good humor and high spirits is a testament to his unerring belief in the importance of this exhibition. Because Apinan has always insisted on transforming conventional perceptions, all of us who have worked with him have been inspired to look at contemporary Asian arts with a new, more complex attitude.

Apinan traveled throughout the region and met with artists and curators and scholars. The group of country advisors, who also contributed major essays to this catalogue, deserve special thanks for being important members of the team: Geeta Kapur, India; Jim Supangkat, Indonesia; Marian Pastor Roces, the Philippines; and Jae-Ryung Roe, South Korea. Their insights and their advice were invaluable not only to Apinan but also to Galleries' staff members when advice was needed on locating a work of art or even an artist. I am delighted that Thomas McEvilley joined at a late stage to write an essay on his perceptions of the history of exhibitions of non-Western art in the West.

Many participants in the original roundtable discussions have continued to be part of our larger network of colleagues and friends. Apinan has thanked them also by name, but I would be remiss if I did not mention lively discussions with David Elliott, Gary Dufour, Kathy Halbreich, Tom Sokolowski, Geeta Kapur, Jim Supangkat, and Jae-Ryung Roe in New York, in Bombay, and elsewhere in Asia. These conversations have informed my own understanding of contemporary Asian art and strengthened the exhibition.

Although most of the works in "Contemporary Art in Asia: Traditions/Tensions" belong to the artists or have been specially made for the exhibition, several works come from public institutions and private collections. I should like to gratefully acknowledge all of the lenders who have agreed to part with their works for a

long international tour (as of the time of writing): Mr. Mahesh Chandra; Chulalongkorn University, Bangkok; Foundation for Indian Artists, Amsterdam; Chester and Davida Herwitz; Kapil Jariwala Gallery, London; John H. McGlynn; Mrs. Padmini Reddy; Singapore Art Museum; Mr. Sharad and Dr. Mahinder Tak; and several private collectors. Subash Kapoor, of Art of the Past, lent an historical work to the New York showing.

At the Asia Society, the small but enormously dedicated staff of the Galleries has worked tirelessly to produce miracles against all odds, as did many free-lancers and contractors. Joseph N. Newland, our publications manager, has managed to maintain his sense of humor and again produce a handsome book in keeping with the spirit of the program. He was ably assisted by Merantine Hens-Nolan, Galleries associate, who also expertly coordinated all of the exhibition graphics and related printed materials. Joseph assembled a first-rate catalogue team that consisted of Brian Wallis, whose insightful editing was remarked upon by all of our authors; Philomena Mariani, who is appreciated for her diligent editorial inputting and proofing; Amie Cooper, who coordinated the production with skill and grace; and Bethany Johns of Bethany Johns Design, to whom we owe the book's stunning graphic design. Photographers are credited elsewhere, but special commendation goes to Manit Sriwanichpoom for his many sensitive interpretive photographs. We appreciate the work of this skilled team and hope that as their reward this book will become an important publication in the burgeoning field of Asian contemporary art.

The organization of this exhibition may be one of the most daunting and complex tasks ever undertaken by the Asia Society. I must admit that at times I really wondered if we were up to the challenge. But the entire staff of the Galleries along with many outside members of our exhibition team has pulled the project off. Jane S. Tai, contracted as exhibition coordinator, provided not only organizational support but, as importantly, her calm wisdom, which soothed frail nerves. Tucker Nichols, Galleries associate, became an amazing details keeper, making sure that we had the necessary information from all of the artists and lenders and coordinating all of the minutiae for the installation. Gen Watanabe picked up data wherever and whenever they seemed in danger of getting lost. Amy McEwen, our registrar, while busy with two exhibitions of our permanent collection, nonetheless provided much needed advice regarding the shipping of artworks from Asia. Alexandra Johnson, with her usual aplomb, managed the details of the exhibition opening and also the artists' stays in New York. Mirza Burgos, as usual, handled my crazy travel schedule and other aspects of my involvement with the exhibition with a great deal of dedication and care. Dawn Draayer, senior development specialist, and Alison Yu, development specialist, assiduously sought the funds necessary to support the exhibition. Linden Chubin, senior program associate, and his able assistant Ann Kirkup helped develop the public programs, while Nancy Blume coordinated the educational programs for schools with colleagues from the Queens Museum and from the Grey Art Gallery. Heather Steliga Chen and her colleagues in public relations worked closely with the media throughout. Special thanks go to former curator Denise Patry Leidy and to Caron Smith, our present associate director and curator, both of whom worked to make sure that the exhibition was on target.

On behalf of the staff of the Galleries, I would also like to acknowledge our heartfelt thanks to the president of the Asia Society, Nicholas Platt; the executive vice president, Marshall M. Bouton; and the board of trustees for supporting this bold and unprecedented move. After this exhibition, it is hard to imagine that the Asia Society Galleries will ever again be able to ignore the contemporary arts of Asian or Asian American artists. It is nice to know that the leadership of the institution has thrown its weight behind this initiative.

The staff of the Asia Society has worked closely with our colleagues at the Grey Art Gallery and Study Center, New York University, and at the Queens Museum of Art, our partners for the New York presentation of the exhibition. Tom Sokolowski, who recently left the Grey to become the new director of the Andy Warhol Museum, was not only an early supporter but also a constant source of advice. He signed on to have a part of the exhibition at the Grey Art Gallery, showing his long-term commitment to contemporary arts from beyond the Euro-American axis. Wendell Walker, gallery manager, became the exhibition designer for all three venues and served as an integral part of the exhibition team. Frank Poueymirou, now acting director, also became an active participant. We are particularly grateful for his incorporation of the exhibition into their World Wide Web site.

The Queens Museum of Art has become a well-known player in the development of interesting and provocative exhibitions of contemporary art and in their steadfast commitment to the development of programs with strong community involvement. We are most pleased that the museum joined in presenting the exhibition in New York. Our special thanks to Carma Fauntleroy, executive director, and Jane Farver, director of exhibitions, for their active involvement and for their advice with a number of things, including finding ways to make the visiting artists feel comfortable during their sojourns in New York. Their staff, from the public relations department to the education department, have all worked closely and collaboratively with their colleagues at the Asia Society.

It is heartening to note that three very different institutions, with distinct organizational cultures, audiences, and locations, can actually come together to present one show. The credit for this smooth collaboration goes to all those involved, who were able to rise above institutional constraints and proclivities for the sake of presenting the show in the best possible manner.

Such complex exhibitions are an expensive undertaking and require financial support from a number of different sources. We are especially grateful to AT&T, the Andy Warhol Foundation for the Visual Arts, and the W.L.S. Spencer Foundation for their early and generous support of the project. The National Endowment for the Arts provided a crucial grant and the Lippobank of Indonesia became one of the corporate sponsors of the project. The Friends of the Asia Society Galleries, The Starr Foundation, The Armand G. Erpf Fund, and the Arthur Ross Foundation provide ongoing support for the activities of the Galleries.

We are delighted that the exhibition will travel to the Vancouver Art Gallery in Vancouver, British Columbia, Canada. It was Gary Dufour, then chief curator there and a participant in our roundtables, who first became a chief supporter of the exhibition and pushed hard to present it to the growing Asian population of that city. J. Brooks Joyner, director, and Daina Augaitis, the current chief curator and associate director, have enthusiastically endorsed the initial idea and have worked hard to make the exhibition presentation in Vancouver as powerful as possible.

The exhibition will also travel to several major urban centers in Asia. It is hoped that by having exhibitions such as this shown at institutions in different parts of Asia, we will begin to address many of the global cultural issues that now confront contemporary art and life.

Last, but definitely not least, our deepest thanks and gratitude go to the artists themselves, the stars of the exhibition, as well as to their assistants and dealers. Without the creative energy and cooperation of these twenty-seven artists, it is unlikely that the exhibition would have come together at all. We will no doubt organize other major exhibitions but I daresay that none will surpass this one for its intense, collaborative energy. I am proud to participate in presenting their art to the North American public. If the work of these dedicated and talented artists fills even a small gap in the enormous lack of knowledge about contemporary Asian culture that exists in the United States, the project will have been well worth it.

V.N.D.

Much of the credit for instigating the exhibition "Contemporary Art in Asia: Traditions/Tensions" must go to Vishakha N. Desai, director of the Asia Society Galleries. In our first encounter, at the Dusit Thani Hotel in Bangkok in 1992, Vishakha shared with me her dream: to create a dazzling, innovative exhibition of contemporary Asian art at the Asia Society in New York. With her advice, guidance, and encouragement, I have undertaken the task of organizing this exhibition. Although it has not always been easy, I am thrilled that I have been able to play a part in making Vishakha's dream come true.

My second large debt is to the more than one hundred artists from various parts of Asia with whom I engaged in dialogue and debate during my research for this exhibition. I have learned much from them. To all of them I extend my heartfelt gratitude.

I must give special thanks to my advisors, who have contributed enormously throughout the project. Their time, patience, and valuable advice have allowed me to appreciate Asian art from many perspectives. I am indebted to Geeta Kapur, Jim Supangkat, Marian Pastor Roces, and Jae-Ryung Roe. Tom Sokolowski, former director of the Grey Art Gallery and Study Center, New York University, and now director of the Andy Warhol Museum in Pittsburgh, has consistently given constructive advice and it has been a pleasure working with him. I also wish to offer my warm thanks to various people who, since the earliest stages of "Traditions/Tensions," have imparted sound wisdom and insight: Toshio Hara, Kim Levin, David Elliott, Michael Meister, Gary Dufour, Gulammohammed Sheikh, Raiji Kuroda, Doug Hall, John Clark, Dinah Dysart, Alice Guillermo, Kanaga Sabapathy, Kwok Kian-Chow, and Eric Torres.

I owe a great debt to various museums, cultural institutions, universities, and galleries that facilitated my research on Asian artists. The Art Gallery at Chulalongkorn University in Bangkok staged the exhibition "Thai Tensions" in 1995, which I curated and which included the Thai artists in "Traditions/Tensions." Charas Suwanwela, Thienchai Kiranandana, Surapone Virulak, and Chumnong Sangvichien of Chulalongkorn University have been particularly supportive, both for me and for the Thai artists. I also wish to express my gratitude to Silpakorn University, Chiang Mai University, Bangkok University, and the National Gallery of Art, Bangkok. Manit Sriwanichpoom, with his expertise in photography, has been a great asset.

My research in Manila would not have been possible without assistance from Pinaglabanan Galleries. I especially want to thank Michael Adams, Agnes Arellano, and Glenda Puyat for their kindness and enthusiasm. I also wish to thank Bobi Valenzuela and Didi Dee from Hiraya Gallery for introducing me to many exciting artists in the Philippines. It gives me particular pleasure to acknowledge the support that came from the Cultural Center of the Philippines, the Metropolitan Museum, the National Commission for Culture and the Arts, the Nayong Pilipino, and the Baguio Arts Guild.

As a member of the international committee for the Non-Aligned Countries Art Exhibition that was held in Jakarta, Indonesia, in 1995, I received enormous assistance from the Non-Aligned Countries organization. I wish to extend special thanks to Edi Sedyawati, Jim Supangkat, and A. Pirous for their support. In Jaarsma, I received assistance from the staff of the Cemeti Art Gallery. I also wish to thank FX Harsono, Krisna Murti, and Wayan Sika for their help during my visits to Jakarta, Bandung, and Bali.

In Seoul, I received kind assistance from Jae-Ryung Roe, who not only arranged meetings with Korean artists but frequently acted as translator. I also want to acknowledge support that came from the National Museum of Contemporary Art, the Seoul Sonje Museum, Kukje Gallery, and organizers of the Kwangju Biennale. In addition, I wish to thank Rhee Jong-Soong and Kim Sun-Jung for their advice on the contemporary art scene in Korea.

Geeta Kapur and Vivan Sundaram gave tremendous support during my research in India. They introduced me to a wide range of exhilarating Indian artists. In Baroda, I received helpful advice from Gulammohammed Sheikh and Nilima Sheikh. In Bombay, a number of people who gave valuable support were Shaila Parikh, Kamala Kapoor, Gieve Patel, and Shireen Gandhy.

I would like to acknowledge special thanks to the Mohile Parikh Centre for the Visual Arts, Gallery Chemould, Sakshi Gallery, Vadehra Gallery, and CIMA.

I am grateful to various art organizations and cultural institutions that gave me opportunities to gain experience in contemporary Asian art in international arenas. Doug Hall, the director of Queensland Art Gallery in Brisbane, has been most generous in inviting me to be advisor for Thailand for the First Asia-Pacific Triennial of Contemporary Art in 1993, and curatorial coordinator for Australia for the Second Asia-Pacific Triennial. I wish to thank Christopher Till and René Block for allowing me to curate the Thai section in the Johannesburg Biennale and Istanbul Biennale, respectively (both 1995). I learned an enormous amount while working on the exhibition "TransCulture" at the Venice Biennale in 1995, and I send special thanks to Fumio Nanjo and the Benesse Corporation.

My very grateful thanks go to the staff at the Asia Society Galleries who have been delightful and great fun to work with: Joseph N. Newland, Merantine Hens-Nolan, Tucker Nichols, Amy McEwen, Linden Chubin, Gen Watanabe, Mirza Burgos, and Alexandra Johnson. Special thanks to Jane Tai too.

I sincerely thank Jane Farver of the Queens Museum of Art and Wendell Walker of the Grey Art Gallery, who contributed immensely to making an expanded "Traditions/Tensions" become a reality in New York City.

I extend my gratitude to Stanley O'Connor and Benedict Anderson, whose insight and wisdom have been inspirational since those early days in Ithaca.

Lastly, my deepest thanks to my wife, mother, and grandmother, who have given priceless moral support for my work. My thanks go to my son, Nath, who introduced me to the Mighty Morphin' Power Rangers and Ninja Megazord. I appreciate his interruptions during my work and I forgive him for destroying three computers in the course of "Traditions/Tensions."

A.P.

Apinan Poshyananda

ROARING TIGERS, DESPERATE DRAGONS IN TRANSITION

The Invention of Tradition, the Delayering of Tensions

Asia: its dynamism is matched only by its diversity. Asia is serene and sickly, seductive and sadistic, desirable and destructive, tranquil and traumatic, democratic and despotic, oriental and disoriented, and much more. There are so many sides to Asia that it can be at times elusive, confusing, and contradictory. Global capitalism and global telecommunications have recently added new dimensions—as well as misapprehensions—to the image of Asia. But the widespread despotism, war, civil tumult, and xenophobia have, for the most part, been obscured by the Pax Asiana, a veneer of relative regional friendliness and willingness to cooperate in local economic growth, trade, industry, and peace.

Asia is often projected as the alterity of Western centers. But this view of Asians as "Others," invented and interpreted by Westerners in search of their own identities, has been widely debated. Indeed, the desire to study, understand, and control the Other under the umbrella of Western hegemony has become something of a cultural industry in itself, spawning a proliferation of academic theses and critical discourses. These Western polemics allow for a stance of supposed superiority, in which possession of knowledge and information provides the power to dominate, restructure, and authorize. Terms slip and slide according to their application and interpretation. The power of language, mediated through the discourse of academic institutions and systematic discipline, facilitates these processes of dominance, restructuring, and authority and allows them to function according

to the desires of those who control and apply them. Therefore, it is no surprise that overused terms like "the Orient," "the Oriental," and "Orientalism" still provide the vocabulary for those who desire to make basic distinctions between East and West.

Literary scholar Edward Said famously defined Orientalism as a style of thought based on an ontological and epistemological distinction of positional superiority.[1] This insight has alerted many readers to the complexities and power relations of cultural analysis but it has also generated considerable controversy. For one thing, the term "Orientalism" differs according to time and place. Its application and meaning has now expanded from the Islamic lands around the Mediterranean to include various regions around the Indian Ocean and the South China Sea. A second problem is the notion of the world divided into unequal halves, Orient and Occident. These naturalized geographical metaphors ground the ideological construction of Others in a specific substance and credibility, what literary theorist Homi Bhabha refers to as "fixity." For Bhabha, fixity and stereotyping are the key signifiers of cultural, historical, and racial difference.[2]

But we might ask: How do these fixed and stereotyped Others look at themselves? Do they construct identities based on postcolonial discourses rooted in specific histories of displacement? And, if so, do terms like "multiculturalism" and "multiple identities" have the same translations and meanings when applied to specific points in non-Western contexts? Do the Others present themselves as objects of desire and obsession balanced between fantasies of origin and

identity? Can their "authentic" origins only be grasped through the specific constructs of their own traditions (thereby creating a shell of protection and sometimes the most defensive reactions against their Otherness)? Or, conversely, as we move toward the new millennium, does the New World Order simply remap and hierarchize Western and non-Western civilizations? Will political economist Samuel Huntington's prediction of a future clash of civilizations through the conflict of cultures dominate global politics? Is it the intention of Western (i.e., Euro-American) nations to heed Huntington's warning and keep its opponents weak and divided? For example, will the West attempt to maintain cultural domination by exploiting differences and conflicts among Confucian and Islamic states?[3]

Or, will the clash between Western modernism and Eastern thought arouse further anti–Euro-American sentiments among Asians? For instance, Asian leaders often remark, as Malaysian Prime Minister Mahathir Mohamad and Japanese Premier Shintaro Ishihara do in the book *The Voice of Asia* (1995), that the Western sense of superiority reflects the racial prejudice that underlies white society. Mahathir, in particular, stresses that these Caucasian attitudes of superiority to nonwhites are "a racial and cultural phenomenon, not a matter of religion." He adds, "If you point this out, Westerners, particularly Americans, deny it vehemently, but this reaction itself proves that the attitude persists…Westerners cannot seem to understand diversity, or that even their own civilization values differed over time."[4] And Ishihara says about racial prejudice, "At the root of European and American racism, I am convinced, is their worship of a monotheistic God the Creator who disparages other deities and regards people who have not been 'saved' as damned."[5]

Such urgent political questions have their basis in Orientalist structures and Asianizing systems that have a long history in Western academic traditions and European cultural imperialism. To varying degrees, the French, the British, the Spanish, the Portuguese, and the Dutch each exerted superiority over Oriental and Asian backwardness during the era of colonization.

Until recently, Central Asia, Asia Minor, Southeast Asia, Indochina, and China were endless terrains of exploitation by the European hegemony. For North Americans, territorial and cultural dominance in Asia and the Orient were mainly associated with Japan, Korea, Indochina, and Southeast Asia. These shifting political interests have generated sharp differences in the changing interpretations of Asia, the East, and the Orient among Europeans and Americans, each new view depending on the particular historical context. It is necessary, therefore, to resist a totalizing view of Orientalism or a treatment of Asianization as a monolithic, developmental discourse that uniformly constructs the Orient, Asia, and the East as the Other of the Occident, Euro-America, and the West.

As various scholars and academics have pointed out, the binary opposition of Occident and Orient is both limited and misleading in that it tends to overlook specific layers of differences and inconsistencies.[6] There are, in fact, various kinds of Orientalisms which exemplify discontinuity and disruption and in many ways defy a static dualism of identity and difference. The French colonial experience in Indochina, for instance, left quite different marks, scars, and memories than the British imperialist rule in India, Burma, Malaysia, and Singapore. There were—and still are—multiple systems of knowledge which act as grids, allowing certain images of Asia and the Orient to enter Western consciousness and filtering others.

Stereotypes and prejudices die hard. Exoticized Western representations of Asians frequently portray them as sensuous, melancholic, weak, unintelligent, and derivative. Stereotypical generalizations project all Indians as subaltern, all Chinese as Communists, all Muslims as fundamentalists, all Arabs as religious fanatics, all Japanese as trade enemies, and all Vietnamese as old foes (but more recently, new friends). Disparities between East and West, distinctions between Orient and Occident often become popular or academic clichés. Knowledge of the Orient and Asia helps to improve, enhance, and deepen the differences through which Euro-Americans extend their power over these regions.

Geopolitics, cartography, and mapping inform us of territorial, religious, racial, ethnic, and cultural divides. For the sake of convenience, we maintain old descriptions of geopolitical regions, even if they were originally invented to preserve the domination of colonizers over the colonized.[7] Imagined communities and complex maps created by cartographers and historians dissect, separate, and dislocate territories and borders as well as races and inhabitants.[8] Often, selective scrutiny can warp reality, but, then again, reality is sometimes overrated.

The much-touted New World Order, for instance, has proven to be full of disorder, chaos, and catastrophe. Through the veils of post–Cold War ideology and the new world information order, power is supposedly dispersed and decentralized, allowing for an unprecedented free play of pluralism and heterogeneity. But global television and information technologies have effectively restructured a new pattern of geopolitical domination based not on wealth but on access to information. At the same time, a powerful and seductive influence, achieved through cultural information industries, has disseminated Western values throughout the world at the expense of local traditions and cultures. These electronically transmitted media have no boundaries or allegiances and tend to mold and standardize tastes, fashions, and beliefs to fit universal models. Through instantaneous information, this new cultural hegemony reinforces old stereotypes and undercuts the power to unfix and liberate the mind.[9] Specifically, this system reinscribes the old binary divisions: tribalism versus universalism, nationalism against imperialism, Third World and First World, Occident and Orient. But what is most subtle in this vast international paradox is the way in which the constant recontextualizing between local and global perspectives that attracts subsidiary players as intricate parts in the balance of power also serves as a strategy to observe and regulate regional cultures and politics. In theory, the bigger the global village, the more powerful its smallest players.[10] Unfortunately, however, the inherent hierarchization in the New World Order often results in a proliferation of relatively powerless subcultures which are perceived less as equal partners than as splinter groups of "thems," as potential "enemies," or simply as disconnected chips in an inscrutable mosaic.[11]

Classical Thai dancers sip Cherry Coke and chat on cellular phones while devotees make offerings at the sacred shrine of Brahma. Worshippers of the Black Nazarene at Quiapo Church buy herbs, charms, and lottery tickets before eating at Jolli Bee and Dunkin' Donuts. Digital images of Ganesh flicker on electronic advertisement screens outside Churchgate Station while "Made in India" by the disco queen Alisha plays full blast. *Sadhus* (wandering hermits) preach and chant hymns on religious ecstasy. Verses from the sacred Al-Qur'an reverberate from Istiqlal Mosque while outside youth sway to "marginalized" music by Iwan Fals. Dizzying decentered centers with rich traditional histories, such as Bangkok, Manila, Bombay, and Jakarta, are fast becoming alternative spaces of exchange and dialogue in contemporary art and culture. While the traditional Western art centers seem drained of life or hung over from political correctness, Asia is emerging as a challenging new arena for art discourse as well as art business. This is why the young biennales, triennales, and art expos in Kwangju, Osaka, Chiang Mai, Baguio, Dacca, New Delhi, Fukuoka, and Sapporo are now major events for artists—even though the organizers sometimes lack expertise, preparation, or funding. More important to artists and audiences are the off-centered excitement that is created and the challenges that are presented by particular sites. Layers of tradition and powerful divergent forces overflow from these nodal points. Places of contradiction, tension, and disorientation, these new artistic centers reflect the paradoxical world of disorder we live in.

In Asia today, huge megacities like Jakarta, Bangkok, Bombay, Manila, and Seoul face the dilemma of preserving their "true" cultural heritage while striving to catch up and compete with the rapid economic and technological advances of the West. As a result, the main tactics for cultural rejuvenation become nostalgia for past traditions and attempts to restage

authenticity in response to external dominating forces. In these attempts to preserve "authenticity" at all costs, defenders of tradition often resort to standards of cultural purity as the goal (or excuse). External threats are projected as poisonous, degrading filth from the materialistic West that will corrupt the pure and innocent mind of the spiritual East. Egocentrism, materialism, individualism, and intellectualism are characterized as debased Western tendencies that endanger so-called Eastern values, such as spiritualism, harmony, togetherness, and refined manners. Local governments and Asian specialists from abroad even stage cultural rescue missions to try to save the "true" and "original" culture. Indigenous juices are squeezed to the last drop to in order to reinvent traditions. Meanwhile, however, the megacities portend an apocalypse, brought on by global epidemics, industrial pollution, labor migrations, and population explosions. The price of each city's greatness is derived from an uneasy tradeoff between vitality and chaos, health and disease, enterprise and corruption. In describing these new megacities, urban theorist Eugene Linden writes, "This delicate balance always threaten to tip, and when it does, cities can spiral into an anarchy that defies all attempts at reversal."[12]

This exhibition, pointedly called "Traditions/ Tensions," looks at the work of twenty-seven artists who live at various nodal points in five Asian countries—India, Indonesia, Thailand, the Philippines, and South Korea. The principal subject that these artists examine is the way that constraints or differences are enacted within the fixity of "true" or "original" cultural traditions. Not surprisingly, each of their countries presents a rich historical and traditional backdrop as well as complex national and cultural differences. The long traditions of these societies are embedded with underlying tensions which are often overlooked. Cultural diversity and national identity tend to arouse fictive versions of art and culture enclosed within homogenous wholes of exotic, tranquil, timeless Asia.

Postcolonial identity, as a process of self-reflection, becomes a persistent questioning of this frame and the space of representation.

"Traditions/Tensions" attempts to make visible certain objects of the gaze that have been overlooked or neglected by art history, art exhibitions, or art criticism. This exhibition attempts, in Homi Bhabha's words, "to look at invisibleness."[13] The work of these Asian artists makes the cultural transformations of our time visible, not only for Western eyes but for the Asian gaze as well.

"Traditions/Tensions" does not aim to be a concise survey of the art of these five Asian countries. Nor does the choice of artists from these countries necessarily mean that they are the most renowned contemporary artists from Asia. Terms such as "tradition" and "tension" slide around like warm grease the moment any attempt is made to define their scope and meaning. Further complications arise when these concepts are translated into languages other than English, including Thai, Indian, Tagalog, Bahasa, and Korean. The title "Traditions/ Tensions"—with the two words separated by a slash—indicates a binarism which may either compliment or contradict specific works in the exhibition according to its interpretation. The slash in "Traditions/Tensions" may cut across the boundaries of these nations, which share an overarching theme regarding problems of tension and hierarchization in relation to cultural and traditional fixity. For instance, when various orientalizing systems interpret the constructions of Asia, their analyses may reveal tensions in various forms: tradition versus modernity; multiculturalism versus multimodernism; race/skin versus gender/class; religion/myth versus egotism/materialism; postmodernism versus postorientalism; globalism versus localism.

The societies of these newly developing and postcolonial countries are in a constant state of flux and transition. For many of them, traditionalism—preservation of indigenousness and the cultural heritage—is the primary goal for their national culture. But when the national culture is seen as part of political formulation, it becomes not only a process of production but also a product. Thus, the production of the national culture confirms the stability and security of the nation. It is no surprise that "selling"

Apinan **Poshyananda**

culture is part of the culture industry package that also supports national political ideals and economic goals. As historian Eric Hobsbawm has pointed out, traditions that appear old or claim to be old are often quite recent in origin, and sometimes they are merely invented.[14] Frequently, traditions are imagined or constructed by cultural institutions or other promulgators in order to inculcate certain values and norms of behavior by repetition. The invention of traditions, characterized by references to an often indeterminate past, involves a process of formalization and ritualization that seeks to evoke nostalgia by recalling "old" or "original" values. Imposing repetition on customary practices (such as the annual celebration of national heroes or members of the royalty, festivals related to historical events, and cultural events related to indigenous and tribal communities) transforms them into part of the national culture. Through various means, art and culture have been adapted to serve in the propagandistic promotion of national identity. In Asia over the past decade there has been a revival of traditionalism: ancient artifacts have been widely used to construct invented traditions of a novel type for novel purposes.

Traditions imply timeless, unchanging, fixed practices. Within Asia's ancient traditions are many interwoven layers of religion, faith, and myth. At times, these traditions act as a force to disseminate or to reinscribe power. For example, they serve to extend the patriarchal dominion of men in Asia's already largely phallocentric societies, in which women, children, and the aged play only supporting roles. However, when the rapid transformation of a society weakens or threatens the social patterns of "old" traditions, some form of adaptation and flexibility must occur. If the society is unable or unwilling to compromise the old traditions, new ones must be made. As a consequence, the multifaceted societies of Asia reflect countless layers of hybridity, crossing, and intermixing of different ethnic, racial, and religious groups. This "cross-breeding" is reflected in the works of contemporary Asian artists and may explain why they do not fit neatly into the images of Otherness constructed according to Western paradigms.

Tensions, frictions, and dislocations emanating from various sources may reveal connecting threads in what initially seems unrelated or disjointed. For instance, attempts by various Hindu, Islamic, Christian, and Buddhist groups to pressure artists into not depicting certain subjects or addressing particular contents have caused underlying tensions and antagonisms. On another level, serious political issues, including famine, disease, violence, crime, migration, prostitution, and pollution (especially in megacities), have caused many artists to respond with pessimism. Other tensions center on race and gender. The patriarchal structure of most Asian countries has restricted the voice as well as the visibility of most Asian women artists. The positioning of women artists in this exhibition is intended to rectify this matter somewhat by encouraging the role of Asian women as speaking subjects rather than mute objects.

But, perhaps surprisingly, the social conflicts that have prompted the works in this exhibition have not always produced angst-filled images. Tensions do not always prompt a heightened sense of crisis; tensions can be interpreted as a creative force. The use of symbolic marks or even the choice of materials may have political meaning; medicinal herbs, ritual offerings, and cow dung may be sensuous and sacred in one context but sacrilegious and distasteful in another. In effect, the artist's choice of medium can be seen as a subversive sign or as an attempt to divert domination from so-called art centers. Painting on canvas, woodcarving, video, installations, and site-specific works are treated by artists from diverse cultural backgrounds that demand reinterpretation according to context.

Contemporary art from Asia should be considered in the context of its sites and venues. If we return to the concept of Asia and Otherness, for instance, can we expect the criteria used to perceive the artworks in this exhibition to be universal? Are viewers entering "Traditions/Tensions" in New York City expected to be knowledgeable enough about Asian history, politics, and culture to understand contemporary art from Asia? Are these works potent and engaging enough to be measured against those

produced from the so-called center of New York? Does "Traditions/Tensions" aim primarily to attract hyphenated Americans with racial and emotional ties to exotic Asia? Or does it intend to plug America into the cultural crossroads in Asia at the time when America is entering a phase of "limited internationalism"?[15] Does it fit into Samuel Huntington's argument about the forthcoming "clash of civilizations," the supposed conflict brewing between Western (American) and non-Western (Islamic, Confucian) civilizations? Or is this art project part of an ongoing scheme for American cultural dominance in Asia?

As a guest curator, living in Asia, such questions have nagged at the back of my mind frequently over the three years I have worked on this project. I have wondered: How will the exhibition be received by American and Asian audiences? Will the message be properly conveyed and understood? How open-minded is the so-called high-powered mainstream art center? Does the stereotypical concept of "fixity" always predetermine conceptions of the derivation, imitation, and appropriation of artworks from Asia and the Third World?

The notion of tension runs through many of the artworks in this exhibition, and occurs in the texts, as well as a means of explaining "invisible" contents or behavior. The aim is not necessarily to reduce tension. Rather, the tangled and intertwined issues regarding Asian traditions and tensions may highlight, overlap, or aggravate certain issues already percolating within the layers of American traditions. Yet, at different sites in Asia, the delayering of traditions/tensions might be interpreted with varying intensities. In one place, the contents or issues addressed in a certain work might be seen as part of the norm, while in another, "foreign" space they may be received in quite the opposite way. The thrill of "Traditions/Tensions" lies not only in selecting Asian artists who are virtually unknown in the West to present their works to an American and Canadian audience but also in traveling this exhibition to cultural crossroads in Asia: there traditions become "real" and exhibitions such as this can form a backdrop for interactive dialogue between art centers within the region.

By confronting these issues, perhaps we can understand more clearly the cultural hybridities that emerge in moments of transition and transmutation. In the process, the concept of homogenous national Asian cultures seen through consensual art traditions can be redefined. Indonesian installations that represent the violence and burden of postcolonialism can be contrasted to Korean history painting of resistance during the colonial period; Philippine mural painting that makes allegorical reference to the Roman Catholic faith can be compared to a Buddhist-inspired medicinal-herb installation from Thailand or a cow-dung painting from India; the native female body is examined as the focus of sexual desire and physical abuse in works by Indian, Philippine, and Korean artists. This is not the "clash of civilizations" that Huntington fears; it is the chink and clang of the heterogeneities and hybrids that make contemporary art from Asia so full of surprises and expectations.

Gazing at Invisibility and Homogenous Empty Time

"The question amounts to knowing whether the Orient yields to interpretation," wrote Eugène Fromentin, the French writer and painter. "To interpret it is not to destroy it....The Orient is extraordinary....It escapes conventions, it lies outside all disciplines, it transposes, it inverts everything....I do not talk here of a fictional Orient."[16] Literature and the visual arts have been potent tools in the sieving and filtering of the Oriental Other. Although the Orient to which Fromentin was referring in 1858 was not Asia, his struggle to come to terms with the Orient of the Ottoman Empire, the Holy Land, and the Near East is a classic example of a Western encounter with alien cultures. In fact, struggles to interpret the Orient through the creative powers of the artist were a major trope in the construction of exotic Others. The multiplicity of the Orient was often projected through imaginative scenes and situations where the artist's gaze offered the viewer a glimpse of romanticism and exoticism.

The Western colonization of Asia resulted in the construction of similar images of otherness

and desire. In Asia, however, it is notable that many native artists adopted the paradigms and techniques of Western art. For instance, the Indonesian painter Raden Saleh (1807–1880) produced heroic scenes and royal portraits that conformed to the conventions of nineteenth-century European Romanticism.[17] Similarly, the Philippine artist Juan Luna (1857–1899) created historical paintings that portrayed heroic groups of blood-stained figures bound up in mortal combat.[18] Raja Ravi Varma (1848–1906), who developed an Indian manner in oil painting, produced stunning portraits but with an Indian stance incorporating theater, mime, and sensuality.[19] Works by these Asian masters reflect complex cultures and multiple identities. They lead one to the question so pertinently posed by art historian Geeta Kapur: "When was modernism in Indian/Third World art?"[20]

Representations of romanticism and exoticism in the art of the colonized and the colonizers can be seen as products of cultural imperialism. Similarly, the display of archaeological objects, artifacts, and crafts from distant societies in Western museums and art institutions can be seen as a redefining and reconceptualizing of alien cultures to fit into specific economic, cultural, political, and ideological needs.[21] Lamentation on the disappearance of "original" traditions and "authentic" indigenous art has prompted museums and collectors to try to rescue these artifacts from extinction. Often seen as timeless and anonymously made, these objects are revered as sacred images but denigrated by radical decontextualization. These objects are considered "high art" and classified according to art-historical context, rarity, and market value. More often than not, the source of these artifacts is not contested. How they got from ruined temples and villages in Asia to museum display cases in Europe and America is not usually questioned. Stripped of their social and religious ties and redefined in new settings according to experts and specialists, they are often given priorities and values over works by living artists in Asia. Fromentin said that interpreting the Orient did not mean destroying it. But he underestimated the dangers of misrepresentation and distortion.

Asian gods and deities are often characterized as having strong feelings and emotions. At times their actions and behaviors surpass the taboos, prohibitions, rites, and dogmas invented and regulated by humans. In different religions and beliefs, certain gods and deities have been eliminated from the pantheon when it was felt that they belonged more properly to esoteric cults, occultism, or primitive societies. When removed from their original contexts and settings, images of these deities were often reconceptualized according to new criteria and new needs. To those who are unfamiliar with their mythical and symbolic meaning, these gods from Asia may as well be inspirational figures for cartoons, comics, or adventure movies. After all, the character and appearance of some of these gods is quite different from the one and only God in the Christian world.

Artists who live in Asian countries with complex and multilayered cultures are fully aware of the burden of negative traditions that might be associated with their works. The persistence of stereotypes means that any of these artists may be prejudged on the basis of his or her nationality, race, or religion. But artists such as N. N. Rimzon, Heri Dono, Roberto Feleo, Ravinder G. Reddy, FX Harsono, Dadang Christanto, and Agnes Arellano are not primarily concerned with self-reflection. Instead, they attempt to reveal the complexity of contemporary Asia through the revival or resurrection of traditional forms. But, again, they do not simply restage the past as a consensual process of invention of tradition. Rather, their works include fragments of tradition that serve to question nationalistic aesthetics and bigotry. The god-human forms created by many of these artists are situated in the "in between" spaces and terrains of difference (race/class/gender/religion) that shape their identities.

The mood emanating from the works of these artists is one of enduring monumentality and calmness. They seem to prefer a controlled treatment of sculptural or poetic space over displays of personal emotions. At least on the surface, the artists' anguish, disquiet, anger are suppressed. This silence raises many questions about how

and with what effects the voice of "Other" can be heard. The question is that once raised by literary theorist Gayatri Spivak: "Can the subaltern speak?"[22] Letting the native speak may imply various intentions. On the one hand, it allows the choked discourses of domination to be enunciated. On the other hand, sometimes the silent gaze of an inner voice is preferable to sound.

In his essay "Archetypes of a Lost Humanity," critic R. Nandakumar comments on **N. N. Rimzon**'s remarkable skill in preventing his sculptures from becoming self-centered.[23] Rimzon's preference for installation helps him to keep away from the head-to-foot verticality of the image which is a natural aspect of the viewer's projected self. The play between mental space and real space becomes significant in Rimzon's interpretation of archetypes of a lost humanity. Rimzon believes that "art should operate in a cultural/ political context and the artist has a role in the society." But he does not take the role of the socially committed artist who uses didactic narrative or political allegory. Rather, he uses what he calls "transformation technique" in his installations. In such works, he explains, "art becomes 'iconlike,' like a Krishna image which is transformed into a spiritual object through chanting."[24]

In *The Inner Voice* (1992), Rimzon expands this mental space by juxtaposing traditional Indian objects and decentralizing the concept of unified vision. The key figure, a standing nude in a contemplative pose, is derived from the spiritual deity of Jain sculpture. Rimzon's intention in linking his work to Jain orthodoxy and the teachings of Vardhamana Mahavira (Great Hero), the twenty-fourth Tirthankara and a contemporary of the Buddha, is to draw attention to the core Jain doctrine which forbids harming any living creature.[25] This doctrine is summarized by the phrase *ahimsa paramo dharma* ("nonviolence is the supreme religion"). One Jainist sect, the Digambara ("sky-clad"), advocated total nudity, a position that is echoed in the refined forms of its sacred sculptures. In Rimzon's work, the central figure is surrounded by cast-iron

weapons; a symbol of nonviolence enclosed by tools that cause injury and harm. The mental space moves the viewer into the expanded field of cultural/political contexts. The swords signify violence which is ingrained in Indian life. But, at the same time, they are like metal rays that cannot penetrate the invisible space that protects the sacred image.

These contradictory signifiers are Rimzon's comment on the violence that resulted in the destruction of the Babri Mosque in Ayodhya in 1992. When a spasm of violence sparked across the nation, Hindu nationalism and mayhem could not be contained.[26] Explosions and killings occurred at random. Men on the streets were stripped bare to verify that they were circumcised, and many who were, were killed. But the enforced nudity also recalled the purist nudity associated with Jainist nonviolence, a major influence on the political philosophy of Mahatma Gandhi. In echoing such multiple associations, Rimzon's *Inner Voice* suggests the possibility of cultural hybridity. In addition, its silence evokes inner chanting. By inviting the viewer to listen and to travel the inward journey, Rimzon raises racial/class/religious/political issues that shift constantly in multifaceted India.

If the closed-eyed figure in *The Inner Voice* suggests introspection, then the faces in Rimzon's sculptures *Three Heads on a Shelf* (1984) and *Man in a Chalk Circle* (1985) signify the opposite attitude. They scrutinize the viewer with a questioning gaze, not revealing any aspect of the self or a particular individual but offering instead the piercing look of anonymous marginalized people. The works of Yogyakarta-based artist **Heri Dono** also focus on the gaze, but it may be that of the *burisrawa* (literally, the greedy and rapacious giant in a *wayang* shadow play) as well as that belonging to indigenous people. Although Dono declares that he is not interested in politics, his sculptures make clear that, like Rimzon's works, they function in and refer to a complex cultural and political context. Dono's *Gamelan of Rumour* (1992), *Watching Marginal People* (1992), and *Fermentation of Minds* (1993), to name three examples, each comment to varying degrees on the tendency of Indonesian authorities to use propaganda

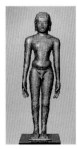

1. *Tirthankara*, Karnataka or Tamil Nadu, India, 7th–early 8th century, copper alloy, H. 26.7 cm (10½ in.), Mr. and Mrs. John D. Rockefeller 3rd Collection, Asia Society, New York.

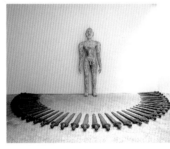

2. **N. N. Rimzon**, *The Inner Voice*, 1992, resin fiberglass, marble dust, and cast iron, H. 207 cm (81½ in.), Foundation for Indian Artists, Amsterdam.

3. **Heri Dono**, *Ceremony of the Soul*, 1995, detail of installation showing stone and plastic figure, H. approx. 90 cm (35 in.), courtesy of the artist.

and censorship to implement national policies and to control the minds of the masses.[27]

Dono views art as a spiritual activity and claims that visual art is his religion.[28] His artistic language is a conglomeration of painting, sculpture, electronic installation, and *wayang* performance. By virtue of the fact that these eclectic art activities sometimes involve the participation of the local community, Dono creates an alternative public arena for critical dialogue. This tendency cuts against the grain of the imagined community or nation of Indonesia, which takes as its motto "Unity in Diversity." Dono incorporates traditional Indonesian art and performance as a way of conveying the fear and instability underlying this fictional national identity. For example, his *Kuda Binal* (Wild Horse), 1992, a performance based on a traditional Indonesian horse-trance dance called *jaran kepang* and staged in a square outside the court in Yogyakarta, involved local people from Kampung Kleben in costumes with props and tear-gas masks. Various scenes in the performance depicted the systematic destruction of nature by human greed and arrogance. Dono's visions of chaos explicitly contradicted national ideologies of harmonious unity.[29] The trance dancing and flower offerings he recreated are traditional practices now considered sinful by the Indonesian state department of religion.

In Dono's installation *Ceremony of the Soul* (1995), the static frontal posture of the stone figures is reminiscent of the Buddha images on the Borobudur. Dono's selection of stones found near this sacred site further demonstrates his intention to adapt traditional materials for specific meaning in contemporary life. These stone images have fiberglass heads and wooden arms and are positioned in neat rows that suggest obedience to a system of discipline and order. At first glance, each one seems to embody the spirit of tradition and to revive the splendor of the past. But as the viewer discovers the assortment of military decorations, radios, lights, and tape recorders attached to these sculptures, their meaning begins to shift. The wide-eyed stare becomes hypnotic and disturbing. Serenity and tranquility turn to authority and threat.

Watchful eyes are everywhere. Through Dono's intervention, these traditional stones have been transformed into icons of power and repression. The eerie mood of surveillance and threat reflect the political condition of Indonesia, in which a concentration of power in the capital of Jakarta frequently results in the marginalization or alienation of peripheral areas, such as Yogyakarta, Aceh, Irian Jaya, and East Timor. Unlike the silence in Rimzon's *The Inner Voice*, Dono's installation is accompanied by the continuous hum of low-hanging yellow fans.[30]

People who hold subordinate positions in society are expected to be silent. But often, even when people are repressed, they still find ways to communicate. Tensions embedded in the gaze of the subaltern are both concealed and revealed in works by **Ravinder G. Reddy** and Navin Rawanchaikul. The wide-eyed frontal stare in Reddy's gilded heads, for instance, is simultaneously sensuous, mesmerizing, and challenging. Reddy's extreme simplification of form recalls not only Indian temple sculptures but also ancient Egyptian and Etruscan stone carvings.[31] The splay-nosed, thick-lipped, almond-eyed attributes of various Indian ethnic and religious groups relate to the hierarchical division of society into castes (*varna*) according to an early Sanskrit text, the Rig Veda. In Reddy's heads, ethnicity and "breed" (*jati*) are made intentionally ambiguous, embalmed within a universalizing golden yellow surface. Yet, their massive and simplified features, both heraldic and heroic, suggest unspoken codes of conduct that rank members of society on a scale from polluted to pure.

Reddy's gilded and elaborately coiffed heads imply an idealized purity but they also recall the marks of inferiority within India's complex caste system, the heads of prostitutes, bonded laborers, untouchables, and people from tribal communities. Many of Reddy's sculptures represent females, in themselves a social group treated as subservient in Indian culture.[32] Women in India cannot directly approach God but must worship through their religious teacher, or *swami* (lord), the "twice-born" man who mediates their access to God. Ironically, while many ancient deities are "imprisoned" behind display cases and

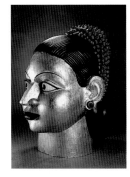

4. **Ravinder G. Reddy**, *Head IV*, 1995, gilded and painted polyester-resin fiberglass, 120 × 74 × 103 cm (47¼ × 29⅛ × 40½ in.), courtesy of the artist.

5. **Navin Rawanchaikul**, *There Is No Voice*, 1993, installation in USIS Library, Chiang Mai, Thailand, with photographs and glass bottles, H. 259 cm (48 in.), collection of Chulalongkorn University, Bangkok.

6. Detail of element from **Navin Rawanchaikul**, *There Is No Voice*, 1993.

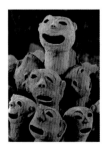

7. **Dadang Christanto**, *Kekerasan* (Violence), 1995, detail of terra-cotta heads, H. 300 cm (118⅛ in.) overall, courtesy of the artist.

museum walls, Reddy's "living" heads pulsate with directness and confidence. In *Woman* (1995), a slightly larger-than-life naked woman with golden skin coolly directs her gaze at the viewer. In this moment of poise and dignity her nakedness seems almost sublime or celestial. Similarly, in *Sitting Woman '95* (1995), the woman's blue body evokes the divine color, the symbol of Krishna. Reddy thereby compels the viewer to ponder tradition as well as the symbolic function of blue in contemporary Indian life. The woman's tinted nudity also hints at the double standard for women in India, as his blue nude is simultaneously venerated and subjugated.[33]

 Navin Rawanchaikul, whose Indian parents settled in Thailand, lives and works in Chiang Mai. He is part of the Chiang Mai Social Installation, an organization that encourages local and international art activities focused on Chiang Mai and its vicinity.[34] In his work, Rawanchaikul is concerned with social roles that are assigned according to class, gender, breed, and age. In one project, he interviewed and documented villagers around Chiang Mai who had been marginalized by the rapidly industrializing culture. In many of the villages there are few young people because they have all migrated to the metropolis to find work. Those who are left are often old, uneducated, or illiterate, and they are treated as powerless, poor, and pitiful. Dislocated and disillusioned, these older locals have no place in the Thai social structure. Rawanchaikul's installation *There Is No Voice* (1993) consists of cylindrical shelves displaying hundreds of glass bottles, each containing a photograph of one of these aged indigenous people. Trapped and eternalized in these glass containers, the jaded black-and-white prints reveal the gaze of ordinary people whose voice has never been heard. When displayed in libraries in Chiang Mai and Bangkok, *There Is No Voice* incites those who are literate and educated. Although the library requires silence, it has no room for the voiceless.

 Role-playing in the social structure is also the subject of Rawanchaikul's installations *Fon Panya* (1993), *Fon Panya and Dee Uraporn* (1993), *When Silence Came, I Swallowed Reality* (1994), and

Preservation of the Voiceless Condition (1994).[35] Both *Fon Panya* and *Fon Panya and Dee Uraporn* involved performances with an elderly couple from Chiang Mai. They were seated in glass display cases like art objects and made to stare at their own autobiographies, which consisted of only their names. In front of them, a little girl listened to her father's dreams and expectations of her future. When exhibited at Chiang Mai University, these works provoked outraged reactions from students and faculty who objected to what they perceived as the artist's disrespectful treatment of these senior citizens. But, in fact, Rawanchaikul's intention was just the opposite: to restore respect to these citizens who have been neglected and made invisible because of their social status.[36]

 For **Dadang Christanto**, this type of dehumanization is the most frightening form of violence, worse even than genocide or ethnic cleansing. His sculptures and performances address the paradigm of oppression that structures all violence, both physical and mental. Christanto's terra-cotta heads and figures are stripped of their dignity and look like lost souls wandering aimlessly. Their dark, hollow eyes perceive nothing; their mouths flap open like gaping wounds.[37] They symbolize the culture of fear and repression that exists in Indonesia, where the state ideology (*panchasila*) and the national unification program have transformed the natural cooperation among the people (*gotong royong*) into the painful sacrifices of voiceless masses.

 The terra-cotta heads of Christanto's *Kekerasan* (Violence) of 1995 are strangely distorted. They have no foreheads, no room for their brains. Many have big ears from listening too much; others have large mouths and small ears, implying that they have authoritative voices. Critic Dwi Marianto said of Christanto's figures, "The making of heads without space for brains is a form of satire à la Dadang [Christanto] about a socio-cultural-political condition where individual brains and brains of communal society are being disempowered and having their function taken away."[38] This sense of powerlessness is emphasized by the fact that though these figures are packed tightly together, they appear

to be disconnected from one another. They form a pyramid of disembodied heads, looking like a stack of inert cannonballs. Inspired by Peter Berger's book *Pyramid of Human Victims: Politics, Ethics, and Social Engineering*, Christanto's sculptures refer to the "humane expenses" of suffering.[39] He laments those Indonesians who have been deprived of education and information and who are forced to live in what he calls the "deaf culture."

Living in the rural village of Bantul, in Yogyakarta, Christanto has found inspiration from the local brickworkers and makers of earthenware. His choice of clay and terra-cotta, local materials used by indigenous craftsmen and rural laborers, allows Christanto to constantly question the hierarchization of the social structure and of the categories "high art" and "low art." By adopting the role of the artisan (*pengrajin*) or potter (*pengrajin keramik*), Christanto makes terra-cotta men and women whose tragic silence echoes that of many Indonesians. With their hollowness and clay feet, Christanto's larger-than-life standing figures could easily crack and crumble.[40] What does this symbolize? Can they talk back? If so, can they be heard or understood?

In contrast to Christanto, **FX Harsono** uses the forms of wooden masks used in traditional Indonesian mask dramas (*wayang topeng*) to interpret the current sociopolitical situation. This device also serves as a way for Harsono to comment on the revival of traditional Javanese tales (such as the Panji cycle of epics concerning the founding of the thirteenth-century dynasty) and the reinvention of theater traditions for the promotion of tourism. At another level, Harsono's masks might reflect the power of language in Indonesia through what Benedict Anderson calls "symbolic speech."[41] In Indonesia, the use of criticism, parody, and "direct speech" by the mass media (particularly such magazines as *Tempo*, *Detik*, and *Editor*) has resulted in strict governmental control of political expression.[42]

Harsono's installation *The Voices Are Controlled by the Powers* (1994) consists of one hundred masks from Yogyakarta, each of which has had its mouth removed. These mouthless masks are arranged in a square on the floor with the cut-off mouths placed at the center. By shifting the function and symbols of these objects, Harsono uses them to tell another kind of tale concerning gossip, rumor, and censorship in everyday life. Here, the mouthless masks symbolize the restriction of free expression for the sake of national security and social order. Harsono's *Voice Without a Voice/Sign* (1993–94) also relates to censorship in Indonesia. Each of the nine large prints represents a hand forming a letter in sign language. Together, the letters spell out "D-E-M-O-K-R-A-S-I." But the clenched fist of several of the letters and the binding of the final hand with rope suggests the constraints on communication caused by the repressive Indonesian government. According to Harsono, the work stands for "democracy and openness, in which the people should be able to express their thinking and opinions freely, but in fact cannot." In Indonesia, he says, "Democracy is only a symbol."[43]

Traditional cultural values and nationalistic forms of representation often get translated into a seemingly natural aesthetic standard. In this way, nationalism often becomes a determining factor in the creation of art, mandating how it should serve the region or nation. For the emergent national cultures of the Philippines, this self-image has often been based on outside models. As Philippine critic Edilberto Alegre points out, "It has been a question of looking at ourselves with the 'wrong' eyes—those of a Westerner: the measuring gaze of Padre Damas, the accusative stare of Uncle Sam."[44] Alegre also notes that students in the Philippines are often taught that in the beginning there were no Philippine people, only pagan tribes that were Hispanized and Americanized by colonization. For this acculturation, the people of the Philippines are made to believe, they should be eternally grateful. But Alegre wants to commemorate his ancestral roots, and he forthrightly asks, "What does it mean to be Pinoy?" In his work, he focuses on marginalized cultural groups, like the Lumad and the Muslims, to signal connections to an indigenous past that precedes and precludes the invention of Philippine cultural traditions as an exotic variety of a Western colonial viewpoint.

8. *FX Harsono*, *Voice Without a Voice/Sign*, 1993–94, one of nine screenprints on canvas, this canvas 180 × 120 cm (70⅞ × 47¼ × in.), courtesy of the artist.

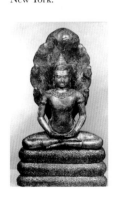

9. *Crowned Buddha Seated in Meditation and Sheltered by Muchilinda*, Cambodia, Angkor period, possibly 12th century, copper alloy with recent covering of black and gold lacquer and gold leaf, H. 28¾ in. (73 cm), Mr. and Mrs. John D. Rockefeller 3rd Collection, Asia Society, New York.

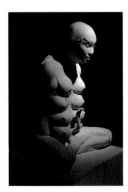

10. **Agnes Arellano**, *Dea*, 1995, cold-cast marble (life cast), H. 85 cm (33½ in.), courtesy of the artist.

Roberto Feleo shares Alegre's desire to revive pre-Christian traditions and culture. In particular, he is fascinated by Bagobo folktales, and he has recreated many of their local myths and deities. The Bagobo are polytheistic; the wide pantheon of *diwata* (gods) they allude to in their songs and myths reside in nine heavens above the skies. In Feleo's *Tau Tao* (Ancestors), he uses six symbolically complex, life-size figures to retell the Bagobo myth of the afterlife. One figure, for instance, represents Lumabat, a hunter warrior who must battle a snake to cross the horizon and enter the skyworld. So he will no longer crave food, Lumabat's belly is split open with a betel nut to remove his intestines. Wari, his brother, is shown falling from the sky because he could not resist the temptation to eat. Mebuyan, their sister, prefers the underworld, where she suckles dead babies with her multiple breasts. Invisible knives carve up the dead body of Tuglay, the father, until he is reduced to nothing but a little boy.[45] By returning to ancestor worship in this way, Feleo reiterates his belief that art should be inspired directly by indigenous cultures rooted in Asian sensibility.

The traditional iconography of *Tau Tao* requires its own dialect and interpretation. Terms such as "life," "death," and "sin," for example, have far different meanings in this context than they may have in Western vocabularies. In Philippine or Asian belief, what happens after death is neither heaven nor hell but reincarnation. Yet, this pre-Christian belief differs emphatically from the teachings of the "national" religion, Roman Catholicism.

Gazing at Feleo's *Tau Tao*, therefore, opens up various possibilities for retrieving local myths and rituals. These relate not only to the Bagobo but also to Agusanon Manobo, Capzinon, Ifugao, Kakanay, Manobo, Tagalog, and others. On another level, the work relates to the ancient *babaylan* (priest or priestess) who, in the pre-Hispanic era, played an important political, social, religious, and cultural role.[46] In several ways, then, *Tau Tao* is a symbol of resistance against the monopoly of Western civilizations which have replaced the beliefs and values of ancestors with corrupting foreign influences and cultural imperialism.[47] The meaning of this vessel for ancestral spirits to inhabit shifts through time, recalling forgotten memories.

While Feleo's concise interpretation of local myths can be regarded as a means to return to the "true" indigenous cultures of the Philippines, **Agnes Arellano**'s life-size body casts have decidedly ambiguous connotations. Her strange and compelling trinity of *Dea*, *Lola*, and *Vesta* (1995) represents the nude women as mothers, Marys, and mythological creatures, and reflects the artist's desire to explain the apparent conflict between ideologies and beliefs. Although she uses the female body as the basis for her sculptures, Arellano's work does not fit comfortably within the canon of feminist art.[48] Arellano draws inspiration from various mythologies (Diana of Epheseus, Mebuyan of Bagobo, the Mexican Mayauel, the Sicilian Black Virgins) and diverse writers (the French Surrealist Georges Bataille, the noted mythologist Robert Graves, and the anthropologist James Clifford).[49] Her works can be seen as a process of shedding skin as layers of interpretation are molded and uncovered.

The central female figure, *Dea*, is actually a fantasy self-portrait in the posture of the Buddha seated in meditation and sheltered by Muchalinda. This image was inspired by Buddha statues similar to those in the Rockefeller Collection at the Asia Society.[50] The feminized figure has multiple breasts like Mebuyan from the underworld, whose body is delicious with milk glands. Between her legs is a female cobra with open hood, erect like a phallus. Her skin is turned inside out like that of a snake in the process of molting.[51] Her arms have metamorphosed into wings which are folded and clipped. The image becomes a deification of self/mother/goddess, who, as Arellano describes her, "is repressed and gagged" by motherhood.[52]

The right-hand figure, *Vesta*, depicts a young pregnant mother in a posture derived from Hariti, the Indonesian goddess associated with fecundity. Her left hand opens in a mudra of generosity; the other holds her left nipple. As a vessel for creation, she is bursting with life. A lizard (*bayawak*), symbolic of fertility, clings

to her back. In contrast, the third figure, *Lola*, is woman as an aged crone who is no longer fecund; her is skin wrinkled and folded. She seeks divination through introspection, as suggested by her closed eyes and the mudra of teaching turned inward. Like the black goddesses Kali and Durga, she is capable of supernatural powers. In this trinity, Arellano not only invents her own female-based pantheon but also interrogates the sexual ambiguity of deities by ascribing to her goddesses the attributes of male gods. Arellano's fashioning of hybrid characters from multiple sources also challenges the fixed cast of the stereotypical national imagination. As Arellano quotes Bataille, "God is nothing if he is not a transcendence of God in every direction…vulgar…horror and impurity…like nothing. It is by blasphemy that man is God."[53] But for Arellano, God has no phallus.

While the quasisacred works by Rimzon, Dono, Christanto, Reddy, and Arellano are erect and upright, several of Feleo's deities plunge or collapse. Through these semigods one can interpret various human emotions, ideologies, and beliefs of societies in fluctuation. **Choi *Jeong-Hwa***, on the other hand, has constructed a digital deity in the form of a dying robot. His sculpture *About "Being Irritated"—The Death of a Robot* (1995) epitomizes the entropic condition of contemporary society.[54] This situation is particularly dire in Korea, where the country's name means "land of the morning calm" but the current state is more like the "land of afternoon corruption and evening violence." Choi's giant, yellow plastic robot is reminiscent of the new breed of popculture heroes and gods, such as the Mighty Morphin' Power Rangers, Ultraman Leo, Ninja Megazord, Lord Zedd, and Ivan Ooze. But the robot is in a state of demise. Unable to rise, it continually struggles and collapses. Its vibrant yellowness seems to scream with sorrow and pain. But this work is not really about dying; there is no time for mourning or nostalgia in contemporary culture. Rather, *The Death of a Robot* is about the continuous torment of man's infatuation with power and self-destruction.

Under the Skin of Postcolonialism and Social Malaise

11. **Choi *Jeong-Hwa***, *"About Being Irritated"— The Death of a Robot*, 1995, fabric, air compressor, movement timer, CD player with speakers, H. approx. 500 cm (197 in.), courtesy of the artist.

One key element of the powerful global discourses shaping contemporary notions of identity is what has been called "eroticized nationalism."[55] Love thy country (more than thy neighbors) is the motto that has been employed by those who seek to use cultural heritage to promote nationalism. More often than not, this approach serves as a cover for jingoism and chauvinism. Meanwhile, the celebration of national holidays and important event cycles, such as independence days, royal birthdays, presidential marriage cycles, veteran's days, and religious days helps to develop feelings of unity, harmony, and patriotism. Sports events have also become popular as a means to encourage love of country; without fail, the opening and closing ceremonies of international competitions include flamboyant displays of the host country's symbols, traditions, and heritage.[56] Cleansed of any kind of sociopolitical or racial tensions, these performances are extremely effective, even though the nostalgic emblems of nationhood are largely invented or totally taken out of historical context. Christmas festivals in Asia are clear examples of the complicated attempt to assimilate Western influences while making them fit preexisting national programs and cultural rituals. In Thailand, for instance, it has become customary for department stores and hotels to embellish Christmas trees and other decorations with portraits of King Bhumibol Adulyadej since his birthday falls near Christmas. This produces the odd conflation of monarch and Santa Claus as analogous symbols of celebration and goodwill to all (Thai) mankind.[57] In Manila, soothsayers perform clairvoyant acts while mediums preach oracles and announce the return of Jesus of Nazareth.[58] Traditional singers and *gamelan* musicians perform under Indonesian flags next to decorations covered with fake snow and plastic reindeers. Traditions are continually invented and assimilated in an ongoing process of hybridity. However, as Homi Babha reminds us, the importance of hybridity is not as a third

moment that emerges from two original sources but as a "third space" which enables other positions to emerge from it. The process of cultural hybridity constantly gives rise to something new and unrecognizable, something that does not necessarily occur in the ordered *musée imaginaire* of national cultures.[59]

In his book *Pinoy na Pinoy!*, Edilberto Alegre attempts to "peel away layers" of Philippine national culture by investigating such subjects as the beginning of nationhood, Mindanao in-migration, the Filipinizing of the American shopping malls, and *demokrasi* Pinoy style.[60] What Alegre calls the "delayering process" becomes analogous to the complex "skin grafting" or "tattooing" found in the hybrid works of the collaborative artists **Reamillo & Juliet** (Alwin Reamillo and Juliet Lea).[61] Their series "P.I. for Sale," for example, consists of photomontages and collages of maps, diagrams, popular icons, and legendary figures that they have "reconstructed and deconstructed." Exploiting the Philippine infatuation with icons, Reamillo & Juliet create new metaphors by jumbling images as diverse as Mickey Mouse, Dr. José Rizal, Marcelo Del Pilar, Ronald McDonald, and Jesus.[62] At the same time, by manipulating cartography, Reamillo & Juliet remap the Philippine archipelago as a disjointed terrain of sexuality and nationalism. Place names are overlaid with added texts. For example, the words "Philipp penis" scratched on the surface of one map refer to the accidental discovery of the islands in 1521 by Ferdinand Magellan; his erection of the Spanish flag of King Philip II is seen as a symbolic rape of the local inhabitants.[63]

In their 1996 work *Kakainin ba nila ang mga saging?* (Will They Eat All the Bananas?), Mother Filipinas is transformed into the lifeless cadaver of Asia, stretched out on the archipelago as operating table. Cut up, disfigured, wounded, the corpse has undergone an extensive autopsy; its bandaged legs are spread wide as surgical scissors snip and peel back the skin. The body-skin map is littered with surgical instruments and metallic gun parts, all deeply embedded in these scabrous, violence-stricken islands. Gaping wounds and body parts float in a sea of choleric

disease. The Siamese-twin faces of Ferdinand and Imelda Marcos, with their monstrous mouths, oversee a landscape of disorder that they have created. Aid arrives in the form of bananas; peeled yellow skin revealing whiteness underneath. These flying bananas metamorphose into an erect penis with peeled foreskin. Relief turns into rape; gang-bang sodomy of the Filipino carcass. Mickey Mouse and Pope John Paul II drift by to witness the event.

Another work in the "P.I. for Sale" series is *Bulang ang taong nakasalaming iyon* (Blind Is That Man with Glasses), 1996, which depicts a procession of clergymen led by President Fidel Ramos who holds his object like a direction finder or compass. The scene ridicules the celebration of Palm Sunday, which marks the Lenten season. An icon with a cross points at the ripped vagina of a former puissant person; an innocent boy hovers nearby. In the background, a man in a *barong* blows a brain bubble; a kidney machine links Ramos with Marcos; an erupting volcano spurts all kinds of debris; and a person carrying the presidential seal flees in the direction of a white-domed building.[64] In *Maga-magang gabi, bayan!* (1995), another kind of macabre sickness is witnessed. Postmortem images of swollen maid-turned-martyr Flor Contemplacion, a Filipina heroine convicted of a double murder, are screened on a shriveled white shirt.[65] The prints are inscribed in yellow, "Proudly Philippine Made."

The sly wit and sarcasm that Reamillo & Juliet employ in their vast installation *B. Lipunan 2000* (1993–95) reflects the lamentable spectacle that was enacted when the Philippines endeavored to join the New World Economic Order. The words "bagong lipunan" alluded to in the title refer to President Marcos's vain efforts to create a new society, while the date "2000" denotes the current government's propagandistic goal: to reach the summit by the end of the millennium. "Progod, Progun, Prolife" are slogans found in Philippine daily life; they suggest any number of contradictory elements. Reamillo & Juliet combine these catchwords with crucifixes formed out of dummy M-16 rifles. These crosses hover over the godlike portrait of President

12. Colossal monument of Ferdinand Marcos, along Marcos Highway in La Union, the Philippines.

13. **Reamillo & Juliet**, *B. Lipunan 2000*, 1993–95, detail of installation showing painting and casts of M-16 rifles, H. of painting approx. 300 cm (118 in.), courtesy of the artists.

Marcos, whose eyes are bleeding like the apparition of the Virgin Mary in Agoo. Meanwhile, the image of President Fidel Ramos flickers across a TV screen in a dim corner, and portraits of past presidents line the wall. A jar of *balut* (unborn duck eggs) symbolizes the prolife and anti–birth-control movement in the Philippines, the largest Catholic society in Asia. These eggs, incubated nearly to hatching, are eaten boiled or raw with salt and alcohol and exemplify male virility. Arranged like a small chapel, this politically provocative installation encompasses layers of criticism regarding the abuse of power. According to the artists, a triad consisting of the government, the church, and the military have "created the conditions of fascism" in the Philippines, producing a suppression of freedom and a feeling of claustrophobia.[66]

While the Philippines endured four hundred years of Hispanic colonization, fifty years of American Hollywood education, and three years of Japanese control, Korea faced a shorter but more intense period of invasion during the Japanese occupation (1910–45). This was followed by American as well as Chinese intervention after World War II. Like the Philippines, Korea suffered greatly under colonization and enforced modernization, experiences that have caused reactionary responses toward dominant foreign countries.[67] While in their installations and mixed-medium works Reamillo & Juliet attack outside forces in the name of modernization and salvation, Korean artists Kim Ho-Suk and Cho Duck Hyun use more traditional practices, such as drawing and painting, to convey their resistance. They focus on the histories of their predecessors as a way of emphasizing the patriotic feelings of the Korean people.[68]

The Koreans call their country Chosun, which translates as "morning freshness." Koreans take great pride in the long history of their peninsula, with its renowned dynasties such as Shilla, Koryo, and Chosun. Ironically, the backdrop of tradition serves as a painful reminder to many Koreans of the colonial period under Japan's rule, when Japanese culture molded the Korean way of life. Evidence of the strong anti-Japanese feeling that persists in Korea was displayed

last year when President Kim Young-Sam ordered the destruction of the National Central Museum of Korea because it was once the headquarters of the Japanese colonial government. Open discussion of the humiliations of the colonial past has aroused patriotic fervor. **Kim Ho-Suk**'s great-grandfather was a leading resistance fighter during the Japanese occupation, and he feels strongly that many of the current sociopolitical problems in Korea stem from the period of colonization.[69] Kim tries to convey his national pride through his portraits of national heroes as well as ordinary folks painted in a traditional manner. Kim's thin, fluid brush paintings on paper are inspired by Buddhist paintings from the later Koryo Dynasty and portray the determined face of Hi Hwang, the fiery visage of a Chosun Dynasty officer, or the blazing eyes of the monk Song Chol. Spurred by contemporary circumstances, including the ongoing sociopolitical crisis, oppression, and riots, Kim began to link these problems to Korea's colonial past.[70]

In his series "The History of Resistance Against Japanese Colonialism" (1990), Kim's interpretation of the painful events is seen through murky, misty washes of black and gray. Ghostlike images lurk on the surface like unhealed scabs that are constantly scratched. Korean women forced to become comfort women huddle together, waiting to attend the Japanese soldiers.[71] Naked Korean men are forced either to work at hard labor or to serve in the Japanese military. Kim's images reveal further humiliation by depicting Koreans who blindly assisted their colonizers and remained pro-Japanese even after the independence. Kim's paintings *The History of Korea's Resistance Against Japanese Colonialism: Armed Uprising* (1991) and *Silent Demonstration* (1992) attest to the courage and allegiance of many Koreans whose tenacity bound them to a common course. Hordes of anonymous faces form human walls that are analogous to silent cries of resistance. Kim's use of eighteenth-century painting techniques reinforces the feeling of resistance against cultural domination, which comes today from neighboring Japan as well as from the West.

14. **Kim Ho-Suk**, *The History of Korea's Resistance Against Japanese Colonialism: Armed Uprising* (detail), 1991, ink on paper, 183 × 183 cm (72 × 72 in.), courtesy of the artist.

15. **Cho Duck Hyun**, *Accumulation*, 1993–95, detail of installation at Institute of Contemporary Art, Philadelphia, with pencil drawings in wooden boxes and lights, H. of drawings approx. 60 cm (24 in.), courtesy of the artist.

If Kim's hazy images of comfort women are blurred like faded photographs, **Cho Duck Hyun**'s drawings of Korean women attempt to capture the details of portraits with an exactitude that sometimes eludes even the camera lens. Like Kim's excruciating images, Cho's series "A Memory of the Twentieth Century" (1993) is exacerbated by the still-active memories of the hardships of colonial domination.[72] Fleeting remembrances revive the heartaches and grief embedded in the subconscious. Graphite and charcoal marks rendered on canvas create hyper-real effects that become more captivating than the original photographs. By encasing his drawings in spotlit boxes with lights that turn on and off, Cho shows the potential of drawing to create dramatic metaphors for the dichotomies between past and present, old and new orders, authenticity and reproduction. These black boxes are as essential as the drawings themselves, for they are symbolic of containers of secretive contents.[73] In *A Memory of the Twentieth Century: Gleg to the Uptake* (1993–95), Cho recaptures a specific moment during the Chosun Dynasty when Korea was forced to open itself to the outside world. With the infiltration of goods and ideas from the West, it was a remarkable time of innovation, novelty, and curiosity, just prior to the Japanese occupation. From old photographs and excerpts from the early twentieth-century writings of Isabella Bird Bishop (the author of *Korea and Her Neighbours*), Cho reconstructs the dramatic confrontation of East and West. By juxtaposing one box, in which Korean school children stare with inquisitive eyes, with another, in which a Scottish family looks back with an unenchanting gaze, Cho recreates the captivating moment of eye contact between "strange" foreigners. Through his meticulous composition, Cho enables two unrelated records to converge and to serve as a symbol of the overlapping of cultures. The title comes from Bishop's very British description of Koreans as "gleg to the uptake," meaning they were "quick and clever." These words are inscribed in English and Korean on the glass panels.[74]

In their protracted series that focus on issues of memory and resistance, both Cho and Kim

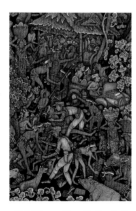

16. **I Wayan Bendi**, *Revolution* (detail), 1992, acrylic on canvas, 146 × 266 cm (57 ½ × 104 ¾ in.) (sight), courtesy of the artist.

have made a deliberate choice to use traditional techniques as a way to induce viewers to come to terms with the past. Here, underlying tensions of colonialism are restrained; the feeling is one of suppressed anger. Although their works are less directly confrontational than those of the Minjoong artists, the drawings and paintings of Kim and Cho allow the experience of the recent past to devise its own context of pain, sorrow, and humiliation.[75]

Nationalism and sexuality are tightly interwoven in the works of Kim, Cho, and Reamillo & Juliet. Issues around colonization and cultural dominance are often seen through the metaphors of rape or mental cruelty, evoking injury to the motherland or violence to women. In his series called "Independence War" or "The Fight for Independence" (1991), **I Wayan Bendi** arouses a similar mix of indignation and nationalistic feeling through his adaptation of traditional Balinese painting. Simultaneously, Bendi's paintings raise critical issues regarding the "selling" of culture through tourism in exotic Bali. Bendi, who runs his own gallery, is based in Batuan, near Ubud, the famous town where tourism and "traditional" Balinese art thrive. Although he is largely self-taught, Bendi was guided by his father, I Wayan Taweng, who painted in the style of the Batuan school, which was derived from the *wayang* epic and folktales of Tantri.[76] The Batuan style differs from the traditional schools of Kamasan and Ubud in its fusion of genre scenes with layers of colonial histories. Bendi depicts a panoramic view of Bali in calamity and chaos: a romanticized Balinese paradise, with bare-breasted smiling women and talented artisans, gives way to farcical battle scenes. Indigenous peoples armed with *kris* and spears clash with Dutch colonizers who assault from sea and air. Like puppets on stage, these enemies act out playful combats. Still, they serve to remind viewers, however lightheartedly, of incidents such as the death march of the Balinese rajas in the *puputans* (suicide ending of a kingdom) of 1906–08, when the Dutch massacred thousands of aristocrats and their followers.[77]

Bendi focuses on symbolism in the Balinese mythic and Hindu world. Images of Barong and

Rangda refer to the struggle to maintain an equilibrium between opposing powers. Offerings to the gods and *odalan* (temple festival) continue despite disturbances from outside forces. Naga Anantaboga and Naga Basuki (dragon-snakes) combine forces with Akupara, king of the turtles, in the Sea of Milk. The headless Kala Rauh severed by the discuslike Cakra of Wisnu is half swallowing Tirtha Amertha (holy water).[78] Tourists armed with cameras roam the island oblivious to these miraculous occurrences. But Bendi includes the sightseers as an integral part of Balinese life. Tourist promotions such as the Elephant Cave, the Monkey Forest, the Turtle Island, and the Temple of Besakih bring enormous income to the paradise island of Bali. But the countless tourist boutiques and art shops that promote the sale of souvenir art seem to threaten the very notion of "paradise."[79] Bendi's paintings question the transformation of Balinese culture into a culture industry as well as the division between fine art/high art and tourist art/low art. This dichotomy produces contradictory readings of the material culture of Bali. Encoded concepts of commodification, authenticity, and cultural property shift according to the location. Not all so-called tourist art fits the category of commodity production.[80] Like definitions of good and evil, understandings of quality and trash can become quite blurred in Bali.

In contrast to Bendi's concoction of past and contemporary themes through narrative iconography, the young Philippine artists of the **Sanggawa Group** use painting as means for social criticism.[81] Like Kim Ho-Suk and Cho Duck Hyun, they feel that contemporary social malaise stems from the colonial past. Engaging the tradition of collaborative mural painting as a potent medium for social dialogue, the Sanggawa have focused on the role of Christianity in the Philippines.[82] Their narrative series "The Voice of the People Is the Voice of God," or "Vox Populi Vox Dei" (1994–95), raises issues regarding the beliefs and ideologies of the Philippine people. Since 1494, the Philippine archipelago has been the key outpost for Roman Catholicism in Asia. In January 1995, on his second visit to the Philippines, Pope John Paul II was welcomed by more

than a million devouts. The visit came in the midst of a running conflict between President Ramos and Cardinal Jaime Sin regarding family planning, with the government encouraging the use of condoms and other contraceptives while the Catholic Church continues to forbid any birth-control devices.[83] Anti-abortion protesters denounced the massacre of babies. On the last day of the Pope's visit to Manila, the Sanggawa Group's "Vox Populi Vox Dei" opened at the EDSA Shangri-la Hotel in Manila. Art historian Alice Guillermo wrote that the paintings "constitute interrogative works, raising questions and challenging the prevailing order....They convey the importance, indeed necessity of action, praxis, in the direction of social change."[84]

In *The Second Coming* (1995), the Pope is shown in full regalia, spotlit on stage, as he steps on the sun and stars of the Philippine flag. Grasping a microphone, Cardinal Sin encourages the "fans" to donate into the almsbags. The crowd is in a state of hysteria cheering their celebrity; the interior with its framed Stations of the Cross crumbles. In a fury, the brown Christ shakes the foundation of the church as mother and child stare at the viewers. The second coming of the title refers to Christ's return as well as to the Pope's visit. *House of Sin* (1994) depicts Cardinal Sin stretched out in his palace like a Roman emperor, holding a bejeweled chalice. He glances at a plate of seedy papaya (also known as "chastity fruit," since it is supposed to be a libido depressant). On the balcony various vignettes are unfolding, including a hooded flagellant lashing himself to suppress sexual desire while a mother and her starving children mourn. The church's campaign for natural birth control ironically contradicts the real social conditions in Third World countries like the Philippines.[85] Sex education according to the Vatican has been described as "sex education in Catholic drag...the final plague."[86] In *Salubong* (Encounter, 1994), the crowned Caucasian Virgin Mary with scepter carried by Malay worshippers seems to welcome fame and fortune as she meets a beauty queen in swimsuit and high heels. The devotional gaze shifts to a lecherous leer.

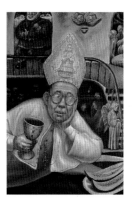

17. **Sanggawa Group**, *House of Sin* (detail), 1994, oil on canvas, 198 × 291 cm (78 × 115 in.), courtesy of the artists.

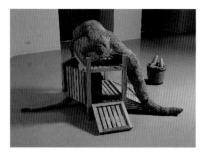

18. *Jakapan* Vilasineekul,
*Chang Tai Thang Tua Auw
Bai Bua Pid?* (Thailand,
Can You Cover a Dead
Elephant with a Lotus
Leaf?), 1993–94, wood,
sawdust, drawing, and
hemp, 110 × 200 × 160 cm
(43⅜ × 78¾ × 63 in.),
courtesy of the artist.

For a nation that has never been colonized, Thailand today faces a severe identity crisis, a plight of religious faith, a scourge of modern slavery, and a real political, social, and economic dilemma. **Jakapan** Vilasineekul often turns to Thai proverbs as a source of inspiration and as a way of commenting on these grievous issues. In May 1992, military violence against the Thai citizenry resulted in countless deaths and innumerable missing bodies; most of this was covered up by the Thai press.[87] When Vilasineekul, who was then living in Germany, heard about the events through the uncensored coverage in the European press, he was spurred to try to interpret the impact that the news had on him. Vilasineekul thought of the Thai expression *chang tai thang tua aou bai bua pid* ("to cover a dead elephant with lotus leaf"), which means that someone is trying to hide something that is too big to be covered up. In *Chang Tai Thang Tua Auw Bai Bua Pid?* (1993–94), an elephant head, meticulously crafted from sawdust, is placed on top of a wooden cage. In the cage is a map of Thailand. Nearby a pair of wooden tusks protrude from a closed bucket. The elaborate symbolism here has nothing to do with the destruction of elephants for ivory. Rather, referring back to the proverb, Vilasineekul's message is that the truth cannot be concealed.[88]

Postcolonial conditions are different in every country. In Java, independence caused the people to take enormous pride in their indigenous traditions and cultures. Dance, in particular, was recognized as an important element in traditional Javanese culture. Of course, today Javanese and Balinese dances are widely promoted within the tourist industry as part of the cultural identity of the region but they are increasingly divorced from the routines of the average citizen of Java. Thus, although **Nindityo** Adipurnomo was trained in classical Javanese dance, he soon began to question the relevance of this tradition to the practice of everyday life.[89] He noticed that the suppression of emotions in classical dance is closely associated with the introversion of the Indonesian people. Introversion bears the burden

within.[90] To portray this emotion, Adipurnomo chose the hair bundle and heirloom to exemplify this adversity. In *Beban Eksotika Jawa* (The Burden of Javanese Exotica) (1993), carved wooden bundles of hair are placed on five Dutch-colonial-style tables which refer to postcolonial rank and status. The chiseled-hair pieces refer to forbidden desires of the Javanese, such as sex, drunkenness, skepticism, and avarice. The lids are ajar to reveal mirror reflections of various tokens, including a *kelama topeng* mask, jewelry, coins, and a phallus with bowtie penetrating a vaginalike shape with enlarged clitoris. Partially revealed and half-censored, these taboos relate to Adipurnomo's invented token of real hair, which is placed on the smallest table, symbolizing Javanese chauvinism. In *Who Wants to Be Javanese?* (1995), Adipurnomo reveals that tradition and contemporaneity coexist as well as contradict. Circular hair shapes made of wood, metal, and mirrors evoke pride in Javanese-ness and its hierarchies. Conversely, the open lids— which look like gaping mouths—display objects of vanity including all shades of nail polish and lipstick. An image of curved forms that look like hair bundles is, in fact, a pair of bare buttocks pierced by hairpins.

Adipurnomo has noted that Javanese reaction against colonialism has produced the curious invention of their own hierarchy, privileging the "high" culture of Java over the "low" Indonesian culture of the coastal regions. As part of a multimedia performance, Adipurnomo created *Lingga-Yoni* (1992), a work inspired by a court dance of nine virgin dancers who each offer themselves to the sultan.[91] The *kris* (sacred dagger), which signifies power and status, is compared to the *lingga* (the symbol of Shiva as recycler; it is phallic in shape). The work makes an analogy to a traditional act at a Javanese wedding: the husband pierces a small plaque with his *kris*, causing red wine to spill out, symbolizing the wife's hymen being pierced by the husband's penis.[92] Adipurnomo's reinterpretations of Javanese symbols constantly question whether traditional revivalism is effective as a form of resistance against foreign influences and neocolonialism.

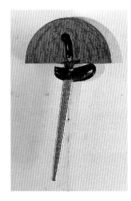

19. **Nindityo** Adipurnomo,
Lingga-Yoni (detail), 1992,
oil on canvas, wood,
copper, cloth, and *kris*
(Javanese dagger), H. of
element approx. 40 cm
(15¾ in.), collection
of John H. McGlynn.

The Awakened Gender

In her article "Woman, Nation and the Other in Contemporary Hindi Cinema," feminist critic Somnath Zutshi considers the spectacular reemergence of nationalism in Asia, which has resulted in conflicts in theoretical and political debate as well as physical violence.[93] Her question "Who are we?" is constantly being reformulated in terms of the alternative, "How are we different from them?" This question of difference raises related problems associated with the so-called Woman Question, an issue which has long haunted Indian nationalist thought. For Zutshi, the Woman Question in Hindi cinema concerns the powerful forces that lay buried within individual women as well as within the nation as a whole. The layers of Self and Other that connect to the control of the nation also link to problems around attempts to control woman, and both concerns inevitably lead to problems of class, race, ethnicity. The Woman Question raised by Zutshi can be applied to contemporary art in India and throughout Asia.[94]

Arpita Singh and **Nalini Malani** are painters whose work focuses emphatically on the Indian body. In their paintings, bodies freely collide, float, and stagger into relentless movement. Enmeshed in multiple layers of living traditions, these bodies evoke the complexities of Indian society. They invite the viewer into a maze of relationships that reveal the private lives of individuals. Women often take central stage in these works. Sometimes they appear tormented, anguished, or wounded; at other times they are brave, proud, defiant. Here, female sexuality does not always come under the male gaze. In fact, these paintings reveal the woman's perception of the world and her experience of it. Domestic scenes depict family feuds, women at work, women dressing and bathing. An old couple sits warmly caressing each other's hands; the aged lady is undressed, probably about to make love. Color is applied delicately in rich luminescent glazes. The surface has a soft, shimmering texture, like female skin. Both artists use the gestures and body language of their figures as a narrative device that sometimes reveals

hidden tensions in the status of woman, particularly Indian woman.[95]

In Singh's *A Woman with a Girl Child II* (1994), a monumental-sized mother cradles a golden child whose hands are clasped. Beside her, small men with craggy faces make signs with their hands as they watch anxiously. The mother, with her eyes closed, is not joyous. The painting is open to interpretation. For instance, it may refer to issues around sex-selective abortion and female infanticide. In India, because of the difficulties and the astronomical expenses of marrying off daughters, it is common practice for mothers to murder their newborn girls by poison or by "putting them to sleep." Female infanticide is most often practiced by poor families that cannot afford to raise a daughter or pay her dowry. In fact, the birth of a daughter could threaten a whole family's survival.[96] Singh's painting refers to the fact that for Indian families, the birth of a girl is often viewed as a crisis. In India, where discrimination is flagrant, it remains better to be male than female. In Singh's painting, the men stare in shock and disappointment at the female baby. But Singh has given special focus to the mother's nakedness; it stands for security as well as vulnerability. "I think these women are vulnerable," Singh says. "It is the last stance when you are cornered and no escape routes are left. You have to face up to what comes… There is growing sense of danger and insecurity in our society. Life is no longer safe and it is visible in my paintings."[97]

The textured surface with jagged, craggy shapes create tension around these naked women. Busy with domestic chores or making offering to gods, they do not notice or are forced to ignore the violence all around them. In some works, the painted frames within frames, scrolls, and scribbles act as a kind of protected enclosure from the outer worlds. In the wake of the 1992 Ayodhya incident, which resulted in violence throughout India, Singh said, "Violation of private space became heightened and often rituals became related with violence." In *Durga* (1993), she depicts her own version of the fearful deity. Clad in white, Durga steps on a man instead

20. **Arpita Singh**, *A Woman with a Girl Child II*, 1994, watercolor on paper, 35.6 × 50.8 cm (14 × 20 in.), collection of Manu Parekh, New Delhi.

21. Lohar Chawl section of Bombay, India, 1996.

22. *Nalini* Malani, page from *Hieroglyphs, Lohar Chawl*, 1990–91, five books with series of photocopied collages and paintings, this page 23 × 28 cm (9 × 11 in.), courtesy of the artist.

23. Arahmaiani, *Lingga-Yoni* (detail), 1994, acrylic on canvas, 182 × 140 cm (71⅝ × 55⅛ in.) overall, courtesy of the artist.

of a lion. She holds a gun, a conch, and flowers as she simultaneously fights and gives blessing. Singh was strongly criticized for her depiction of this goddess as well as for her particular representation of the fallen man, who is said to resemble the assassinated Rajiv Gandhi.[98]

Malani freely chooses influences from modern art. The fragments in her works reveal her refusal to be lured into the opposition "traditional" versus "modern." Her admiration for works by Rembrandt, Vermeer, Delacroix, and Degas is reflected in her use of color and composition. But that is only part of the richness in Malani's intricate paintings. Her ability to observe, cogitate, and ponder over numerous ideas and themes, and then to overlay them ingeniously in her oeuvre forces us to realize complexities that lie within Bombay, India's internationally famous urban disaster. Malani draws endless visual inspiration from Lohar Chawl, the trade-center slum where her studio is situated.[99] Wholesale merchants and distributors of electrical gadgets and switches clutter in tiny shops. *Pathiwala* and *hamali* (loaders and coolies) sway their hips in rhythmic strides as they carry the merchandise high on their heads like an eternal burden. Sweat-stained clothes are uniforms of the working class who are trapped and bonded in the intricate patron-client relationship of the business hub of Lohar Chawl. The pavements are also the living quarters of these workers; places to rest, sleep, mourn, love, and work. In this plagued landscape of poverty, bodies are pressed against bodies and refuse is piled in alleyways where it stinks, seethes, and comes alive in the monolithic heat. She once wrote, "Emotions that grip one in the ordinary context of life: oppression, anxiety, self-absorption, anger....I am obsessed of 'getting into' these people....Recall them from my memory and to achieve the 'right' inflexion of muscle or a wince of the lips." The books that comprise her "Hieroglyph" series consist of layered and reappropriated images: European masters, Binode Behari Mukherjee, and the Kalighat paintings

that are incorporated with ordinary life of Lohar Chawl.[100] Turning the pages of Malani's books is analogous to peeling away layers of society where the paradoxes of rich and poor, pity and pride, bitterness and determination are put on display. Within the intricate networks of commerce lies a stratum of daily religious practices as devotees worship the sacred icon inside the Hanuman Temple. At night, the luminescent neon image of the divine monkey is lit at the entrance.

Malani's collaboration in the performance of Heiner Mueller's *Medeamaterial* has inspired her to explore the ways human emotions, such as hysteria and torment, are revealed through bodily changes. Metamorphoses of the body, changes of skin, and birth defects are issues raised in Malani's series "Mutants" (1994). Unlike the "Hieroglyph" and "Degas Suite" series, these paintings are mirrors of violence in India and other Third World countries. Imperialism, in the guise of democracy and freedom, has resulted in dominant-subordinate positions. Atrocities caused by the hydrogen bomb and radioactive tests in peripheral places (such as the Pacific islands) have directly influenced Malani's work. For example, she explained that high levels of radioactivity have resulted in "jellyfish" babies being born to Micronesian women. These mutant babies look like blobs of jelly with no heads. Malani's "Mutants" are analogous to those monstrosities. They also refer to poverty. Damaged people on crutches and stumps become metaphors for homelessness and dispossession. Their bisexuality adds to the feeling of discomfort and deformity. In a sea of redness, a girl grows inside a man; a green creature bursts out like uncontrolled fantasies. These mutants are evidence of something gone awfully wrong in our society. Yet, they manage to be neglected and ignored, as if their ghastly appearance were not apparent to onlookers whose curiosity demands a freakish new species, a mutant social form, a deplorable new order.

The Bandung-based artist **Arahmaiani** defines art as "creating a point of contact between the spiritual and the material." Her choice of symbolic images can be contrasted to the figurative

paintings of Singh and Malani. Arahmaiani believes that Indonesian people, feeling the loss of freedom to speak, are inclined to suppress their grievances, anxiously forgiving and tolerating. In facing the issues of sex and religion head on, Arahmaiani confronts the interpretation of morality within the context of the confusing and contradictory Islamic society she inhabits. She cites as an example the fact that whenever a woman menstruates, she is forbidden from performing religious rituals or entering sacred places; it is generally believed that she is "contaminated." And, while religious laws take a firm stance regarding women's responsibilities for sexual relations within the bonds of marriage, the fact that there is little control of the sex industry seems to promote a two-sided view of female sexuality. By manipulating sacred symbols in specific contexts, Arahmaiani's works on the theme of sex and religion have generated hostility among the defenders of Islam. In *Lingga-Yoni* (1992), Arahmaiani combined Malay-Arabic and Palawa scripts with symbols of sexual organs to challenge religious constraints and freedom of faith.[101] It is generally considered sacrilegious to include forms of "cosmic copulation" (inspired by the fifteenth-century *lingga-yoni* from Chandi Sukuh Temple in Central Java) with Arabic letters that are inseparable elements of the sacred Al-Qur'an.

But Arahmaiani always tries to interrogate the power of language and of signs that connote oppression and dogmatism. In her exhibition "Sex, Religion, and Coca-Cola," her painting *Lingga-Yoni* and another work containing a display cabinet of objects caused reverberations among Muslim viewers. The display case in *Etalase* (1994) suggests how objects are given symbolic power through the framing devices of the culture industry. In this case, Arahmaiani has placed several exquisite and possibly precious items in a museum setting: the Al-Qur'an, a pack of condoms, a Coke bottle, and a Buddha, among others. On the basis of inclusion and exclusion, tension is created around objects which signify the sacred and the profane, authenticity and trash, the colonial past and neocolonial present. By juxtaposing symbols of Islam, copulation, and cultural

imperialism in the same context, Arahmaiani conflates the obsession with rituals and the superficialities that generally accompany them. For her, the dangers of blind infatuation with anesthetized symbols of religion can be as demeaning and depressing as ecstasies over Western values and materialism. As a Muslim woman artist, Arahmaiani has placed herself in a challenging position. Not only is her art a catalyst for the inevitable debate over "Is it art?" but it also raises more fundamental questions about the marginality of women within Indonesian patriarchal society and mainstream art.[102]

Although paintings by Singh, Malani, and Arahmaiani differ in medium from sculptures and installations by **Yun Suknam**, Araya Rasdjarmrearnsook, Imelda Cajipe-Endaya, and Soo-Ja Kim, their works are connected by the common themes of female subjectivity. Yun's *Day and Night* (1995) is an installation of painted wood with cherry blossom pink and bright green embroidered furniture. Unlike Marisol's representational images which are linked with Pop Art, pre-Columbian art, and Early American woodcarving, Yun's wooden fragments relate directly to the art of common folk in Korea and to the role of Asian women in patriarchal society.[103] Yun draws inspiration from direct experience of hardship in her family where her mother carried the burden of domestic chores and raising children. In addition, the work comments on her own role as mother and wife, a task that demands various capacities from morning till night. In the sculpture, the mother, in traditional costume, protects the angelic baby and dutifully serves the faceless husband. As she shifts to her nocturnal role, more of her internal psyche is revealed. The empty pink room turns eerie and chilling as the chairs with skeletal, unpolished legs transform into sinister torturing traps with razor sharp instruments awaiting the master of the house to sit.[104]

In her 1995 installation *Buang* (Trap), **Araya Rasdjarmrearnsook** makes a visual comparison between being a woman and the process of being fixed, framed, oppressed, and blocked by social mores. Like a frail invalid or corpse, the sculpted figure of woman lies in a canoe-shaped

24. **Yun Suknam**, *Day and Night*, 1995, detail of installation showing painted wooden figure and plastic doll, H. of element approx. 165 cm (65 in.), courtesy of the artist.

25. **Araya Rasdjarmrearnsook**, *Buang* (Trap), 1995, detail of installation with wood, metal plates, clay, and fiberglass, H. approx. 152 cm (60 in.), courtesy of the artist.

wooden bowl (which doubles as a cradle or a coffin). Her body lacks a torso, and where one would be is nothing more than a heap of crumpled scraps of transparent material and misshapen pieces of clay, looking like the residue of something that has been gnawed by death. This morbid effect is heightened by framed etchings of skeletons that hang nearby; a bundle of sticks that have been burnt to charcoal; and two heavy logs and a large stone held precariously in mid-air by thin wires. Rasdjarmrearnsook explains that the objects relate to the situation of women in Thailand: "Most women fall into the trap set up for them by society. Thai women are closed, blocked, and oppressed by moralizing social norms. The female corpse lies in her coffin, women can't stand up because they're trapped by the double standards society places on them."[105]

Related to *Buang* are two other installations by Rasdjarmrearnsook, *Time: Object Was Aborted* (1995) and *Prostitute's Room* (1994). These two works also focus on provocative issues for women in a sexually discriminatory culture: abortion and prostitution.[106] In the latter work, blood is smeared on glass bowls which are placed in a darkened tentlike enclosure. The odor of dried blood in the damp space elicits a palpable sensation of violence and compels the viewer to re-experience the brutality against the female flesh. Rasdjarmrearnsook's installations are not confined to inequalities against Thai women, however. She also addresses the growing problem of female slavery, trafficking in migrants from neighboring Burma, Laos, and Cambodia and forcing them into a modern form of slavery through prostitution. In some cases, families of these women are proud of their new earning power. Despite the risk of violence and disease, many of the girls are sold into prostitution by their parents and return home with honor. They then repeat the cycle by sending their own daughters to brothels and pimps.

Migrant workers in Asia come in many guises. For instance, millions of Filipina Overseas Contract Workers (OCWs) have fanned out across the world to join the diaspora of Philippine labor.

26. *Imelda* **Cajipe-Endaya**, *Filipina: DH*, 1995, detail of installation showing found objects, plaster-bonded textiles, and text, H. of element approx. 60 cm (24 in.), courtesy of the artist.

Waves of colonization and multinational economic invasion have forced Filipina domestic helpers to earn hard currency for their families back home. While they underpin economic gains abroad, many pay a high personal price. Familial separation, harassment, maltreatment, violence, helplessness, and insanity are some of the costs these domestic workers have to bear.[107] **Imelda** **Cajipe-Endaya** is known for her outspoken feminist views and her participation in many protest rallies and marches against the U.S.-Marcos dictatorship. But she has also long been involved with OCWs and woman-as-victim groups. She believes the word "Filipina" should not be a synonym for maidservant. Rather, the many roles filled by Filipinas—as *babaylan* (priestesses), mothers, and wives—should counterbalance the image of them as migrant workers or victims. Yet, Filipinas abroad have been hailed as contributors to the development of other countries. Not all become maidservants. Many succumb to the call for cheap labor and answer advertisements for mail-order brides, nightclub hostesses, and artistic dancers.[108]

Rage at this situation fueled the emotional response to the hanging of Flor Contemplacion in Singapore, but it was the story of Sarah Balabagan that impelled Cajipe-Endaya to create the room-sized installation *Filipina: DH* (1995) as a tribute to all Filipinas.[109] In this work, textured domestic artifacts, petrified in black, are interspersed with mementos of familial and religious devotion. Plastic statues of the Madonna are placed next to worn-out slippers; Mater Dolorosa's rays (symbolic of the mother/virgin/victim) adorn the ironing board; postcards and mittens are clipped to sentimental cassette tapes; framed on a sweater is the single word "*dignidad*" (dignity). In this context, ordinary and sacred objects become interchangeable. In one corner, a changing gallery of images of Filipinas is projected onto a wall of maid's uniforms. A portrait of Flor Contemplacion flashes by. Elsewhere, there is a line of battered suitcases, a faded national flag, and numerous letters and souvenirs that symbolize the one dream coveted by all these OCWs: a wish for freedom. The installation is Cajipe-Endaya's prayer that one day her country

need not export Filipinas as domestic workers. Although she realizes that art may not solve problems, she hopes it can spur inspiration or outrage for the women of the Third World.[110]

Traditional attire or folk costumes often serve as emblems of national identity and yearning for the past. For Cajipe-Endaya, it is the denigrated uniform of the Filipina housemaid that best fulfills the symbolic function of Philippine national costume. For **Soo-Ja Kim**, who lives and works in Seoul, fabric and textile signify multifarious layers of the alternative tradition, the "woman's" tradition. Kim does not see textiles, patterns, and decoration as inferior mediums of artistic expression. On the contrary, Kim is fascinated by the possibility of combining in "femmages" the formal practices of collage and assemblage with traditional handicraft techniques, such as sewing, piercing, hooking, binding, and knotting.[111] Kim writes, "In Korea, we use cloth as a symbolic material on important occasions such as coming of age ceremonies, weddings, funerals, and rites for ancestors. Therefore, cloth is thought to be more than a material, being identified with the body—that is, as a container for the spirit."[112] As a feminist artist, Kim has been associated with essentialism, since her works reflect a search for an essential feminine aesthetic connected to sewing and the use of cloth.[113] In *Sewing into Walking* (1994), Kim combines bundles of cloth and video monitors with images of herself in landscape. This combination creates a spatial play between inside and outside. Kim also refers to the metaphor of the in-and-out movement of a threaded needle by showing herself walking towards Mount Mai or carrying the "burden of life" (bundles of goods) at the village at Yangdong-ri, near Kyongju. These images on monitors interact with viewers in the gallery who can also see and touch the wrapped fabrics. Kim regards the human body itself as a complicated bundle, so cloth becomes for her something akin to a skin or bandage that separates the inside of the body from the outside. Through her actions, Kim merges the motions of sewing and walking, and her body becomes a metaphor for the bundle and for womanhood.[114]

The sensitive consideration of women as victims is not confined to work by female artists. *Kamol* Phaosavasdi, whose art has focused on deterioration of natural resources and the entropic condition of life, has used the analogy of Mother Nature as a victim of rape and abuse. His series of water and land projects includes room installations that address abuse to the land caused by urbanization and tourism.[115] In *Mode of Moral Being* (1995–96), Phaosavasdi interprets the exploitation of woman and child labor by the sex industry as a form of violence. Video monitors covered with mosquito netting reveal alternating images of classical Thai dancers and go-go dancers in full swing. A vendor cart inspired by beer bars on the streets of Bangkok is converted into an all-purpose vehicle for selling sex, a sort of mobile brothel. Inside, bathed in the glow of red lights, are objects and symbols of sexual desire. Worship of the sex industry appears in the numerous *lingga-yoni* forms which serve as reassurance for good business. For Phaosavasdi, the infrastructure of contemporary Thailand has been transformed into a society of consumerism, specializing in fast food and fast sex.[116] He reminds us that the "selling" of culture, especially through trade in Asian women and children, comes in many forms.

In Phaosavasdi's video, images of Thai cultural heritage interspersed with national promotions allude to the fact that tourism has become the principal economic engine for the country. Montaged images of writhing brown/yellow flesh stimulate visions of the real and the imaginary. The "seduction effect" exercised by the imaginary Asia is intermixed with exoticism, sexual attraction, and the desire to control.[117] Now that Bangkok, Pattaya, and Chiang Mai have become sexual playgrounds and comfortable frameworks for unquestioned "white" superiority, the availability of Thai flesh as a sex commodity offers reinforcement for the perpetuation of masculine power and domination. Since phallic penetration is often seen as the erotic correlative of social/racial/gender superiority, the genitalia of Thai women (or young boys) become mere receptacles. Phaosavasdi constantly intercuts ideas with "artistic" entertainers to convey

27. **Soo-Ja Kim**, *Sewing into Walking*, 1994, detail of installation showing used clothing, bedcover, TV monitor, H. of element approx. 90 cm (36 in.), courtesy of the artist.

28. **Kamol** Phaosavasdi, *Mode of Moral Being*, 1995–96, detail of installation showing interior of wooden trolley, H. of element approx. 30 cm (12 in.), courtesy of the artist

the complexity of these deep-rooted and often self-inflicted problems. Trapped in bars devoted to erotic kitsch, for instance, many girls are forced to specialize in fantasy shows that include eels, snakes, beer bottles, or displays of clenching ability involving ping-pong balls, razors, or darts. This bizarre profession and the willingness of some Thai women to accept it seem to surpass the conventional image of Asian women as docile, feminine, and childlike. As victims of a general social malaise, they work to satisfy the desires and the dominance of their customers. As one mama-san in Phaosavasdi's video says, regarding the hygiene of her hostesses, "Thailand has plenty of water. Our girls take shower several times a day, so they're very clean."

The awakening of gender issues in Asia has created complex situations when the multifarious issues overlap. The traditional binary hierarchies—male/female, class/caste, heterosexual/homosexual—rarely fall neatly into place. **Bhupen Khakhar**, a well-known genre painter who lives in Baroda, creates eclectic works that address the feminine aspect of male homosexuality.[118] Trained in economics and commerce, Khakhar first joined a firm of chartered accountants in Bombay. But he attended evening art classes and in 1961 he gave up his job and joined the Faculty of Fine Arts in Baroda. Khakhar's paintings reflect a mixed bag of cultural influences, including Henri Rousseau, David Hockney, bazaar oleographs, and mass-produced calendars.[119] His ability to astutely reflect Indian contemporary life is particularly evident in his early works, such as *Celebration of Guru Jayanti* (1980). Khakhar's perspicacious view allows him to capture the bizarre and peculiar. But how bizarre is bizarre? And how is peculiar quantified in the Indian context? In *An Old Man from Vasad Who Had Five Penises Suffered from Runny Nose* (1995), a seated naked figure with disheveled white hair and widespread legs displays his "peculiarity." Like lotus leaves, his five penises protrude in many directions. For Khakhar, this depiction is far from strange. As he tells it, "In Vasad, it is common to have five penises but not a runny nose."[120]

Nudity is acceptable in India as long as it is in context. In *You Can't Please All* (1981), the

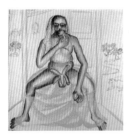

29. *Bhupen* Khakhar, *An Old Man from Vasad Who Had Five Penises Suffered from Runny Nose*, 1995, watercolor on paper, 110 × 110 cm (43¼ × 43¼ in.), courtesy of the artist.

30. A *hijda* in Chowpatti, Bombay, India, 1996.

nakedness connotes sexuality in context of male nudity—a theme which Khakhar has explored in depth.[121] Khakhar has recalled that the subject of male homosexuality first surfaced in his paintings in the late 1980s, after his sojourn in England. In *Yayati* (1987), Khakhar's sexuality is declared in his version of one scene from the Indian epic *Mahabharata*, in which the old king becomes impotent and asks his son to give him youth. The men are shown just as their penises are about to touch. The nude men in *White Angel* (1995) seem to be radiating orange and yellow, flowing and fusing into one entity. A white silhouette tickles a smiling man who caresses his penis. Couples are shown warmly loving, crossdressing, and performing fellatio.

Khakhar also became captivated by images of men in drag. His *Sakhibav* (1995) depicts a *hijda* (eunuch dressed as a woman) or transsexual exquisitely draped in transparent saris as (s)he drinks tea. There are over three thousand *hijdas* in Maharashtra; their licentious activities compel them to belong to various subcultures. Inspired by Vaishnava tradition, in which Krishna is considered male and the rest of worshippers are seen as female, Khakhar's paintings of transvestites throw light on the conceptualization of sexual positionality.[122] Here, *hijdas* defy the binary logic of gender. With a woman's soul confined in a man's body, *hijdas* seem further marginalized than the victimized women.[123] "Feminine" masculinity and femininity as fantasy may seem far beyond the pale of Asian phallocentrism. Yet, living in a country where the notion of equal rights seems to have been lost, Khakhar's paintings concern the widely debated issues regarding the right to love. And, of course, such disputation—over same-sex desire, gay marriage, domestic partnership, and "straight"/"bent" amour—occurs in many places outside Mother India.

Medicinal Herbs, Sacred Cow Dung, Yellow Pigs, Toe-Sucking Is Best

As Asia gears up its modernization in the "Asian way," global trends are forcing the West to confront the rise of the East. Asia now has enormous influence and will undoubtedly have greater

impact in the next millennium. This year, 1996, is the year of the mouse; the year 2000 is the year of the dragon. According to many believers, in the "dragon century," Asians will oversee and dominate the global balance of power. Ironically, the occurrence of the economic miracle before the turn of the century has forced many Asian dragons to become desperate. As the decentered realities of the West are turning to Asia, urbanization, industrialization, and high technology have driven Asians to face their own storm clouds in the guise of alienation, multiple identities, fragmented selves, decease, crime, pollution, ecological destruction, famine, collapse of family structure, and loss of faith in religion. Out of dolor and desperation, various artists have attempted to make sense of their own feelings of anxiety and consternation.

For **Montien Boonma** and **Sheela Gowda** this is reflected in their alluring and contemplative choice of indigenous materials. Boonma lives in Bangkok and his art is intertwined with Buddhist faith (*Buddha saddha*), which is based on the notion of the spiritual quest. In his sculptures and installations, inspired by Buddhist teaching, transcendental meditation, faith healing, and cleansing with medicinal herbs, Boonma engages the viewer with his personal experience and with the activities of specific time and location for which each work is created.[124] The mediums and artifacts selected for Boonma's works include ash, terra-cotta, alms bowls, candle wax, clay pots, and medicinal herbs. Many series of his works are related to religious conviction, prolonging life through worship, and ways of facing death.

In *House for Practicing the Mind* (1994–95), Boonma uses quiet, dimly lit rooms to create enclosures of space for contemplation. Metal-encased sculptures arranged in the form of mandala suggest a centered space used for ritual action. Boonma's sculptures involve a deployment of space and require viewers to participate by bending, crouching, and twisting inside the "sacred" enclosures to listen to humming or chanting sounds. In another enclosed space, the artist has placed countless casts of human lungs that repeat each other like mindful meditation. Smeared all over the lungs and walls are ancient

medicinal herbs from Thailand. The lungs are metaphors for the controlled breathing essential in meditation, while the herbal pigments that produce all kinds of exotic smells symbolize the healing process. Within this meditative space, the viewer is drawn to breathing organs which function as vessels for the inward/outward and upward/downward circulation of air in the body while praying and meditating. Instead of the sound of invocation, rhythmic inhaling and exhaling become symbolic acts of connection and contact as the smell of medicinal herbs soothe and heal inner wounds, rage, and discontent. An encounter with Boonma's installation becomes an experience of aroma and fragrance that evokes ancient medicinal curing places (*alok-hyasan*) where patients are healed and cleansed by herbs and meditation.[125]

Gowda lives and works in Bangalore. Her art is committed to a different kind of faith, one which concerns religious ideas and practices that sometimes turn faith to fanaticism. Her subversive art deals with the violence ingrained in social structures. In this way, her art practice becomes a metaphor for open wounds and the healing process.[126] Gowda also reflects on the tribulations of being a woman in India. When a political cataclysm caused a schism in her country, for instance, it had direct impact on her as a woman. For Gowda, cow dung is the essential medium that is an integral part of life and tradition in India. Her use and application of cow dung serves as a poultice on the trauma of a nation splintered by religious factions and as a way of healing through nonviolence.

Gowda's art went through a drastic change during the period of disturbances by Hindu fundamentalists and the Bombay riots in 1992.[127] At that time, she switched from painting to cow dung. As the cow is considered sacred in India, cow dung is naturally loaded with meanings other than cow shit. For instance, in Kerala, the image of Kamadeva (god of desire) is made of cow dung decorated with flowers. In Karnataka, a cone of cow dung with sprigs of grass stuck into it symbolizes Ganesh. The Shaivite's white caste mark on the forehead is ash made from ritually burning a ball of dry cow dung. In everyday

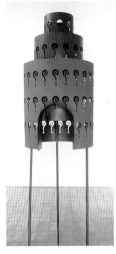

31. **Montien Boonma**, *Sala of the Mind*, 1995–96, detail showing steel and graphite element, H. 270 cm (106 ¼ in.), courtesy of the artist.

32. Cowdung cake drying wall, Bangalore, India, 1996.

33. **Sheela Gowda**, Work in progress, 1996, detail of installation with cow dung, rangoli powder, and kum kum on paper, dimensions variable, courtesy of artist.

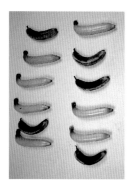

34. **Choi Jeong-Hwa**, from the series "Made in Korea," 1992, fruit and plastic fruit, courtesy of the artist.

life, cow dung is used as fuel, in mud walls, and in folk toys. Rituals and domestic chores carried out by Indian women involve the use of cow dung. With its multiple connotations, cow dung interweaves layers of meaning related to femininity, tradition and violence, religion, and politics. As Gowda writes, "The cow symbolizes non-violence in India....Exploring the connection I saw between sensuality and violence, the choice of cow dung was a conscious one."[128] Like torn skin or a cleaved wound, blood red mixes with textured ochre pigments on fragments of fabrics. These mixed-medium gashes and widening tears across brown surfaces evoke physical as well as mental violence. On an overt level, they are reminders of vehemence for the sake of faith, religiosity, and masculinity. But on another level, they stand for the effects of domestic violence on women and children. Cow dung, with its antiseptic properties, symbolically cures the unseen wounds.

In the era of global media technologies, the questions of how and what culture signifies are becoming increasingly complex and perplexing. "Original" traditions, invented long ago, have become embedded in myths of one culture's particularity and are generally challenged by notions of cultural hybridity. **Choi Jeong-Hwa**'s humorous yet critical works straddle the borders between kitsch and quality, hybrid and original, fake and real. Choi points out that he does most of his "research" on the activities of daily life in places such as the Namdaemun Market.[129] Garish plastic buckets, decorative lights, juicy beef, rotten vegetables, synthetic food, and postcards intensify his enthusiasm to capture markets as places of consumption and commodity. In his series "Made in Korea" (1992), Choi explores issues of "real" and "fake" by juxtaposing synthetic and natural objects. For instance, "banana" has a double meaning when applied to hybridized Koreans trying to become authentically "Western": yellow outside, white inside. In *Seeds* (1995), molded-latex pig heads lit from within are stacked on a mother-of-pearl surface. Choi blurs the division between "high" art and "low" art by combining mass-produced goods and handicrafts, both of which are typically Korean. In *Plastic Happiness*

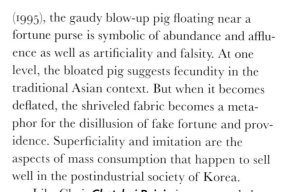

(1995), the gaudy blow-up pig floating near a fortune purse is symbolic of abundance and affluence as well as artificiality and falsity. At one level, the bloated pig suggests fecundity in the traditional Asian context. But when it becomes deflated, the shriveled fabric becomes a metaphor for the disillusion of fake fortune and providence. Superficiality and imitation are the aspects of mass consumption that happen to sell well in the postindustrial society of Korea.

Like Choi, **Chatchai Puipia** is concerned about the state of human behavior in a milieu of flux and transition. But whereas Choi avoids any high art or self-representations, Chatchai focuses on the production of numerous series of self-portraits in oil on canvas. His choice of medium raises the question of traditions. Whose traditions, whose inventions, whose art histories are these? This issue creates an almost schizophrenic slant to Chatchai's images, which seem torn between the highly revered cultural heritage of Buddhism and the desire to emulate Western values and novelties. Here, the artist's cynical view of the hybridization of culture becomes the metaphorical Thai "banana" cast as the self. *Siamese Smile* (1995) is a yellow self-portrait as a deranged lunatic, grinning with a blank stare. This is a joke on the national slogan: Thailand as the Land of Smiles. But smile-a-while campaigns aimed at promoting the country's image are hard to take seriously in light of Thailand's recent reputation for corruption, AIDS, pollution, and military barbarism.[130] Still, come what may, Thais have always put on a false smile to perpetuate the image of a nation of beautiful, Buddhist inhabitants. Only recently, with a loss of faith in the government, the economy, and even Buddhism itself, have many Thais openly expressed a lack of confidence and self-esteem. Puipia's *Something Smells Around Here* (1994) and *Toe-Sucking Is Best* (1994) reflect this dilemma, and capture the sense of frustration and anguish for Thai citizens caught in the midst of a rapidly industrializing society trying to compete in an age of global telecommunications. Puipia's work offers a sober reminder that an overemphasis on materialism and monetary gains can lead to false happiness and demeaning superficiality.[131]

35. *Chatchai Puipia*, *Toe-Sucking Is Best*, 1994, oil, acrylic, pencil, and newspaper on canvas, 200 × 180 cm (78¾ × 70⅞ in.), courtesy of the artist.

Puipia smells the repugnant odor of corruption but as an isolated individual he can only take comfort in sucking his own toe. In this uncomfortable position, he still attempts to smile as his hand plays with the sunflower that covers his penis.

In *Civil War*, German author Hans Magnus Enzensberger examines the disturbing reality behind the rhetoric of a united Europe.[132] He reflects that the end of the Cold War did not establish a New World Order. If anything, it has served to magnify the problems of nationalism, racism, and ethnicity that have lain dormant for decades. Samuel Huntington has added further to this grim picture by predicting that the conflicts of the future will occur along the cultural fault lines separating civilizations. Western civilization, with its two major variants, European and North American, will face confrontations with non-Western civilizations. Huntington raises the specter of "the West versus the rest" and describes the Confucian-Islamic connection that has recently emerged to challenge Western interests, values, and power.[133] The scene is set, he claims, for some real heavy clashes between political-religious-ethnic blocs.

Contemporary art can hardly change global politics. However, like multifaceted mirrors, it can reflect and even re-present the pressing issues in the warped and weird world that we live in. Trying to understand it, we may at first encounter fragments and dislocations that seem transgressive but senseless. But why not? Like being disoriented in an unknown city with its twisted network of streets and alleys, there will be uncertainties and surprises. It is not our intention for "Traditions/Tensions" to tell the whole story (as if such a thing could be told). On the contrary, this exhibition seeks only to reveal aspects of cultures in transition that may shift stereotypes and fixities of Otherness. As time goes by, these issues may be supplanted by new ones. Ignoring them altogether would be the easiest thing to do. But like a persistent itch, they keep coming back. By confronting these issues, we may hope to grasp a clearer understanding of the geopolitical context in which each culture takes its own shape with its own historical specificities and trajectories.

By considering the changing relations in various cultural centers throughout Asia, we have been able to link in this exhibition the overlapping issues of nationalism, postcolonialism, gender, race, and ethnicity evident in contemporary Asian art. These artworks suggest the widespread existence of not only an anti-imperialist nationalism but also a reaction to internal colonization with a deepening of cultural and economic neocolonialism in the pan-Asian region. Some of the works are easily graspable, others take an act of conviction for viewers to venture into areas of confusion or unease. But after a disorienting adjustment to these "strange" and "exotic" works, it is hoped the viewer will be able to reconceive the miragelike "clash of civilizations." It is sad to imagine that some people want tumult and bedlam in the world because peace means bad business.

To alleviate this perception and to elevate the general awareness of contemporary art from non-Western countries, "Traditions/Tensions" is appropriately inaugurated by the Asia Society, the cultural institution where America and Asia, partially, meet.

Notes

1. As Edward Said wrote in *Orientalism*, "In short, Orientalism is a Western style for dominating, restructuring, and having authority over the Orient." Edward Said, *Orientalism: Western Conceptions of the Orient* (New York: Random House, 1979), pp. 2–3. Said's writing has been influential on studies of both the East and the West, the colonizers and the colonized, the dominators and the dominated. However, his presentation of Orientalism as monolithic has been challenged by various scholars. See Homi Bhabha, "The Other Question: The Stereotype and Colonial Discourse," *Screen* 24, no. 6 (Nov.–Dec. 1983); James Clifford, "On *Orientalism*," in *The Predicament of Culture* (Cambridge, Mass.: Harvard University Press, 1988); *Public Culture* 6 (Fall 1993), a special issue on the debate over *Orientalism*; and John MacKenzie, "The Orientalism Debate," in *Orientalism: History, Theory and the Arts* (Manchester and New York: Manchester University Press, 1995), pp. 1–15.

2. Homi Bhabha, "The Other Question: Stereotype, Discrimination and the Discourse of Colonialism," in *The Location of Culture* (New York: Routledge, 1994), pp. 66–84.

3. Samuel Huntington, "The Clash of Civilizations?" *Foreign Affairs* (Summer 1993): 22–49. See also Said's response to Huntington's article: "The Clash of Definitions," in *Arts, Culture and Mécénat: A 21st Century Vision* (Tokyo: Kigyo Mécénat Kyogikai, 1995), pp. 35–40. For Huntington's views on Asian democracy and economic versus cultural interests, see "American Democracy in Relation to Asia," in *Democracy & Capitalism: Asian and American*

Perspectives (Singapore: Institute of Southeast Asian Studies, 1993), pp. 27–43.

4. Mahathir Mohamad and Shintaro Ishihara, *The Voice of Asia: Two Leaders Discuss the Coming Century* (Tokyo: Kodansha International Ltd., 1995), p. 76.

5. Ibid., p. 97. Both writers defend Islam and Buddhism as tolerant religions while they feel that in the name of Christianity Europe colonized parts of Asia and Africa. Surprisingly, there is little discussion in the book about racial discrimination in Asia where, for example, the Chinese have been called racial supremacists and Japanese are often regarded as racial exclusivists.

6. In addition to James Clifford, Homi Bhabha, Aijaz Ahmad, and John MacKenzie, Lisa Lowe makes a strong case for viewing Orientalism as heterogenous and contradictory. See Lisa Lowe, "Discourse and Heterogeneity: Situating Orientalism," in *Critical Terrains: French and British Orientalisms* (Ithaca: Cornell University Press, 1994), pp. 1–29.

7. Such geopolitical designations as Near East, Middle East, Asia Minor, and Far East imply distances in relation to the centers where those terms were invented. When one's center is situated in Asia, the Far East or Asia Minor become quite near and not so minor. Surprisingly, there are not terms such as Near West, Middle West, Europe Minor, and Far West.

8. Benedict Anderson, "Census, Map, Museum," in *Imagined Communities: Reflections on the Origin and Spread of Nationalism* (New York: Verso, 1991), pp. 163–85.

9. Apinan Poshyananda, "From Hybrid Space to Alien Territory," in *TransCulture: La Biennale di Venezia* (Tokyo: Japan Foundation, Fukutake Science and Culture Foundation, 1995), pp. 74–78.

10. John Naisbett has discussed at length changing trends in an expanding world in which small has become increasingly powerful. He observes how the modernization of Asia will forever reshape the world as we move toward the next millennium. See John Naisbett, *Global Paradox: The Bigger the World Economy, the More Powerful Its Smallest Players* (London: Nicholas Brealey Publishing, 1995) and *Megatrends Asia: The Eight Asian Megatrends That Are Changing the World* (London: Nicholas Brealey Publishing, 1995).

11. Apinan Poshyananda, "A Frame Works? Non-Aligned, Non-Alien Ping Pong" (paper delivered at the seminar "Contemporary Art of the Non-Aligned Countries: New Perspective on International Contemporary Arts," Jakarta, Indonesia, Apr. 29–30, 1995). Despite new perspectives and new paradigms in determining international art in the posthegemonic, post–Cold War era of the New World Order, the shift from a defense-based, security-related East-West axis to a trade-oriented North-South axis can be problematic as well as hierarchical. The idea of using art as a link to maintain a South-South dialogue among Non-Aligned Movement (NAM) countries still faces barriers and differences in political ideologies.

12. Eugene Linden, "Megacities," *Time* (Jan. 11, 1993): 37.

13. Homi Bhabha, "Interrogating Identity," in *The Location of Culture*, pp. 46–47.

14. Eric Hobsbawn, "Introduction: Inventing Tradition," in *The Invention of Tradition* (Cambridge: Cambridge University Press, 1984), pp. 1–14.

15. Asia Society, "Asia's Powers at the Crossroads," in *The Williamsburg Conference* (New York: Asia Society, 1995), pp. 11–19.

16. Eugène Fromentin, *Une Année dans le Sahel* (1858), quoted in English in Maryanne Stevens, "Western Art and Its Encounter with the Islamic World, 1798–1914," in *The Orientalists: Delacroix to Matisse, European Painters in North Africa and the Near East* (London: Royal Academy of Arts, 1984), p. 15. Also see the discussion on international Orientalism and the Danish view of the Near East in the nineteenth century in Brigette von Folsach, *By the Light of the Crescent Moon: Images of the Near East in Danish Art and Literature, 1800–1875* (Copenhagen: The David Collection, 1996).

17. Helena Spanjaard, "Modern Indonesian Painting: The Relation with the West," in *Indonesian Modern Art: Indonesian Painting Since 1945* (Amsterdam: Gate Foundation, 1993), pp. 15–36. Raden Saleh was educated at the art academy of the Hague and spent the greater part of his life in Europe. He died in Indonesia. From 1900 to 1942, a small group of Indonesian artists adopted the romantic vision of Saleh.

18. Luciano Santiago, "The Loom of Colonial Art, 1521–1890," in *Art Philippines* (Hong Kong: Crucible Workshop, 1992), pp. 49–51. Juan Luna was among several Philippine artists who studied in Europe. He won several prestigious painting awards at the Exposición Nacional de Belles Artes in Madrid for works with titles like *Death of Cleopatra* (1881) and *Spoliarum* (1884).

19. Geeta Kapur, "One Hundred Years: From the National Gallery of Modern Art Collection," *Art and Asia Pacific* 2, no. 1 (1995): 83–87. Raja Ravi Varma developed a style of oil painting that was distinguished for its accurate observation of details. He influenced the painters of Bombay and students at the J.J. School of Art. Some of his exquisite works are *Portrait of Maharashtrian Lady* (1893) and *The Galaxy* (ca. 1889).

20. Geeta Kapur, "When Was Modernism in Indian/Third World Art?" *South Atlantic Quarterly* 92, no. 3 (Summer 1993): 473–514. For further reading on Asian modernism and art, see John Clark, ed., *Modernity in Asian Art* (Honolulu: Hawaii University Press, 1993); *Asian Modernism: Diverse Development in Indonesia, the Philippines, and Thailand* (Tokyo: Japan Foundation Asia Center, 1995); Astri Wright, *Soul, Spirit, and Mountain: Preoccupations of Contemporary Indonesian Painters* (Kuala Lumpur: Oxford University Press, 1994); and Apinan Poshyananda, *Modern Art in Thailand: Nineteenth and Twentieth Centuries* (Singapore: Oxford University Press, 1992).

21. For further discussion of Western misunderstandings about non-Western arts promoted by the display of "exotic" artifacts in museums, see Anderson, "Census, Map, Museum," in *Imagined Communities*; Clifford, "Histories of the Tribal and the Modern" and "On Collecting Art and Culture," in *The Predicament of Culture*; Sally Price, *Primitive Art in Civilized Places* (Chicago: University of Chicago Press, 1989); Annie Combes, "Inventing the 'Postcolonial':

Hybridity and Constituency in Contemporary Curating," *New Formations*, no. 18 (Winter 1992): 39–52; and Craig Clunas, "Oriental Antiques/Far Eastern Art," *Positions: East Asia Cultures Critique* 2, no. 2 (Fall 1994): 318–55.

22. Gayatri Spivak, "Can the Subaltern Speak?" in *Marxism and the Interpretation of Culture*, edited by Cary Nelson and Lawrence Grossberg (Urbana: University of Illinois Press, 1988), p. 297. See also Spivak's discussion of the subaltern in "Subaltern Studies: Deconstructing Historiography," in *In Other Worlds: Essays in Cultural Politics* (New York: Routledge, 1988), pp. 197–221.

23. R. Nandakumar, "N. N. Rimzon: Archetypes of a Lost Humanity," pp. 169–74. See also the essay by Santo Datta in *Six Contemporary Artists from India* (Geneva: Centre d'Art Contemporain, 1987), pp. 17–25, and Victoria Lynn, "Between the Pot and the Sword," *ARTAsiaPacific* 3, no. 2 (1996): 86–89.

24. N. N. Rimzon, interview by author, New Delhi, Jan. 30, 1995.

25. The theme of self-conquest is supremely important to the Jainas. As a result, Jainism has become the world's most rigorously ascetic faith. Sometimes Jainas carry their nonviolence motto to an extreme, as when Jaina monks and nuns cover their nose and mouth with a fine cloth mask to ensure that they do not accidentally kill germs while breathing.

26. Sudip Mazumdar, "India's Holy War," *Newsweek* (Dec. 21, 1992): 16–19. See any map of India and Pakistan that pinpoints the riots and other altercations that took place after the destruction of the Babri Mosque. At the time, Rimzon was in New Delhi. He was questioned by the police, who had raided the foundry in Selanpur where the metal weapons for *The Inner Voice* were cast. On the Babri Mosque, see also Jonah Blank, *Arrow of the Blue-Skinned God: A Classic Journey through India* (London: Simon & Schuster, 1994), pp. 11–23. On the Bombay riots, see Dileep Padgonkar, ed., *When Bombay Burned* (New Delhi: UBS Publishers' Distributor, 1994).

27. See Martinus Dwi Marianto, "The Experimental Artist Heri Dono from Yogyakarta and His 'Visual Art' Religion," (Australia) *Art Monthly* no. 64 (Oct. 1993): 21–24.

28. Heri Dono, interview by author, Yogyakarta, Indonesia, Apr. 24, 1995.

29. Heri Dono, *Kuda Binal* (Wild Horse), program for performance, Yogyakarta, Indonesia, July 29, 1992. See Jim Supangkat, "Heri Dono," in *The First Asia-Pacific Triennial of Contemporary Art* (Brisbane: Queensland Art Gallery, 1993), p. 13.

30. The fans in Dono's installation are placed low intentionally to cool these sacred/authoritarian images. The choice of yellow is also significant as it symbolizes Golkar (Golongan Karya or Functional Grouping), the ruling party in Indonesia.

31. See Gieve Patel, *Ravinder Reddy: Painted Sculptures and Reliefs, 1989–91* (Bombay: Sakshi Gallery, 1991), n.p.

32. Robert Stern, *Changing India: Bourgeois Revolution on the Subcontinent* (Cambridge: Cambridge University Press, 1993), pp. 40–45.

33. Ravinder G. Reddy, interview by author, Bangalore, India, Jan. 26, 1996.

34. The Chiang Mai Social Installation is a biennial art event run by artists; it tries to raise "social consciousness" by focusing attention on the rapidly changing environment and lifestyle of the region. Like the Baguio Arts Festival in the Philippines, the Chiang Mai event encourages the participation of artists from all countries, including Japan, Australia, Singapore, Indonesia, Germany, and the United States.

35. Navin Rawanchaikul, *There Is No Voice* (Bangkok: Amarin Printing and Publishing, 1994).

36. Navin Rawanchaikul, interview by author, Bangkok, Sept. 1, 1995.

37. The distorted faces of Christanto's terra-cotta figures are similar to those in the political cartoons of Sibarani, the editorial cartoonist for the left-wing daily *Bintang Timur* in the late 1950s and early 1960s.

38. Martinus Dwi Marianto, "Metafora Kritis Dadang Christanto Melalui Terakota," *Perkara Tanah* (June 1995): 5.

39. Dadang Christanto, interviews by author, Yogyakarta, Indonesia, Jan. 19 and Dec. 16, 1995. See also Marsana Windhu, "Kekerasan dan Perhitungan Kesengsaraan?" *Perkara Tanah* (June 1995): 6–7.

40. Although Christanto prefers working in clay with his fingers, he has supervised the casting of his male and female figures in fiberglass. One thousand and one of these figures were partially submerged in the sea near a beach in Ancol, Jakarta, in early 1996.

41. Benedict Anderson, "Cartoons and Monuments: The Evolution of Political Communication under the New Order," in *Language and Power: Exploring Political Cultures in Indonesia* (Ithaca: Cornell University Press, 1990), pp. 152–93. Anderson discusses the power of "symbolic speech" in visual political communications through public monuments and rituals, cartoons, films, and advertisements.

42. For a discussion of the structure of repression and struggle for the right to freedom of expression in Indonesia (especially concerning the banning of the three major magazines in 1994), see *Indonesia 50 Years After Independence: Stability and Unity, On a Culture of Fear* (Bangkok: Asian Forum for Human Rights and Development, 1995), pp. 128–50.

43. FX Harsono, interview by author, Jakarta, Dec. 14, 1995.

44. Edilberto Alegre, *Pinoy na Pinoy! Essays on National Culture* (Manila: Anvil Publishing, 1994), pp. xi–xii.

45. Statement by Roberto Feleo on *Tau Tao* for the exhibitions at the Hiraya Gallery, the Cultural Center of the Philippines, and the Museo ng Kalinangang Filipino. See also Francisco Demetrio, and Gilda Cordero-Fernando, Fernando Zialcita, *The Soul Book: Introduction to Philippine Pagan Religion* (Manila: GCF Books, 1991), for which Feleo created the black-and-white illustrations.

46. Roberto Feleo, interviews by author, Manila, Sept. 24 and Nov. 5, 1995.

47. Demetrio et al., *The Soul Book*, pp. 126–38.

48. For examples of Agnes Arellano's self-portraits, see *Ex-Change Berlin-Manila* (Manila: Pinaglabanan Galleries, 1986); *Ex-Change Manila-Berlin* (Berlin: Raab Galerie, 1988); and *Agnes Arellano: Myths of Creation and Destruction, Part II, The Temple of the Sun God* (Fukuoka: Mitsubishi-Jisho Atrium, 1990)

49. Agnes Arellano, interviews by author, Bangkok, Dec. 28, 1994; Johannesburg, March 1995; and Manila, Sept. 23 and Nov. 26, 1995. Among the extensive list of sources reviewed by Arellano for this pantheon of goddesses are Georges Bataille, *Eroticism* (London: Marion Boyars, 1987); Robert Graves, *Intimations of the Black Goddess* (combining three Oxford Lectures, Michaelmas Term, 1963); Clifford, *The Predicament of Culture*; Michael Meister, ed., *The Nature of Religious Imagery* (Philadelphia: University of Pennsylvania Press, 1984); and Demetrio et al., *The Soul Book*.

50. *Treasures of Asian Art: The Asia Society's Mr. and Mrs. John D. Rockefeller 3rd Collection* (New York: Abbeville, 1994), pp. 106–7 (figs. 93, 95). Arellano derived the two accompanying female figures from images of Amitabha from Candi Borobudur (ninth century A.D.) and Mrgathali, Uma-Mahesvara (early seventh century A.D.).

51. Arellano's own pet cobra, named Gloria, died on Apr. 18, 1995.

52. Quoted from Arellano's unpublished notebooks.

53. Ibid.

54. Toshio Shimizu, "Visions of Happiness," in *Visions of Happiness: Ten Asian Contemporary Artists* (Tokyo: Japan Foundation ASEAN Cultural Center, 1995), pp. 15–24; and Shimizu, "Territory of Mind," in *Territory of Mind: Korean Art of 1990s* (Tokyo: Contemporary Art Gallery, Art Tower Mito, 1995), p. 83.

55. The term "eroticized nationalism" is used in the introduction in Andrew Parker, Mary Russo, Doris Summer, and Patricia Yaeger, eds., *Nationalisms and Sexualities* (New York: Routledge, 1992), pp. 1–14.

56. For instance, at the Southeast Asian Games, held in Chiang Mai, Thailand, in 1995, a strong emphasis was placed not only on Thai-ness but also on Lan Na–ness, the cultural heritage of the northern Thai region. Countless classical dancers performed on the soccer field during the opening and closing ceremonies while giant snakes (*naga*) blew fire and water. This sports event was a national confidence-building exercise for the Thais: as expected, the host won the most medals. It was reported that the Indonesians, the Thais' closest rivals, had a hard time resisting the promiscuous allure of Chiang Mai nightlife, despite their assiduous prayers and fasting. Another source reported that free condoms were distributed to the athletes.

57. Every year, portraits of the king are displayed on the streets with the Christmas decorations. However, strict etiquette prevents the king from being portrayed as Santa Claus. In December 1995, following the death of the king's mother, candy-colored Christmas lights were officially discouraged since the country was in mourning.

58. Lauro Gonzales, interview by author, Manila, Nov. 25, 1995. Gonzales claimed to be Jesus Christ, the leader of the Chosen Group of Christ the King. He performed "miracles" and healed "illness and problems" in front of Black Nazareth Quiapo Church. He said he and his chosen saints were in the process of preparing the Spiritual Government in the Philippines. Gonzales also announced that those who wanted to film him in the "second coming" could contact him at the Church every Friday and Sunday.

59. Jonathan Rutherford, "Interview with Homi Bhabha: The Third Space," in *Identity: Community, Culture, Difference* (London: Lawrence & Wishart, 1990), pp. 201–21.

60. Alegre, *Pinoy na Pinoy!*, pp. 3–7, 38–49, 243–47.

61. Reamillo & Juliet, letter to the author, Feb. 13, 1996. Both artists acknowledge that the cross-cultural nature of their relationship/partnership is a challenge to their collaborative work. For them, making art has become a process of responding from these different cultural backgrounds (Australian, Philippine). "I" and "we" become interchangeable, enabling them to work within "spaces of ambiguity," which, at the same time, broaden the range of possible interpretations and the potential for critical engagement. For collaborative works by Reamillo & Juliet, see Bobi Valenzuela, "The CCP Thirteen Artists Awards, Notes on the Exhibition," in *13 Artists Awards 1994* (Manila: Cultural Center of the Philippines, 1994), pp. 4–5; and *TransCulture: La Biennale di Venezia*, pp. 151–56.

62. Reamillo was heavily criticized for the announcement card for his exhibition "P.I. for Sale" at the Hiraya Gallery in August 1994. Designed with an image like a banknote, it showed José Rizal lying on a couch with a surgical instrument being hammered into his genitals.

63. Poshyananda, "From Hybrid Space to Alien Territory," in *TransCulture*, pp. 77–78.

64. Reamillo & Juliet, letter to the author, Feb. 16, 1996. By substituting *panggulo* for *pangulo*, they altered the slogan on the presidential seal of the Philippines (*sagisag ng pangulo ng Pilipinas*) to read "Seal of the Chaos of the Philippines." With regard to the spread legs of the women that form the "M" logo, the artists suggest that this could stand for Mary, Marcos, Martial Law, Mickey Mouse, McDonalds, Multinational Capitalism, Machiavelli, Military, Macho, or Meldy.

65. Flor Contemplacion, 42, was convicted of double murder for the 1991 deaths of fellow Filipina maid Della Maga and her ward Nicholas Wong, and was hanged by the Government of Singapore on Mar. 17, 1995. The event resulted in widespread protests, riots, and burning of the Singaporean flag. See "Welcome Home, Flor," *Today* (Mar. 18, 1995), p. 1; Malou Talosig, "Protests Mount vs. DFA," *Today* (Mar. 19, 1995), p. 1; and "Sin To Lead Flor Burial Rites Today," *Philippine Daily Inquirer* (Mar. 26, 1995), p. 1.

66. Reamillo & Juliet, interviews by author, Baguio, Philippines, Dec. 17, 1993; Manila, Aug. 17, 1994; Venice, June 9–10, 1995; and Bangkok, June 19, 1995. Both artists discussed the layers of intense violence in the Catholic-dominated society of the Philippines. Sexism and machoism play an enormous part in this mental violence. Typical symbols are erotic and masochistic movie billboards and the slogans on the sides of jeepneys. These signs are often enmeshed with religious fervor, especially in the devotion of Jesus Christ. In everyday life, religious icons mix comfortably with sexual and macho emblems. Inspired by the familiar Manila sticker "Pro-Gun: Peaceful, Responsible Owners of Guns," Reamillo &

Juliet began to produce their own slogans; these included "Pro-God: Praise, Respect, Obey God" and "Pro-Life: Please Respect Our Life." These slogans refer parodically to the institutionalized violence that took place in the Philippines during the reign of President Marcos. Reamillo & Juliet juxtapose this past with the sort of violence against the body and mind that takes place in the Philippines today. On the "omnipotence" of President Marcos, see Jaoquin Bernas, *Dismantling the Dictatorship: From MIA Tarmac to EDSA 1986* (Manila: Ateneo de Manila University, 1990).

67. See Bruce Cummings, "The Legacy of Japanese Colonialism in Korea," in *The Japanese Colonial Empire*, edited by Roman Myers and Mark Peattie (Princeton: Princeton University Press, 1984); Ian Buruma, "The Old Japanese Empire: Taiwan and South Korea," in *God's Dust: A Modern Asian Journey* (London: Vintage, 1989), pp. 161–226; and Yossef Bodansky, *Crisis in Korea: The Emergence of a Navy and Dangerous Nuclear Power* (New York: SPI Books, 1994).

68. Yong Chul Lee, "Culture in the Periphery and Identity in Korean Art," in *Across the Pacific: Contemporary Korean and Korean American Art* (New York: Queens Museum of Art, 1993), pp. 10–17.

69. Kim Ho-Suk, interviews by author, Seoul, Apr. 5 and Sept. 21, 1995.

70. See *Ho-Suck Kim* (Seoul: Gana Art Gallery, 1991); and Bum-Mo Yoon, "Ho-Suck Kim's Works: Apujong-Dong, Poor Villages, and Historical Sites," in *Art Vivant, Contemporary Korean Artists: Ho-Suck Kim* (Seoul: Sigongsa, 1994), n.p. See also Carter Eckert, Ki-Baik Lee, Young Ick Lew, Michael Robinson, and Edward Wagner, *Korea Old and New: A History* (Seoul: Ilchokak Publishers, 1990), pp. 264–69.

71. George Hicks, "Ghosts Gathering: Comfort Women Issue Haunts Tokyo as Pressure Mounts," and Louise do Rossario, "A Quest for Truth: Sex Slavery Issue Affects Ties with Asian Nations," *Far Eastern Economic Review* (Feb. 18, 1993): 32–37. About 80,000 women, mostly Koreans, are believed to have been forcibly recruited by the Japanese military in World War II to provide sexual services to Japanese soldiers as the Imperial Army advanced across Asia. An additional 120,000 women are believed to have been drafted as laborers. See also Hicks, *The Comfort Women: Sex Slaves of Japanese Imperial Forces* (Chiang Mai: Silkworm Books, 1995), pp. 39–54, 153–78, which includes photographs of Korean comfort women of Women's Voluntary Service Corps and others who were forced to work at Myitkyina in Burma and Okinawa in Japan.

72. See Christopher French, "Two Mysteries Colliding: The Art of Duck-Hyun Cho," *Duck-Hyun Cho* (Seoul: Kukje Gallery, 1993), n.p.; Robert Fouser, "Duck-Hyun Cho and the Art of 'Memories,'" unpublished manuscript, pp. 1–23; Rhai-Kyoung Park, "Site and History: Counterpoints in Korean Contemporary Art up to the 1990s," in *The Tiger's Tail: 15 Korean Contemporary Artists for Venice '95* (Seoul: National Museum of Contemporary Art, Korea, 1995), pp. 6–8.

73. Cho dramatizes the use of light as a symbol that links the present with the past. Moments of complete darkness evoke an interactive process in coming to terms with the past.

74. Cho Duck Hyun, interviews by author, Seoul, Apr. 4, 1995; Venice, June 7, 1995; and Kwangju, South Korea, Sept. 19, 1995.

75. Minjoong art (people's art) is a form of Korean art that fiercely criticizes the social system. It was most active during the 1980s, particularly among intellectuals. See *Korean Minjoong Arts: 1980–1994* (Seoul: National Museum of Contemporary Art, Korea, 1994).

76. See Suteja Neka, "The Development of Painting in Bali," in *Neka Museum: Guide to the Painting Collection* (Ubud: Yayasan Dharma Seni Museum Neka, 1986), pp. 8–19; and A.A.M. Djelantik, "Contemporary Balinese Art: Continuity in Change," in *Contemporary Balinese Art* (Jakarta: National Museum, 1995), pp. 3–15. Bendi's predecessors, such as Ida Bagus Made Togog (1913–1989), explored the dark and mysterious moods of Balinese ritual and folklore, completely filling the space of their paintings with masses of figures. Many of Bendi's works depict feasts celebrating major life-cycle rituals. See also Garrett Kam, *Perceptions of Paradise: Images of Bali in the Arts* (Ubud: Yayasan Dharma Seni Museum Neka, 1993), pp. 89–96, 189.

77. Adrian Vickers, "Savage Bali," in *Bali: A Paradise Created* (Berkeley and Singapore: Periplus Editions, 1989), pp. 33–36.

78. Fred Eiseman, Jr., "The Sea of Milk," in *Bali: Sekala & Niskala*, vol. 1 (Berkeley and Singapore: Periplus Editions, 1990), pp. 63–67.

79. See Vickers, *Bali*, pp. 194–208. Also I Wayan Bendi, interview by author, Bali, Apr. 25, 1995.

80. For discussion on the related issue of tourist art and collecting as consumption, see Ruth Phillips, "Why Not Tourist Art? Significant Silences in Native American Museum Representations," in *After Colonialism: Imperial Histories and Postcolonial Displacements*, edited by Gyan Prakash (Princeton: Princeton University Press, 1995), pp. 98–118.

81. The Sanggawa Group consists of Elmer Borlongan, Mark Justiniani, Karen Flores, Joy Mallari, and Federico Sievert. Artists who also participated in the *Vox Populi Vox Dei* series were Emmanuel Garibay, Anthony Palomo, and Mikel Parial. In a statement for the *Vox Populi Vox Dei* exhibitions, the members of Sanggawa wrote, "Christianity, as we learned from our history textbook, is a gift from our colonial past. Whatever transpired and molded us thereafter may at times be described as gory, oppressive, and humiliating, but Filipinos are proud that, at least, the experience has converted them into Christians. To be Christian, more often Catholic, is an identity which he will not part with—as if one has to be Christian first before he can have a soul." *Sanggawa: Vox Populi Vox Dei* (Manila: Hiraya Gallery, 1995), n.p.

82. Today there are numerous religious organizations such as Jesus Miracle Crusade and El Shaddai. Among the miracle icons worshipped are the Lady of Fatima and Santo Niño. Every year on Good Friday penitents are nailed to the cross in imitation of Jesus Christ. On Mount Banahaw, near Lake Laguna, devouts from occult sects whip and injure themselves in praise of Jesus Christ.

83. See the coverage in Amando Doronila, "In the House of Sin," *Asiaweek* (Jan. 6, 1995): 26–32; and Kenneth Woodward, "Life, Death, and the Pope," *Newsweek* (Apr. 10, 1995): 46–49.

84. Alice Guillermo, "Art with a Voice: The Sanggawâ Murals," in *Sanggawa: Vox Populi, Vox Dei*, n.p. Also see Guillermo's full-length text in the pamphlet.

85. Karen Flores and Mark Justiniani, interviews by author, Manila, the Philippines, Sept. 24 and Nov. 24, 1995.

86. Randy Engel, "Sex Education in Catholic Drag: An Analysis of *Love and Life*," and "The Vatican and Sex Education," in *Sex Education: The Final Plague* (Quezon City: Kalayaan Press, 1989), pp. 119–68, 169–220.

87. The military coup d'état which overthrew the government of Prime Minister Chatchai Choonhavan in April 1992 resulted in mayhem and carnage which became known as the May Massacre or Black May.

88. Jakapan Vilasineekul, interview by author, Bangkok, Sept. 1, 1995. See also *Jakapan Vilasineekul* (Bangkok: Silpakorn University, 1994) and *Thai Tensions* (Bangkok: Chulalongkorn University, 1995).

89. Wright, *Soul, Spirit, and Mountain*, pp. 99–108.

90. Nindityo Adipurnomo, interviews by author, Yogyakarta, Indonesia, Apr. 24 and Dec. 17, 1995.

91. For sketches and ideas of this performance, see *Nindityo Adipurnomo, Sutrisno, Mella Jaarsma, Nunung WS/ Sulebar Soekarman* (Yogyakarta: Cemeti Gallery, 1992), pp. 4–7.

92. Eiseman, *Bali*, pp. 161–70.

93. Somnath Zutshi, "Woman, Nation and the Other in Contemporary Hindi Cinema" in *Interrogating Modernity: Culture and Colonialism in India*, edited by Tejaswini Niranjana, P. Sudhir, and Vivek Dhareshwar (Calcutta: Seagull, 1993), pp. 83–142.

94. The "woman question" implies notions of ethnicity and femininity as well as ones around identity, authenticity, and difference. Trinh Minh-ha has raised these issues in her studies that are relevant to works by Asian women artists. See, in particular, Trinh Minh-ha, *Woman, Native, Other: Writing on Postcoloniality and Feminism* (Bloomington: Indiana University Press, 1989).

95. See *Arpita Singh* (Paris: Musée National d'Art Moderne, 1986); Nilima Sheikh, "Materialising Dreams: Body and Fabric," in *Arpita Singh: Paintings, 1992–94* (New Delhi: Vadehra Art Gallery, 1994); and Geeta Kapur, "Nalini Malani," in *A Critical Difference: Contemporary Art from India* (Aberystwyth: Aberystwyth Arts Centre, 1993), pp. 7–8.

96. Elisabeth Bumiller, "No More Little Girls: Female Infanticide Among the Poor of Tamil Nadu and Sex-Selective Abortion among the Rich of Bombay," in *May You Be the Mother of a Hundred Sons: A Journey among the Women of India* (New Delhi: Penguin Books, 1990), pp. 101–24; and Chandrika Naik, "Sisterhood of Slaves," *Indian Express Bombay* (Jan. 5, 1994): 9.

97. Arpita Singh, interview by author, New Delhi, Jan. 30, 1995.

98. Arpita Singh, interviews by author, Pattaya, Thai-

land, Aug. 28, 1994; and New Delhi, Jan. 30, 1995. See also the interview with Singh by Ella Datta in *Arpita Singh* (Calcutta: Centre of International Modern Art, 1995), n.p.

99. See Ashish Rajadhyaksha, "The City of Desires," in *Nalini Malani: Hieroglyphs and Other Works, Painted Books, Installation, 1991–92* (Bombay: Sakshi Gallery, 1992); and Kamila Kapoor, "Nalini Malani: Missives from the Streets," *Art and Asia Pacific* 1, no. 2 (1995): 41–51. On chawls in Bombay, see V. S. Naipaul, "The Scrapers and the Chawls," in *India: A Wounded Civilization* (London: Penguin Books, 1977), pp. 57–72.

100. Nalini Malani, interviews by author, Bombay, Feb. 4, 1995; Johannesburg, Feb. 27, 1995; Bombay, Jan. 24, 1996; and Copenhagen, Apr. 30, 1996. For information related to Malani's "Mutants" series, see Winin Pereira and Jeremy Seabrook, *Global Parasites: Five Hundred Years of Western Culture* (Bombay: Earthcare Books, 1994), pp. 15–25.

101. In *Lingga-Yoni*, the Malay-Arabic script translates as "Nature is Book," while the Palawa script translates as "Courageous, honest in fulfilling his duty, Leader of Mankind, His Excellency Purnawarman." During Arahmaiani's exhibition "Sex, Religion, and Coca-Cola" in 1994, this painting, along with parts of her installation that included the Al-Qur'an and condoms, were removed by members of the Muslim Students Movement (Himpunan Mahasiswa Islam).

102. Arahmaiani, interviews by author, Jakarta, Apr. 25 and Dec. 14, 1995; and Bangkok, Mar. 12, 1996.

103. See the catalogues for the exhibitions *Across the Pacific* (p. 42) and *Tiger's Tail* (pp. 6–8, 92–93).

104. Yun Suknam, interviews by author, Seoul, Apr. 2, 1995; Venice, June 7, 1995; and Seoul, Sept. 18, 1995.

105. Araya Rasdjarmrearnsook, interview by author, Bangkok, Sept. 1, 1995. Also see Khetsirin Knitthichan, "Installations of Despondency," *Nation* (Dec. 18, 1995), Section C1–2; and Wiriya Sungkhaniyom and Jennifer Sharples, "Portrait of the Artist as a Thai Woman," *Bangkok Post Sunday Magazine* (Mar. 10–16, 1996): 14–21.

106. See Apinan Poshyananda, "Araya Rasdjarmrearnsook," in *Africus: Johannesburg Biennale* (Johannesburg: Transitional Metropolitan Council, 1995), pp. 216–17; and Araya Rasdjarmrearnsook, "The Fading Fragrance of Jasmine: Drinking Coca-Cola with the Buddha in the Mind," in *Araya Rasdjarmrearnsook* (Bangkok: National Art Gallery, 1995), n.p.

107. With regard to these challenges, see Jonathan Karp, "A New Kind of Hero," *Far Eastern Economic Review* (Mar. 30, 1995): 42–45; and Buhay Marino, "Our Heroes, Their Battle," *Sunday Inquirer Magazine* (Apr. 9, 1995): 12–13.

108. Imelda Cajipe-Endaya, interviews by author, Manila, Sept. 25 and Nov. 3, 1995. See also Alice Guillermo, "Endaya's Winds of Change," *Observer* (Dec. 13, 1981): n.p.; and Ino Mapa Manalo, "Vibrant Vistas, Social Violence," *Philippines Free Press* (Sept. 10, 1988): 34–35.

109. Imelda Cajipe-Endaya, statement on her installation *Filipina: DH* at the National Commission on Culture and the Arts, Manila, 1995. *DH* stands for "domestic helper."

110. Cajipe-Endaya's emphasis on native women can be related with Trinh Minh-ha's notion of "difference"

as a special Third World issue. See Trinh, *Woman, Native, Other*, pp. 79–116.

111. Soo-Ja Kim, interview by author, Seoul, Apr. 3, 1995. See also Jae-Kil Yoo, "Formative Characteristics Shown in Soo-Ja Kim's *Sewing* and *Deductive Object* Works," in *Art Vivant, Contemporary Korean Artists: Soo-Ja Kim* (Seoul: Sigongsa, 1994), n.p.

112. Soo-Ja Kim, "Cloth and Life," in *Art Vivant: Soo-Ja Kim*, n.p.

113. Kim-Hong Hee, "Woman, the Difference and the Power: Feminine Art and Feminist Art," in *Woman: The Difference and the Power* (Seoul: Hankuk Museum, 1994), pp. 28–40.

114. Kim's bundle/body can be identified with ethnicity and womanhood which applies to Trinh's pertinent question, "Whose duality?" Kim touches not only on the "woman question" but also on the oppressor/oppressed, First World/Third World relationship. See Trinh, *Woman, Native, Other*, pp. 103–6.

115. Apinan Poshyananda, "Whose Body, Whose Politics?" in *Strategies for Survival—Now! A Global Perspective on Ethnicity, Body, and Breakdown of Artistic Systems*, edited by Christian Chambert (Stockholm: Swedish Art Critics Association Press, 1995), pp. 264–71.

116. See *Thai Tensions*, pp. 10–11.

117. For discussion of "seduction effect," see Annette Hamilton, "Fear and Desire: Aborigines, Asians, and National Imaginary," *Australian Cultural History*, no. 9 (1990): 14–35. Special Issue, *Australian Perceptions of Asia*, edited by David Walker.

118. See Geeta Kapur, "Introduction," in *Contemporary Indian Art: An Exhibition of the Festival of India 1982* (London: Royal Academy of Arts, 1982), pp. 3–9, 52–53; *Bhupen Khakhar* (Paris: Musée National d'Art Moderne, 1986); *The Spirit of India: Bhupen Khakhar* (The Hague: Galerie Nouvelles Images, 1993); and Victoria Lynn, "India Songs," *India Songs: Multiple Streams in Contemporary Indian Art* (Sydney: Art Gallery of New South Wales, 1993), pp. 16–17.

119. Bhupen Khakhar, interview by author, Baroda, India, Jan. 27, 1995.

120. Salman Rushdie wrote about this painting in *Bhupen Khakhar: Recent Paintings* (London: Kapil Jariwala, 1995). Rushdie mentioned his great-uncle Aires, who became Khakhar's regular model and, in Rushdie's opinion, Khakhar's lover as well. Rushdie described Khakhar as "a fortyish floppy-haired fellow he was then, wearing huge glasses with lenses the size and shape of portable TVs, and behind them, an expression of such perfect innocence that it instantly made you suspicious of a prank."

121. Bhupen Khakhar, interview by author, Baroda, India, Jan. 5, 1995. As Khakhar explains, in Vaishnava worship, priests (*gonsaji*) wear women's clothes as part of rituals to honor Krishna's masculinity.

122. Buphen Khakhar, interview by author, Baroda, India, Feb. 5, 1995.

123. Khakhar's variations on the feminine man can be related to recent theoretical writing on femininity in homosexuality. See, for example, Kaja Silverman, "A Woman's Soul Enclosed in a Man's Body: Femininity in Male Homosexuality," in *Male Subjectivity at the Margins*

(New York: Routledge, 1992), pp. 339–88. For a discussion of Khakhar's *Yayati*, see Edward Lucie-Smith, *Race, Sex, and Gender in Contemporary Art: The Rise of Contemporary Culture* (London: Art Books International, 1994), p. 202.

124. See Tani Arata, "Montien and the Contemporary Thai Scene," in *Montien Boonma: The Pagoda and Cosmos Drawn with Earth* (Tokyo: Japan Foundation ASEAN Culture Center, 1991), pp. 8–9; and Albert Paravi Wongchirachai, "Montien Boonma," *Art and Asia Pacific* 2, no. 3 (1993): 74–81.

125. Apinan Poshyananda, "Montien Boonma," in *Montien Boonma: Fourth Istanbul Biennale* (Bangkok: Amarin Printing and Publishing, 1995), p. 16. See also Sabine Vogel, ed., *Fourth International Istanbul Biennial* (Istanbul: Istanbul Foundation for Culture and Arts, 1995), pp. 58–60, 90–91.

126. Janaki Nair, "Society in a Daub of Dung," *Economic Times* (Apr. 12, 1993): 6.

127. Sheela Gowda, interview by author, Bangalore, India, Jan. 27, 1996. In our interview, Gowda recalled how she felt religious fanaticism and machoism had become intertwined. The concept of *Ramaraja* (god-king) became highlighted for political propaganda as curiosity and cruelty seemed to converge. In some of her paintings with cow dung, dark gaps and spaces became analogous to picking at and probing open wounds.

128. Sheela Gowda, letter to author, Dec. 26, 1995. See Sudhir Kakar, "Victim and Others," in *The Colors of Violence* (New Delhi: Viking, 1995), pp. 139–45, for a discussion of Gandhi, psychoanalysts, and cows.

129. Choi Jeong-Hwa, interview by author, Seoul, Apr. 4, 1995.

130. Puipia's *Siamese Smile* can be compared with the satirical song called "*Siam Muang Yim*" (Siam Land of Smile) by the group Khon Darn Kwean. The lyrics say that Thai life causes dry smiles, tasteless smiles, boring smiles, disappointing smiles, sad smiles, and smirky smiles.

131. Chatchai Puipia, interview by author, Bangkok, Feb. 20, 1994.

132. Hans Magnus Enzensberger, *Civil War* (London: Granta Books, 1994).

133. Huntington, "Clash of Civilizations?" pp. 39–41, 45–49.

Thomas **McEvilley**

EXHIBITION STRATEGIES IN THE POSTCOLONIAL ERA

Artist, Critic, Curator

In the art-related ideology of the modernist era, the idea of the autonomy of the artist was paramount. The German poet Hans Friedrich Schiller compared the artist to a god, or an enlightened being, who simply could not do wrong.[1] He was above the laws of society because he saw into the beyond and, hence, could lead into it; since the transcendent areas of reality that art was supposedly leading toward were still, by definition, unknown, they were supposedly not susceptible to governance by the rules of the presently available reality. The artist or poet was a metaphysical adventurer out on the razor's edge of human experience, an explorer forging boldly into the future and leading the rest of the culture behind him. This was the characteristic doctrine of the Romantic era, which extended from about 1800 till about 1960, more or less coextensive with high and late modernism.

In the postwar United States, this doctrine of the Romantic era was dimly maintained in Clement Greenberg's assertion that the critic and curator were powerless, it was the artist himself who determined the fate of his work: the artist curated his work, the artist criticized it. He or she dealt only with pure form and could not be troubled with the problem of placing his work within the conditional realm of social terms. The idea that obtained for, say, the members of the New York School was that the artist was only responsible for the work while it was in his studio. Its fate in the outside world was a matter to be disdainfully neglected. Put these two ideas together and one has the greater idea that the fate of the work in the world is innately built into it by the nature of what happened in the studio.

From the postmodernist standpoint, which began to emerge around 1960, this doctrine has come to seem questionable. For one thing, the history of the demise of Abstract Expressionism seems not to confirm this ideology.[2] Viewed as historical fact, the fate of the work in the world was actually determined less by the artists' intentions than by the ambient system of criticism and curation. The work of the Abstract Expressionists was appropriated from the intentions of its makers by a series of exhibitions arranged by the United States government. Paintings by Jackson Pollock, Franz Kline, Barnett Newman, Mark Rothko, and others were sent to Europe as essentially "weapons of the cold war,"[3] meant to uphold the idea of American freedom and spontaneity against the idea of robotic working-class happiness presented by the art of the Soviet Union in the same period. It was finally, in other words, neither the artist nor the critic who determined the fate of the work, but the curator. The work was not in fact autonomous due to its aesthetic purity; rather, it was subject to political and other agendas enforced on it from outside.

Issues Around Foreign Curators

In recent years there has been a surge of interest, in the West, in contemporary art from Africa. A series of exhibitions has essayed the intimidating project of presenting the art of a vast foreign continent to an audience unfamiliar with it. A crucial milestone was the show of contemporary African art curated by Grace Stanislaus at

the Studio Museum of Harlem in 1990.[4] Stanislaus sought advice from more or less official sources in African nations and more or less went along with their established canons, producing a show that included a lot of what might be called official art. While this show may have been true to the views of the contemporary African cultures from which it arose, it did not attract widespread attention in the West.

One year later, Susan Vogel organized the exhibition "Africa Explores," at the Center for African Art, also in New York City.[5] Vogel took a different tack, rejecting the canonical lists of artists provided by official African sources and finding the work she would exhibit by informal, and sometimes "sensibility based," criteria; these criteria, of course, were formed at least in part by conditioning from a foreign—that is, a non-African—culture, whereas Stanislaus had more or less accepted the criteria provided by the African nations themselves.

As it happened, Stanislaus's show was less influential in shaping the Western impression of contemporary African art than Vogel's. So Western viewers end up, for the moment, with an impression of the reality of contemporary African art that differs strikingly from that of the African tradition itself. Perhaps the result of this slippage will be fruitful and dialectical, sublating into a synthesis of these two approaches. In any case, the alteration in cultural history that may result from these exhibitions was due to modes of curatorial intervention rather more than to the decisions that artists made in their studios.

The Role of the Curator

It is true, of course, that an artist makes a work with a certain intention; that is, he or she aims the work at the world in a certain way. But often this aim is invalidated or countermanded by the additional aiming that a curator gives the work in exhibiting it. In the final analysis, it is the curator who puts the work into a particular context, one that presents it to the viewer as the embodiment of a certain ideological request.

In the modernist period, a curator ordinarily strove for an impression of sameness, one that assumed a certain universality of values underlying the works in the exhibition. This was often accomplished by excluding alternatives from view. One effect of this sameness was to bind together the intended audience of the exhibition, usually through collective national or class interests. The sameness of the works tended to reinforce the feeling of sameness among the members of the group. This is one way in which exhibition strategies figure into relations of power: as one community seeks to gain power, it binds itself together through various methods, including the pictorial, to increase its solidarity in the enterprise.

In the postmodern or postcolonial era, this modernist curatorial strategy, like many artistic strategies of the period, has sometimes been reversed. In such cases, the curator seeks to highlight not sameness but difference. The motive is to dispel the modernist postulation of universals in favor of a relativized cosmos that attempts to allow each thing to be itself.

The West and the Rest

One of the most highly focused areas of curatorial control has been the West's practice of exhibiting objects from other—often colonized or previously colonized—cultures. Seen broadly, there have been three main phases of this activity.[6] First, in the nineteenth century, objects from cultures regarded as "primitive" were exhibited in curio rooms. They were, literally, objects of curiosity, but they were also trophies, signs of the ability and prerogative of Western explorers to penetrate other cultures and take what they wanted. The second move, which took place around the turn of this century, recontextualized such objects in ethnographic or anthropological museums. Interest was shifted toward a more scientific study of non-Western cultures, but always with a white Western methodology that implied a hierarchical advantage. In the third phase, beginning in about the 1930s, objects were routinely transferred from ethnographic to art museums. Though this shift was ostensibly intended to level the hierarchy by "raising" the aesthetic value placed on non-Western or

nonmodernist art, works from colonized cultures were still labeled "primitive."

In recent years, there has been renewed attention in museological and critical circles to Western curatorial practices with regard to previously colonized cultures. These actions may be seen as a succession of smaller stages within the third phase, which I would call the "art museum phase." The current show, "Traditions/Tensions: Contemporary Art in Asia," may be regarded as a further step in the development of this phase.

"'Primitivism'" and Its Aftermath

An understanding and practical response to this "art museum phase" has been crucial to discussions of postmodern and postcolonial issues in the arts in the West. The specific problems involved first attained high profile with the exhibition "'Primitivism' in 20th Century Art" organized at the Museum of Modern Art in New York City in 1984 by William Rubin and Kirk Varnedoe.[7] Briefly, that exhibition presented historical works from so-called primitive societies alongside works of classical European modernism and posited certain relationships between the two categories. In a relatively few cases, it was argued that the modernist artist had been influenced by African, Oceanic, or Native American objects of the types exhibited. But in most cases, the argument for influence on Euro-ethnic artists was rejected and the similarities observed were attributed to underlying spiritual "affinities" that supposedly bind all humans. Thus, the fact that modernist works often look like so-called primitive ones was used to demonstrate that modern Western art expressed universal values.

That the argument could be reversed— into a claim that the nonmodernist works had expressed the universals first—was not noted. Moreover, the nonmodernist works were treated in a dismissive way that robbed them of dignity. They were not dated (rough dates *were* in fact available) nor were they accompanied by any discussion of their meaning or function in their original contexts. It was as if they did not come from real cultures but were appendages to the West. They were simply there, isolated,

unexplained, evidently unimportant except insofar as they resembled modernist works. They were brought to heel behind the boot of modernism, as the societies they came from had been brought to heel in the colonial era. The exhibition, for all its visual glories, seemed covertly designed to revalidate Western hegemony by restating the modernist hierarchization of cultures familiar from the German philosopher G.W.F. Hegel and other Western thinkers. It is not merely coincidental that in so doing the Museum also implicitly revalidated the hegemony of its own collection. Numerous writers criticized the show on such grounds, and it became a symbol of an old way of thought unwilling to admit its obsolescence.

In the following decade or so, curators at various European and American museums tried to redress the situation with revised exhibition strategies. In 1986, a show called "Other Gods," curated by Rebecca Kelley-Crumlish at the Fundacio del Sol in Washington, D.C., readdressed these issues by showing a greater reverence toward traditional cultural forms. Something similar might be said of the exhibition "Sacred Spaces," curated by Dominique Nahas at the Everson Museum in Syracuse, New York; that show focused on the traditional idea of the *temenos*, or ritual precinct, with its potent inner icon. As their titles indicate, these exhibitions both tended to perpetuate the association of premodern or non-Western cultures with religion and, hence, with the nonrational. Without explicitly hierarchizing Western and non-Western cultures, these shows did, nevertheless, maintain "reason" as the characteristic trait of the modern West and "feeling" as the characteristic trait of the rest of the world.

In 1987, the show "Die Gleichzeitheit des Anderen" (The Simultaneity of the Other) was mounted at the Kunstmuseum in Bern. The curator, Jürgen Glaesemer, perhaps warned by the critical disaster of the "'Primitivism'" exhibition, did not presume to mix Western and non-Western artworks. Instead, he chose Western works that made reference to other cultures in some way or other. As the balance tipped away from the Eurocentric modernist mold, the

Centre Pompidou in Paris staged what is probably the most famous of the revisionist shows addressing these issues: "Magiciens de la terre," organized by Jean-Hubert Martin and Mark Francis in 1989.[8] Described by its curators as a show of contemporary art from around the entire world, "Magiciens" combined the works of fifty Western artists with the works of fifty non-Western artists, with no implications of influence or hierarchy. Although the title suggests an association of non-Western cultures with magic or the nonrational, the show took no explicit stand on religion.

"Magiciens de la terre" had several reception problems. In the first place, as in the exhibition "Africa Explores," the curators did not follow the canons of the various non-Western cultures involved but forged their own way through the available material. They were guided by a sensibility that often reflected little familiarity with the traditions involved; in other words, they viewed the non-Western traditions in Western ways. The exhibition was intended to open the doors of Western art discourse to non-Western art and, at the same time, to open the Western tradition to the realization that it was not an absolute. In the curators' relativistic approach to global pluralism, no tradition was given cultural hegemony over another; each culture was regarded as an end in itself, or as its own center. In the catalogue, each artist was given two pages to use in whatever way he or she wanted, and on each page a map of the world, printed in the upper-right-hand corner, showed that artist's residence as the center of the world.

This generous pluralism was respected. But because of the curators' desire to maintain the purity of each tradition, they unfortunately chose not to exhibit hybrid works. Works that attempted to conflate various traditions—Indian and European, for instance—were not included; only works that arose directly from their own tradition, without incorporation of external elements, were shown. In the case of India, then, rather than selecting complex works by artists struggling to comprehend the interface between India and the West, the curators chose works devoid of outside input. Sometimes, these pieces

seemed irrelevant to the remarkably fertile and ongoing project of multicultural hybridity in India. Similarly, in dealing with Native American art, the curators chose traditional Navajo sand-painters rather than self-consciously contemporary Navajo artists who merge the problems of their Native American heritage with the practices of the ambient contemporary art environment. Thus, there was a certain isolation surrounding each non-Western tradition that was exhibited; each seemed locked into itself. This had the effect of reconstructing or reinforcing old boundaries that are now dissolving, now allowing cultural energies to flow into and through one another.

A problem with all of these exhibitions, and with others of the same tendency, is that they were all organized by Westerners (mostly white males but also white females). So, in structure, if not in spirit, they all reproduced the colonialist procedure of Westerners going into a foreign culture, appropriating what they wanted without respect for the original context, taking it home, and using it for their own purposes.

Alternatively, an exhibition called "Fusion," organized by Susan Vogel for the Museum for African Art in 1994, took a further step toward a genuinely multicultural practice. In the catalogue of that exhibition, four of the five West African artists represented (the fifth was deceased) spoke at length, in his own voice, in extended free-form interviews.[9] Though, again, it was a white Western male doing the interviewing, the direction and content of what was asserted about the work, its sources, and its purposes, came from the artists themselves, without any external agenda being enforced on their utterances. A more hybrid model of curatorial practice was followed by Kathy Halbreich and Thomas Sokolowski when they worked with Japanese collaborators Shinji Kohmoto and Fumio Nanjo for the show "Against Nature: Japanese Art in the Eighties" in 1989.[10]

Contemporary Art in Asia: Traditions/Tensions

The present exhibition seems to me to position itself at the forefront of this sequence in several ways. Organized by the Asia Society in New

York City, it clearly redresses at least one part of the Western discourse: the dominance of white Western male authorities. This show was originated by the Asia Society Galleries' director Vishakha Desai, a woman of Indian origin. It will be shown at two North American museums, but all other venues will be Asian and will address the audiences for whom—and, in a sense, from whom—the work was actually made. The chief curator, Apinan Poshyananda, is a Thai art historian, trained in the United States but a resident of and operating in Thailand. And, the other curators are not Westerners reaching into foreign cultures in a helpless miming of colonial procedures; for each Asian nation, there was an advisor from its own culture. Lastly, all the essays in the catalogue—except for this one—were written from within, rather than from outside, the cultures represented.

A second key point is that the reach or scale of this exhibition is conceived differently from most of the others in question. "Traditions/Tensions" limits itself to art from five Asian nations not necessarily linked regionally or by overlapping traditions—India, Indonesia, Thailand, the Philippines, and South Korea. This selection represents three very different cultural zones: South Asia, East Asia, and Southeast Asia. The common trait that links these five nations and gives cogency to their being represented together is their recent emergence into global importance through burgeoning capitalist economies. This circumstance compels artists in these countries to address the rearranging of the world order and national priorities. "Magiciens de la terre," on the other hand, seemed to reflect the aftermath of the colonial project of world domination precisely because of its global reach. The situation might be compared to Marx's famous remark, in *The Eighteenth Brumaire*, that everything in history happens twice, first as tragedy and then again as farce.[11] In this case, the tragedy was the colonialist project itself; the farce is the constant replaying of it on the level of contemporary art.

A third difference is that "Traditions/Tensions" approaches the work from these five nations without prejudices about some purported purity of tradition. The reality of dissolving boundaries and increasing hybridity is accepted as a situation to be acknowledged and dealt with. Clearly, as one sees in this exhibition, the rising economic power of these nations has produced a corresponding rising complexity in their cultures. In this exhibition, this socioeconomic shift of balance is presented in its visual aspect, adding cultural fullness and integrity to what the world has so far regarded as primarily an economic phenomenon.

Thus, "Traditions/Tensions" has some claim to be regarded as the most genuinely postcolonial of the exhibitions mentioned here. It shows neither, on the one hand, control by or obeisance to the West nor, on the other hand, dread of the West in favor of an insistence on the purity of other traditions. It acknowledges the international arena that includes the West, while each culture involved remains its own center and articulates its own self-definition. For the first time, we have a show of contemporary Asian art that arises from Asia itself, yet with connections, both institutional and cultural, to the West. There is a confidence to this stance that might not have been possible even as recently as a decade ago.

The New Situation

So, the reception problem has been altered; it has, in a sense, been turned inside out. It is no longer a matter of non-Western or non-Euroethnic peoples confronting Western models; it is now a situation in which the West has to adapt to the independent self-definition of other cultures in a way that it has long resisted. The Western or European version of civilization has long-ingrained habits about its responses to cultural objects from other traditions. The sequence of museological shifts mentioned above—from curio room to ethnographic museum to art museum—shows that there has been an intellectual rethinking of this subject for almost a century. Yet, now, for the first time, the West is itself confronted with artifacts and ideas that it does not control but can no longer ignore. Their fate does not depend on Western reception; it is rushing along on its own course. Yet, this unstoppable shift of world balance certainly

Thomas McEvilley

does involve the West. Again, there is an economic bottom line to the cultural situation. These nations have become our trading partners. But this is not taking place in the old way, with the West extracting raw materials from the rest of the world and manufacturing and marketing the finished products. Now, it is finished products, from clothing to computers, that emerge from Asian centers of production to enter the West. And, along with these consumables, come other finished products in the form of artworks, literature, and ideology.

What Now?

This process seems firmly in place and irreversible. Yet, it is by no means clear how the West will deal with the situation on a cultural level. In the next few years, this question will work itself out. For now, one can only speculate. There do seem to be several options, however. One possibility is that the West may contract around its inherited self-image in an essentially reactionary stance, rejecting outside input even though the West itself has enforced its own outside input on other cultures for centuries. This seems unlikely on purely economic grounds. Capitalism will meet its markets wherever they may arise, and culture will follow.

The question, of course, does not have to do strictly with the present exhibition, but with a more general shifting that will bring others in its wake. How will Western art viewers adapt their vision to objects created in and formed by circumstances quite different from their own? Some will no doubt study the material closely and attain a new perspective of connoisseurship on its basis. Others will be attracted to work that resembles some Western work that they have long appreciated. Still others will take the opposite approach and be attracted by the exoticism of artwork that looks strange and other. In the long run, these various responses will likely merge into a somewhat more advanced mode of cultural hybridity. In the postcolonial era, this is no small thing. It means that the traditional rigidity of the Western idea of selfhood will be relaxed—with whatever accompanying tensions. Each Western viewer who learns how to see this work will become, in part, a new and more complex person.

A major shift in world balance is underway. In it, culture will play an important role through this process of altering selfhood. As previously colonized societies come to experience themselves as their own centers (again), their arts will serve the function of both integrating them around expressions of their own selfhood and evincing new attitudes toward the West. If the West is up to the challenge, the future will have a different face, one not yet predictable. This future will have been shaped, in part, both by artists of many nations and by the curators who have patiently and incrementally advanced the project of understanding them.

Notes

1. See, for example, Wilhelm Windleband, *A History of Philosophy*, 2 vols. (1901; New York: Harper Torchbooks, 1958), p. 603: "The man of genius, free from all external determination by purposes and rules, merely lives out his own important individuality as a something valuable in itself—lives it out in the disinterested play of his stirring inner life, and in the forms shaped out by his own ever-plastic imagination."

2. Much of the discourse on this topic is gathered in Francis Frascina, ed., *Pollock and After: The Critical Debate* (New York: Harper and Row, 1985).

3. See Eva Cockcroft, "Abstract Expressionism, Weapon of the Cold War," in ibid., pp. 125–34.

4. See Grace Stanislaus, *Contemporary African Artists: Changing Tradition* (New York: Studio Museum in Harlem, 1990).

5. Susan Vogel, ed., *Africa Explores: 20th Century African Art* (New York: Center for African Art and Munich: Prestel Verlag, 1991).

6. This distinction was explored in Susan Vogel, ed., *Art/Artifact: African Art in Anthropology Collections* (New York: Center for African Art, 1989).

7. For much of the controversy surrounding this exhibition see Russell Ferguson et al., eds., *Discourses: Conversations in Postmodern Art and Culture* (New York: New Museum of Contemporary Art and Cambridge, Mass.: MIT Press, 1990), pp. 339–424.

8. Jean-Hubert Martin et al., eds., *Magiciens de la terre* (Paris: Centre Georges Pompidou, Musée National d'Art Moderne, 1989).

9. Thomas McEvilley, *Fusion: West African Artists at the Venice Biennale* (New York: Museum for African Art and Munich: Prestel Verlag, 1993).

10. See Kathy Halbreich, Thomas Sokolowski et al., *Against Nature: Japanese Art in the Eighties* (New York: Grey Art Gallery and Study Center, New York University/Cambridge, Mass.: MIT List Visual Arts Center, 1989).

11. Robert C. Tucker, ed., *The Marx-Engels Reader* (New York: W.W. Norton and Company, 1972), p. 594.

Geeta Kapur

DISMANTLING THE NORM

प्रचलित मानकों का विस्थापन

INDIA

The Monolith

Despite the variety of well-appointed actors in the theater of Indian art, there was until recently an aspiration for the artist to become a central national figure. It was hoped that the artist might be able to articulate in work and speech a historical position that would clearly demarcate a hospitable national space. This ideal of an integrated identity had as much to do with the mythic imaginary of lost communities as with nationalism and its political utopia. But it also had to do with Third World anti-imperialism and postcolonial personae.[1]

In the postindependence ethos, M.F. Husain (b. 1915) is the primary example of the national artist, marking the conjunction between the mythic and the secular and then between secular and aesthetic space. Along with a selection of his peers, Husain has helped to make modern art in India autonomous—but that, of course, is already an institutionalized notion in bourgeois society. And, by virtue of the socialist register in the liberal society of postindependence India, the modern artist occupies yet another institutionalized cultural space: as the peoples' representative. These two contradictory modes of formalizing the Indian artist's identity—as autonomous and as a spokesperson for the people—are held together by an idealized notion of the artist immersed in an undivided community. It is to facilitate this utopic identity that an artist like Husain invokes a pantheon of benign gods in conspicuously modernist imagery. In a reworked iconography, they are the artist's mascots in the ideological terrain of a national culture.

The integrated identity of the Indian artists was, in an anti-imperialist sense, combative and political. Some artists, like Somnath Hore (b. 1921), were communists; others, like J. Swaminathan (1929–1994), were communist-anarchist; and yet others, like K.G. Subramanyan (b. 1924), were Gandhian. Most saw themselves as belonging to a community of social-democratic or left-liberal Nehruvian intelligentsia. And while there might be conservative artists, there would hardly ever be a fundamentalist artist among them. Until recently, the identity of the Indian artist was modern and secular. And if that identity questioned modernity, it did so on the basis of a tradition that had been, despite the invocations of sacred myths and symbols, "invented" during a nationalist resurgence and was therefore sufficiently secularized.

Or this seemed to be so until we began to interrogate this past. In so doing, we recognized in hindsight a certain bad faith in some of the terms of nationalist cultural discourse. In particular, the sectarian and religious was not looked at directly but was often smuggled in, making both the modern and the secular into well-meaning but too quickly exposed masquerades.

What most needed questioning in recent decades was the artist's presumed expertise in slicing through the layers of this stratified society, as if to touch simultaneously the high caste, the *dalit* (a person of low caste, an untouchable), and the tribal cultures—to draw from them imaginative inspiration but to leave the source compressed within a too steeply hierarchical structure. What also needed to be challenged in the postindependence period was the mapping of the artistic imaginary onto a transcendent

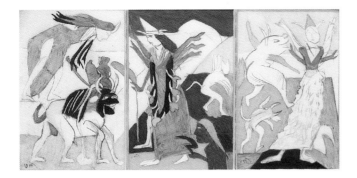 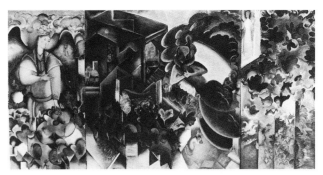

1. K.G. Subramanyan, *Triptych I*, 1990, reverse painting with gouache and oil on acrylic sheet, 91.2 × 183 cm (40 × 72 in.), private collection.

2. Gulammohammed Sheikh, *Visitation*, 1992–96, oil on canvas, 152 × 304 cm (59⅞ × 119¾ in.), private collection.

horizon, for this was the scale at which the heroic self-representation of the national artist was pitched.

Indeed, in India, the terms "modern" and "secular" so completely stood in for contemporaneity that modernism as such was never really problematized. It was made into a matter of aesthetic choice, existential temperament, this or that style, and the auteur's characteristic signature. But all these modernist assumptions, covered over by the jargon of authenticity, soon required an overhauling of both practice and discourse. Since the 1960s, then, Indian artists have engaged in this task, whether through ironic inversions of iconography, as in the instances of K.C.S. Paniker (1911–1977) and K.G. Subramanyan (fig. 1); through its secular conversion into the numinous, as with J. Swaminathan; or through its libidinous excesses, as in the work of Gulammohammed Sheikh (b. 1937) (fig. 2). Certainly, the polemic around a modern Indian identity has not inhibited artists from making free use of the tradition, even to this day. Conversely, every time the tradition is reworked, it is an act of invention and therefore also of self-subversion. And nowhere is this more provocatively proven than in the kitsch-sublime, homoerotic tableaux of Bhupen Khakhar (b. 1934). Khakhar, almost more than any other Indian artist, has helped to dismantle the civilizational monolith.

I would maintain that the norm of an integrated Indian identity was honorable, but such a view does not hold so well now. While cultural imperialism dressed up in euphemistic phrases is becoming the more globally rampant, our critical task is further situated—paradoxical as it may seem—in the framework of a national culture. But from the other end, as it were, what most needs unmasking is the civilizational

profile that cultural practitioners in India, artists among them, have hitherto adopted.[2]

For an artist, of course, these questions are honed at the level of practice. The formal logic, the stylistic dovetailing, and the contending ideologies of modernism were never systematically investigated in the sometimes fortuitous, sometimes passionate syncretism of contemporary Indian art. Now, all of a sudden, nationalist protectionism in art (as in economics) has been dropped and the vexed category of the Indian/modern stands exposed. As thresholds open up in every direction, what emerges is a newly differentiated politics, plus a long overdue art-historical retrospection on sources and language.[3]

Since the 1980s, the politics of Indian art have moved from a Marxist-progressivist base to a radicalism that responds ideologically to these issues. But they respond in the choice of a reflexive language. Younger artists—sculptors in particular—engage more directly with the image as object and with the question of cathexis; they engage with the implications of the transfer of desire from the matrix of tradition into commodification per se. Ravinder G. Reddy (b. 1956), for instance, has found a way of further monumentalizing the iconic form in classical Indian sculpture. By presenting it as a gilded fetish object in the popular mode, he equates the eroticism in the high and low traditions, making the icon a voluptuous object of contemporary delight—humorous, parodic, and boldly accessible. In contrast, N.N. Rimzon (b. 1957) adopts an archaic-classical mode to make possible an apotheosis: in a suppressed ritual of carnal love, in the concealing of the sacred, in the violence and purification of art. He directs the image, whether anthropomorphic or symbolic, toward a hermetic state and, further, toward an asceticism

3. K. P. Krishnakumar, *The Thief*, 1985, painted fiberglass, approx. 152 × 91.5 × 61 cm (59⅞ × 36 × 24 in.), private collection.

that reinstates the aura but challenges the processes of reification. In his tragically brief career, K.P. Krishnakumar (1958–1989) adopted a heroically expressive mode (fig. 3). He used gesture, often profoundly comic, to beckon the viewer, and to signal the lost humanism that he hoped to reinscribe in the local liberationist politics in his home state of Kerala.

There is a transgressive spirit in the contemporary art scene that includes a welcome polemic on the correct application of the modernist canon. More recently, there is a critical reckoning of global postmodernism through conceptual maneuvers. In the work of Vivan Sundaram (b. 1943), each dispersed element in the sculptural ensemble is notated to assume the possibility of reconfiguring the world (fig. 4). Sundaram's anarchic gestures, his metonymic positioning of objects, and his continually evacuated self stand in counterpoint to the formal structures of a conscientious order. His art objects and installations resonate in and through a public space, making possible the recovery of social meanings and, thereby, a deferred form of subjectivity.

The interrogation of identity by the Indian artist has coincided with a loss of a certain equation between history, sovereignty, and the subject.[4] This is also the "loss" of a monadic self that is conceptually male. The gain is a centrifugal force wherein the artist pulls out fragments of Otherness and clads the self, but sparsely. Is this, then, a no-norm artist? Or is this a consciously masquerading subject who is more often than not a mock-Surrealist with astonishing layers of interiority still immanent? We have to find ways of conceptualizing this oddly symbolic, variously displaced art practice that manifests itself in the stark gestures of civilizational avatars, dismantled.

4. Vivan Sundaram, *Gateway*, from the installation/exhibition *Memorial* at AIFACS Gallery, New Delhi, 1993, painted, rusted tin trunks with neon sign, 229 × 216 × 84 cm (90⅛ × 85 × 33 in.), collection of the artist, Delhi.

What was the norm that needed to be dismantled in Indian art? I would answer that there was a properly clad, national/modern that was by and large male. And it may be that it is being stripped bare by the brides, even! Consider Nalini Malani (b. 1946), who demonstrates a devolution of subjectivity to the point of disintegration, even a measured degeneracy. She gestures toward the world by filling up the world-vacuum with her own subjectivity, now worked through the body and soul of a "mutant." The mutant's body, serialized in drawings and paintings of changing scale, is evidence of the concealed modes of violent expropriation within global capitalism; its soul offers "the truth of the victim."[5] Malani's anti-aesthetic coincides with a refusal to concede a sane social space in which meaning can be reconstituted; the tattered fabric of the world unfurling in the wake of the woman's willful descent will have to serve as the proverbial mantle of universal shame.

This theatrical language is shared by Navjot Altaf (b. 1949), who, however, packs the nakedness of her sculptures (fig. 5) with the rude resistance of archaic goddesses positioned within the inverted traditions of feminism. The steadily growing oeuvre of Arpita Singh (b. 1937) holds the ground in another way. Her core image of the girl-child, traced through the successive phases of her life into motherhood, forms the core of an allegory that contains explicit images of subjective and social violence. This is often portrayed in the form of the direct combat of wrestling bodies. However, the frame that surrounds the painting holds this played-out terror in a kind of balletic balance. The protagonist matures with the awkward grace of a saint in Singh's paintings and an apotheosis is concealed not least in the painterly manner itself.

Beyond Eclecticism

The attack on a monolith is always accompanied by a celebration of eclecticism and hybridity. Eclecticism serves to emphasize the democratic right of politically subordinated cultures to invent new syncretic traditions of their own (usually through nationalism) and to participate in an international discourse of modernism. We know for a fact that decolonization is an especially propitious moment for the constrained imagination to open the floodgates of the national/modern mainstream, rupturing its too-conscientious project with heterodox elements that then enlarge the scope of contemporary art practice.[6]

Artist-teachers in India have sometimes argued that colonial cultures achieve a synchronous complexity by intricately weaving local, vernacular, and ethnic strands around a standard heritage.[7] By allegorical extension, national cultures in their postcolonial status also achieve certain lost parities. From there on, it becomes a colonial-into-postcolonial project, in which eclecticism is both an exuberant practice and a defensive rearguard action. Eclecticism helps to legitimize derivitiveness and to contain it— up to the point that it is transformed into independent creative action and serves to define difference or even radical alterity.[8]

In relation to such an achievement, it is important to remember that artists in Third World contexts work with developed adaptations of modernist canons. There is a short but intense history of Indian modernism that is perfectly consonant with economic and political modernization; it does not require that one and only alibi: postcolonial eclecticism. Tyeb Mehta (b. 1925), a modernist of an earlier generation, is typical of several mainstream figures who accept the necessity of cross-referentiality as a reflexive device. He is wedged like a historical marker in the project of Indian modernism. His inscription of a figural metaphor for terror on a brilliantly painted ground reads like a death mask in the context of late–twentieth-century art; it is a conscious painterly act of mourning and cathartic celebration at once (fig. 6). His figural ensembles simultaneously invoke the Arcadia of classical modernism (Matisse and Léger), mythical devouring (of the goddess Kali), and contemporary tragedies (such as the marginalization of his own Muslim community within what is designated as a national secular space). But Mehta is not eclectic in the sense that he works toward a highly synthesized image that finally resolves into classical iconic poise. So, consider the question of eclecticism further.

I will play the role of devil's advocate and suggest that Indians have been too ready to capitalize on eclecticism simply because it is a privilege of complex civilizations that have strongly syncretic aspects. Although, in principle, I am in favor of these honorable if pragmatic conventions

of eclectic art practice, I take this critical position because once hybridity is established as a multicultural norm within the postmodern (which is itself constituted in large part by the debates raised by the diverse cultural processes released by decolonization), then hybridity could mask the sharper contours of an identity forged by the diverse pressures of a cumulative modernity, decolonization, and global capitalism. A continued insistence on eclecticism and its conversion to various ideologies of hybridity within the postmodern can serve to elide the diachronic edge of cultural phenomena and thus ease the tensions of historical choice. It can lead not only to nostalgia but also to a kind of temporal recoil. This recourse to eclecticism could lead to conservativism and complacency since every choice and combination is ratified by the participatory spirit of postcolonialism/postmodernism.

To put it in more ideological terms, we must look not for hybrid solutions but for dialectical synthesis. The heterodox elements from the national culture itself—which is to say the counterculture within it—must first be put into the fray, whether this is the marginalized cultures of tribals and *dalits*, the suppressed voices of women, or the visual inputs of the popular.[9] A space for contradictions has to be opened within the national/modern paradigm so that there is a real (battle) ground for cultural difference and so that identities can be posed in a far more acute manner than postmodern notions of hybridity can accommodate.

An avant-garde artist in the Third World has to recognize that if the logic of modernism is both syncretic and secular, then it must also be radical; that it is semiotically diverse but also pitched to the substantial sign of history. This is hardly new in the Third World experience. Already in the 1960s, Latin American cinema had staked out the grounds to demonstrate that the Third World avant-garde was not simply a carnivalesque spectacle but that it was positioned at the cutting edge of Third World poverty and was thus precisely, historically, pointed.[10]

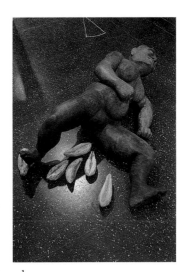

5. Navjot Altaf, *Palani's Daughters: Seven Pieces*, 1995, painted wood and plastic, 41 × 175 × 120 cm (16⅛ × 68⅞ × 47¼ in.), collection of the artist, Bombay.

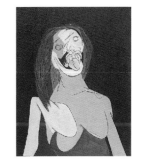

6. Tyeb Mehta, *Kali (Head)*, 1995, acrylic on canvas, 76 × 61 cm (29⅞ × 24 in.), private collection.

This is now the 1990s. There are altogether different ideologies at work in the expanded field of Third World cultural practice. Transnational corporations induce a form of multiple penetration that results in novel equations between the local and global. This not only suppresses the international through the reinscription of artists in the universalist model of anthropological discourse, it also gives them an immanent command over Otherness that is, by now, purely emblematic.[11] To fabricate in order to textually deconstruct an art object—without the responsibility to position historically either the self or the practice in question—would make the need for linguistic coherence, let alone political risk, redundant.

This may be the precise time to reconsider why the postcolonial artist might, in fact, refuse the passport of cultural hybridity into the postmodern. It may also be the time for the avant-garde to question hybrid art forms, and to treat plurality as a means of posing a series of alternatives that have some bite left from the earlier, more dialectical notion of contradiction.[12] Contradiction is positioned in a diachronic scale of values; it works through disjuncture.

India/Asia: The Expanded Field

Every avant-garde is situated in a disjuncture. Within national cultures, there were certain homogenizing values available, including sovereignty. In India, moreover, the tradition of the modern was strong enough to produce its own canon. And there was a desire to see this canon defined as high culture on a par with the civilizational ideal. But the very existence of this modernist canon within the citadel of high culture in India produced a need for art to be seen as autonomous and for an institutionalizing of this autonomy in cultural terms. Here, I am suggesting that the time has come for this norm, assiduously cultivated through the decades after independence as a sort of complement to the notion of sovereignty, to be dismantled. This is a somewhat voluntarist task in that both aesthetic autonomy and cultural sovereignty are cherished values in India. If they have to be dismantled, it must be for a purpose that has a higher political

efficacy as well as a greater creative potential— at least, a more reflexive positioning of the artist within the present historical moment.

As it happens, there is not only voluntarism at work in this argument: once the state and the national bourgeoisie are already in the process of dismantling themselves, the Indian artist is certain to have to shed "his" singular identity to arrive at a more performative, a more alert presence. But this is not just a matter of pitching identity in a certain way; it is not so much a mode of being or self-representation through an existentially authentic art form. Rather, what needs to be worked out is a new style of making, of placing, of reconstituting the world of objects and values in the fragmented gestalt of our times.

Indian social historians now frequently work with the idea of the fragment, accepting that it provides a part-for-whole significance in the moment of loss—the evacuation of a humanist utopia, for example—that the present historical vision must sustain.[13] This fragment may be seen as something split off, in volatile movement and by an ideological disengagement, from the pressure of any given hegemonic culture. Or it may be an element that was never integrated and which then further devolves to withstand assimilation: for example, the point at which the feminine transforms itself into a feminist position, or that at which the *dalit* consciousness performs an act of cultural secession in order to create a state of extreme alterity.

Working thus at the brink, the positions of marginality are foregrounded. The point is to go beyond the well-known primitivist trope in which the cultural praxis of traditional societies is placed. There is still a continuing interest, from an anthropological point of view, to open out the sacred and the self-incorporating secret with which objects in the world and in art are imbued—to open these out into process and materiality so as to be able to recode them for present cultural purposes. This requires the deployment of a social science methodology as much as it requires an analogous commitment to avant-garde art practice. This is the double take at work in the discourse of culture and politics in India today.

I would go a step further and say that the model for the avant-garde may have to come from social studies, first and foremost. Consider how subalternist historians work with social theory/social action, how insistently they pursue the critical function of breaking down the paradigm, the category, the object of attention, including the subject.[14] This is a means of replacing contemplation, which happens also to be the mode of receiving modernist art, with phenomenological encounter and discursive analysis, which coincide with the mode of apprehending the historical avant-garde.

Continuing on the anthropological track to figure alterity and its radical intent, there is now an open interest in primitive materialism and tribal cosmologies, especially as these concern indigenous peoples in Australia, the Americas, Africa, Asia, and the Pacific. The counter-taboo against any interference on the part of the metropolitan artists in the world of the tribal artists was based on one kind of ethic (epitomized by the writings of the anthropologist Claude Lévi-Strauss). This has been broken to the extent that interaction between so-called closed and open communities is taken as inevitable in the present electronic age. Every space has been invaded or will be shortly. A new ethics of reciprocity has to be devised that is equally wary of the ethnographic sentiment for conservation; art-historical desire for a traditional aesthetic; national appropriations and imperialist robbery; and, finally, artistic masquerade on behalf of the people.

Asian cultures are faced with a difficult situation.[15] It is far more difficult than the debates around the 1984 Museum of Modern Art exhibition "'Primitivism' in 20th Century Art: Affinity of the Tribal and the Modern" or the 1989 Centre Pompidou exhibition "Magiciens de la terre."[16] Speaking for Asian societies, there is an ethics of identity that requires not only posthumous reciprocity and retribution but also a devalorization of the self or subjective indulgence in an act of *living solidarities*. We should recall how Swaminathan, our own artist-turned-ethnographer, once risked a face-to-face encounter between the Indian tribal and urban art under the name of the contemporary in the twin museums he set up in 1982 for Bharat Bhavan, Bhopal (fig. 7). He thereby opened a debate around the problematic of modernity which will not cease until it goes beyond his own position on the subject and meets up dialectically with a distinctly non-Western avant-garde.

7. J. Swaminathan, Untitled, 1993, oil and mixed pigments on canvas, 117 × 174 cm (40 × 68½ in.), private collection.

Other options that come up continually in the Asian region can also be noted here. The classical civilizations of the Asian region hold out a continuing lure for the transcendental. There tend to be revivals of a contemplative aesthetic based on a reattribution of the mystical in the heart of dissenting cultures. This tendency is usually contrasted with a loosening of iconic severities, even a deliberate destruction of classicism. In the matrix of Asian cultures, the metaphysical is a vexed category on account of more recent secular convictions; this is precisely a matter for an aesthetic avant-garde to tackle. Oddly enough, a classicism has been built into the project of the avant-garde by the pristine virtue of formalism. I am referring to the historical and metaphysical avant-garde in the Soviet Union of the 1920s, which remains a propitious possibility for a rethinking of the subject today.

In most Third World countries, civilizational memories are now covered over by more recent manifestations of nationalism. The Mexican mural movement remains the seminal case in this century; the history of national liberation movements and their occasional reversals is a continuing subject of representation. These representations are accompanied by strategies of future survival where the relay of blood and memory from the liberation struggle gives the viewer a simultaneous vision: the revolutionary image and a landscape with debris.

Most postcolonial societies have seen a dispersal of their populations through successive waves of migration, and therefore they are subject in their cultural manifestations to mediations of the diasporic imagination.[17] The immigrant questions imperialism and the national culture simultaneously, thus depriviledging the hierarchies set up in the located culture. Equally, however,

the deconstruction of capitalist myths is acted out more and more outside the West and, in fact, this now takes place in the Eastern locations where the Transnational Corporations (TNCs) find their local collaborators. So the issue of location is important again, this time inversely, as a site of global exploitation and of cruel profit. This is to say that the politics of culture is ever and again played out on location. This is also where the avant-garde must pitch itself.

Like other Third World cultures, the Asian region is rich terrain for the formation of new subjectivities, especially feminist subjectivities long held captive by the heavily guarded patriarchies of the region. It is while interrogating hegemonic aspects of the collective consciousness and national allegory, both personified by male protagonists, that female subjectivity will form within the ancient cultures of the "Orient." In the process of radical recodings, this subjectivity will serve to become the very basis for a hermeneutics that reveals suppressed knowledges, including especially female knowledges.[18] Women artists in the region are quite in the forefront in their insistence on deconstructing the patriarchal structure by the most marginal of moves. Sheela Gowda (b. 1957), for example, uses as her artistic medium cow dung, something that is part of the everyday economy of the Indian woman, who must recycle excreta as house plaster and fuel. Even as the woman's material existence is signified by the use of this one raw material, an anti-aesthetic is also benignly signified, accepting ridicule and recoil as part of the regenerative project.

A Poetics of Displaced Objects

The sensuousness of the majority of Third World art as opposed to the cool signs thrown out by Western artists has been a matter of delighted comment as well as intellectual embarrassment among contemporary art critics. We have to find other ways of speaking about the conceptual and material predispositions of Asian artists. The incarnate experience should be able to include a poetics of space in the larger phenomenological sense in which these traditional

cultures knew, still know, how to function. I am speaking about the possibility of introducing circumambulation of the body-self in the installation form, especially in site-specific works. Such spaces might be designated as predisposed precincts that give to the act of spectatorship a gliding vision and a temporal, often meditative, dimension. It is no wonder that the intervention of contemporary artists from Asia tends to be more about redefinition of identity through a reinscription of the body, a resurrected presence in the dismantled condition of self. And it is no wonder that the installation form itself has been so optimistically pursued in recent decades.

Installations in these countries are based on a relationship to materials and skills that is quite different from that known in the West. We must remember that, in Asia, the material is still connected with artisanal practice, with handcraft. The artists have skills; there are artisans in transitional stages within a village and urban market economy who have traditional skills. There is a question of skill as paid labor and the problem of exploitation of indigenist practices. And there is also a question of authenticity—not an issue of being within a tradition but of possessing a language that transcends it while respecting the material conditions of artisanal practice.

We must further remember that the object of art, both by itself and in the theatrical mise-en-scène of the installation, is quite differently conditioned in societies that have an active tradition of magic, fetish, and ritual, including elaborate performances. This is further complicated by the fact that the object in the installations of many Asian artists signals an in-between stage of use and exchange value. In a situation of incomplete modernization and uneven market economy, there is something like quasi-commodification at work: older forms of fetishism survive within new forms of reification in the consumer culture. The object installed within such a context is neither fully functional, nor sacred, nor entirely part of the market. There is reference to all three of these aspects at once and, of course, to a fourth aspect: the making of art with its own parameters stretched between art-historical context and formal autonomy

(including the paradoxes and ironies this enfolds). This in-betweenness can give the object in these installations a peculiarly liminal presence.

Given that Indian art, for example, has been so dominated by the metaphorical, the assembly and installation of objects in foregrounding metonymic meanings perform yet another function: the processes of condensation are eased and the artist is able to introduce the poetics— and politics—of displacement.

Neo—Avant-Garde Alternatives

In his formulation of the historical avant-garde, German theorist Peter Bürger provides some key characteristics to go by: an anti-institutionalism, including an opposition to the institutionalized autonomy of art (or, to put it another way, the enshrinement of autonomous art within bourgeois culture) that has to be interrogated; a reconnection between art and life; and an integration of high and low cultures.[19] I want to reiterate the point that the avant-garde can be only situated in a moment of real historical or political disjuncture. Therefore, it will appear in various forms in different parts of the world at different times.[20]

To develop this argument, I would like to extrapolate from the American critic Hal Foster's reflections on Bürger's argument, particularly when he critiques what he considers Bürger's sectarian position on the avant-garde of the 1920s.[21] What interests me is that, intentionally or not, Foster's position can be extended to speak about avant-garde initiatives in the non-Western world. For a long time now, Latin American cultures have followed a radical agenda that has developed into a cultural dynamic quite independent of their Euro-American antecedents. In order for an African or Asian avant-garde to come into its own, it must make at least two moves simultaneously: one, dismantle hegemonic and by-now-conservative features of the national culture itself; and two, dismantle the burdensome aspect of Western art, including its endemic vanguardism. That is to say, such an avant-garde would have to treat the avant-garde principle itself as an institutionalized phenomenon, recognizing the monstrous assimilative capacity of the

museum, the gallery, the critical apparatus, the curators, and the media.

Given that the avant-garde proposition is as much about historical intervention in the here and now as it is about a retroactive understanding of avant-garde art, a quick retake on the American neo—avant-garde might help here, particularly since it so mediates and dominates the art-historical discourse on the subject. It is worth remembering that in the American context the parameters of the debate on the avant-garde are conditioned by their own telescoping of modernism. The first great modernist art in the United States only emerged so late as the 1940s. By the 1960s, American art critics had already signaled the end of modernist art and the positioning of the neo—avant-garde. American modernists, having pushed an ideology of freedom in the Cold War years on the single ticket of heroic abstraction, especially the Greenbergian ideology of purist painting, had brought it to a quick impasse. With the next generation of more academic art historian-critics in the lead, American artists became the exemplars of a severely disciplined vocation. The neo-avant-garde of the 1960s—mainly Pop Art and Minimalism, positioned in relation to the suppressed histories of Dada and Constructivism—did claim to respond to the outwardly directed radicalism of the decade. The Conceptual opposition to the modernist aporias of the period were based in some part on the intrepid stand of youthful revolutionary energy, intent on upturning, as in the decade of the 1920s across Europe and Russia, the last bastions of bourgeois modernism. But if the American neo—avant-garde replayed the battle with modernism, we should remember that it was in terms of a very reduced notion of modernism and modernist painting: Duchamp was face-to-face with Matisse and Picasso, Rodchenko with, say, Beckmann, but Donald Judd and Carl Andre faced only a Noland or, at best, a Pollock. A too-precise battle, too easily won, straightened the discourse of the neo-neo into the politics of experience/interpretation of the art object as such. Although this politics did gain its larger significance when it came into the phase of feminist Conceptualism in the 1970s.

There is no reason whatsoever for the rest of the world to subscribe to the vocational stringencies of the American neo–avant-garde. Certainly, there is no reason to condemn the sensuous or eccentric or excessive acts of art making that attract non-Western artists. Greenberg's aesthetic meant very little in the Third World. The debates conducted by *October*, the Dia Art Foundation, and the New Museum of Contemporary Art are certainly invigorating but, by definition, there can be no determining discourse on the avant-garde as it is not a moral, academic, or aesthetic force but a *historical* one. It is consequently a highly volatile and, in the argument I am pursuing, varied phenomenon. The political forms of cinema and the magical narratives in literature from Latin America knock peremptorily at the gringo citadels; there is enough in the neighborhood to break any notional monopoly of the American neo–avant-garde. And there have been other models: in painting itself, such attenuated forms of narrative reflexivity as the American-born R.B. Kitaj gave to English Pop Art and to the School of London find reverberations in the narratively inclined Indian painters; the mythic-romantic aspect of Conceptual Art practiced by Joseph Beuys and his followers has been adopted in many parts of the non-Western world; and the New Image painters—whether Anselm Kiefer in Germany or the florid Italians like Francesco Clemente and Enzo Cucchi—may strike a chord in Third World postmodernism, given the Expressionist bias of their first-generation modernists (the good reasons for which cannot be spelled out here). An Indian artist does not aspire to be part of the monumental trans–avant-garde; for the same reason, the American neo–avant-garde is seen as a discreet phenomenon within mainstream internationalism. Renegades from the American canon—from the painterly to the post-painterly to the neo–avant-garde—gain other meanings in other contexts, once they are unstrung from the logic of an American master discourse on the avant-garde.

Reiterating the issue, once we admit history—over and above art history—as the matrix from which the notion of the avant-garde arises, then there are always plural histories in the reckoning. And though in the (still operative) imperialist phase of internationalism, this plural history is split into active agents and others, this view has been repeatedly challenged since liberation politics came on the agenda. As Mexico and the Soviet Union challenged Europe in the pre–World War II era, and as Cuba and Vietnam challenged the United States in the postwar era, contemporary Euro-American cultural discourse cannot function without a recognition of the major shakeups in its hegemonic assumptions. Hopefully, now this challenge will come from Asia, which also promises to be its economic rival and ultimate nemesis!

Among other larger battles, alternative neo–avant-gardes will emerge in opposition to the power structures of American art, academia, and, above all, politics. They do in fact emerge within the United States to challenge the biggest monolith of all: the American state and its capitalist backup. They will emerge on both sides of the divide. I am more concerned, of course, with the Asian side.

If the avant-garde is based on a sense of the future as it must be, this lies elsewhere—in the enlarged theater of political contradictions. As for that elsewhere: it has little to do with the fancy dress of multiculturalism and more to do with a major rethinking of historical experience through political reflexivity and cultural action.[22] Nor is such transgressive energy to be nurtured in the raw; the idea of the classical is fully present in these cultures and the recoding requires adequate formal means. The acts of radical desublimation are that much more complex in cultures based on a sublimation of civilizational ideals through centuries. This is the dialectic at work in the art of Asia today.

And this cannot be trivialized either by postmodern discourse or by the kind of postcolonialism that levels down to ethnic banalities. Plurality makes better sense in its excessive forms at the brink—of subjectivity in the extreme and in the possibility of political risk, best known perhaps to the artists of the Third World as they struggle to recoup their historical position within the terms of a new global imperialism.

Notes

1. See Tapati Guha-Thakurta's art-historical exegesis on the national-modern in her *The Making of a New "Indian" Art: Artists, Aesthetics, and Nationalism in Bengal, 1850–1920* (Cambridge: Cambridge University Press, 1992). Guha-Thakurta furthers this work in her essays "Visualizing the Nation," *Journal of Arts & Ideas*, nos. 27–28 (March 1995); and "Locating Gandhi in Indian Art History" in *Addressing Gandhi* (Delhi: SAHMAT, 1995).

The historical antecedents of the nationalism debate have been elaborated in an extensive study by Partha Mitter, *Art and Nationalism in Colonial India, 1850–1922: Occidental Orientations* (Cambridge: Cambridge University Press, 1994).

The contemporary dimension of the debate on the artist inhabiting a national space has been admirably evaluated through the account of one art institution designed for pedagogy and practice in postcolonial India: see Gulammohammed Sheikh, ed., *Art in Baroda* (Delhi: Tulika, 1996).

2. See Tejaswini Niranjana et al., eds., *Interrogating Modernity: Culture and Colonialism in India* (Calcutta: Seagull, 1993).

3. I have developed this argument further in "The Centre Periphery Model, or How Are We Placed? Contemporary Cultural Practice in India," *Third Text*, nos. 16–17 (Autumn–Winter 1991); "When Was Modernism in Indian/Third World Art?" *South Atlantic Quarterly* 92, no. 3 (Summer 1993); and "Navigating the Void," in *Globalization and Culture*, edited by Fredric Jameson et al. (Durham, N.C.: Duke University Press, forthcoming).

4. Vivek Dhareshwar has discussed this issue intensively in his essay "'Our Time': History, Sovereignty and Politics," *Economic and Political Weekly* 30, no. 6 (Feb. 11, 1995).

5. Veena Das formulated this phrase, which she uses insistently in her essays. See Veena Das, *Critical Events: An Anthropological Perspective on Contemporary India* (Delhi: Oxford University Press, 1995).

6. For more on this moment of decolonization, see Homi Bhabha, *The Location of Culture* (London: Routledge, 1994).

7. K.G. Subramanyan, one of the most eminent artist-teachers in contemporary India, has elaborated on the uses of tradition in the making of art (especially as this was developed in Rabindranath Tagore's University at Santiniketan). He extends the idea of a living tradition through an ever-renewed eclecticism. See the three compilations of his essays: *The Moving Focus: Essays on Indian Art* (Delhi: Lalit Kala Akademi, 1978); *The Living Tradition: Perspectives on Modern Indian Art* (Calcutta: Seagull, 1987); and *The Creative Circuit* (Calcutta: Seagull, 1988).

8. For a political historian's perspective on the problem of colonial culture and derivative discourse, see Partha Chatterjee, *Nationalist Thought and the Colonial World* (Delhi: Oxford University Press, 1988).

9. This interrogation is furthered in Tejaswini Niranjana, ed., "Careers of Modernity," a special issue of *Journal of Arts & Ideas*, nos. 25–26 (Dec. 1993). For discussions of popular culture, especially the cinema, see also *Journal of Arts & Ideas*, nos. 23–24 (Jan. 1993); and *Journal of Arts & Ideas*, no. 29 (Jan. 1996).

10. See Jim Pines and Paul Willemen, *Questions of Third Cinema* (London: BFI, 1994).

11. Hal Foster complicates this issue to bring out its dialectic in "The Artist as Ethnographer," in *Global Visions: Towards a New Internationalism in the Visual Arts*, edited by Jean Fisher (London: Kala Press/INIVA, 1994).

12. For a passionate polemic on the necessity of working with contradiction as part of the project of anticolonialism, see Benita Parry, "Signs of Our Times: A Discussion of Homi Bhabha's *Location of Culture*," *Third Text*, nos. 28–29 (Autumn–Winter 1994).

13. See Partha Chatterjee, *The Nation and Its Fragments: Colonial and Postcolonial Histories* (Princeton: Princeton University Press, 1993).

14. See Gyanendra Pandey, "In Defense of the Fragment: Writing About Hindu-Muslim Riots in India Today," *Economic and Political Weekly*, annual number (March 1991).

15. A range of views on the Asian art front are presented in John Clark, ed., *Modernity in Asian Art* (Sydney: University of Sydney, 1993). See also Caroline Turner, ed., *Tradition and Change: Contemporary Art of Asia and the Pacific* (Brisbane: University of Queensland Press, 1993).

16. There is an extended polemic on these two shows. See, for example, Thomas McEvilley, "Doctor Lawyer Indian Chief," *Artforum* (Nov. 1984), reprinted along with related texts in Russell Ferguson et al., eds., *Discourses: Conversations in Postmodern Art and Culture* (New York: New Museum of Contemporary Art and Cambridge, Mass.: MIT Press, 1990), pp. 339–424. On "Magiciens de la terre," see Cesare Poppi, "From the Suburbs to the Global Village: Afterthoughts on 'Magiciens de la terre,'" *Third Text*, no. 14 (Spring 1991).

17. I am referring to the kind of mediation conducted by Gayatri Chakravarty Spivak and then Homi Bhabha over the past two decades on the question of the postcolonial consciousness. In particular, I am referring to Bhabha's thesis in *The Location of Culture*. Reference should also be made to works of fiction from the diasporic sphere that mediate by finding fictive spaces for the denouement of the postcolonial imaginary, as in the inimitable Salman Rushdie.

18. Seminal work has been done in this field through the study of Indian literatures. See Susie Tharu and K. Lalitha, eds., *Women Writing in India: 600 B.C. to the Present*, 2 vols. (New York: Feminist Press at CUNY, 1993).

19. The generative formulation of the problematic comes from Peter Bürger, *Theory of the Avant-Garde* (Minneapolis: University of Minnesota Press, 1984). I am also indebted in the following argument to related positions found in Peter Wollen, "The Two Avant-Gardes," in *Readings and Writings: Semiotic Counter Strategies* (London: Verso, 1981); and in Andreas Huyssen, *After the Great Divide: Modernism, Mass Culture, Postmodernism* (Bloomington: Indiana University Press, 1986).

20. This has specific reference to the position of plurality and cultural politics in the postcolonial era developed by Paul Willemen. See his "An Avant-Garde for the 90s," in *Looks and Frictions: Essays in Cultural Studies and Film Theory* (London: BFI, and Bloomington: Indiana University Press, 1994).

21. I am referring here to Hal Foster's position on the avant-garde in the postmodern era, and, in particular, to his closely argued essay "What's Neo about the Neo–Avant-Garde?" *October*, no. 70 (Fall 1994).

22. For a perspective on the issue of multiculturalism in the visual arts, see Fisher, ed., *Global Visions*.

Jim **Supangkat**

MULTICULTURALISM/MULTIMODERNISM

Multikulturalisme/Multimodernisme

INDONESIA

"Contemporary Art in Asia: Traditions/Tensions" could be viewed solely as an exhibtion of Asian art in America. The purpose of the show, as stated in the proposal, is "to introduce American audiences to the rich, flourishing art scene from among five Asian countries." Although this is the basic thinking behind the exhibition, I think the matter is not that simple. There was, for instance, an earlier exhibition at the Asia Society called "Asia/America: Identities in Contemporary Asian American Art," which presented work by Asian American artists. I think it is important to see the connection between these two exhibitions. The source of this link is easier to grasp in the case of the "Asia/America" exhibition. Since it addressed the issue of multiracial America, the "Asia/America" show seemed clearly related to the issue of multiculturalism, the subject of heated discussions in the United States over the past five or six years. And since these two exhibitions are connected, I get the strong impression that "Traditions/Tensions" is also in some way tied to the contestation over multiculturalism.

I first learned of the critical debates around multiculturalism in the United States through the writings of the American art critic Lucy R. Lippard. In her book *Mixed Blessings*, she outlines a pattern of cultural domination in the United States by a homogenized Euro-American society, and the consequent marginalizing of "mixed race" groups, who, although they can still be recognized as Africans, Native Americans, Asians, and Latin Americans, should not necessarily be viewed in relation to racial or ethnic differences in the general sense of those terms. As I understand it, "mixed race" is a social phenomenon reflected in the conflicts over race and gender

differences and is not automatically linked to the idea of hybridity. Lippard describes the consequences, saying, "Participation in the cross-cultural process, from all sides, can be painful and exhilarating. I get impatient. A friend says: remember, change is a process, not an event."[1]

On the basis of such statements, I sense that within the development of contemporary art in America, multiculturalism exhibits a political dimension; in other words, art is not observed solely from the point of view of aesthetic values. Indeed, Lippard states,

> The contemporary art world, a somewhat rebellious satellite of the dominant culture, is better equipped to swallow cross-cultural influences than to savor them.... Ethnocentrism in the arts is balanced on a notion of Quality that "transcends boundaries"—and is identifiable by those in power. According to this lofty view, racism has nothing to do with art; Quality will prevail; so called minorities just haven't got it yet. The notion of Quality has been the most effective bludgeon on the side of homogeneity in the modernist and postmodernist periods, despite twenty-five years of attempted revisionism. The conventional notion of good taste with which many of us were raised and educated was based on an illusion of social order that is no longer possible (or desirable) to believe in. We now look at art within the context of disorder.[2]

Although Lippard is speaking about the situation in the United States, I have noticed that this cross-cultural exchange within multiculturalism has an international dimension. Lippard even includes within her study certain "Third World" artists from the developing countries of Africa, Asia, and Latin America. In order to

justify this line of thinking, she quotes Vietnamese filmmaker and writer Trinh T. Minh-ha, who says, "There is a Third World in every First World and vice-versa."[3] Lippard also quotes artist Paul Kagawa's view that

artists who create works which support the values of the ruling-class culture are ruling-class artists, no matter what their color. The "Third World artist" (hereafter T.W.A.) is one who produces in conscious opposition to the art of the ruling class, not just to cause trouble or to be "different," but because the artist is sympathetic with "Third World" people in other sectors of society and the world. Not all "Third World" people are aware of the oppression (or its cause), but all T.W.A.s must be because they are, by our definition, a voice of the oppressed.[4]

From these statements, I have formed a clear opinion of the relationship between "Tensions/Traditions" and multiculturalism in the United States. It seems that this is to be an exhibition of the works of what Kagawa calls "Third World Artists"; it is meant to follow the "Asia/America" exhibition, which displayed "Third World Artists within the First World." But, from what I can glean through reading about cultural developments in the United States, these exhibitions seem to be a major advance in the current debate over multiculturalism. Much has apparently changed since Lippard published *Mixed Blessings* six years ago.

For one thing, it seems the issue of multiculturalism is being ever more widely discussed in the United States. This is in part due to the controversies over the 1993 Whitney Biennial, which I gather was widely perceived as the "multicultural biennial." In a seminar in Jakarta in April 1995, American curator Mary Jane Jacob noted,

The previous 1993 Whitney Biennial, which focused on the multicultural movement as an expression of artists, who were themselves outside the established mainstream, met with fierce objections because it threatened the existing power structure.... Here the American puritanical legacy, denouncing arts as unproductive and morally destructive for the society, came face-to-face with a multicultural agenda that *promoted art as an expression of self identity, potentially restorative, and necessary to the creation of a new, more inclusive society.*[5]

What interested me in this lecture was Jacob's constant reference to the "mainstream" as the dominant force opposed by the multicultural movement. I have found that this generalized notion of the mainstream comes up frequently in international art forums, and I can only infer that what is being referred to is the institutionalized version of cultural modernism that emerged in Europe and America around mid-century. This critical standard is based, as Lippard says, on "a notion of Quality that 'transcends boundaries'—and is identifiable only by those in power."

In her most recent book, *Conversations Before the End of Time*, American art critic Suzi Gablik also discusses this issue of the opposition between modernism and the multicultural movement. I get the impression from reading Gablik's book that this modernism-versus-multiculturalism controversy is a sign that change is coming in the United States. And I think Gablik sees this change occurring throughout the world, as well. This is particularly clear in her dialogue with the well-known art dealer Leo Castelli. In that conversation, auspiciously titled "A Farewell to Modernism," Castelli says,

There was a certain sadness that I felt about it [multiculturalism], but, well, with the Whitney show, I realized that I had to change my attitude, and not be rejecting, as people generally are.... It was a sea change, not just any change: I would say that there is a clear and evident involvement with social problems of all kinds, and they are not filtered. They're there, brutally.[6]

At another point, Castelli remarks, "But there is also that sense that a new era had begun, and if we want to find a turning point—which is, of course, something that's a bit artificial—the Whitney show certainly was one."[7]

When Gablik prods Castelli further, urging him to comment on changes in the development of art worldwide, he says,

There are lots of people who foresee total disasters, and probably we are heading toward immensely more important changes than have

occurred, let's say, during the past century. Now we are beginning to realize, perhaps, that all these inventions, the wars, and the political and geographical changes are coming to a head. All this has been brewing for many, many decades, and it's becoming more evident that all these changes will have results that we can hardly foresee. For instance, America will be an entirely different country in 10, 20, 30 years from now with all these multicultures that we have.[8]

I do not think that the opinions expressed by Castelli are exaggerated. There is indeed a relationship between the social changes taking place in America and those occurring in the rest of the world. Outside of the United States, more and more signs of change are emerging. Critical discussions regarding domination by the mainstream are also expanding and developing. But if the domination of modernism is seen in America in the conventionalized practices of art institutions, outside of America it is seen more in the large international exhibitions, such as Documenta, the Carnegie International, and the Venice and Sydney biennials. These exhibitions constitute forums for the development of the international mainstream. And the impression has developed recently that these exhibitions do not show the works of artists who work outside the mainstream.

This critical attitude toward the domination of the mainstream has given birth to a number of international exhibitions that aim specifically to provide new forums. Among these new international exhibitions and forums are: the Havana Biennial in Cuba; the Asia-Pacific Triennial of Contemporary Art in Brisbane, Australia; the Johannesburg Biennial in South Africa; the Kwangju and Cheju biennials in South Korea; the Asian Art Show in Fukuoka, Japan; the Regional Artists Exchange (ARX) in Perth, Australia; and the "Contemporary Art of the Non-Aligned Countries 1995" exhibition in Jakarta.

In such forums, discussions of mainstream domination are clear and sharp. For instance, in her introduction to the catalogue of the "First Asia-Pacific Triennial of Contemporary Art" in Brisbane, Caroline Turner, curator of the Queensland Art Gallery, stated:

While there is no theme for this exhibition, there is a thesis; that is that Euro-American perspectives are no longer valid as a formula for evaluating the art of the region. The confidence, relevance and vitality of the art will be a revelation to many curators in the West. The opportunities for intraregional interchange generated by forums such as the triennial will, it is to be hoped, provide new ways of looking at art on the basis of equality without a "center" or "centers," as well as an approach to cultural interchange open to the future in which we can recognize what we have in common and yet respect what is different.[9]

Turner even went so far as to identify the whole notion of the domination of the mainstream as a distinctly Euro-American construction. "What we have in Asia instead," she pointed out, "are strong intraregional cultural interchanges, which, like cross-cultural exchange in the multicultural movement in the United States, have caused discussions of contemporary art to take on a political dimension."

Having noticed a similarity between the movements opposing the domination of the mainstream/modernism around the world (in particular, in the writings of Lucy Lippard and in discussions at international art conferences), I fantasized about the possibility of a global multicultural movement. After all, isn't there already a general international struggle against the principles of modernism and the ruling-class values they reflect? And haven't many of the principles of multiculturalism already been reflected in changes in the international art discourse? Suddenly, I felt like predicting the worldwide emergence of cross-cultural exchanges among cross-cultural groups, all of them trying to achieve the sorts of breakthroughs that are now taking place in the United States.

But then I began to doubt that this could really happen. If multiculturalism were to become a global issue, would Asianness or Africanness not surface in contemporary art and head us directly back into the issues of ethnicity, indigenousness, and, finally, exclusivism? Besides that, what of the confrontation between "otherness" and the homogenized values of Euro-American

society? Wouldn't the whole thing simply return to an East-West dichotomy? Also, are Lippard's "cross-cultural exchanges" within the multicultural movement in the United States really the same thing as the "intraregional cultural interchanges" pointed out by Caroline Turner? And, finally, what makes us think that the changes in the art of the world as a whole will (or should) follow those occurring in the art of the United States?

These doubts became even stronger as I tried to delve into one small aspect of this situation: multiculturalism in Indonesia. But by analyzing the current conditions in a very familiar environment, I have arrived at an opinion and a conclusion that are far different from what I would have predicted.

A Multicultural Indonesia

The people of Indonesia, like the people of America, constitute a multicultural society. In Indonesia there are more than three hundred ethnic groups with vastly different traditions and over five hundred dialects. Although Indonesia experienced the hybridization of its culture during the 350 years it was ruled by the Dutch, it has not shown a similar hybridization process among its ethnic cultures during the past fifty years of independence. In fact, it was Indonesia's prolonged colonization that gave rise to the multicultural conditions that produced the new hybrid cultures. Many of the indigenous cultures were substantially transformed under the influence of the Western culture imposed by the Dutch colonial forces.

These new cultures were the product of the feudal elite, a small segment within each ethnic group who gained power by collaborating with the colonial forces. This phenomenon has caused many of the "traditional cultures" of Indonesia to become ambiguous. They are "original" and "hybrid" at the same time—having traditions that reflect the influence of the West, while retaining the original ethnic traditions still embraced by the larger segment of society.

One example of this kind of hybrid culture is the High Javanese culture, which is now known as the traditional or classic culture of Java. (During the colonial period, Java Island was the base for all of the administrative and socioeconomic activities of the colonial administration.) Western influences entered High Javanese culture in a peaceful manner, without confrontation. And within the hybrid culture that developed, a tradition of "high art" emerged during the seventeenth and eighteenth centuries. This was particularly evident in the emergence of the art of painting in Indonesia. Previously, painting was unknown in any of the local ethnic cultures.[10]

This example raises the fundamental question of whether the occurrence of modernism in the development of Indonesian art is just a continuation of the Western-influenced hybrid culture and is, therefore, equivalent to the modernism that emerged in Europe and is associated with ruling-class values. Modernism is the key political force in the development of art in Indonesia. This can be seen in the fact that, since its emergence, modernism in Indonesia has had a political dimension that goes beyond artistic considerations. In the struggle for independence, for example, there was a social revolution in Indonesia. A majority of the population opposed not only the Dutch colonial government but also the feudal social structure that had been advocated by the Dutch. The modernist art movement in Indonesia in 1930s was sparked by nationalist artists who repudiated the colonial administration and feudalism, and modern art became the "expression of the people." For this reason, the emergent modernism was an important sign of a rejection of feudal elitist values in independent (modern) Indonesia.[11]

This modernism was not just a result of modernity or even part of the process of modernization. This modernism reflected idealism. There are similarities in the emergence of this modernism and the first stirrings of modernism in Europe. (Here, I am speaking of modernism as it evolved in the eighteenth century, not the late modernism that was codified in the 1950s). As in the West, Indonesian modernists rejected conventional values and academic art, stood up

1. S. Soejoyono, *Seko, the Guerrilla*, 1947, oil on canvas.

2. Dullah, *Preparing for Guerrilla Warfare*, 1948, oil on canvas.

for individual freedom, and focused on subjects that had their roots in social reality. But Indonesian modernism exhibited some differences as well. For one thing, it contained strong elements of idealism and socialism. The rejection of feudal and elitist conventional values in Indonesian modernism was coterminous with an opposition to the power and pressure exerted by the colonial administration. The themes of the people and of individual freedom (understood as the basic rights of freedom and independence) were colored by nationalistic sentiments that had been growing in Indonesian society since the beginning of the eighteenth century.[12]

But the rejection of colonialism was not the sole issue in the onset of Indonesia's struggle for independence in 1945. At that time, the fledgling state of Indonesia also faced the threat of disintegration due to the multicultural nature of its population: each of the archipelago's three hundred ethnic groups had its own traditions and its own brand of idealism. Since Indonesia had been a federation of states in which each ethnic group had autonomy and power over what went on in its individual region, there was considerable social tension during this revolutionary period. In addition to political turbulence, there was also bloodshed. All the signs seemed to indicate that the new nation would shatter apart. Thus, the multicultural situation that confronted modern Indonesia involved not only the problems arising from cultural diversity but also those stemming from a host of other, preexisting sociopolitical phenomena.

Edi Sedywati, an Indonesian anthropologist and archaeologist, once wrote of this type of multiculturalism:

Within this state, every ethnic group has the same status as members of the unified nation. It seems that no notion of majority-minority dichotomy is put into any national discourse regarding indigenous ethnic groups.... the idea of unification, regards towards one's primordial bounds is deemed necessary and positive, as it gives feeling of rootedness in one's culture, and at the same time that feeling will still be valid within the new nationality.[13]

Within this type of multicultural situation, modernist principles constitute political choices that can hinder disintegration. They can provide a neutral medium for the expression of unity. In Indonesia, they functioned to highlight the concept of an independent and unified nation, as opposed to a continuation of specific ethnic cultures. In particular, modernism and nationalism were attempts to avoid the privileging of Javanese culture ("Javanization" has long been an extremely sensitive issue in Indonesia), which, it was feared, would cause jealousy and suspicion among other ethnic groups.

The threats inherent in this kind of multicultural social condition have, in fact, made Indonesia modern. Whether or not this was agreeable to all, the political decision to state respect for and to acknowledge politically the traditions of the more than three hundred ethnic groups has meant that all are accepted as indigenous elements of a unified Indonesian culture. This point was specifically outlined in the constitution and is what made it possible for Indonesia to achieve independence.

Because of this necessity for forming a political consensus, Indonesia's modernist discourse did not include the rejection of tradition. This peculiarity meant that the avant-garde allegiance to progress and the new, which forms the basis for Western modernism, is no more than a thin layer of Indonesian modernism. In Indonesia, modernism developed without tension alongside many other kinds of art that remained within a traditional framework. In other words, modernism in Indonesia did not necessarily conform to the European modernist rejection of tradition, and the discourse of modernism/modernity in Indonesia cannot be fully interpreted as "modernization."

But neither can modernism in Indonesia be viewed as "Westernization." Even though the modernism of "the New" could be perceived as Western while the modernism that gathers together three hundred ethnic traditions is seen as Eastern, there is no necessary conflict between the two. However, echoes of the old West-East dichotomy are heard throughout Indonesia even today. There is no real basis for the

development of that dichotomy. Rather, in investigating the propagation of the West-East debate between 1920 and 1940, I found that the artificial distinction was encouraged by the Japanese "Greater East Asia" campaign. In this prewar propaganda blitz, the Japanese attempted to use the notion of Easternness as a way of rejecting colonialism, which was identified with the West. Hidden behind this regional advocacy of Easternness—put forth by the Japanese in slogans reflecting their own fierce opposition to the West—was a fervent nationalism (national identity) which had been suppressed during the colonial period (the Dutch colonial administration was notorious for its policy of suppressing all forms of indigenousness). The view gained considerable influence in Indonesia during the Japanese occupation through the efforts of the main Japanese cultural institution, Keimin Bunka Shidoso.[14]

The Eastern pole of the East-West polemic in Indonesia also reflects the struggles of modern Indonesia to come to grips with its own multicultural nature. Since the national identity of modern Indonesia could not be derived entirely from any one of the three hundred ethnic traditions, an umbrella large enough to accommodate them all was required. The concept of Easternness turned out to be the most appropriate umbrella. Still, for the purposes of unifying those three hundred ethnic traditions, this overarching concept could just as easily have been "Westernness," except that Westernness was explicitly identified with the colonial administration.

In my opinion, both the Eastern and Western poles of this debate in Indonesia are options within a dialectical attempt to find the best way to move forward. In fact, the Eastern pole is often not fully concerned with Eastern values and ways of thinking, but is rather a stereotypical moral stance regarding spirituality, collectivity, and intuition. At the same time, the identification of the West is frequently colored with sentiments rooted in the colonial period, which gives even the valid aspects of Western views a negative connotation. But almost all West-East debates in Indonesia end up in a kind of syncretism that embraces neither the East nor the West. In fact,

Western views are often seen as containing some "good" and are therefore capable of having a "good influence" which is needed and must be taken into consideration.[15]

Generally, though, the terms of this West-East dichotomy have been confined almost entirely to theoretical debate, and have not been reflected in the development of art as a practice or activity. There has been no movement to oppose Western aesthetics, for instance, and no revival of tradition; there has not even been an antitraditionalist movement. In Indonesia, the art academies teach only the modern art of the West, and never divide the program into modern Western styles and traditional Eastern styles, as is done in art schools in Japan, India, and Thailand. This indicates that art education in Indonesia—which is an important aspect of the development of modern Indonesian art—does not perpetuate the West-East split.

When the West-East issue does arise in discussions of art in Indonesia today it lacks the context of nationalism (since the once-pressing issue of national identity is no longer as relevant). But because no other context has emerged to replace nationalism, the West-East issue now seems hollow, it no longer has meaning. It lingers largely as a xenophobic, sloganistic expression of official rhetoric used to justify the government's political stances or its suspicion of developments it cannot comprehend.

In December 1993, when I organized the National Biennial in Jakarta, I was criticized by the mass media for advocating "the negative influences of the West," mainly in the form of postmodern installation art (this was the first time that installation art had appeared in a national biennial exhibition). A few months later, when an experimental art festival was held in Surakarta in Central Java, *Kompas*, Indonesia's largest and most influential independent newspaper, decided to "take action." They published an editorial deriding the Westernized art but assuring their readers that any negative influence would soon be "swallowed by time." They wrote:

> *That this is a reaction to the sociopolitical and sociocultural situation can be understood, but the question arises as to whether our people are*

3. Henk Ngantung, *The Evacuation*, 1950, oil on canvas.

4. S. Soejoyono, *Friends in Revolution*, 1947, oil on canvas.

indeed so organized as to motivate this kind of "art." And if they destroy the arts and communication, which would mean anarchy, there is always the question as to whether that art is no longer art, but rather only a personal expression.... [Western] influence is always necessary because it is like a mirror in which we can look and see our own situation reflected. This kind of thing has become a kind of tradition in Indonesian society. The result is that many [negative] influences are simple swallowed up in time, while not a very few survive to become part of the cultural legacy of our people.[16]

Clearly, within the multicultural conditions of Indonesia, modernism carries no connotations of superiority. But then, the modernism that exists in Indonesia is a far cry from that of the far more homogenized Euro-American society, and does not reflect the values of the ruling class. In Indonesia, modern society has developed according to a different model than that followed in Europe and America. The ruling class and the elites in Indonesia have, for instance, remained closer to traditional values and in no way comprehend modernism. On the other hand, modernism in Indonesia does not contain the tensions of ethnicity, indigenousness, or difference of races. Neither is modernism mainstream nor are the nation's more than three hundred ethnic traditions marginalized. Rather, this modernism is limited to being a largely metropolitan phenomenon (since it occurs only in major cities). It does not force values, quality standards, or modernist thinking on traditional art, and there is no traditional art that "has the intention" of developing into modern art. In fact, Balinese art, like Aboriginal art in Australia, has maintained its traditional framework and yet has become more "contemporary" than most Indonesian modern art.

The fact that Indonesians have had to juxtapose three hundred ethnic traditions with an emergent modernism has fortified the pluralistic conviction that culture is always made up of a variety of substances and that it cannot be related to only one framework with one absolute truth. Indonesian modernism does not necessarily reflect hybridity or constitute a "melting pot" of the many ethnic traditions. This is in part because modernism is not based on those ethnic traditions and it is not the sole representation of modern/contemporary Indonesian culture. Although there has been some mixing of modernism and ethnic traditions, the mutual influence has failed to change the basic framework of either.

In this sort of multicultural context, it is hard to imagine cross-cultural exchanges like those cited by Lucy Lippard, which reflect "the deep social and historical awkwardness underlying that exchange." This is not to say that I do not agree with her view that the values of modernism as institutionalized in the United States are repressive and force homogenized Euro-American values on society. But Lippard implies that the debate over these values of modernism is black and white. In Indonesia, modernism is neither black nor white. It is gray. In fact, I would even say, it is a pale gray.

Multimodernism

Modernism in Indonesia is part of a global modernist movement but it has had only a selective interaction with more mainstream forms of modernism. Critics and art historians throughout the world can easily recognize modern Indonesian art; it reproduces the styles, idioms, and tendencies that are characteristic of the history of modernism. But Indonesian modernism, which is generally perceived as not showing a modernist development and assumed to constitute a part of Indonesia's local tradition, is a marginalized modernism.

Actually, it is not surprising that a concept of idealism, like modernism, should develop differently in a different context. Indonesian modernism has emerged from far different conditions than the dominant Euro-American modernism. Interestingly, though, there was once a close encounter between Indonesian modernism and American modernism. This occurred in 1990, when the "Festival of Indonesia in the United States" was being planned. This festival, which was intended to provide a total look at Indonesian culture, neglected modern Indonesian

art almost entirely. All of the major galleries and museums in the United States refused to exhibit contemporary Indonesian art; they suggested that it be shown in anthropological museums instead.

That incident speaks for itself. The observations by Lippard and Jacob on art institutions in the United States make clear the situation which led up to that rejection. It is the same sort of refusal that had already been experienced by women artists and artists of color in the United States. However, there has been no need for a face-to-face confrontation. Unlike the Third World artists in the First World, who have to accept that situation whether they like it or not, Third World artists outside the First World, whose works have been rejected by the institutions of the United States, have other choices. Several international forums and exhibitions that have begun outside the mainstream have been particularly interested in exhibiting "marginalized" art. More and more, such opportunities have opened up over the past five years. This is a sign that there are changes in the development of art worldwide. And it is in these international contexts that Indonesian modernism has been presented.

This is also true of the various modernisms that have been developing in other Third World countries. In these new exhibition and discussion spaces—in Tokyo, Fukuoka, Brisbane, Havana, Johannesburg, Cheju, and Singapore (and the roundtable discussion at the Asia Society in New York in 1992, for that matter)—I have seen art historians, artists, and art critics from developing nations excitedly explain the development of modernism in their own individual countries, from the earliest to the most recent developments (including contemporary art). In my experience, these kinds of presentations have provided the main interest in these international forums outside the mainstream.

But the opposition to the domination of the mainstream that is demonstrated in these forums is not intended to force recognition or more opportunities to exhibit in the First World. Rather, what is suggested is that, despite surface similarities, local conditions and sociocultural

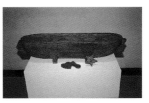

5. Anusapati, *The Wooden Game*, 1989, wood.

backgrounds have caused modernism to take different forms in different places. Thus, mainstream modernism is simply that which has developed in Europe and America. It probably even encompasses differences within it. And the larger point is that none of the forms that modernism has taken should be rejected or discredited. Forms of modernism that exist outside the mainstream have been rejected by the mainstream not only because of the suspicion that their ties to tradition, ethnicity, and indigenousness are too strong but also because the very basis for their development is not understood. This lack of comprehension, I believe, is due to a very basic difference in perspective: mainstream modernism is convinced of the fixed, the absolute, and the universal, whereas modernism outside of the mainstream is based in pluralism.

To evaluate this situation properly, in my opinion, it is necessary to understand not only the differences that result from multiculturalism (i.e., ethnicity, indigenousness, differences among races) but also the differences within modernism itself. Those differences—particularly those that stem from various rates of development—depend not on discrepancies in cultural background but on substantial differences in both sociopolitical background and premodern exposure to Western culture.

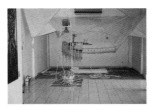

6. Nyoman Erawan, *Kalantaka Maatra (A Protest on Behalf of Bali's Fishermen)*, 1995, mixed media installation.

When Caroline Turner set forth her views about intraregional cultural interchange at the Asia-Pacific Triennial of Contemporary Art in 1993, many suspected that she was raising the issue of cultural diplomacy in order to establish a program for friendship between nations that political diplomacy had failed to accomplish. But I think that Turner's statement must be seen as a step toward a serious consideration of the similarities and differences in the experience of modernism in the Asia-Pacific region. "We recognize what we have in common," Turner stated, "and yet respect what is different." This key concept is not limited to efforts to discuss the varieties of modernism from country to country; rather, it must be understood as an acknowledgment that modernism is a plural phenomena and that pluralism does not deny the universal aspects.

Unfortunately, it seems that it is impossible to link this concept of pluralism to the more specific discussions of multiculturalism, which are determined by the situation of each particular state. Pluralism is more directly related to the concept of "multimodernism," which constitutes an effort to evaluate and analyze a fundamental aspect of modernism that has been missing from most discussions; that is the recognition that there are many developments outside of the mainstream that are not often considered. The mainstream discourse of modernism, as can be seen in the views of Lippard and Jacob, has been shaped by a Western paradigm, one that presumes the domination of a homogenous, white, patriarchal Euro-American society.

Even so, multimodernism is related to the difficult and complex multicultural conditions that exist in America. Inherent in these conditions are many possibilities for misunderstanding, misinterpretation, and miscommunication. In fact, the situation reminds me of the story of the building of the Tower of Babel: there, the idealistic dream of constructing the monument failed because of confusions that arose from misunderstanding and miscommunication. Therefore, in order to give a clearer picture of the problem of art within the context of multimodernism, I would like to borrow the words of Lucy Lippard and describe it as "art within the context of disorder."

Multimodernism reflects a complex process of seeking. Art historian T.K. Sabapathy of the National University of Singapore best delineated the new premises and methodologies required to comprehend multimodernism when he wrote,

> Critics and historians of art will have to step outside their prescribed, privileged grounds, and become familiar with different or other models of articulating discussion or accounts of artistic practices and values. And among these are also to be included new or different usages of employing terminology which has art historical origins in the West.[17]

Thus, multimodernism not only analyzes the varying forms of modernism but also views them as material for rereading the analysis of the history of art. One of the very basic elements of multimodernism is the consideration of new, critical thinking toward the absolute, universal, totalizing character of modernism (and, for that matter, postmodernism, which may or may not be outside the mainstream).

As a methodology, then, multimodernism offers a quite different approach to modernism, one that makes clear that not all varieties of modernism develop under the paradigm of the West. It suggests, for example, that even theories of representation that are conceived in developing countries might be based on a wholly different point of view. As Palestinian-American literary theorist Edward Said has observed, most Western-based representation "has been repressive because it doesn't permit or make room for interventions on the part of those represented."[18] Multimodernism requires a multidisciplinary approach because within the confusion of existing theories (in which no confidence can be placed), only reality can function as the proper basis for the formation of new observations. Within this multidisciplinary approach, the sociopolitical, socioeconomic, and sociocultural aspects must be considered in order to properly analyze differences and similarities. Within this type of approach, the conditions of multiculturalism, those that are found in America as well as those found in Indonesia, must be important considerations.

So, this is not only a matter of taking into consideration the presence of hybridity, ethnicity, or indigenousness in modern or contemporary art. It is also a matter of considering the parallelism of modernism and traditional frameworks, each of which have their own idioms, convictions, and principles of aesthetics. We must accept that these are all radically different from one another and continue to develop, even now, as in the art of Bali or the Aboriginal art of Australia.

Ambiguity of Contemporary Art

Within multimodernism, the whole concept of "contemporary art" cannot help but appear ambiguous. For one thing, the term can never reflect the full scope of contemporary reality

because it refers back to developments within the mainstream (and the reasons for this reference themselves constitute a theme within mainstream thinking). But in recent international exhibitions in which Third World artists have participated, in particular, the meaning of the term "contemporary art" has become blurred. This has occurred in part because it has been taken for granted that its meaning is understood in the same way by all. I am concerned that this situation will, once again, result in the domination of cultural production by a hegemonic theory. If we want to continue to speak of "contemporary art," we should at least introduce the more nuanced understandings we have achieved through the consideration of the different circumstances in developing countries. In other words, we should not try to create a new worldwide paradigm for contemporary art (which may or may not exist), but to prevent misunderstanding.

Misinterpretation, more than anything else, will obscure the many levels of reality or multiple meanings offered in the work of Third World artists. A small but significant recent example may illustrate this point. Indonesian artist FX Harsono was invited to make a presentation in Brisbane on the development of contemporary art in Indonesia.[19] Among the issues he discussed was the tendency of Indonesian artists to leave the large cities for the interior and to create their art in the midst of the rural population. This comment caught the attention of Australian artist Pat Hoffie, who asked Harsono about the status of museums and other art institutions in Indonesia. She seemed to want him to confirm that Indonesian artists, like many contemporary artists worldwide, were questioning the authority of art institutions. But because Harsono did not understand the question, he responded with the conventional view that museums are necessary to the development of art in Indonesia because they present the history of art to the public and raise the level of appreciation for art among the Indonesian people. Hoffie may have been surprised at this answer but it is accidentally linked to the reality of contemporary Indonesia, where modern art museums have failed to develop—in fact, they hardly exist at all. The lack of such institutions in Indonesia has created the general impression that the status of modern or contemporary art is not understood by the Indonesian public. As a result, all artists in Indonesia—even the most radical—hope for the greater development of art institutions.

Harsono is among a growing legion of Indonesian artists, including Dadang Christanto, Andar Manik, Semsar Siahaan, Heri Dono, Moelyono, Agung Kurniawan, Tisna Sajaya, Agus Suwage, and Dyanto, who address sociopolitical issues in their work. Moelyono and Semsar Siahaan, in particular, believe that artists should not only create artworks but also work to instill a political awareness among the populace. They have become directly involved with the day-to-day problems of impoverished rural people, many of whom must constantly confront the existing sociopolitical situation in the form of injustices surrounding land distribution and use.

Although these radical artists work in rural areas, they exhibit their works in galleries, museums, and exhibition halls in large cities like Jakarta, Bandung, Yogyakarta, and Surabaya. This fact makes clear that there is no effort by Indonesia's art institutions to screen or prevent the showing of challenging works (though this may be because of a lack of comprehension of the purpose or content of those works).

Art institutions in Indonesia are merely museums, galleries, and exhibitions spaces; they do not employ curators. However, that does not mean that such presentations always go smoothly or without any intervention. Confrontations have occurred at exhibitions by these radical artists, though not with representatives of the art institutions; the confrontations have been with the security forces of the government over issues unrelated to art. The current political situation in Indonesia has caused the security forces to view almost every expression of artistic creativity as they would a demonstration designed to disrupt society and bring chaos. Under the pretext of preserving peace and stability, they often shut down exhibitions that they feel could create disruptions.

Moelyono's 1993 exhibition in Surabaya, which focused on the brutal murder of a young female labor activist, was closed by security just before the opening. Since then, because of the strong self-censorship among the "official" art institutions of Indonesia, Moelyono's work, which is highly political, has not been exhibited. He has all but disappeared from contemporary art exhibitions both in Indonesia and abroad.

It is true that installations like Moelyono's that have sociopolitical themes are interesting and controversial. And installation art always attracts international attention because it is readily recognizable as a trend within contemporary art. Moreover, the political themes underscore Paul Kagawa's view that such works by Third World artists "are, by our definition, a voice of the oppressed." However, this perception once again displays a misconception. What makes the artists of Indonesia oppose governmental authority or the ruling class is not the oppressive values of modernism as reflected in the policies of art institutions. Their rebellion is, rather, a result of specific political developments in Indonesia.

In mainstream art practice, there are general sociopolitical issues that emerge and can be seen as characteristic themes of contemporary art. In the development of Indonesian art, on the other hand, it is generally very specific sociopolitical problems that become part of the discourse of modern art. From its beginnings in the 1930s through its most recent developments, Indonesia's modern art has been colored by sociopolitical themes. Throughout these years, for instance, the modern art of Indonesia has been characterized by a "moralistic" defense of the people. Such social themes are important elements for analysis if one wishes to examine the differences between the modernist discourse in Indonesia and in the mainstream. But such themes should not be taken as signs of a shift from modern to contemporary art (as suggested by Leo Castelli's comments on the 1993 Whitney Biennial).

I am concerned that the emphasis on the sociopolitical content of contemporary Indonesian art—and that of other developing countries as well—will inevitably draw that work

into the discourse of the mainstream. Already I see this tendency in the formation of a kind of stereotype in the views of advanced nations: that developing nations are repressive states in which democracy cannot develop or expand. I fear that this stereotype will become a fixed identity. In fact, this view reflects the surprisingly rigid bipolarity of the postcolonial era, which often merely reiterates the divisions of the colonial period. Whereas there was once a distinction made between "modern" and "traditional" societies, using progress as the measure, now the division is between "developed" and "not-yet-developed" societies, using democracy as the measure.

The excessively politicized nature of this perception has the potential to lead to misunderstandings. This can be seen, for example, in Australian art historian John Clark's comments on a work by Indonesian artist Hedi Haryanto titled *Terdesak* (Backed into a Corner). Clark writes, "One would have to be a very obtuse Indonesian government official indeed not to see the political confrontation carried by Haryanto's *Terdesak*, which combined a circle of nails with their penetration of the empty center of two halves of a split log."[20] As it turns out, Haryanto's work has a totally different meaning. The "two halves of a split log" that Clark describes are actually parts of a traditional Javanese container meant to hold honey from bees. The nails and the circle of iron in the work are simply modifications of the design of that traditional tool, as well as a sign of the artist's creativity. It is only a coincidence that this work suggests shackles.

Haryanto is, in fact, a good example of an artist who pays specific attention to the simple materials and technologies of Indonesia's grassroots communities. These self-sufficient segments of Indonesian society continue to practice a way of life that is now being "backed into a corner." Haryanto's work, which focuses on the use of bamboo, wood, ceramics, and paper, is typical of a wider effort to find a place for such traditional Indonesian materials in contemporary art. Among other artists experimenting with these possibilities are the sculptor Anusapati, the first Indonesian artist to use these tools and techniques,

and the painters Dadang Christanto and Nindityo Adipurnomo. This tendency can also be seen in the art of the Philippines, where it constitutes a major development in contemporary art. There, the use of local materials originally stemmed from attempts to locate a Filipino identity.[21] But now, Filipino artist Charlie Co cites this trend as the dividing line between modern and contemporary art. "The modern era, in my view, was when I was still using Western materials," he says. "In this contemporary era, I use local materials."[22]

Related to the Indonesian artists' experimentation with local materials and technologies is the critical discourse around the notion of "low art." As art critic Sanento Yuliman says,

> Art related to the weaker elements of the economy and the poor living standards of the uneducated (within the context of not having access to formal education, or modern schooling), poverty stricken segment of the populace. This art is integrally involved with modest technology, hand-made, or locally produced equipment.... this grassroots level art is traditional art. But the term "traditional" in this context has become confused because the sociocultural conditions defined as traditional are difficult to find in their entirety in Indonesia. The self-sufficient traditional segment of society, which in the past formed the mainstream element of Indonesian society, has now become marginal.[23]

This Indonesian interpretation of low art accepts traditional art as a reality. On a critical level, it calls into question the whole concept of representation, which, as Edward Said notes, often "doesn't make room for interventions on the part of those represented." It also suggests that traditional art and culture—which are often set against modern art in national and international debates, and are defined as "national identity" in official arts—are no more than a myth. Finally, this discourse of low art attempts to demystify the situation by pointing out that the actual traditional culture has been marginalized. It has been pushed aside or "backed into a corner," not only by the principles of high art and modernisms but also by the concept of "traditional culture" itself.

Notes

1. Lucy R. Lippard, *Mixed Blessings: New Art in a Multicultural America* (New York: Pantheon Books, 1990), p. 6.

2. Ibid., pp. 5, 7.

3. Ibid., p. 15.

4. Ibid.

5. Mary Jane Jacob, "The Audience, the Other" (paper presented at the seminar "Unity in Diversity in International Art," Jakarta, April 1995), Department of Education and Culture, Republic of Indonesia, Jakarta, photocopied seminar proceedings, p. 17.

6. Suzi Gablik, *Conversation Before the End of Time* (London: Thames and Hudson, 1995), pp. 460–62.

7. Ibid., p. 472.

8. Ibid., pp. 468–69.

9. Caroline Turner, "Introduction," in *The First Asia-Pacific Triennial of Contemporary Art* (Queensland, Australia: Queensland Art Gallery, 1993), pp. 8–9.

10. Jim Supangkat, "Indonesian Contemporary Art: A Continuation" (paper presented at the seminar "Potential of Asian Thought," Tokyo, October 1994), Asia Center, Japan Foundation, Tokyo, photocopied seminar proceedings, pp. 53–68.

11. Jim Supangkat, "A Brief History of Indonesian Modern Art," in *Tradition and Change: Contemporary Art of Asia and the Pacific*, edited by Caroline Turner (Queensland, Australia: University of Queensland Press, 1994), pp. 47–57.

12. Jim Supangkat, "The Emergence of Indonesian Modernism and Its Background," in *Asian Modernism* (Tokyo: Japan Foundation Forum, 1993), pp. 204–13.

13. Edy Sedywati, "Reflections on Multiculturalism" (keynote speech at the seminar "Unity in Diversity in International Art," Jakarta, April 1995), Department of Education and Culture, Republic of Indonesia, Jakarta, photocopied seminar proceedings, pp. 10–11.

14. Supangkat, "Emergence of Indonesian Modernism," p. 211.

15. See Achidat K. Mihardja, ed., *Polemik Kebudayaan* (Jakarta: Library of Education of the Department of Education and Culture, 1954). This book is a collection of articles regarding the East-West debate that occurred in Indonesia in the 1930s.

16. Unsigned editorial, *Kompas Daily* (Apr. 23, 1994).

17. T.K. Sabapathy, "International Contemporary Art: Artistic Movement within the Framework of International Contemporary Art, Some Implications" (paper presented at the seminar "Unity in Diversity in International Art," Jakarta, April 1995), Department of Education and Culture, Republic of Indonesia, Jakarta, photocopied seminar proceedings, p. 109.

18. Phil Mariani and Jonathan Crary, "In the Shadow of the West: An Interview with Edward Said," in *Discourses: Conversations in Postmodern Art and Culture*, edited by Russell Ferguson et al. (New York: New Museum of Contemporary Art, 1993), p. 95.

19. This artist's talk took place in connection with the First Asia-Pacific Triennial of Contemporary Art at the Queensland Art Gallery, Queensland, Australia, in 1993.

20. John Clark, "Art Goes Non-Aligned," *Art and Asia-Pacific* 2, no. 4 (Oct. 1995).

21. See Teresa Albor, "The Philippines: The Search for Identity" (in the special section, "Pacific Rim: An Art World Blooms"), *ARTnews* 91 (Summer 1992): 93–94.

22. Charlie Co, in a discussion at the "Asian Modernism" exhibition, Asia Center, Tokyo, Oct. 1995.

23. Sanento Yuliman, "High Art, Low Art," *Tempo Magazine* (Kalam) (Jan. 1992).

PHILIPPINES

BODIES OF FICTION, BODIES OF DESIRE
Mga Katawan ng Kathâ, Mga Katawan ng Pagnanasa

> *The fictional voice is the voice which can tell*
> *its story anywhere and over and over again.*
> *It is the voice of white history.*
> — Paul Carter, *The Road to Botany Bay*

Although Filipinos have been schooled in English for most of the twentieth century, linguists observe that a great many of them continue to think in tenacious vernaculars. Literate Filipinos believe that art exists, simply as an article of faith in modernity. But the fact that words like "art," "religion," "nation," "history," "culture," "democracy," and "modern" exert pressure on the shape of their experience is by no means a matter of course. There are, to begin with, no equivalents for any of these categories in the vernacular languages. And when native syntax does absorb equivalents, the meaning is doubtless altered.[1] Churches, emporia, hospitals, museums, books, schools, and the ballot are loci of enchantment and fear in the Philippines, with no trace of irony. These institutions are still vaguely alien but are nonetheless perceived as nodes of a seductive power metastructure. Similarly, patriots, politicians, doctors, teachers, bankers, bureaucrats, lawyers, professionals—of course, priests and nuns, and, in fact, artists—fascinate the people as embodiments of successful vectors: they represent a modernity that is desired, however late in the day. And it is this fascination, rather than a more systematic cognition, that assures belief in, say, the category of "art,"

[AN INCOMPLETE LISTING OF CONTEXTS IN WHICH APPEALS TO TRADITION ARE MADE IN THE PHILIPPINES PRESENTLY]

The tabloids reported a moral-cum-legal quandary concerning a wealthy young man who was the principal suspect in a recent gruesome rape-murder case. The prosecution needed a sample of his semen in order to establish his guilt. At issue was the obvious way of acquiring this sample—regarded in some quarters as a violation of traditional Christian morality. The word "masturbation" was not used in the story.

In his Pulitzer Prize–winning book on the Philippines, an American writer asserted that Filipinos remained essentially unchanged throughout the period of American tutelage in democratic institutions. This was because of tradition, the author claims; that is, the tradition of patron-client relationships, in which the American colonial government found itself embedded as the uneasy, if not unwilling, patron. A Filipino scholar reviewing the book notes that this so-called patron-client tradition, thought to have protected Filipinos from American influence, was itself an American invention.

A popular comedienne has of late professed to be a born-again Christian. She understands that the most difficult change and the greatest sacrifice demanded of her is to overcome "materialism." As one test of her renewed spirituality, a friend encouraged her to destroy a Chinese vase, a precious possession, because they recognized demon-like figures lurking beneath the glaze. This rite of passage of sorts was reported in the entertainment section of a newspaper, which added that since she has re-embraced traditional values she is exceptionally happy.

especially among Filipinos overwhelmed by the still-unexhausted energies of that modernity.

As elsewhere, those lingering modernist energies continue to reduce peasants, nomads, tribal [*sic*] people, and the poor—in other words, the majority of the Philippine population—to the "folk." Indeed, whole universes of experience, which remain occluded while they await change, are provided a vanishing point in the tiny-ness of that single word "folk." Folk songs, folk beliefs, and folk medicine become shadows of—that is, not quite—songs, beliefs, and medicine invested with universal significance. This tendency seems inevitable, following the track of global capitalism. But it may be said specifically of the Philippines that this reduction of multifarious cultures to the "folk" sustains a binary that is in turn perpetuated by what, at first glance, appears to be a cut-and-dried linguistic divide. Systems of meaning rhetorically sucked into the Western signifier "folk" cannot be similarly drawn into any available local terms. It would be like sucking in one's breath.

As a result, Filipinos have learned to be extremely refined about what is and is not possible to say in this or that language. In due course, a multilingual poetics has been crafted.

But it continues to bleed out into uncharted directions, only two of which are recognizable at the moment: a submission to or yearning for fragments of worlds that are imagined to be legitimate (articulated in English, or in invented equivalents to English words, introduced into the national language), and simultaneously, a covert preservation of local knowledge (in various vernaculars, or in English words charged with local meanings).[2] The mental gymnastics required to negotiate this paradox are so obvious that they have acquired their own sobriquets among Philippine writers, including such phrases as "folk Catholicism," "split-level Christianity," and "Pinoy Baroque."[3] However, such coinages propose a too-easy and ultimately false syncreticism, and elide the violence inherent in such characterizations. (For instance, the native half of these double terms is adopted as a mere adjectival supplement to the syntactically more important proper noun; thus, "folk Catholicism" is a unitary expression.) Self-subverting, these phrases undermine elated reports that, for example, Christianity or international modern art were "indigenized."[4] Without acknowledgment that archaic systems of ideas survive—if often through deadly metamorphoses—there is no

-->

A scholar studying so-called millenarian cults—their institutions of female priesthood and egalitarian solidarity, their links to "pocket rebellions" during the last century or so, and their tradition of conferring saintlike status on heroes of the Philippine Revolution—has become a believer in this cosmology. Some among her peers believe that her scholarship has been undermined by this transgression of the traditions of academic distance.

Some gay scholars are considering whether the institution of transvestite shamanism—which is documented in Spanish colonial records from the central Philippines—is a tradition to which they are linked or to which they *should be* linked discursively.

Many commentators on the Philippine art scene assert that there is no tradition of criticism strengthening the field. Instead, they think, there exists a tradition of "taking things personally."

The Moral Recovery Program initiated by an august senator advocates a "renaissance" of a quadripartite set of traditional values: *pagkamakatao* (people oriented), *pagkamaka-Divos* (God oriented), *pagkamaka-kalikasan* (environment oriented), and *pagkamakabayan* (nationalist). The literature on this program suggests that this set of core values could very well serve as a fulcrum of consensus, principally because the terms used are nonsectarian, nonpartisan, and nondenominational. The point is emphasized that no single religion is privileged.

A scholar proposed that the epic tradition of the Philippines constitutes a "master narrative of liberation." Asked why he is appropriating the phrase "master narrative of liberation," he replied that he sees no reason why Filipinos should be barred from using any term available.

During the visit of Pope John Paul II to the Philippines in early 1995—the occasion for a spectacular image of some two million Filipinos attending one of his masses—it was reported that hundreds of teenagers from upper-crust schools had signed a pledge vowing to remain virgins until they wed. The reports suggested that this commitment issued from the intensity of feelings generated by the Pope's visit.

contest, no conflict; and, tautologically, there is no syncreticism because all is erasure in the face of imperialism.

The vocabulary of geology is especially useful in visualizing the ground of tradition as active and substantial and subject to dramatic or imperceptible processes of subduction. Slippage, fissuring, accordioning, folding in, absorption, collapse; building up—all irruptions within highly local dynamics—elude confinement in fixed strata. Specialists need to direct their attention toward volatile chemistries and traceries of ancient and current traumas. And if potential for equilibrium or disaster is calibrated with a healthy respect for the indeterminate, it may be possible to gain an understanding of forces that reverberate jaggedly and fracture the binary formulations so fundamental to Western epistemologies into capillaries—not just vivid fault lines—of stress.

To expose the inadequacy of neatly oppositional binaries, one need only point out that the very figure of a language "divide" stems from a Western metaphoric tradition that is not universally applicable. In the Philippines, for instance, matters are certainly far more complex than a split between English and a vernacular. In fact,

the situation—hardly describable as a magisterially coherent tongue, on the one hand, and babbling in Babel, on the other—virtually defies description. It encompasses a vastly complicated genealogy of symbolic exchanges that did or did not transpire at specific moments between and among at least two European languages and a plethora of Austronesian tongues, the sounds of those languages, the relative power to compel of written ciphers both alien and native (and native voices, words, meanings, shifting relata, arrested in alien text), and the variations in narratives and tales. Furthermore, it involves interest in the nuances of domination played out in multiple dislocations and relocations of "official" languages as they recede into, alter, or merely jostle local conceptual systems.[5]

Entries in a Borgesian Encyclopedia

Dominance is only seamless from the perspective of a system of logic that is obsessed with investing written language (and the institutions it produces) with immutable substance. Among peoples who have refined mimicry (and perhaps cannibalism) of alien languages as a strategy for survival, being dominated politically may not

The premiere ballet company takes great pride in its repertoire of modern dance suites based on traditional culture. The company is also proud of its institutional tradition of artistic innovation. While watching a performance based on the culture of a Philippine highland society, a person in the audience who hails from that highland society was deeply offended by the use of male loincloths by the female dancers. The viewer did not think much of the company's appeal to the tradition of artistic license.

The First Lady of the Philippines has been wearing couture featuring "indigenous" or traditional textiles. Some of her clothes are fashioned from blankets that formerly hung behind corpses during the prolonged traditional wakes (which feature an extended witnessing of the putrefaction of the flesh). It may be assumed that the First Lady was not informed of this traditional function of these textiles.

Many commentators casually suggest that the reason for the ease with which women in the Philippines are assuming positions of leadership is an ancient tradition of matriarchy. There is also a marked ease with which many male writers gleefully declare their machismo by claiming that they are "under the *saya*" (that is, under the [wife's] skirt).

Philippine Studies scholars agree that there is no ancient tradition of matriarchy in the Philippine archipelago. Nonetheless, there is a scientific basis for establishing that a tradition of bilateral kinship is more or less universal in the islands of Southeast Asia, and that it involves, in a substantial number of cases, matrilocal arrangements.

A row occurred when someone proposed to the Department of Education, Culture, and Sports that traditional values could be reinculcated in schoolchildren by reintroducing *pagmamano*, a symbolic gesture by which an individual in a position of authority places the backside of his hand on the forehead of a kneeling or bowing person, who thereby acknowledges deferential status. It was pointed out that *pagmamano* was instituted by

necessarily be the same thing as being dominated culturally. Foreign words have been micro sites for tussling with Reason, which often makes for simultaneous displays of submission and intransigence. Australian writer Paul Carter supposes that "[Australian] Aborigines often seemed to mimic white preoccupations to the point where their own identity was wholly concealed."[6] But the contemporary Filipino artist who imagines "conceptual art" ahistorically, as an infinitely pliable construct available to everything and nothing, is also taking liberties with white history.

A good example of a sliver of Western civilization that got snagged into local cosmology is the word *siruhano*, which literally means "surgeon" in Castilian. Today, *siruhano* serves to specify a kind of healer in the highly differentiated classificatory system for traditional healers in "lowland Christian" Philippines.[7] This specific application of the word *siruhano* takes advantage of the original reference to Western curing practices involving intrusion into the body and produces the faint connotation of "psychic surgery." Even so, the *siruhano*'s experiential space is still largely circumscribed by local constructions of well-being and illness and of the body and its life essences (concepts articulated through such words as the all-but-untranslatable *loob*, which means, roughly, "inside"), constructions that operate quite independently of white medicine. In this case, the utility of the word *siruhano* does not mark an essential change in the relevant scheme of things; *siruhano* picks up an echo of the word "surgeon" but at once wrenches it out of its history. And this is only one of many kinds of linguistic operations, all with equally unpredictable effects: the clandestine survival of native knowledges, the uneven capitulation to colonial institutions, the utter effacement of particular memories, the instances of profound fusion, and so forth.

There are many examples of this kind of appropriation and misappropriation of imperialist language.[8] An encyclopedia of such minutiae would be Borgesian. But what precisely do such examples prove? In some cases, these subtle conceptual shifts have profound political implications, particularly in relation to issues of identity. When a Filipino says *bakla* (or *baklaq*)[9] today to mean "homosexual," the word is being used largely with reference to the English word "gay," inclusive of but not exclusively denoting the political weight of this word in the Western world of the twentieth century. It seems merely

Spanish friars during the colonial period. The debate was joined by persons who feel that this gesture has already been wholly incorporated into the Filipino tradition of respect for elders—and that, anyway, very few Filipinos recall the Spanish colonial genesis of the tradition.

The President of the Philippines also caused a row when he asked a study group to consider the addition of an Islamic crescent to the design of the Philippine flag. Filipino Muslims, he said, should be able to recognize themselves in the national emblem. Incensed commentators argued that a century-old tradition of revering this particular design already exists and that this considerable reservoir of nationalist feeling should not be dissi-

pated. The flag, said the seriously offended, is a secular emblem. Humorists quipped that including the Islamic crescent might pave the way for additions of a Christian cross, a pink triangle for gay liberation, a logo for animist groups, and, why not, a unicorn for dreamers.

An advertisement on television featured a distinguished-looking Filipino in traditional *barong Tagalog*, the national male costume, advocating a return to honorable behavior. The ad was for a bank, and it was talking about payments on loans. The man in the ad concluded his spiel by resoundingly articulating the necessary Filipino value—in Spanish, *palabra de honor*.

The commission created by the President to plan the celebration for the centennial of the declaration of Philippine independence in 1998 is disseminating literature reifying a century-old tradition of nationalism. Critics have pointed to the irony that key members of the commission are progeny of elite leaders of the revolution.

One of the leading folk dance companies articulates itself, through choreography supported by research, as the conservator of authentic ethnic traditions—with great emphasis on *authentic*. The artistic director does not consider their costuming, proscenium theater, international touring, choreography, research, or staging to be problems.

happenstance that the word is Tagalog, because today's version of the word *bakla* has little connection to the traditional use of the word, current until the early twentieth century in the Philippines, which was a verb meaning "to motivate," "to induce," "to alter," "to persuade," "to cause," "to instigate," or "to occasion."[10] And then again, the ongoing transformations of "Westernized" *bakla* into new words of a vernacular-in-the-making (i.e., *bakling, klabing, klaving, vading, vadaf, vadiday,* and likely ad infinitum) tend to relocate usage to fluid categories referencing present-day homosexual experience in the Philippines.

The word *bayani,* meaning "hero" today, is another case altogether. The ancient *bayani* (and its cognates *bagani* and *berani*) meant "warrior," and this is probably a coarse translation. *Bayani* metamorphosed from "warrior" to "hero" when the concept of "nation" first emerged in the Philippines a century ago. Nations need heroes, these are conjoined constructs, and the unloading of the unsavory connotations of warrior was thus efficacious. In the past decade, Filipinos have taken to calling overseas workers *bagong bayani,* or "new heroes," an unsuccessful piece of fiction for reasons obvious to anyone familiar with the horrors of migrating abroad to serve as cheap labor. Therefore, *bayani* is at least three different words: a lost word from local political-spiritual systems, a modern construct central to the language of nation-building, and now a negative sign conveying the betrayal of the promise of the nation.

Like *bakla* and *bayani,* the word *sining,* which was reinvented in this century to signify the Western construct "art," could very well be a word in English.[11] *Sining* is fictive, a seemingly local term, but in fact a coinage meant to be uttered as history is embraced. As "art," it has no reference whatsoever to any similar category in traditional Tagalog knowledge systems. (The archaic verb *sining* meant "to think" just as *agham,* currently the word for "science," traditionally meant "to know."[12]) In other words, neither *sining* nor *bakla* have a true past; their current meanings derive exclusively from the experience of modernity in the Philippines. Unlike *bakla,* however, which spontaneously adhered to the category "gay" in popular language use, *sining* was deliberately chosen amid a political effort to create a national language for the Philippines in the twentieth century. And while *bakla* may merely replace an extinct word for a native gender category related to (though probably not equivalent

Philippine history is taught with an emphasis on the conclusion that the Philippine Revolution of 1896 is linked—via the education of expatriate middle-class Filipinos in France and Spain at the last turn of the century—to the tradition of the Enlightenment.

A senator was curious as to why Filipinos did not seem to have absorbed either the American tradition of the entrepreneur-as-heroic-individual or the Protestant work ethic, despite their apparently wanton embrace of all other minutiae of American life. It was suggested that Protestantism did not have as much time to take root in the Philippines as did Roman Catholicism. Besides, according to a number of commentators, Filipinos appear to have found Roman Catholic rituals extremely dramatic and seductive (or perhaps Filipinos simply do not "take" to saintless denominations).

A recent book proposed that the current trend of nonelite sections of certain northern Philippine towns turning from Catholicism to Protestantism and to Christian churches founded by Filipinos may be seen as a rejection of social hierarchies in which Roman Catholics arrogate to themselves the dominant positions. It also appears that poorer Catholics are effectively shunted out of legitimate Catholic worship as practiced by the elite, and continue to express themselves in terms of "a folk tradition [with] indigenous elements such as ricefield, household, and ancestral spirits, and a morality that emphasizes contractual rather than an ethical aspect in man's relation to the transcendent order."

A great many contemporary Filipino artists make an issue of using indigenous materials as an assertion of faith in that which is considered local tradition, and in opposition to that which is perceived to be alien, and alienating, cultural importations. Many are installation artists who express no discomfort with the late-modernist genesis of installation art.

to) today's homosexual, *sining* attempts to conjure up a completely modern category, *precisely because the aura of ancientness surrounding the word is employed to provide this new category with a history it would not otherwise have*. In any case, this may account for the wide currency of *bakla* as a functional Tagalog word while *sining* remains confined to specialist articulations of the nation, its citizens, and their desires—in this case, their desire to have art.

The Problem with the Priestess

Filipino artists—self-aware as Filipinos and as artists—generally submit to a binary view of their historical space. Discussions of Philippine contemporary art seem fairly impossible without citing the dichotomies West/East, foreign/indigenous, international/local, dominant/subjugated, politicized/formalist. Implicit in these dyads is the convention, amplified in the exercise of colonialism, of conceiving reality in relation to bounded cultural and political territories. Implicit, too, are the associated metaphors of the frontier (located at the slash), identity (located on either side of the slash), and mixing (located in the doubling). Responding to the asymmetry of power inherent in this bisected universe, Filipino artists who consider themselves politicized try to fortify the oppositions, vivify the differences between sides, and limit the intermixing. Intoned thus, in oppositional terms, the ambitions of Filipino artists can be heroically articulated. For instance, researcher Norma Respicio declares,

> *Traditional art is rooted in the people's life. The people's rich history of struggle is certainly a fathomless material to work on by contemporary artists in other visual forms. They are rich watersheds upon which to create new forms, bring about fresh significations for old motifs that would advance people's interests, articulate their world view,* their one-ness with nature and the land, *and give free reign to their* magnanimous and unfettered spirit. *Being pro-people is having faith in the* essence of traditional art *which is the celebration of life. The contemporary artist is challenged to take the role of the* priestess *Kallupayan, who gave new life to the* epic hero *Wadagan. The traditional artist can be the Kallupayan of today. The artist can imbue traditional art with life, more vigor, greater resplendence, and new meaning [emphasis added].*[13]

The chairperson of the Senate Committee on Women and the Family, a male and a favorite of the Catholic Church and the Opus Dei hierarchy, intended to go to the Beijing Conference to fight against liberal views on homosexuality, the role of women, and the use of artificial contraception. According to the senator, these liberal views corrupt the traditional solidarity of the Filipino family. He also announced that he would initiate a law banning the use of condoms.

Two thousand women from Philippine government and nongovernment organizations intended to go to the Beijing Conference. For many, the agenda was to contest the position of the Catholic Church. Many were reconsidering the "Westernness" of traditions of feminism in the Philippines.

Most comprehensive surveys of Philippine art are constructed as a linear progression: prehistoric art (including artifacts from archaeological sites), "folk" and "ethnic" art, Spanish colonial art, and then Philippine modern art. To date, no one has questioned this evolutionary construct.

Regarding the kidnapping of a Catholic priest by "Muslim terrorists" in southern Philippines, a Catholic bishop said, "There are people on our side who do not follow us and our teachings any more and are ready to answer in kind—an ambush for an ambush, a killing for a killing." He added, "These different [Christian] groups are ready to go for an eye for an eye....We cannot control these groups anymore."

Hope and anger are politicized and aspiration is worded as an injunction: enunciate the other. Still, nativist paeans are as self-subverting as coinages like "folk Baroque," even if the inflection is shifted to the native. That white colonial reveries are resurrected is not the only problem here; more alarming is the disclosure that such fantasies, now bodies of desire to Filipinos, are reified as concepts deemed essential to emancipatory agendas. Certainly, it may someday be demonstrated that an unknown society in the Philippine archipelago celebrated life and was one with nature and was unfettered and so forth in ways that do not reiterate the European daydream of the noble savage. This awaits sophisticated investigation, provided that methodologies are invented for representing several cosmologies-in-flux at once (so "participatory research" or "living with the people" are at best interim tactics). Meanwhile, the inherited fantasies appropriate what remains of local knowledge to Western discourse and gravely reduce the possibility of knowing the substance of difference.

"Indigenous" is a useful word to consider in connection with desire.[14] Like *bakla* and *sining* and *demokrasya* (democracy), it is a modern category, linked to the cultures it presumes to describe only through newly constructed rhetoric. Obviously, before the current threats of cultural eradication, the word was unnecessary. Only recently have peoples who eluded the ground-zero of colonization begun to view themselves as "indigenous." (By the same token, only in the twentieth century did many so-called tribal groups of the Philippines feel the need to identify themselves with the name of a tribe.[15]) But it is even more recently that this word "indigenous" has gained a more general political charge (and not in the least because enough contemporary Filipino artists parlay it in their efforts to construct a rhetorics of self-affirmation). Invested with desire, the phrase "indigenous materials"—to denote a fragment of a jungle vine, for example— is expected to signal at once nature, natives, innocence, ritual, the primeval, the traditional, the sacred. Unfortunately, today, that "jungle vine" might just as easily suggest Tarzan. In fact, Tarzan may be the more straightforward signified, because who knows what that jungle vine may have signaled to those persons now described as indigenous? Hair cleansing, perchance?[16]

The notion of indigeneity is notoriously difficult to pin down, and the indigeneity of artistic

A group of relatives of victims of Japanese atrocities during World War II are fighting for a remembrance of the carnage many of them witnessed. They are particularly embittered because world history makes no mention of 100,000 Filipinos who were killed in several districts of Manila during the mere twenty-eight days that the city was being liberated by the Americans, and pounced upon by trapped Japanese soldiers who had no hope of surviving. They are trying to understand Japanese atrocities in terms of the tradition of *bushido*. Many of them do not wish to critique the large-scale destruction of Manila—the second-most-destroyed Allied city in the aftermath of the war—by American forces.

A lawyer asked the Senate to investigate an attempt by some Catholics to prosecute members of a group called the Brahma Kumaris, described in one newspaper as "an alleged religious sect which traces its roots to India." The lawyer said that the attempt by some Catholics to harass members of this Brahma Kumaris group "smacks of a kind of bigotry which should have gone out with the Age of Inquisition and does not belong to our time and age." The so-called sect was labeled "anti-Christ."

Ownership of extensive parts of the former American R-and-R base, Camp John Hay, which has been turned over to the Philippine government, is being contested on the grounds that it is ancestral domain. The claimants are an important tribal family, and they aver that the American colonial government recognized their proprietary rights in a decision penned by Justice Oliver Wendell Holmes, Jr., in the early twentieth century, only for the decision to be overturned by the Philippine Senate. Current plans for developing the base into a major tourist center (to be financed—the government hopes—by a consortium of Japanese, German, Thai, Indonesian, and Taiwanese parties) are hamstrung by the claims. The claims are underpinned by resurrected notions of traditional property.

traditions is even more phantasmic. There is little evidence of weaving on the backstrap loom in the northern Luzon Cordilleras, home of the erstwhile ethnic groups, before the early twentieth century. In the adjacent Ilocos coastal area, churches were built by local hands almost at the outset of Christianization in the sixteenth century. A century of Cordillera backstrap weaving is regarded as indigenous; four centuries of Ilocano church architecture and decoration is regarded as colonial. But calibrating indigeneity relative to the presence or absence of external "influence" means buying into a nineteenth-century diffusionist discourse that has been fully refuted in this century as well as the associated fixation of the Euro-American bourgeoisie on issues of origin and authenticity. All of which only serves to reveal indigeneity as an extremely malleable concept, stretchable willy-nilly to sustain the frame of a gripping but ultimately impoverishing dialectic. But this is not to say that local knowledge or the notion of culture are without political value. As anthropologist James Clifford points out, "There is no need to discard theoretically all conceptions of 'cultural' difference, especially once this is seen not simply received from tradition, language, environment but also as made in new political-cultural conditions of global relativity."[17]

We might ask, then, where this conception of cultural difference lies in the Philippines. What are the conditions and cultural practices specific to the local space? At the moment, we have only clues about what may have been and what seems unlikely. Textile motifs, patterns, and designs, for instance, may not originally have been conceived as "motifs," "patterns," or "designs." Faith in a mother of God may be ancient, though today she is the Virgin Mary; the idea of a local matrilineal tradition, supporting certain trajectories of feminist deconstruction in the Philippines, is not. Even artistic matters that are normally taken for granted, like color and the chromatic scale, deserve review. The Hanunoo Mangyan "color categories" do not correspond to the chromatic values now assigned, for example, to the terms "red" and "blue."[18] Using the cultural units "spectral opposition" and "intensity opposition," the Mangyan classify orange-red (*marara*, or *mararaq*) as "dry" and light green (*malatuy*) as "fresh," but bring in the notions of wetness and dryness as well as lightness and darkness. Other Philippine language groups which assert their modernity retain nonchromatic references to specific colors

Anthropologists think that the word "tribe" is inaccurately used in most cases in the Philippines. The village- or hamlet-centric social units in traditional Philippines do not constitute tribes. And in many of these villages, there were no traditions of real property. There were, however, traditions of collection or self-definition intricately connected to physical space.

Leaders bewail the lack of a tradition of historical thinking in the body politic. To this lack is credited the nonchalance with which the Marcoses—Imelda and Ferdinand, Jr.—propose themselves to the populace as legitimate politicians.

When the Pope visited the Philippines, police reports recorded an all-time low in the incidence of crime. The chief inspector credited this to "papal fever." A newspaper columnist suggested that a "haze of holiness" prevented Filipinos from attacking each other momentarily: "Our experience of religion is really closer to that of the indigenous, or tribal, groups than it is to the Western ones....That was what we fell into during the Pope's visit: a trance....A trance by its nature is fleeting.... A moment of concentrated ecstasy...a moment removed from ordinary life. It's the same thing with our concept, or experience, of democracy.... [It is] something external, dramatic, ecstatic. It is something that happens with elections and toppling tyrants. It is not something internal or practiced in daily life....But you have something like

this, and you have people who will think nothing of being penitent one day and being murderous the next. The Filipino...will find nothing incongruous in flogging himself on Good Friday and stabbing others the rest of the year."

There are still many who subscribe to the belief that the epitome of traditional Filipina womanhood is Maria Clara. She is the fictional heroine of José Rizal's fin-de-siècle novel *Noli Me Tangere*, who suffered with grace, elegance, and forbearance.

in their vernaculars.[19] But where local equivalents for color categories in English promise some depth of understanding, quick assertions about, for instance, "indigenous line, form, color"[20] squander that possibility.

The word for the female shaman of Southeast Asian animism, *baylan*, cannot be synonymous with the word "priestess" (particularly if care is being taken to avoid the extraneous and appalling references to exotic female characters in, say, *King Solomon's Mines*). Indeed, "shaman" may even be a misleading translation of *baylan*. Siberian animism, from which the word "shaman" is derived, belongs to a different order of things than the *baylan*'s animism. Surely, that difference is important. For the *baylan* exists, changes, contends with modernity like everyone else in the Philippines. In the same way, some chanters of an epic on the island of Mindanao are reportedly commenting on current wars in the voice of the epic's protagonist. And, even more to the point, Filipino historian Reynaldo Ileto reports that during the turn-of-the-century Philippine Revolution the Tagalog chanters of Christ's passion re-enunciated local cosmology to accommodate modernizing political notions.[21] Similarly, the southern Tagalog poem-prayer-dance-song

called the *subli* (*subliq*) may be richly analyzed as, among other things, an oral record of the trauma of (and local ways of absorbing) Christianization.[22]

Tradition has always grappled with tension. Indeed, tradition *is* a discourse on tension. Otherwise, it would not be a tradition, a structure of continuity, distinctively configured but never in isolation. There is no slash between tensions and traditions.

The oft-repeated suggestion that Filipino contemporary artists assume the role of the priestess recuperating a primeval innocence exhibits the overblown scale of the desire for respect and honor. It also exhibits the futility of a project that pursues edenic truth instead of acknowledging its own immersion in a technology of realization, of fiction making. For fiction—liberating, repressive, questioning, mourning—is the only potential for contemporary art making, which can claim to represent neither the quintessentially Other nor the utterly universal.

If we return to Norma Respicio's characterization of the Filipino artist, we find a catalogue of fictions, each derived from Western history. There is the quest for a chimerical unity. There are the motifs of resurrection (a Judeo-Christian

Politicians running for national office generally acknowledge the need to court the strange, charismatic leaders of the many "millenarian cults" in order to win elections. Journalists know that a number of these groups have massive memberships and are armed (such as the PBMA in Surigao). One set of scholars views these groups as historically linked to the myriad politico-religious groups that staged revolts during the colonial period and sees their formation as informed by an indigenous cosmology expressed through a grammar constructed of bits and pieces of Christian teaching. To some, the lineage of these groups includes the *Katipunan*, which initiated the Philippine Revolution. Another set of scholars, arguing from the perspective of a linear evolution in consciousness, regards these groups as unscientific aberrations.

Connoisseurs and dealers who have handled gold jewelry from Philippine archaeological sites agree on its exceptional craftsmanship and beauty. Comparisons are usually made to Egyptian or South American Indian goldwork. But because such highly developed pieces have always been associated in those contexts with court or urban settings, at issue with the Philippine pieces is whether they were actually made locally. There are those who are, therefore, awaiting the archeological discovery of urban sites in the archipelago.

A professor of Asian Studies was asked by a student how she feels about the total lack of evidence that urban or supra-village polities existed in the Philippines prior to the colonial period (or, indeed, the fact that Filipinos never created anything like Borobudur). The professor replied that these lacks make her uncomfortable, and ashamed.

Discussions regarding the emotional issue of victimized Filipina entertainers in Japan generally emphasize poverty as the cause. Few analysts seem to have noticed surveys that indicate that many of the women do not come from horrendously poor families but are impelled by notions of "progress" and "the good life" associated with free consumer spending. Other studies indicate that even if their families know of the women's

image) and resuscitation implicit in the image of pumping "fresh signification" into old motifs (a very Renaissance concept). There is the serving up of tradition to contemporary artists: the nobility of appropriation. There is heroism, challenge, epic. In this thicket of fictions there is no room for evoking the people who invented Wadagan and Kallupayan. But since this evocation may be structurally impossible anyway, the location of grief is, rather, in the very nature of that belief or fascination in art that prevents Filipino artists from laying bare the limitations of those fictions, those "voices which can tell the story anywhere and over and over again," which constitute "the voice of white history."

While this story can be told over and over again, as indeed it is, its sense belongs to the singularity of its moment, the impossibility of repetition, the instantaneity and wordlessness and fictionlessness of Kalinga tradition—which is not constructed as *tradition*—as it took tension to its bosom. Here, the body is neither a body of fiction nor a body of desire; it is a body of knowledge.

Endnote: Bare Breasts

"In the mountains of Kalinga-Apayao, the women and their families were threatened with inundation of their ancestral lands to make way for the 'gods' of progress in the Chico River dam. Refusing to accept destruction of their barrios, displacement of their families, and rejecting empty promises, the bare-breasted Kalinga women dismantled the military camp with determined action and success."[23]

move into prostitution, there is high regard for them—so long as the radios and TVs and clothes keep coming from abroad. Nonetheless, when appraised, this phenomenon is generally credited to "American influence."

A former important official of the cultural hierarchy gave a paper advocating the creation of national culture as a deliberately planned amalgamation of all regional cultures. Some people who heard the paper spoke with considerable anxiety about what sounded like a plan for social engineering.

The literature and publicity surrounding the creation of an East ASEAN Growth Area—bounded by the cities of Zamboanga, Davao, and General Santos in the Philippines' Mindanao; Kuching in Malaysian Sarawak; and Menado in Indonesia's Sulawesi— emphasize traditional trading ties in this area, which should be reanimated.

A documentary was made concerning the desire among Filipinos for Caucasian physical features. The narrative juxtaposed the smashing of the aquiline noses of church sculptures of saints as acts of rebellion during the period of struggle for independence and the current big business of nose-lifts (and skin-whitening). Another marker of tension: many local images of the Virgin Mary, which generate phenomenal worship, have brown

or black faces, yet Eurasians still dominate the entertainment industry.

When a crisis exploded around the staging of a conference on the problems of East Timor at the University of the Philippines, few Filipinos seemed to know where East Timor was. Thus, it was within the tradition of left vs. right that this issue was articulated. Nonetheless, part of the discussion raised the issue of traditional Indonesian-Philippine "brotherly ties," which were thought to be crucial in solving the "Mindanao problem." Indonesia is hosting a series of peace talks with "Muslim rebels."

Notes

1. In previous centuries, the word *bayan*, used in this century as the word for "nation" in the national language, referred to "day," "space," and "weather," among other meanings. Also in the national language: *pananampalataya* is "faith" rather than "religion"; *kasaysayan*, used today to mean "history," derives from the word *saysay*, meaning "to relate," which in the past presumably did not involve the idea of linearity; "democracy" is simply *demokrasya*.

2. I outlined this paradox in "I Am 400 and Multi-Lingual," *Art and Text*, no. 43 (1993): 46–51.

3. Eric Torres claims that the term "Pinoy Baroque" is a "colloquial term of endearment." See his "How To Create an ASEAN Mainstream," in *The Aesthetics of ASEAN Expressions: Second ASEAN Workshop, Exhibition, and Symposium on Aesthetics* (Manila: ASEAN Committee on Culture and Information, 1994), p. 173.

4. Such "reports" are articulated, for instance, thus: "In the countryside [Christianity] merged with the folk beliefs and rituals of a people who used to venerate sacred groves and caves. The result: a syncretic faith—folk Christianity…a folk religion that exalts the mystical and the miraculous over the doctrinal and rational…. With respect to the indigenization of Christianity, parallels may be drawn between the Philippines and former colonies of Spain in Latin America." See ibid., p. 172.

5. The refiguration of Castilian as it "receded" into Tagalog during the Spanish colonial period is described in Vicente Rafael, *Contracting Colonialism: Translation and Conversion in Tagalog Society under Early Spanish Rule* (Quezon City: Ateneo de Manila University Press, 1990).

6. Paul Carter, *The Road to Botany Bay* (Chatham, England: Mackays of Chatham, 1987), pp. 333–34.

7. I am indebted to Enrico Azicate, whose scholarship on the history of medicine in the Philippines was the source of this information.

8. For instance, Filipinos wholly accept the word *simbahan* for "church"—meaning the building-as-sign, the institution, and the site of worship—and have apparently banished the archaic use of *simbahan* (or *sambahan*), meaning a nonarchitectural "place of worship." Similarly, the Hiligaynon word *banwa*, which traditionally meant "terrain," "homeland," or "the sea from island to island," is now inconceivable to present-day speakers of the same language, for whom *banwa* is "town." See William Henry Scott, *Barangay: Sixteenth Century Philippines* (Quezon City: New Day Press, 1994).

9. The "q" indicates a glottal catch.

10. Pedro Serrano-Laktaw, *Diccionario Tagalog-Hispano* (Manila: Imprenta y Libreria de Santos y Bernal, 1914), p. 78.

11. An extended discussion of the word *sining* is part of my essay, "The Necessity of the Craft Problematic," in *The Necessity of Craft*, edited by Lorna Kaino (Perth: University of Western Australia Press, 1995).

12. Juan de Noceda and Pedro de Sanlucar, *Vocabulario de la lengua Tagala* (Manila: Impreso con las Licencias Necessarias en Manila en la Imprenta de la Companie de Jesus, 1754).

13. Norma Respicio, "A Celebration of Life," in *Aesthetics of ASEAN Expressions*, p. 106.

14. The word for "indigenous" in the national language today is *katutubo*. This word is not recorded in early Tagalog-Spanish dictionaries, although *tubo* (*tuboq*) is an ancient Austronesian word conveying "growth." Today's *katutubo* is transliterated thus as "local growth."

15. "Tribal" names were assigned by colonial administrators, missionaries, and travelers, and often did not correspond to the social relations or the notions of community in relation to space as understood by the péoples so classified. Nonetheless, those imposed names have been assumed by the peoples thus named as a result of the emergence of a consciousness of the concepts "tribalness" and "indigeneity" in relation to "nation."

16. Hair-cleansing may not be so specious a suggestion. One vine (indeed, one used by some artists) has been traditionally processed with beaters to produce a "shampoo." It is likely that this process belongs to archaic traditions involving beaters on a variety of materials: pottery, bark, drums, food.

17. James Clifford, *The Predicament of Culture: Twentieth Century Ethnography, Literature, Art* (Cambridge, Mass.: Harvard University Press, 1988).

18. Harold Conklin, "Hanunoo Color Categories," *Southwestern Journal of Anthropology* 2 (1955): 339–44. Conklin's work was discussed from the perspective of semiotics in Umberto Eco, "How Culture Conditions the Colors We See," in *On Signs*, edited by Marshall Blonsky (London: Basil Blackwell, 1985), pp. 157–75.

19. The Tagalog word for green was *halong tiyang* at least until the eighteenth century. The meaning is lost, although *luntian* is "green" today.

20. Alice Guillermo, "The Development of Philippine Art," in *Tradition and Change: Contemporary Art of Asia and the Pacific*, edited by Caroline Turner (Brisbane: University of Queensland Press, 1993), p. 76.

21. See Reynaldo C. Ileto, *Pasyon and Revolusyon* (Quezon City: Ateneo de Manila University Press, 1979).

22. Credit is due music scholar Elena Rivera Mirano, whose work on the *subli* and the vocal music of the southern Tagalog has given me many rewarding trajectories for theoretical work.

23. Myrna Francia, "Asian Women Doing Theology," in *Woman and Religion*, edited by Sr. Mary John Mananzan (Manila: Institute of Women's Studies, St. Scholastica's College, 1992), p. 88.

A number of academics who conceive of themselves as nationalists have made it their mission to guide their students against newfangled, useless "theory" from Western centers.

There are a considerable number of Filipino Muslims who introduce themselves as "Muslim first, Filipino second."

The on-again, off-again issue concerning the claims of the Sultanate of Sulu on the territory of Sabah is viewed in some quarters as a continuing test of the Philippine leadership's commitment to asserting the significance of Muslim tradition in the national body politic. Within the Philippines, only the Muslims can claim to have developed a supra-village polity outside the imposed colonial system.

An educational and PR documentary on Intramuros, the city-fortress built by the Spanish colonial government, stated: "It all began here."

Jae-Ryung Roe

ENCOUNTERING THE WORLD: THE PAST AND THE PRESENT

세계와의 만남의 역사: 그 어제와 오늘

The year 1995 was one of special historical significance for Korea: the nation celebrated fifty years of independence from the colonial rule of Imperial Japan. Since 1945, Korea has undergone half a century of modernization, Westernization, and change. So, throughout 1995, the nation reflected on its history, looking back and assessing its past performance, as well as defining the present position of Korea in the world. But it was also a year for establishing a collective national agenda, accepting that the past is behind us, embracing the challenges of the present, and preparing Korea for the next millennium. Accordingly, there were many public events to celebrate the fifty years of independence, and the way that these events were staged and the debates they raised were symbolic of the contested nature of history.

One of the most controversial events of the year was the government's decision to demolish the building of the National Museum in Seoul. This massive baroque building has been a subject of debate since at least the 1970s. It was originally built by the Japanese occupation forces in 1918 as the headquarters of the colonial governor general. It was from this center, then, that the colonizers orchestrated their oppression and subjugation of the Korean people. And, what was worse, the building was constructed along the central axis of the Kyung'bok royal palace grounds, the symbol of sovereignty of the last Korean dynasty, destroying some two hundred structures of the palace.

Those who favored demolition argued that the obliteration of this building, the foremost symbol of our colonial past, was necessary to eradicate colonialism from the collective memory and

to achieve true liberation and independence. Those who opposed demolition, on the other hand, claimed that the building had unparalleled historical significance. Not only had it been the seat of the colonial power but, since liberation, it was the site of other historical and political events: the first president of the new republic and his administration were housed there; the Korean flag was first hoisted on this site when allied forces recaptured Seoul from North Korea during the Korean War; and, since 1986, it has served as the National Museum, housing the country's cultural treasures. Thus, it is both a symbol of the oppression of colonialism and an emblem of the rebirth of modern Korea.[1]

During public ceremonies on August 15, celebrating Independence Day, the spire atop the dome of the building was removed, as a first step toward the eventual demolition of the entire building. Politicians proclaimed that the "dark past" was now behind us and that "a second liberation," an era of globalization, national prosperity, and ultimate unification lay before the Korean people. Aside from the sheer rhetoric of such public events, the fifty years since independence was also summarized in terms of some staggering statistics: per capita income has increased from $67 in 1953 to an estimated $10,000 in 1995, and the volume of exports has risen from $25.3 million in 1950 to $93,676.4 million in 1994.[2] These figures demonstrate the rapid and sustained long-term growth in the post–World War II period that has been primarily based on industrialization. As a consequence, Korea has been dependent on foreign trade, on absorbing technological skills and managerial know-how from developed countries, and on

SOUTH KOREA

adopting an "outward-oriented development strategy."[3] For Korea, modernization has been a "catching-up" process—rising to the model of development and modernity that has cut across national boundaries and cultural differences.

Over the past fifty years, the visual arts have been shaped by interactions between the Korean art community and art from overseas. But unlike industrialization, the assimilation of modernism in the arts has neither delivered sustained growth nor facilitated a harmonious catching-up process. As noted by cultural critic Marshall Berman, the experience of modernity and the cultural production of modernism claim to be international and universal but, in fact, they enfold a paradoxical unity of struggle and contradiction, of ambiguity and anguish. And, as with the debate over the National Museum, modern art in Korea has also been fraught with contentions and disunity. This fractious history refutes the simplistic assumption that modernism in Korea has been a one-way process of assimilation.

The Past

Korea's earliest encounters with overseas powers were a result of tourism, commerce, military campaigns, religious missions, and scientific exploration.[4] These were the kinds of projects that first exposed the isolated neo-Confucian Chosun Dynasty (1392–1910), known as the "Hermit Kingdom," to Imperial Japan, Russia, the United States, and Europe (fig. 1).[5] These incursions also brought the importation of various novel and strange cultural forms and practices to Korea beginning in the seventeenth century. Unlike China or Japan, where Western culture and art was introduced directly by Western visitors, Korea first received Western ideas and cultural goods via China. However, the import of Western culture was limited during the seventeenth century due to the isolation policy of the Chosun Dynasty and the age-old belief that China was the center of the universe (realms outside China were presumed to be occupied by "barbarians").

Information on Western art was first made available to Koreans through the illustrations in church publications brought by missionaries from China. But the most frequent way foreign cultural forms crossed the Sino-Chosun border was with the official envoys to China (who numbered around three hundred annually). They brought back to Korea souvenirs, gifts, and artifacts, and they published accounts of their travels and encounters with the outside world. In China, the cathedral was the favorite place for envoys to visit, and it seems to have been an important source for experiencing Western art. The envoys also acquired pictures drawn or painted by Western artists, mostly portraits of the envoys.

Korean exposure to Western culture increased substantially during the reigns of King Yongjo (1724–76) and King Chongjo (1776–1800), when a new, more pragmatic approach emerged. Shifting away from the conventional Confucianism that had dominated both private and public thought, this new view encouraged innovation and social change; new ideas and technologies were embraced. This created a conducive environment for assimilating foreign knowledge from China. One mid-eighteenth century observer noted, "There is no one who claims to be a scholar or of some rank who does not read the books from the West….[And] as of late, envoys to China have brought back many paintings from Western nations."[6]

The Korean establishment had two reactions to foreign art. On the one hand, there was a general aversion to the imagery and iconography of Western painting. Several texts refer negatively to the representation of "disheveled hair and [a] body without clothing," "short hair without a hat and the disorderly clothing that reveals the naked body," "clothing without stitching," and "dark spirits."[7] On the other hand, there seems to have been avid interest and even wonderment at the technical execution and mimesis in the artworks that were "almost like the real thing" and which made "the painted

1. Isabella Bird Bishop, *South Street, Seoul*, c. 1985. Isabella Bird (1831–1904) traveled extensively throughout Asia and visited Korea four times between 1894 and 1897. Accounts of her travels were published in *Korea and Her Neighbours* (copied from *Korea and Her Neighbours*, New York: Revell, 1898).

object come to life."[8] Knowledge of Western painting techniques was ultimately an important influence in forming a new style of portrait painting in eighteenth-century Korea. Though few artworks survive, art historians speculate that Western-influenced painting was widespread among artists working in Seoul. This hypothesis is based on the fact that in the few paintings that have survived, the artists incorporated Western pictorialism (two-point perspective, chiaroscuro, and a scientific observation of nature) into the conventions of traditional ink painting (fig. 2). The result, then, was a hybrid creature that assimilated to the artists' own techniques the style of Western painting. What is especially striking is the Korean artists' mastery over Western elements and their effortless incorporation of foreign aspects into their own art.

This mode of painting, which adopted foreign materials, techniques, and aesthetics, was later called *suh'yang hwa* (Western painting). And with the increasing presence of *suh'yang hwa* in the art community, it became necessary to define traditional ink painting as a separate practice. For this, the term *dong'yang hwa* (Oriental painting) was coined.[9] The acceptance of *suh'yang hwa* was shaped by the power of Imperial Japan in Korea. Japan's victory in the Russo-Japanese War of 1904–5 paved the way for Japanese supremacy in the region and its annexation of Korea in 1910. With over forty years of experience in centralizing and directing their own society, since the Meiji Restoration, the Japanese applied their experience and twentieth-century technology to the task of organizing, mobilizing, and controlling the development of Korea to meet the economic and political goals of the empire.[10] The thirty-six-year presence of the Japanese in Korea and the implementation of their imperial cultural policies during that time permanently transformed the nature of Korean art.

After 1910, many Japanese artists came to Korea. Art academies and studios were established to teach *suh'yang hwa*. The first such art academy was founded in 1911 by a Japanese artist to teach the "ladies and gentlemen of Chosun" drawing, oil painting, and watercolor.[11] Although there were no known *suh'yang hwa* artists working in Seoul at that time, the fact that this academy advertised in the daily newspaper suggests that there was a general demand for this style of art. Thereafter, Japanese artists came to Korea in increasing numbers to live and work, and generations of Korean painters went to Japan to study *suh'yang hwa* (fig. 3). By the 1920s, there were also artists who went to Europe and the United States but, because they were so few in numbers and because their influence on Korean art was minimal, Japan remained the most important force in shaping the early modern art of Korea.

The number of Korean artists trained in Japan reached its peak during the 1930s. Some Korean artists who went to art school in Japan would stay in Tokyo for years and would participate in the prestigious national exhibition held annually. But other Korean artists rejected the academism of established venues and associated with the avant-garde artists who practiced more contemporary European styles. On their return to Korea, many of these first and second generation Japan-trained *suh'yang hwa* artists became teachers, art administrators, and committee members and jurors for major exhibitions. They dominated the Korean art world both during and after colonialism. And since the colony's cultural dependence on the empire continued long after independence, Western or modern painting was often contested by an art community that was strongly nationalistic in sentiment. Modern art of the West met with strong resistance not only because it marked a difference from traditional practices and conventions but also because it was brought to Korea by the colonizer.

A major force of resistance in Korea was the communist movement, which was established in the early 1920s. The communists initially said that they were going to challenge the empire and to fight for independence through the solidarity of the proletariat. But they also gained wide support from the intelligentsia and the artistic community. A radical branch of the arts, the KAPF (Korean Artists Proletariat Federation), was formed in 1925, and, through nationwide networking and publications, expanded into a

2. Anonymous, *Painting of a Dog*, n.d., ink on paper, The National Museum, Seoul.

3. Ko Hui-dong, *Self Portrait*, n.d., oil on canvas, The National Museum, Seoul.

broad cultural movement. These leftist artists generated their own critical theory about the sociopolitical role of art, and they rejected the Korean art scene of their day, claiming that it was dominated by convention and "corrupt," purist aesthetics. In 1934, eighty members of the KAPF were arrested by the imperial police and its leading members were forced to sign a consent to the break-up of the federation.[12] Previously loyal members were soon collaborating with the colonial government. One noted leftist artist painted a picture of a group of Korean women who sacrificed their gold hairpins to the empire's war effort. Such artists were labeled pro-empire collaborators, and their "defection" signaled to many the demise of the communist resistance in the art community.

Postcolonial Korea was a time of turmoil as well as a period of reconstruction and new beginnings. The art world was divided by rampant sectarianism; there were left, right, and neutral positions on all political and ideological issues. The greatest disputes were between the nationalists and the pro-imperialists. Each side claimed hegemony and sought to control the nation's course and to define the present and future of the Korean art community. The pro-empire collaborators were ostracized from public life after independence by the Japan-bashing nationalists, but they soon reestablished themselves. The pro-empire artists were then confronted by both an ultra-nationalist, extreme right artists' organization and the newly reformed artists of the left. The ensuing chaos centered on disagreements over artistic agendas, with the basic dispute between those who favored social realism and those who rejected politics in art in favor of some union of traditional art forms and modernism. But all sides were unanimous in seeking to eradicate all traces of colonialism and to create a new national art for Korea that would reflect the sensibility of the Chosun people.

The brief ideological dominance of leftist artists ended during the period from 1945 to 1948, when U.S. forces occupied South Korea and Soviet forces occupied North Korea. The American forces in the South closed down presses and arrested leftists in massive numbers; at the

same time, by institutionalizing rightists and the politically neutral, the Americans helped the artists of the right to control the art scene.[13] The most important measure for officially sanctioning artists of the right and institutionalizing moderate and nonpolitical art practices was the annual juried exhibition known as the "Kuk'jun" (National Art Exhibition), which was inaugurated by the government in 1949 and continued until 1979—no doubt the longest surviving art institution in modern Korea.[14] The Kuk'jun reinforced conservative academism and made conventional figurative painting and sculpture the mainstream style of post–Korean War Korea.

One circle of young artists, known as the Informel Group, rejected the outdated mainstream art sanctioned by the Kuk'jun and professed a new mode of expression that manifested itself in mural-scale paintings encrusted with thick layers of paint applied with vigorous brushstrokes. The members of the Informel Group identified themselves with the postwar generation of European artists and with the movement Art Informel, which was also shaped by the artists' experiences of war.[15] The Informel Group emerged at a pivotal moment in Korean art; these were the first artists trained in Korean—rather than Japanese—art schools, and this was one of the first autonomous art movements in Korea. But at the same time, Informel engaged directly with the international art scene as Korean artists began to participate in major international exhibitions and biennials.[16]

By the mid-1960s, however, the Informel Group had become a mannerism. It had lost much of its vigor and excitement and the artists were no longer the young renegades that had once defied the establishment. Informel was followed by the increasingly rapid assimilation of Western art styles (which paralleled the explosive growth of the Korean economy and industry): Op Art, assemblage, geometric abstraction, conceptual and performance art. As a result, Korean art in the 1970s was characterized by a predominance of monochromatic, minimalist painting and sculpture. This was differentiated from Western Minimalism by being linked to

notions of spirituality in East Asian art and distinctively Korean aesthetics.[17] This Korean Minimalism was based on a progressive subtraction of expressive elements whereby what remained was an austere formalism of simple marks, scratches, and patches of color. By eradicating the representational altogether, Korean Minimalists reduced painting to an emotionless and expressionless pure object (fig. 4).

The assimilation of modernism in Korea met with resistance from the margins of the art community. A sophisticated critique of modernism had been developing in Korea since the 1960s, when the Hyunshil-dong'in Group (Reality Group), a short-lived student movement led by the activist Kim Jee-Ha, published its manifesto. In this statement, the group challenged the prevailing art discourse, which they claimed was based on a fallacy about absolute subjectivity in art. This attitude of art for art's sake, they argued, did not allow for the particular context of Korea and had led to stasis and formalism. The Hyunshil-dong'in Group advocated, instead, an art that would represent the everyday reality of the Korean people. Their notion of populism positioned the people as the agents of change in the constitution of national identity; their idea was that the people should have political power.[18] In visual terms, this concept of the popular as the national was translated as realism. Since it was immediate, spontaneous, and lucid, realism was deemed the only style appropriate for depicting the lived experiences of the people.

The significance of the Hyunshil-dong'in Group is that they created a politicized consciousness within the Korean art community. As such, they were the forerunners of the nationwide Minjoong art (People's Art) movement of the early 1980s. The critical basis for Minjoong was the belief that Korean modernism was a result of misguided attempts to mimic the West and a by-product of neocolonialism and cultural imperialism; it was, therefore, neither native to Korea nor pertinent to the everyday experiences of the Korean people.[19] The Minjoong artists sought to retrain themselves, to unlearn what they had been taught at art school, to develop a pictorial style that was pertinent to the reality of Korean

society. New methods of representation were sought in the traditional, non-Western pictorial conventions of Korean art, such as folk paintings, Buddhist paintings, or woodblock printing. Since they saw art as a consciousness-raising medium, Minjoong artists nationwide worked together on collaborative projects and held workshops on location at factories and farms, on college campuses, and on city streets (fig. 5).

This division between the modernism of the establishment and the Minjoong of the anti-establishment defined the situation of contemporary art in Korea in the 1980s. By the early 1990s, however, this bipolar rift had fractured, and today Korea is dealing with an art community that defies neat categorization. What has emerged is a clear distancing from the past and from the history of modernism, a mastery over the anxieties about the assimilation of Western modernism, and a redemption from the previous obsession with national identity and tradition. For years, the emphasis on their cultural heritage was the only way Koreans had of differentiating their art from the sameness and hegemony of other international art. Now, the freedom and confidence that Korean artists feel parallels a change in the spatial conception of the national culture. National borders were once conceived as walls separating the Korean nation from neighboring cultures and from the incursion of Western art. But the recent structural shifts in the global economic and political environments have necessitated a rethinking of the whole issue of boundaries and an autonomous national culture. The changing attitude this has brought about is reflected in the newly adopted public discourse about the globalization of Korea, which is also shaping critical discussions about contemporary art.

4. Chung Chang-Sup, *Returning (77-M)*, 1977, 197 × 110 cm.

5. Kim Kwan-young, Nam Kyu-sun et al., *The Joy of Reunification*, 1986, mural, Shin'chon, Seoul.

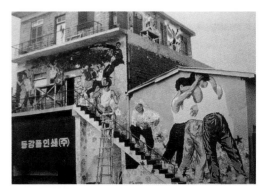

The Present

Dramatic structural changes in politics, economics, ideology, and military strategy since the mid-1980s have realigned the old East-West opposition. With new communication technologies and information systems, the nature of economic transactions is also broadening and changing. This has increased international dependency, globalization of production, mobility of people and services, and transfers of goods and capital, and accelerated global integration. These rapid and extraordinary shifts have created a challenging environment for Korean industry. Consequently, the Korean government has proclaimed a national program of *segehwa* (globalization), a public awareness campaign that is to not only maintain the growth and competitiveness of the Korean economy but also to create a collective vision for the present and the future.

The *segehwa* program was announced by President Kim Young-Sam in late 1994 and again in January of 1995. Since that time, *segehwa* has been one of the most visible and widely used terms in the Korean media, being applied to everything from the economy and trade to culture and the arts. One area that reflects the public awareness of *segehwa* is foreign-language education. Foreign-language skills have always been important for Korea since its survival has depended on communicating with the international community. But since early 1994, there has been a sudden increase in the demand for foreign-language instruction.[20] English skills have become a prerequisite for applying for a job, and government employees are tested on English before they are promoted. Some companies have organized in-house language-training sessions, and many large corporations, like Samsung, have whole corporate-run language-training centers where they send employees for periods of intensive language study. This phenomena does not apply only to the job market. In 1995, Kids Club, an international franchise teaching English to pre-schoolers and elementary school children, opened in Korea. During its first year, there was an overwhelming demand to open Kids Club branches throughout the nation, and now the school receives over a hundred new applicants each month (fig. 6). The zeal among Koreans to overcome language barriers is but one aspect of human resources development in the *segehwa* project.

Segehwa has also been the most prevalent concept in recent public discussions about contemporary art. In the context of a decentralized and ruptured art community, the discourse about becoming globally competitive and about gaining international recognition for Korean contemporary art is the one unifying element on the agenda. In 1995, Korean contemporary art had unprecedented exposure in the national media because of the promotion and hype surround-ing two major art events. Together, these occurrences were said to have "created a stage for Korean contemporary art in the center of the international art world," "focused the international art world on Korean contemporary art," and served as "a springboard for the *segehwa* of Korean contemporary art."[21]

Undoubtedly, the major art event in Korea in 1995 was the Kwangju Biennial (Sept. 20–Nov. 20, 1995). This exhibition brought to the city of Kwangju 1,288 artworks by ninety-two artists from fifty-eight nations (fig. 7). The Kwangju Biennial was conceived as a global festival of contemporary art and promoted as "the first [i.e., largest, most extensive] of its kind to be organized in the Asia-Pacific region."[22] The exhibition itself was titled "Beyond the Borders" and featured extensive coverage of the global art scene, with particular attention to so-called marginal cultures and nations.[23] Since the event was originally planned to commemorate the fifteenth anniversary of the Kwangju prodemocracy movement, the project had built-in political significance and credibility.[24] And because of this, the biennial was able to gather support from the citizens of Kwangju, as well as from

6. Learning English from native speakers at Kids' Club.

corporations and the government. The organizers of the biennial claimed that it would heal the wounds of history and console the people of Kwangju; it would bring the international art world to Kwangju and present the cultural heritage of the region to an international audience.

Once the festival was underway, there was nonstop media coverage and promotion. During the first week, there was daily reporting on the evening news, on every television station. There were morning television specials with on-the-spot commentators, there were banners on many of the streets of Seoul, and there were even pre-recorded telephone messages providing updates on the biennial when Koreans dialed 114 for directory information. The Kwangju Biennial was an extravaganza by any standard. It cost somewhere around $22.7 million to stage (which came from both private and public money) and made a profit of approximately $10 million—all in all a healthy success for the city of Kwangju and for the organizing committee. Attendance at the biennial was overwhelming, with official estimates placing the total number of visitors at over 1.63 million, or about 20,000 to 30,000 visitors a day. These figures are all the more remarkable when one considers that most major international art exhibitions, such as Documenta or the Venice Biennale, only draw around 300,000 visitors total. Surprisingly, the number of foreigners attending the festival was estimated to be only about 23,000, or 1.4 percent of the total. For this reason, and despite the official pronouncements of the exhibition's success, many in the Korean art community regarded the biennial as a failure. They pointed out that it was not a truly international event, that it lacked overseas promotion and international press coverage, and that it did not succeed in promoting the *segehwa* of Korean art.

The other major art event of 1995 was the opening of the Korean pavilion at the 15th Venice Biennale. In Korea, there was a lot of excitement in the art community about this event, and it received wide press coverage in popular publications and daily newspapers. Korea was the twenty-fifth nation to acquire a national pavilion in Venice, but only the second Asian nation to

do so, following Japan. The aspirations for the *segehwa* of Korean art were the pavilion building itself, designed to resemble a sailing vessel. The metaphor of a ship sailing toward the Adriatic Sea symbolized Korean art expanding overseas and reaching toward the global art scene, and to embody the expectation that in the future this site will serve as the platform for the *segehwa* of contemporary Korean art.

7. Perspectival view, in the middle ground, of the main venue of the Kwangju Biennial.

There was additional hoopla about the international recognition of Korean contemporary art at the biennial when Korean installation artist Jheon Soo-Chun received a special prize. His installation consisted of rows of hundreds of clay statuettes, replicas of the terra-cotta figurines excavated from burial grounds dating back to the ancient Shilla Dynasty (57–935 C.E.). These were laid on top of a transparent glass-paneled platform under which the artist had heaped a mass of industrial junk and waste. In this work, Jheon Soo-Chun was juxtaposing artifacts from the past, the excavated vestiges of a buried civilization, with the detritus of contemporary civilization. The prize was taken as an encouraging sign for Koreans, an assurance that international recognition for Korean contemporary art is increasing. Although the award went to an individual artist, it was perceived as a recognition of the collective achievement of the art community of Korea.

It has been increasingly common for Koreans to refer to the activities of individual artists as representative of the "we," the national collective. This tendency toward synthesis, toward making sweeping judgments about the character and identity of the national art community, means that Koreans often regard nationalism in art as if its meaning were transparent. But despite this widespread habit of discussing the work of Korean artists in terms of the national and the

communal, the *segehwa* of Korean contemporary art will always be determined by the strengths and weaknesses of individual artists.

In the exhibition "Contemporary Art in Asia: Traditions/Tensions," the artists from Korea each deal with very different media and subject matter; each has developed a mature personal expression that communicates its meaning to viewers with strength and power. This is in part because they were born and raised in Korea. Their personal responses to political changes and their travails in coping with the consequences of the nation's past—the history of modernity, the burden of assimilation and catching up, the lingering memories of tradition, and the tensions created in the process of change—have shaped the development of their art. Their experiences will resonate with those of artists from the other regions represented in this exhibition. And, one hopes, the public will enjoy the opportunity to witness and to share the personal histories of the artists and the public histories of the cultures on view.

Notes

1. An important factor in protesting the demolition of the National Museum building concerned the safety of the irreplaceable artifacts of the museum's collection, which many felt would be endangered if they had to be moved to a temporary site. A new building to house the national collection is still only in the planning stage, scheduled to open between 2005 and 2010.

2. The interim figures for these increases are also revealing: per capita income was $100 in 1963, $396 in 1973, and $2,014 in 1983; exports rose from $882.2 mil. in 1970 to $17,214 mil. in 1980 to $63,127.2 mil. in 1990. See *Hankuk-Eun'haeng'ui Tong'gae* (Data of the Korea National Bank) (Seoul: Korea National Bank, 1995).

3. The term "outward oriented development strategy" refers to a set of policies aimed at utilizing factors and markets available abroad by forming a close link between domestic and foreign economies. In this growth strategy, foreign trade based on specialization and division of labor, competition in foreign markets, importation of the best available technology and know-how, and foreign capital inflow are essential ingredients. On this strategy, see Il Young Chung, ed., *Korea in a Turbulent World: Challenge of the New International Political Economic Order and Policy Responses* (Seoul: Sejong Institute, 1992), p. 358.

4. Benedict Anderson writes about the importance of maps as a tool for imperial expansion, especially in connection with European imperialism in Southeast Asia in the nineteenth century. The second half of the nineteenth century was the golden age of military surveyors in all regions of Asia, as mapping and census-taking were important tools for both surveying and surveilling the geography and the people. More than a simple scientific abstraction of reality, maps were a visualization of what they purported to represent, a real instrument to concretize imperial projections onto the earth's surface. The "discourse of mapping" was a paradigm that both administrative and military operations worked within and served. See Benedict Anderson, *Imagined Communities: Reflections on the Origin and Spread of Nationalism* (London: Verso, 1991).

5. These projects, through which the imperial forces experienced Korea, produced various accounts of their encounters with Korea and her people. And whether they were ethnographic studies, missionary reports, or travel writings, they produced firsthand accounts of experiences in an unexplored, exotic, and "primitive" Korea. See Hendrik Hamel, *Hamel's Journal and a Description of the Kingdom of Korea, 1653–1666* (Seoul: Royal Asiatic Society, 1995); Isabella Bird Bishop, *Korea and Her Neighbours* (New York: Revell, 1898); Percival Lowell, *Choson, the Land of the Morning Calm* (Boston: Ticknor and Co., 1886); A. Henry Savage-Landor, *Corea, Land of the Morning Calm* (London: Heinemann, 1895); Elizabeth Keith, *Eastern Windows* (London: no publisher, 1928); Elizabeth Keith, *Old Korea* (London: no publisher, 1946); and Horace G. Underwood, *The Call of Korea* (New York: Young People's Missionary Movement of the United States and Canada, 1908).

6. Quoted in Hong Sun Pyo, "Chosun-hooki'ui Suh'yang hwa' kwan" (Late Chosun Attitudes on Western Painting), in *Hanguk Hyundai Misul'ui Hyungsung* (The Formation of Korean Modern Art) (Seoul: Iljin-sa, 1988), p. 154.

7. Ibid, pp. 160–61.

8. Ibid.

9. The earliest known use of the term *suh'yang hwa* is in an article in the daily newspaper *Dong-A Ilbo* in 1920; this article suggests that by then it had become part of the vocabulary in art discourse. The designations *dong'yang hwa* and *suh'yang hwa* denoted two separate painting cultures and perpetuated the notion that Korean painting was bound to tradition and convention while Western-style painting was innovative and modern.

10. Michael E. Robinson, *Cultural Nationalism in Colonial Korea, 1920–1925* (Seattle: University of Washington Press, 1988), p. 39.

11. Ku-Yul Lee, "1910 nyun Chun'hooki'ae Nae-han'haet'tun Ilbon'in Hwa'kadull" (Japanese Artists in Korea Around 1910), in *Hankuk-hyundai Misul'ui Hu'rum* (The Progression of Korean Modern Art) (Seoul: Iljin-sa, 1988), pp. 174–75.

12. Suh Sung-Rok, *Hankuk'ui Hyundai Misul* (Modern Art in Korea) (Seoul: Mun'ye Chul'pan-sa, 1994), pp. 62–87.

13. Ibid.

14. The Kuk'jun included works in the categories of Oriental painting, Western painting, sculpture, crafts, and calligraphy; submissions to each category were screened by a panel of jurors. This format replicated the Sun'jun, an annual exhibition that was inaugurated by the governor general of Korea during the Japanese occupation as a means of intervention and surveillance of the colony. Suh Sung-Rok, *Hankuk'ui Hyundai Misul*, pp. 89–102.

15. Art Informel was a movement in European painting that paralleled Abstract Expressionism from around 1945 to the mid-1950s. The term was first used by the French critic Michel Tapié in reference to works by Jean Fautrier, Jean Dubuffet, Henri Michaux, and others. It designates the "lyrical abstraction" that gives direct expression to subconscious fantasy, in contrast to the more rigorous abstraction derived from Cubism and De Stijl.

16. The 1961 Paris Biennial and the 1963 São Paulo Biennial were the first overseas large-scale art events in which Korean artists were represented.

17. The white monochrome in minimalist painting was affiliated with an age-old spirituality in Korean art and with a traditional aesthetic that is based on harmonious relationship with nature, as described in the following: "The color white is to us more than just another hue. It is a spirit before being a color. Before it exists as the color white, the white bears reference to a cosmos… an arena in which all properties are created" (Lee Yil, "Preface," *Korean Artists: 5 Variations on White Exhibition* [Tokyo: Tokyo Gallery, 1975], n.p.); and "It is only through color simplification that the artist can achieve a meditative harmony, lifting the spirit above desire and into a cosmic freedom which is the traditional aim of East Asian art" (Lewis Biggs, "Working with Nature," in *Working with Nature: Contemporary Art from Korea* [Liverpool: Tate Gallery, 1992], p. 9).

18. David Forgacs, "National-Popular: Genealogy of a Concept," in *Formations of Nations and People* (London: Routledge, 1984), pp. 83–98.

19. It was argued by members of the Minjoong art movement that modernism had reproduced the hegemonic structure of the international art world wherein Third World cultures have become dependent consumers and markets for cultural production from the West: "Our interest in Western modern art was generally focused on novel modes or methods of art making, or limited to questions of how to adopt various styles, and there was not much of an attempt to examine art within its social context. The adoption of Western modern art did not go beyond the facile imitation of techniques or stylistic variations, and remained conspicuously superficial and narrow." Sung Wan Kyung, quoted in *Minjoong Misul 15 Nyun* [Fifteen Years of Minjoong Art], edited by Yul and Choi Tae Man (Seoul: Sal'm'kwa Kkum, 1994), p. 16.

20. The domestic market for foreign-language education in the private sector is estimated at $125 million, and if one takes into account the money spent on private tutorials and the market for textbooks and cassette tapes, the estimated total spending on learning a foreign language would be much higher. There are at present some 580 registered teaching facilities in Seoul and 2,000 nationwide. The immigration office has issued some 1,960 teaching visas in one year to those who have entered the country as language instructors. *Weekly Economist*, no. 305 (Sept. 13–20, 1995): 11–32.

21. "Sege'sok'ui Hankuk Misul," *Sege Ilbo* (daily newspaper) (June 9, 1995).

22. *Hankuk Kyung'jae Shin'moon* (daily newspaper) (Sept. 18, 1995).

23. The biennial actually included several separate exhibitions: the major show, "International Exhibition of Contemporary Art," plus "Art as Witness: Kwangju in Memory of May," "InfoART," "Korean Contemporary Art," "Eastern Spirit and Ink Painting," and "The Originality of Korean Modern Art."

24. Details of the Kwangju prodemocracy movement have only recently been made public, and it is still unclear exactly what occurred because of the circumstantial evidence surrounding the events. What is known is this: during the vacuum of leadership following the assassination of President Park in 1980, demonstrations in Kwangju were brutally suppressed by army paratroopers. Several dozen civilians were killed in the fracas. Rioting ensued and the citizens of Kwangju came together in outrage to expel the troops and wrest the city from authorities. They took over government facilities, radio stations, and arsenals. An army division was sent to Kwangju to put down the riot and was given orders to open fire on anyone who resisted. This led to several hundred more civilian casualties.

Apinan Poshyananda

CONTEMPORARY THAI ART: NATIONALISM AND SEXUALITY À LA THAI

ศิลปะไทยร่วมสมัย : ชาตินิยมและเพศนิยมแบบไทย ๆ

For Thailand, the year 1996 was full of activities related to preservation and reinvention of traditions. The Golden Jubilee of King Bhumibol Adulyadej, celebrating his fifty years on the throne, was marked by a veritable patriotic frenzy among a citizenry that proudly claims that their nation has never been colonized. Glitzy portraits of the monarch accompanied by colorful flashing lights were common sights on the streets and highways, outside department stores and shopping malls, inside karaoke bars and massage parlors. At the same time, there were fabulous sound-and-light extravaganzas to mark the seven-hundredth anniversary of Lanna (northern Thailand). These pageants reenacted through performance various episodes from that region's history. The year also witnessed grand-scale cremation ceremonies for several beloved personalities, including the Princess Mother and the highly revered monks Phra Rachnirojrangsri Khampheepanyavisit, Somdet Phra Phutthak-hosachan, and Somdet Phra Wanarat, dramatic rituals that elevated these figures posthumously to the status of miraculous personas.

These events are examples of the wide range of cultural activities that interweave and cultivate concepts of nationhood and Thainess (*khwampenthai*). On such occasions, the power of the media and nationalist propaganda are exercised to the fullest. Their goal is to fortify the illusion of stability and security through the spectacular promotion of Nation, Religion, and Monarchy—the three pillars of nation-state ideology in Thailand.[1] By their symbolic affirmation of these concepts, the Thai people are expected to experience and accomplish their Thainess.

Nationalist discourses are generated to establish the concept of a collective imaginary, to distinguish the "national self" from the "national others." In Thailand, the national discourse has been designed to foster notions of the "right" and the "good" and to perpetuate the rich and revered traditions that have been passed down from ancient ancestors. Culture has always been seen as a distinctive characteristic of Thailand, essential to the stability and integrity of the nation. King Chulalongkorn, who ruled from 1868 to 1910, is remembered as a great leader who shrewdly adapted Western science, technology, and culture to traditional components of the Thai past. During World War II (1938–45), the Phibun Phibunsongkram government inaugurated many ambitious projects to disseminate and reiterate Thai culture in the face of outside influences from Europe and Japan.[2] In 1979, the National Culture Commission was established to oversee the preservation and promotion of Thai culture. The National Identity Board and its Subcommittee for the Propagation of Thai Identity also sponsor countless programs, publications, and events intended to provide examples of culture for "good" and "obedient" Thais to follow.

The reverence of icons has a long history in Thailand. This pertains not only to the idolization of Buddhist and Hindu images but also to the glorification of kings. The celebration of the *devaraja*, or god-king, as protector has long been fostered as part of the royal prescription (*phrarachaniyom*).[3] In addition, supreme patriarchs, abbots, heroes, and members of the royal family have long been commemorated in the form of images, monuments, life-size

posthumous sculptures, coins, and amulets.[4] Since the 1930s, the Department of Fine Arts in Bangkok has produced this kind of official art and promoted heroic national artworks as symbols of the Thai nation.[5] This is a type of "consensus art," a stylistically formulaic art, using traditional subject matter, screened by official committees, and disseminated in the form of public monuments. In such works, individuals or groups are generally portrayed in an academic style that strives for verisimilitude and technical virtuosity. This mode of heroic realism has served as a crucial part of cultural engineering in the invention of Thai tradition.

Intense love of country—in the form of eroticized nationalism or infatuated patriotism—has been promoted in Thailand through the proliferation of such public monuments, posters, and billboards. In addition, the revitalization of icon worship, cult personalities, supernatural powers, and occult mysticism has provided channels of mental and spiritual release for the Thai people at a time when their country is coping with globalization and industrialization.[6] Ironically, the more that advanced technologies are forced into society, the more people crave transcendental and psychic forces. For example, an equestrian statue of King Chulalongkorn, cast in Paris by French sculptors in 1908 and installed in the Royal Plaza in Bangkok to arouse patriotism and reverence for the monarch, has recently been reinterpreted through mysticism and animism. It has become a focal point for the cult of Sadej Poh Ror Ha (the Royal Father King Rama V), whose worshippers believe that faith in their spiritual father can bring miracles and success. Thai historian and social critic Nithi Iawsriwongse has suggested that King Chulalongkorn stands for modernity and progress. In short, he is the symbol of an ideal state that people want, but which does not exist in reality. A state that is efficient, accessible, accountable, and compassionate. The kind that uses wisdom instead of force for change.[7]

This movement, which emerged soon after the military coup d'état and massacre of civilians in 1992, has been further explained as a response to industrialization by the Bangkok middle class, whose new needs and aspirations could not be satisfied by the old spirit cults. The invention of the King Chulalongkorn cult provides them with a modern guardian angel, one who is especially revered by the urban business sector (ranging from street vendors and small shop owners to real-estate entrepreneurs and stock speculators). In contrast to the worship of other national heroes (such as King Naresuan the Great, King Mangrai, King Phra Ruang, King Phra Chao U Thong, King Phra Chao Sri Dhammasokaraja, or King Phra Phuttayotfa), the King Chulalongkorn cult has achieved its greatest popularity with the culture industry, which thrives on the production of royal portraits, memorial coins, posters, and miniatures.

Heroic realism, particularly as immortalized in the monuments and portraits of these national heroes, has been essential to the glorification of nationhood and national identity in Thailand.[8] At times, equestrian statues and other sculptures of these heroes are extolled for the mystical aura that seems to surround them and is believed to emanate spiritual forces that can protect and defend Thai citizens from "evil" spirits. These "bad" elements are perceived as external threats, and are often detected in the guise of colonization, modernization, Westernization, Japanization, communism, socialism, and globalization. Heroes and heroines from the past, such as King Taksin, Phra Srisuriyothai, and Khunying Mo, perfectly embody the infatuated love of nation and need for national security that typifies the Thai people.

Living heroes are more complicated. One person's hero can be another person's villain. As Buddhism booms in Thailand, for instance, many religious institutions are becoming more like corporation headquarters than places of worship. High-tech nirvana and instant karma are promoted internationally through computerized databases and CD-ROMs. Monks have become superstars.[9] Luang Phor Khoon, one of the most celebrated living monks, has hordes of followers, including leading politicians, military generals, and celebrities. Luang Phor Khoon fever has attracted donors as well as consumers, who avidly purchase charms, lockets,

and souvenirs blessed by the aged chain-smoking monk. Some followers even claim that drinking this monk's urine has brought them good fortune.

On the other hand, monks turned villains have contributed to skepticism in Buddhist faith. One charismatic monk, Yantra Ammaro Bhikku, faced a series of criminal charges for fathering a child, having sex with his female followers, and using credit cards to pay for illicit sex while traveling overseas to preach Buddhism.[10] Another abbot, Phawana Bhutho, was arrested and jailed for raping numerous tribe girls who were lured to his monastery by nuns.[11] Notorious incidents that tarnished the Sanggha included a novice monk arrested for roasting dead babies in a cult of baby spirits; an ex-convict monk who raped, murdered, and burned a lone English tourist; and various gay monks who have been caught in midst of prohibited sexual acts. Taken together, these incidents have produced a crisis of faith that is of enormous concern to those responsible for upholding the ideology of the nation-state.

The concept of a "pure" Thai-Buddhist society has also been central to creating feelings of homogeneity and harmony in Thailand. But scandals have tarnished the pure image of the Land of the Smile: the allegations that Thailand is supporting the Khmer Rouge guerrillas; the leading politicians involved in the Pacific heroin trade; the child prostitution and sex supermarket. Defenders of Thai identity have tried to deflect any misconceptions or disgrace connected with these scandals by using propaganda to bind Thais more intensely to their cultural community and traditional society. Despite vast cultural differences in ethnic groups and hill tribes, the national pride and the concept of homogeneity are encouraged through the slogan "Unity in Diversity."[12] Racial and ethnic backgrounds that reflect heterogenous elements are outweighed by the ideology of harmonious unity for the sake of national security. Given this tendency toward national stability, it is not surprising that issues of multiculturalism and multiple identities, which have caused such heated debate elsewhere, are eschewed in Thailand.

The purity of one's Thainess is ranked according to a strict hierarchy determined by indigenous bloodlines and ancestral heritage; it is measured according to specific characteristics and idiosyncrasies. Qualities that detract from Thainess are generally ones that are perceived as "foreign," such as *farang* (white-skinned foreigner), *khaek* (dark-skinned foreigner), *chine* (Chinese), *yepun* (Japanese), *lao* (Laotian), *khamen* (Cambodian), *phama* (Burmese), or *vietnam* (Vietnamese). Yet, at the same time, it is the national cultural policy to assimilate and tolerate these alien sources in order to absorb them into the infrastructure of Thai ideology. Thus, Thai consciousness advocates desire for hegemony over inferior races and identities. Minority groups such as the Shan, Akkha, Hmong, Lahu, and Lawa are seen as dependent and powerless, always ready to be exploited. The Khmers, Burmese, Laotians, and Vietnamese are neighbors, but they are also foreigners who pose a potential threat to Thainess.[13] With the collapse of communism, new sources of menace have been invented for national security and protection of the Land of the Free.

Contemporary Thai art is geared toward political correctness. Art institutions, competitions, and exhibitions are all organized to cater to consensus art. The assumption is that such art must reflect characteristics that are uniquely Thai. The promotion of Thainess through contemporary art is taken seriously by government bodies as well as corporate sponsors. As one might expect, there is little room for political dissent or for issues around gender, class, racism, or xenophobia in the so-called mainstream art of Thailand. Although multiple identities are encouraged through contemporary art, they must always evoke feelings of integration and eclecticism rather than disruption and disorder.

In addition to promoting the creation of public monuments in the 1930s and '40s, the Thai Department of Fine Arts has always sought to inculcate national consciousness through the development of art curricula and through the supervision of the National Art Exhibition. Desire for a unified Thai character and sentiment was also stressed by Silpa Bhirasri, formerly Corrado

Feroci (1892–1962), an Italian sculptor who settled in Thailand in the 1930s and became known as "the father of modern Thai art."[14] In the late 1950s and early 1960s, many artists adopted nostalgic scenes of the countryside and subject matter related to the revival of Thai tradition as ways to express national identity. Another favorite theme was that of Thai women exoticized and eroticized by the male gaze. Even the artists' choice of materials, like tempera, gold leaf, mahogany, teak, handmade paper, and bronze, indicated an emphasis on the local and the indigenous.

Thainess itself became a significant factor in cultural production. Thai-centrism was applauded by artists and art teachers as a necessary means to distinguish national characteristics from the influence of Western art styles. The division between Thai art and non-Thai art produced a dramatic confrontation in 1964, when a painting by Prapat Yothaprasert depicting a folk festival was awarded the gold medal at the National Exhibition of Art. A group of artists who preferred avant-garde, nonfigurative abstraction boycotted the exhibition, the most prestigious art contest in Thailand, as a protest against its conservatism. The controversy was resolved when King Bhumibol Adulyadej, who regularly participated in this annual exhibition as an invited artist, held a tea party at the Chitr Laddha Palace to mediate an agreement between the opposing sides.[15] But the king's intervention brought only a temporary truce between the Thai traditionalists and the avant-garde.

In the early 1970s, painters such as Thawan Duchanee and Pratuang Emjaroen began to incorporate Buddhist subject matter into their work. Duchanee's use of macabre sexual scenes alongside images of the Buddha was misinterpreted as sacrilegious; as a result, his canvases were vandalized by defenders of Thai identity. Emjaroen integrated concentric abstract forms with the Buddhist symbol of the turning wheel. Emjaroen's representations of the Buddha were often shown decapitated and riddled with bullet holes to remind viewers of the internal political strife that rocked Thailand during the mid-1970s and led to several massacres. These paintings reveal the fractures and instability that underlie the nation's pose of stability.[16]

Corporate patronage also began to take an active role in art sponsorship in the mid-1970s. Through the Thai Investment and Securities Company (TISCO), the Bank of Thailand, and Bangkok Bank, a client-patron relationship was established in the contemporary art world as a way to foster "fine" taste and tradition. Venturing into the role of art patrons, financiers shifted the notion of patronage from courts and temples to banks and corporate institutions. This trend was followed by Thai Farmers Bank, Siam Commercial Bank, and various other corporations. By the late 1970s and '80s, art patronage by nongovernment institutions had expanded the patron-client relationship by raising conditions of barter: art products could now be exchanged for both wealth and recognition. The stereotype of anonymous artisans or starving artists exploited by wily art dealers shifted considerably. With increased cash flow, contemporary art became associated with commodity and profit. The principal equation for success simply called for artists to supply patrons with more and more consensus art, nonthreatening styles of art used to illustrate subject matters that revere Buddhism and Thai consciousness. The main stylistic demands of this neotraditional Thai art were technical virtuosity (preferably with an array of finicky details) and a profusion of garish colors (gold being the favorite). In 1977, a Department of Thai Art opened at Silpakorn University to fulfill the increasing demand for nationalist art.[17]

A desire to sidestep reality is a common characteristic of the Thai people; it has even been said that Thais prefer to live in a false world.[18] Neotraditional Thai art embraces characteristics related to allegory and fiction but it has been a most effective catalyst for arousing patriotism and creating a sense of Thai unity. This regressive stylistic has benefited tremendously from the fact that it conforms to national cultural policy and values, and that it reinforces a desire to return to the roots of Thai civilization. Neotraditional Thai art can be separated into three categories: the representation of an imagined

indigenous space through neo-Buddhist art; the depiction of rural scenes related to nostalgic yearning for a lost past or cultural heritage; and the glorification of monarchical leadership and the accomplishments of the royal family.

Typical of neo-Buddhist painting are scenes of Traiphum Phra Ruang relating to the three worlds of traditional Theravada Buddhism: the paradise of deities separate from the under-world; the four continents of the human world; and Mount Meru, the earth's central peak, sur-rounded by oceans and other mountains. In these invented scenes of ecstasy and delight, the viewer confronts the Buddhist world at the cen-ter; Europe, America, Africa, and the rest of the human sphere are subsidiary and peripheral. Paintings with Buddhist subjects, such as "Lotus Blooming in the Triple World," "Toward Nir-vana," "Bhuddabhumi," or "Celebrating the Holy Relic," indicate a desire to embrace the funda-mental values of the Thai Buddhist tradition but to cleanse and purify them.[19] Fictional scenes of the "Lives of the Buddha" (*tosachat*) are favor-able subjects among neotraditional painters. For instance, the book *The Story of Mahajanaka*, written by King Bhumibol Adulyadej to mark the fiftieth anniversary of his accession to the throne, is elaborately illustrated by neo-Buddhist painters.[20] Allegorical interpretations of the text stress energy, perseverance, and endeavor as means to achieve success. Fictional images of Buddhist iconographies are thus suitable for parables and anecdotes, especially when they evoke divine love and patriotic fervor. As a tran-scendental dimension, spiritual space is ele-vated above material space. At the same time, indigenous space is conveyed as a privileged domain, reserved for those within Thai borders.

Yet, the Buddhist faith is also occasionally imagined beyond national boundaries, as in the murals executed during the 1980s at Wat Buddha-padipa in Wimbledon, near London.[21] There, contemporary scenes and events are injected with Buddhist meanings, so that old and new, time and space are collapsed into a coherent cultural context. Images of Margaret Thatcher and Ronald Reagan are dominated by the "Lives of the Buddha" and the "Victory over Mara," for

instance, while scenes depicting King Bhumibol and Queen Sirikit imply royal/divine activities that recall the cult of *devaraja*. Not only do these murals extend the indigenous space of Buddhism and Thainess far beyond the national borders but the exposition of the ideology of Thainess in this temple also turns it into a space for national cultural promotion. Now, Wimbledon advertises both world-class tennis and Thai Buddhism.

In such promotions, representations of Thai national culture are orchestrated to suppress any evidence of erotic kitsch, decadence, drugs, sex shows, or massage dens. The murals assert veneration in Buddhism as well as good, clean fun as most typical of the Thai people. As in the false world of theme parks, viewers are enter-tained by visual extravaganzas with little con-cern for its seeming contradictions. In the current economic situation, Buddhism and the banking business seem to merge very well. Mural decora-tions with Buddhist stories, which earlier were adapted for hotel suites and lobbies, have now become fashionable in corporate headquarters. For instance, the mural painting titled *Land of Universes* (1995–96), recently installed at the head office of Siam Commercial Bank in Bangkok, deftly unites neo-Buddhist art with the material space of corporate business.[22] The unacknowl-edged shift from the materialist domain of stocks and monetary funds to the celestial realm of Buddhist universes signals the sorts of contradic-tions that typify displaced images in Bangkok. The implication can only be that the sacred environment now lies in the union of the banking and Buddhist empires. There, in the City of Angels, air-conditioned lobbies with thick flow-ery carpets emanate a pulsating, sacred Thainess and anything seems possible.

Corporate patronage encourages artists to uphold Thai culture against the pressure of Western influences, which are regarded as non-Thai or anti-Thai. In addition to the ever-popular Buddhist subjects, there is a constant demand for tranquil scenes of uncontaminated country-side. Artists often imagine Thai purity as some-thing that exists "out there," amid the hills and rural people, away from the polluted metropolis of Bangkok. Paintings of village life and regional

festivals are popular in office buildings, where they serve as windows of escape, links to a harmonious joy of life far from the urban concrete jungle.[23] But the most potent signifier of passionate nationalism is the insatiable demand for historical paintings related to icons and celebrations of the Chakri Dynasty. On special occasions linked to royalty (such as the birthday cycles of King Bhumibol, Queen Sirikit, and Crown Princess Sirindhon), banks and corporations often sponsor painting contests that are both ambitious and highly competitive as they supposedly reflect the sponsor's loyalty and patriotism as well as the national character.[24] In these competitions, Thai consciousness is constructed and promoted through historical painting and Thai iconography. As usual, the standards for quality are based on institutionalized forms of consensus art and their ability to convey national identity and "pure" ethnicity.

When the artist's creative imagination and the viewer's artistic judgment are shaped by a desire for an imaginary Thainess, artworks often function as vehicles to express a "we-self" as opposed to an "otherness." Infatuation with Thainess is so ingrained and indoctrinated in the art system that even the art market is forced to revolve around the idea that Our nation, religion, and monarchy are "purer" than Theirs. Repetitious scenes that reiterate these messages confirm the concept of the national imaginary. Neotraditional Thai art is expected to instruct viewers in the highly revered and uncontaminated values of nationhood. Therefore, contents and qualities that are regarded as non-Thai or anti-Thai are suppressed or forced through a systematized process of self-censorship. Faced with parochial standards of art practice, many Thai artists have searched for a new vision or expression precisely to avoid the Thai-centric view or the notion of art-for-Thai's-sake. Not surprisingly, many Thai artists are intrigued by issues of identity.

For radical Thai artists, a favorite issue is the national identity crisis brought on by the influx of foreign cultures. They dare to represent the people's lack of faith in the government and the military, a condition fueled by such incidents as the May Massacre in 1992 or the scandalous actions of various abbots and politicians.[25] These artists paint scenes of monks masturbating, police gang-raping civilians, fathers trading young daughters into the flesh market, generals giving fellatio in a fiendish orgy. In one street performance, an artist mimicking a soldier rammed a plastic phallus-truncheon into a paper replica of the Democracy Monument as he shouted, "I will fuck you. The Democracy whore. I'll fuck you on and on."[26]

Macabre and sordid themes seem to interest Thai viewers, who have been numbed and anesthetized by government and corporate art. Some blasphemous images are made specifically to arouse scandal or for self-promotion. But these artists walk a fine line between celebrity and notoriety. Although they are sometimes hailed by the media for daring to defy censorship and to confront the dark side of authority, they often face the backlash of sensationalism. And when these artists transform the protectors and promoters of Thainess into villains and monsters, they are inevitably regarded by many as threats to national security. Still, when their works manage to avoid overloaded political whining and sexual implications, they serve as a necessary counterbalance to the shopworn, doctrinaire versions of neotraditional Thai art.

Vasan Sitthiket's series of "Inferno" paintings was created at a time when faith in Thainess had reached its lowest point. In his reinterpretations of the Traiphum, the stories of the Three Worlds, Sitthiket has created an indigenous Buddhological space in which all hell seems to have broken loose. Apocalyptic landscapes that presage the bloody mayhem that took place in Bangkok replace images of Paradise and nirvana. Ghostlike bodies twitch in spasms, instantaneously reenacting needs, aggressions, and anxieties in an endless, exitless labyrinth. Through such scenes of torment, Sitthiket criticizes the violence and deterioration of morals in contemporary Thai society.[27] In his paintings of orgiastic scenes, such as *Fucking on Our Head* (1995), *Phra Siam Dewathiraj Hang Himself* (1995), and *Expressway to Nirvana* (1995), his ridicule of eroticized

patriotism is pushed to an extreme. But his videos more pointedly mock the idea that Thai values are exploited by the elite to gain power and control. One video depicts nationalistic "prick heads" raping the map of Thailand from all sides.[28] Here, the sadistic machoism that epitomizes the Thai male yearning for maternal/pampered affection is shown in the act of loving/raping the land/mother (wound/womanhood), the Thai nation. Despite the announced desire to protect her from external threats, she is fetishized as an empty hole, ever ready to satisfy all kinds of lust.

Until recently, installation, performance, conceptual, and site-specific art have been characterized as Western influences that might degrade the purity of Thainess. Artists who practice these art forms are often dismissed as too experimental or are erroneously linked to political and dissident art. Moreover, their use of ephemeral materials often means that their works are rejected as impractical to exhibit or collect. Ironically, the number of Thai artists doing installation works is rapidly increasing, with several now receiving the international recognition they deserve. Contacts with their counterparts in Southeast Asia, Japan, and Australia have given these artists fresh impetus to regard installation as means to express identity and indigenousness.[29] Although installation is still seen as an art practice imported from Europe and America, Thai artists have drawn inspiration for their site-specific installations from local rituals, practices, and spaces, including temples, cemeteries, markets, and villages. Indigenous materials, such as ash, herbs, jasmine, soil, bamboo, ceramics, and clay, have also been selected as signifiers of site-specificity and the issue of what is Thai and what is not Thai.

By commenting on the crisis of Thainess, many installation artists hope that their works will motivate viewers to redefine fixed values and stereotypes. Instead of blindly condemning Western culture as the cause of the decline of morals and spiritual faith, these Thai artists question the necessity of conforming to dogmatic beliefs in an age of globalization and technology. By pursuing the theme of Thainess in transition, they draw the audience into a specific space where the issues around identity and location can be considered. Installation art, which was previously used mainly to subvert institutional art, is now central to this project because it signifies both Thainess and internationalism. Although not all installations are successful, the most fascinating integration occurs when artists highlight tensions between the opposing views. Often new and older images are redefined and reworked in hybrid forms. Quotidian objects, such as candles, clay, or alms bowls arranged in the form of a pagoda or stupa, become signifiers of the superstitious nature of beliefs in life after death, spiritual myths, and the necessity of merit-making ceremonies.[30]

Montien Boonma, whose installations are deeply involved in meditation, confrontation with death, and faith in Buddhism, allows his evocative works to precipitate various associations. He invites viewers to contemplate the layers of allusion and interpretation contained in the symbols he chooses from local ceremonies and rituals. For Boonma, the experience of art is quite similar to meditation: a confrontation with emptiness and nothingness within a specific space approaches the sensuality of death.[31] Boonma's site-specific works in canals, temples, gardens, or other enclosed spaces have aroused international attention. Although he stresses that his work is not Buddhist art (*Buddha silpa*), Boonma's use of Thai consciousness in shaping his installations serves the need for the construction of national imaginaries in the context of international art events, like biennials and triennials.

In a slightly different way, the young artists in Chiang Mai, who sought to transform the ancient city into an open arena of installations, have added new dimensions to the concepts of identity and locality. Instead of creating nostalgic images of Lanna as commodities for the capitalist market economy, the artists who instigated the Chiang Mai Social Installation try to induce "social consciousness," in which everyone has the potential to be a cultural producer.[32] As in an international contemporary temple fair, artists and theorists with different cultural opinions are invited to participate. They address key

issues related to Thainess, such as the rise of Buddhism-Socialism; the Buddhist attitude in contemporary society; and the pervasive problems of prostitution, drugs, crime, and mental illness. Installations at various cultural landmarks, temples, and cemeteries bring viewers into situations where traditional and contemporary images are enmeshed and redefined.

The issue of the construction of images about self and Other, particularly in relation to gender, is extremely complex in Thailand. Cultural stereotyping in contemporary Thai art tends to either erase differences or safely contain them. But issues of female subjectivity at the periphery have recently begun to emerge through works by some women artists.[33] There are many Thai female artists whose works depict feminine subjects, such as sisterhood, womanhood, or motherhood. However, in the phallocentric Thai society, they are generally forced to play the role of passive, sweet, submissive, subservient, second-sex participants in the hierarchical-bureaucratic-patriarchal framework. The male-biased committees of jurors in art contests tend to regard such stereotypical works by women artists as perfunctory and hardly capable of matching the great achievements of the male artists. This narrow-minded view has created a situation where images related to femininity or femaleness are used only to compliment the "aura" of male artworks.

Yet, in some art competitions, such as those that celebrate the birthday cycles of Queen Sirikit, Princess Mother, and Crown Princess Sirindhon, the subjects of womanliness and motherhood are promoted as a means to express nationalism. Admiration for these members of the royal family is equated with love for the Motherland of Thailand. Images of devotion to these royal ladies extends and intensifies the propensity for woman worship in the patriarchal society. (Of course, there is some irony in the fact that awards in these ostentatious events are usually dominated by male artists.) In contrast, as subjects in contemporary painting and photography, Thai women are often portrayed as sexual commodities or objects of the gaze and regarded as iniquitous or wicked. Some defenders of Thainess have even taken the extreme view that nudity is some kind of social epidemic that has spread as a result of "poisonous" Western values. As if Thai innocence had been recently contaminated by foreign influences, the Thai public expressed outrage last year over the display of images of Thai actresses and celebrities in the nude.[34]

Video karaoke is very popular now, with female singers crooning popular folk songs about the hardship of Thai peasants or lip-synching harvesting melodies; they dance innocently to the tune. These videos would fit with the general promotion of Thai womanhood and nationalism except for the fact that as these female vocalists dance jovially in the green rice fields they wear nothing. Few Thai female artists convey the message of degradation and discrimination of women in their work. Domestic violence, forced labor, gender discrimination, and prostitution are some of the topics recently explored by women artists such as Araya Rasdjarmrearnsook and a group called Hers. However, in a society where there is so much violence against the female body, there has been surprisingly little critical response to this situation in contemporary art.

The imaginary enclosure that constitutes the national boundary serves to contain the fictitious Thainess that simultaneously endures and invents the values of the "national self." When these values are intensified, "national others" become less significant. Terms like "Third World," "NIC," "Southeast Asia," "Asia Pacific," Europe," and "America" have relevance only in the context of the Thai national community, defined and protected by a celestial realm of sacred deities. The pendulum swings constantly between Thai and non-Thai, depending on the obsession and infatuation of the We-self that is refracted through artworks, revealing a complex series of perspectives on nationalism, patriotism, identity, and Thainess.

Notes

1. For a discussion on national identity and Thainess, see David Wyatt, *Thailand: A Short History* (New Haven and London: Yale University Press, 1982), pp. 223–42; Sulak Sivaraksa, *Siam in Crisis* (Bangkok: Thai Inter-Religious Commission for Development, 1990), pp. 175–87, 298–99; Craig Reynolds, ed., *National Identity and Its Defenders: Thailand, 1939–1989* (Melbourne: Monash University, 1991), pp. 4–32; and Thongchai Winichakul, *Siam Mapped: A History of the Geo-body of a Nation* (Chiang Mai: Silkworm Books, 1994), pp. 1–6.

2. Joseph Wright, Jr., *The Balancing Act: A History of Modern Thailand* (Bangkok: Asia Books, 1991), pp. 98–104.

3. Apinan Poshyananda, *Modern Art in Thailand* (Singapore: Oxford University Press, 1992), pp. 7–9.

4. Apinan Poshyananda, *Western-Style Painting and Sculpture in the Royal Thai Court* (Bangkok: Bureau of the Royal Household, 1993), vol. 1, pp. 10–17.

5. Helen Michaelsen, "State Building and Thai Painting and Sculpture in the 1930s and 1940s," in *Modernity in Asian Art*, edited by John Clark (Sydney: Wild Peony, 1993), pp. 60–74. See also Poshyananda, *Modern Art in Thailand*, pp. 33–49.

6. Jutarat Tongpiam, "Clothes Make the Medium," *Bangkok Post* (Feb. 22, 1996): 27–28.

7. Sanitsuda Ekachai, "Sadej Pho: What Lies Behind a Cult of Worship," *Bangkok Post* (Aug. 18, 1993): 25, 31. See also Suthon Sukpisit, "Devotion and Conflict in the Statue's Shadow," *Bangkok Post* (Feb. 2, 1993): 23.

8. Sanitsuda Ekachai, "A Country Less Fit for Heroes to Live In," *Bangkok Post* (Mar. 17, 1993): 31. This reports that in a lecture by Nithi Iawsriwongse, "Heroes in Thai Culture," he said, "Cultural heroes are those who have introduced new social patterns or innovations which benefit people of later times…They are essentially the personifications of ideals. They will be honoured as long as their actions are still perceived as beneficial. Once they stop being relevant they will fall off the stage."

9. John Naisbitt, "The Marketing of Buddhism," in *Megatrends Asia: The Eight Asian Megatrends That Are Changing the World* (London: Nicholas Brealey Publishing, 1995), pp. 101–02.

10. After a lengthy investigation, Yantra Ammaro Bikkhu was defrocked in 1995. While awaiting further charges, he disappeared. It is believed that he is living in the United States. See "Raingam phiset" [Special Report], *Matichon Weekly* 15, no. 757 (Feb. 24, 1995): 13–15.

11. Phawana Bhutho was defrocked and is in jail for child abuse and other charges.

12. On "unity in diversity" in relation to Asian and non-aligned countries, see Apinan Poshyananda, "A Frame Works? Non-Aligned, Non-Alien Ping Pong," in "Unity in Diversity in International Art," Jakarta, Apr. 29–30, 1995, seminar papers.

13. For more on the creation of We-Self vs. Others and the borders of Thainess, see Winichakul, *Siam Mapped*, pp. 164–70.

14. Silpa Bhirasri (Corrado Feroci), an Italian painter who later changed citizenship and lived in Thailand for three decades, became a benevolent figure in modern Thai art. As the father not only of modern Thai art but also of the fine art institution Silpakorn University, the spirit of Silpa Bhirasri is still very potent. In 1995, angry Silpakorn students and art teachers demonstrated against the cover illustration of the weekly newspaper *Phu Jatkan* (Manager), which showed a statue of Bhirasri with a sign marked "Sale 50%" below it. Such father worship of the Bhirasri icon demonstrates the level of obsession with cultural heroes in Thailand.

15. Piriya Krairiksh, *Art in Thailand Since 1932* (Bangkok: Thammasat University, 1982), p. 74.

16. Apinan Poshyananda, "Thai MODERNism to (post?) modernISM, 1970s and 1980s (Seeing "Yellow" from a Thai Perspective)," in Clark, ed., *Modernity in Asian Art*, pp. 222–36.

17. CON-tempus, the Bangkok Fine Art Center, *Thai Art Exhibition* (Bangkok: Amarin Printing and Publishing, 1995), pp. 4–6. Herbert Phillips, "The Education of Thai Artists," in *The Integrative Art of Modern Thailand* (Berkeley: University of California Press, 1992), pp. 35–42. See also Ahmad Mashadi, "Brief Notes on Traditionalism in Modern Thai Art," in T.K. Sabapathy, ed., *Modernity and Beyond: Themes in Southeast Asian Art* (Singapore: National Heritage Board, 1996), pp. 61–68; and Somporn Rodboon, "History of Modern Art in Thailand," in *Asian Modernism: Diverse Development in Indonesia, the Philippines, and Thailand* (Tokyo: Japan Foundation, 1995), pp. 243–51.

18. Ian Buruma, *God's Dust: A Modern Asian Journey* (London: Vintage, 1991), pp. 25–32.

19. See numerous examples in the catalogue for the "Thai Art Exhibition" and in *Bualuang Paintings* (Bangkok: Bangkok Bank, 1996). Apart from figurative painting inspired by temple murals and manuscripts, abstract forms are experimented with in combinations of decorative spiral and flame-like *kanok* patterns. Examples of abstract Buddhist paintings are by Pichai Nirand, Chalood Nimsamer, Thongchai Srisukprasert, Jantana Jamtim, Apichai Piromrak, and Komkrit Sawatdirom.

20. King Bhumibol Adulyadej, *The Story of Mahajanaka* (Bangkok: Amarin Printing and Publishing, 1996). The King discussed the themes and content of the illustrations with the artists who worked on the book. These neo-Buddhist images show explicitly how fictional space is imagined to arouse readers to be captivated within the enclosures of spiritualism and patriotism.

21. Wat Buddhapadipa Foundation, *The Mural Paintings of Wat Buddhapadipa* (Bangkok: Amarin Printing and Publishing, 1987). For discussion of Chalermchai Kositpipat and Panya Vijinthanasarn, see John Hoskin, "A Question of Attitude," *Art and Asia Pacific* 3, no. 3 (1995): 42–49.

22. Panya Vijinthanasarn, interview by author, Bangkok, Sept. 1, 1995. Vijinthanasarn and a team of ten artists decorated the murals in the lobby for nearly two years. They were paid approximately 8.5 million baht.

23. The promotion of the homogenous brotherhood of Lanna artists reached a climax at the 1994 exhibition "Ha Salaa Lanna" (Five Northern Artists), when it was seen as a transparent means of exploiting local culture ("Lanna-ness") for commercial gain. See Khetsirin Knithichan, "The Artful Protester," *Nation* (Dec. 17, 1994): C1–2; and Apinan Poshyananda, "Smile-a-While Campaigns for Cultural Correctness," *Art and Asia Pacific* 3, no. 3 (1995): 34–41.

24. See the following catalogues of painting contests: *Thai Farmers Bank Painting Competition in the Celebrations for the Auspicious Occasion of H.M. the King's Sixtieth Birthday Anniversary* (Bangkok: Thai Farmers Bank, 1987); *Thai Farmers Bank's Art Contest in the Celebration Marking the Auspicious Occasion of the Thirty-Sixth Birthday of H.R.H. Princess Maha Chakri Sirindhorn* (Bangkok: Thai Farmers Bank, 1991); *Exhibition of Paintings in Honour of H.M. Queen Sirikit's 60th Anniversary* (Bangkok: Amarin Printing and Publishing, 1992); *Thai Farmers Bank Painting Competition in the Celebrations for the Auspicious Occasion of H.M. Queen Sirikit's 60th Anniversary* (Bangkok: Amarin Printing and Publishing, 1992); *Art Exhibition to Celebrate the Golden Jubilee of His Majesty's Accession to the Throne* (Bangkok: Siam Commercial Bank, 1995).

25. Apinan Poshyananda, "Behind Thai Smiles," *Art and Asia Pacific* 1, no. 1 (1993): 17–24.

26. This was a performance by Surapol Panyawachira on the street near the Art Forum Gallery in Bangkok in May 1993. See Chanyaporn Chanjaraen, "Set Pieces of Bait," *Bangkok Post* (May 19, 1993): 31.

27. Sanitsuda Ekachai, "Vasan's View of Life: Hell Wherever You Turn," *Bangkok Post* (June 29, 1991): 31.

28. Vasan Sitthiket, *An Art Exhibition: No Future* (Bangkok: Sunday Gallery, 1995).

29. For a discussion of the meaning and practice of installation art, see Julie Ewington, "Five Elements: An Abbreviated Account of Installation Art in Southeast Asia," *Art and Asia Pacific* 2, no.1 (1995): 108–15; Apinan Poshyananda, "Making Art Public in the Forest of Concrete," in *A "New Century" for City and Public Art: Faret Tachikawa Art Project* (Tokyo: Art Front Gallery, 1995), pp. 140–44; and Apinan Poshyananda, "From Hybrid Space to Alien Territory," in *TransCulture: La Biennale di Venezia 1995* (Tokyo: Japan Foundation and Fukutake Science and Culture Foundation, 1995), pp. 74–78.

30. For further discussion of installation art in Thailand, see Somporn Rodboon, "Thai Contemporary Installation," *Art Monthly* (Australia), no. 72 (August 1994): 20–21.

31. Apinan Poshyananda, "Montien Boonma," in *Orient/ation: The Vision of Art in a Paradoxical World* (Istanbul: International Istanbul Biennial, 1995), pp. 90–91.

32. See Chanyaporn Chanjaraen, "Chiang Mai Art Festival," *Art and Asia Pacific* 1, no. 4 (1994): 32–33. The third Chiang Mai Social Installation was on view from Nov. 19, 1995 to Feb. 19, 1996.

33. The best-known Thai woman artist whose work focuses on violence and gender inequality is Araya Rasdjarmrearnsook. Her installations, such as *Prostitute Room* (1994) and *Isolated Moral Female Object in Relationship with a Male Bird* (1995), concern Thai women in patriarchal society.

34. Chitraporn Vanaspong, "Ruang poh nai suemuanchon" (Nudity in the Mass Media), *Siamrat Weekly* 42, no. 16 (1995): 15–20.

ARTISTS' WORKS

Nindityo Adipurnomo

Arahmaiani

Agnes Arellano

I Wayan Bendi

Montien Boonma

Imelda Cajipe-Endaya

Cho *Duck Hyun*

Choi *Jeong-Hwa*

Dadang Christanto

Heri Dono

Sheela Gowda

FX Harsono

Bhupen Khakhar

Kim *Ho-Suk*

Soo-Ja Kim

Nalini Malani

Kamol Phaosavasdi

Chatchai Puipia

Araya Rasdjarmrearnsook

Navin Rawanchaikul

Reamillo & Juliet

Ravinder G. Reddy

N. N. Rimzon

Sanggawa Group

Arpita Singh

Jakapan Vilasineekul

Yun *Suknam*

Nindityo Adipurnomo

Indonesia

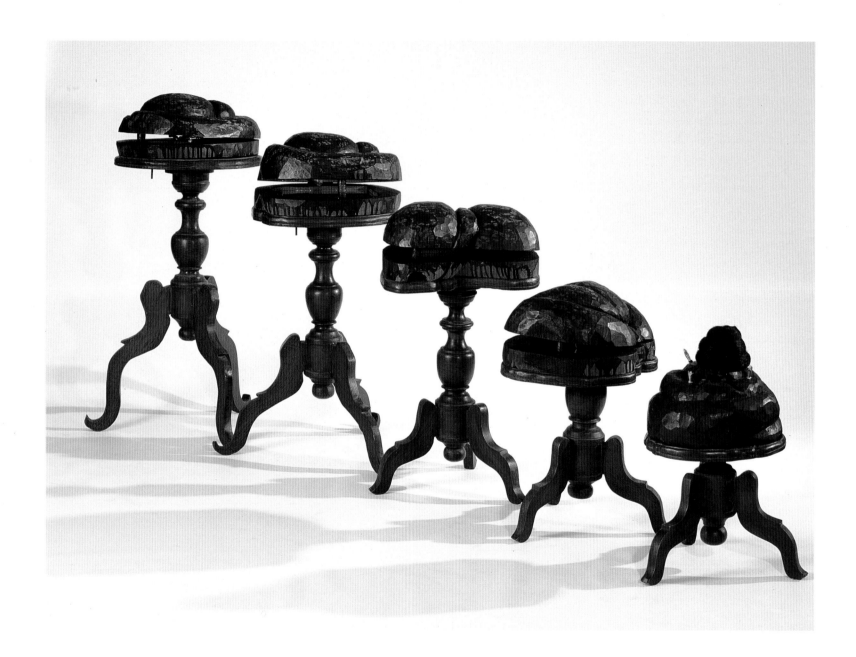

Beban Eksotika Jawa
(The Burden of Javanese Exotica), 1993
Wood, photographs, jewelry, and mirrors
120 × 400 × 50 cm (47¼ × 157½ × 19⅝ in.)
Singapore Art Museum

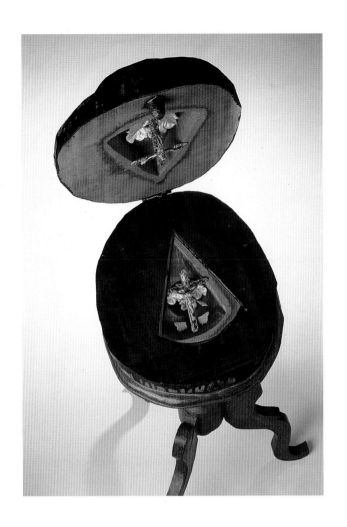

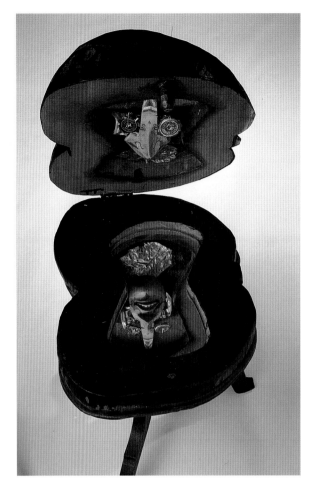

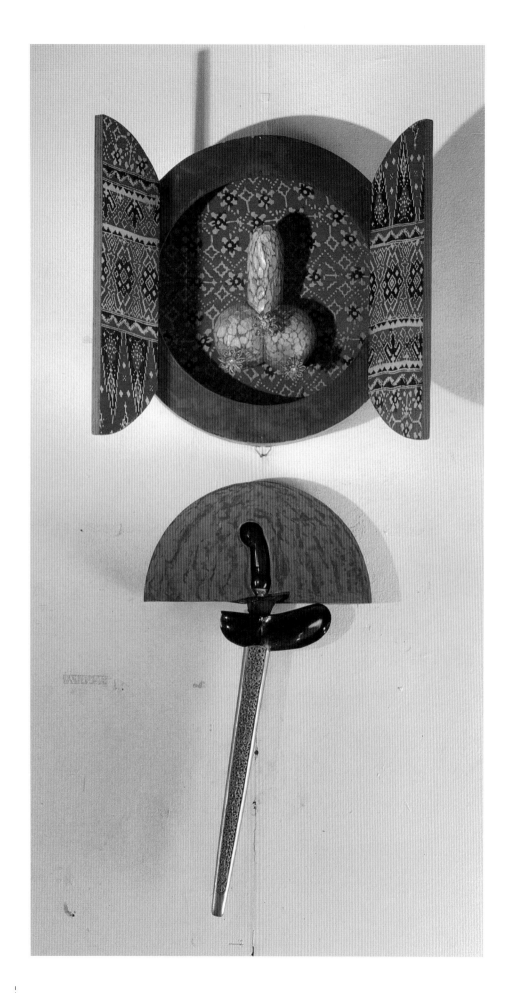

Nindityo Adipurnomo

Lingga-Yoni, 1992
Oil on canvas, wood, copper, cloth,
and *kris* (Javanese dagger)
80 × 50 × 40 cm (31½ × 19⅝ × 15¾ in.)
Collection of John H. McGlynn

Arahmaiani

Indonesia

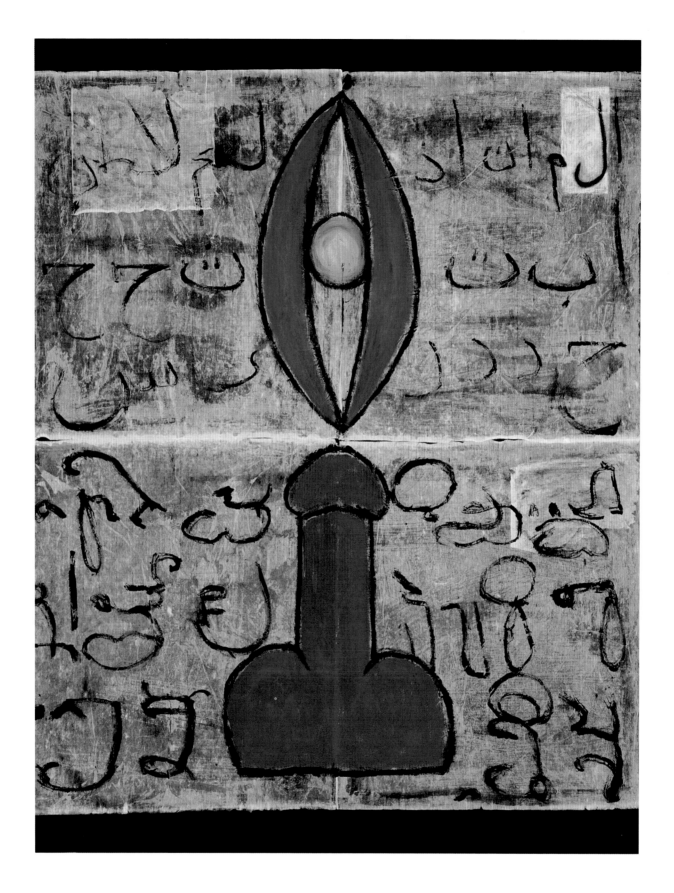

Lingga-Yoni, 1994
Acrylic on canvas
182 × 140 cm (71⅝ × 55⅛ in.)
Courtesy of the artist

texts on painting:
"Nature is Book"
(Indonesian language, Malay-Arabic script)

"Courageous, honest in fulfilling his duty,
leader of mankind, his excellency
Purnawarman"
(Sanskrit language, Palawa script)

Etalase, 1994
Display case containing photograph, icon,
Coca-Cola bottle, Al-Qur'an, fan, Patkwa
mirror, drum, box of sand, and pack
of condoms
95 × 146.5 × 65.5 cm (37⅜ × 57⅝ × 25¾ in.)
Courtesy of the artist

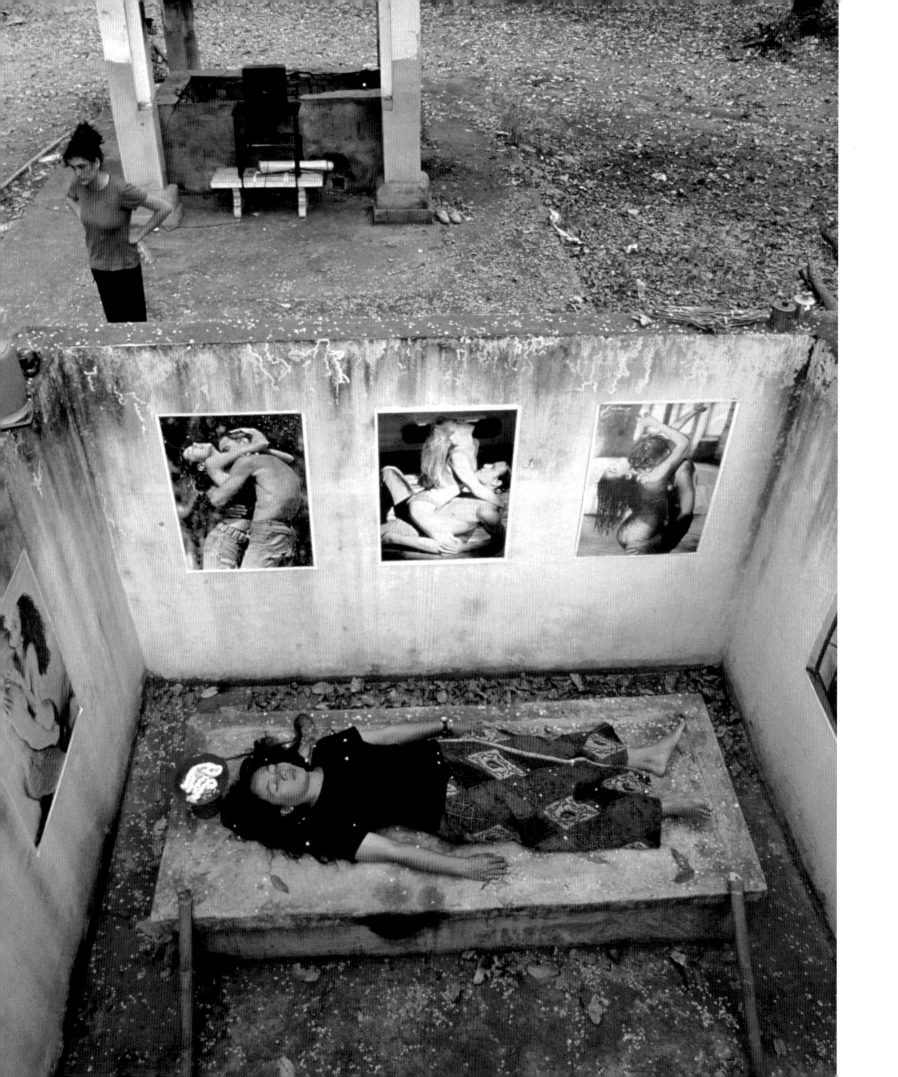

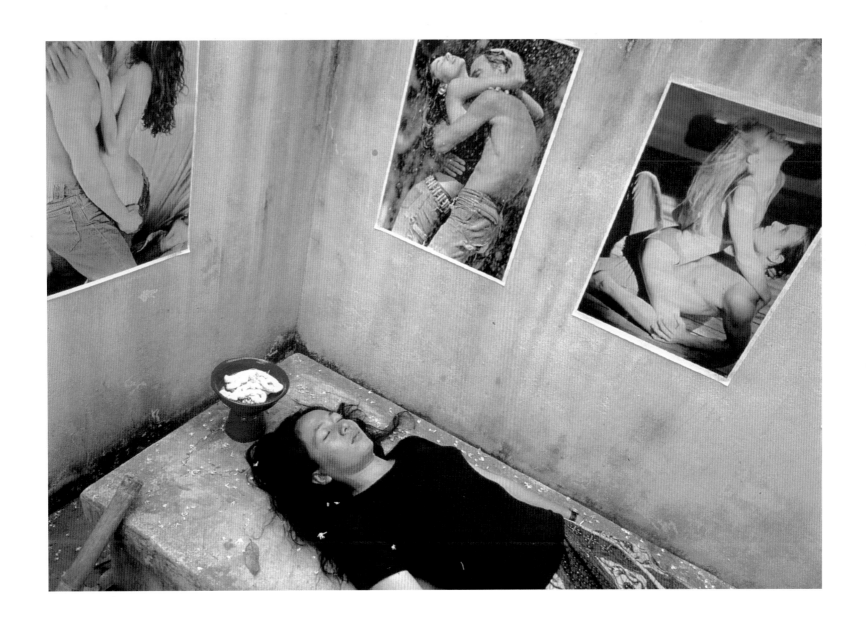

Offerings from A to Z, Part 3,
performance at Padaeng Cemetery,
Chiang Mai, Thailand, January 1996

Agnes Arellano

Philippines

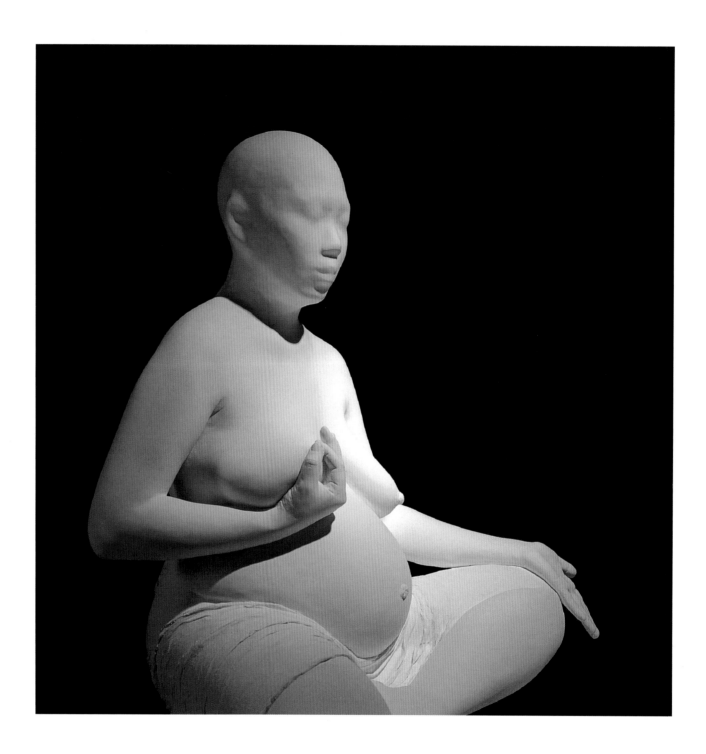

Vesta, 1995
Cold-cast marble (life cast)
138 × 72 × 91 cm (54⅜ × 28⅜ × 35⅞ in.)
Courtesy of the artist

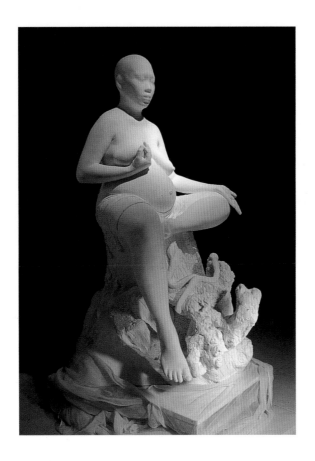

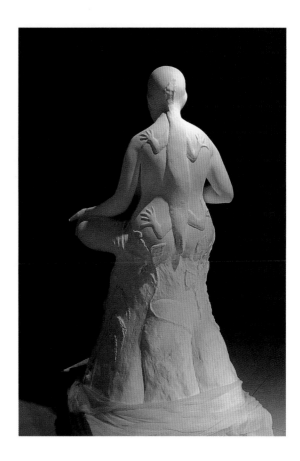

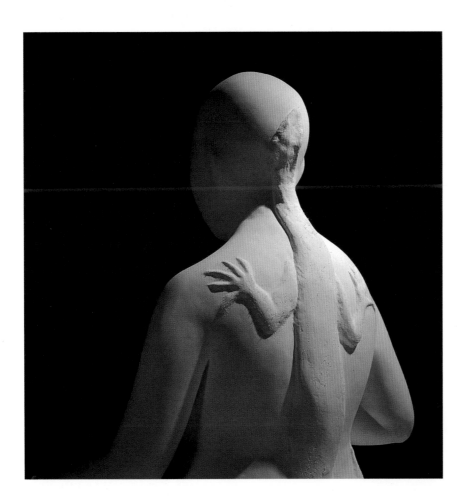

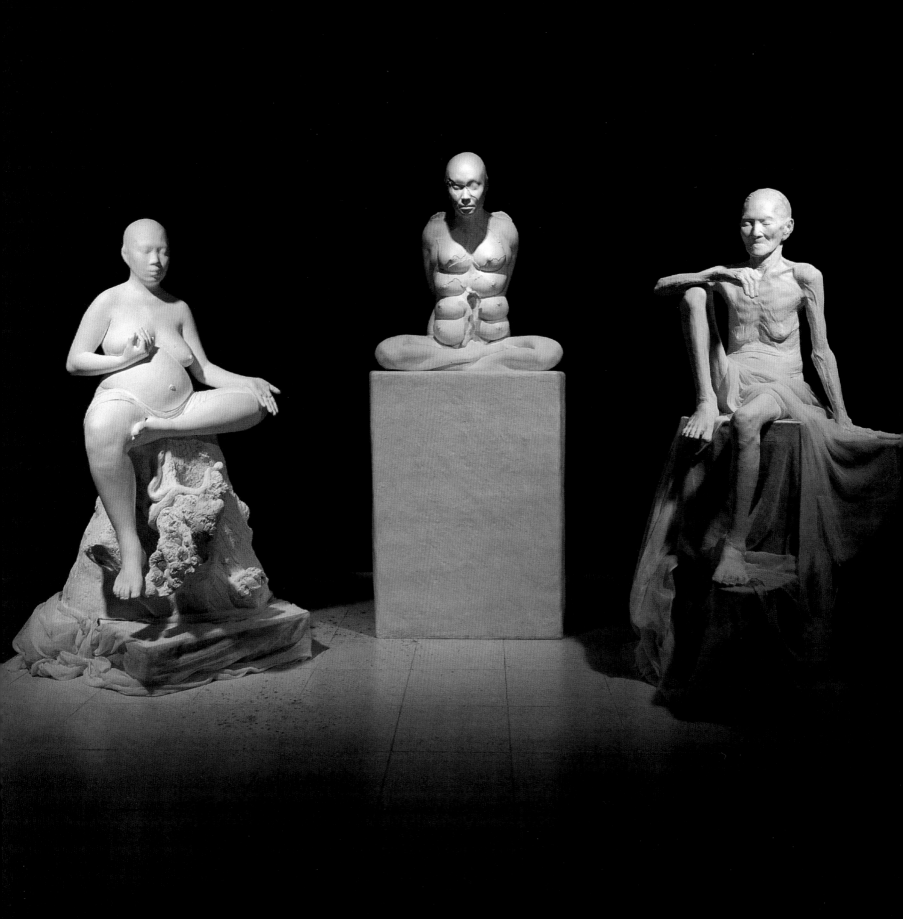

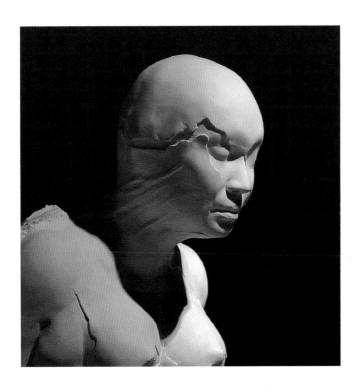

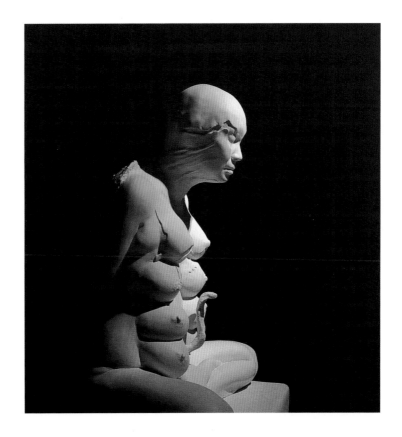

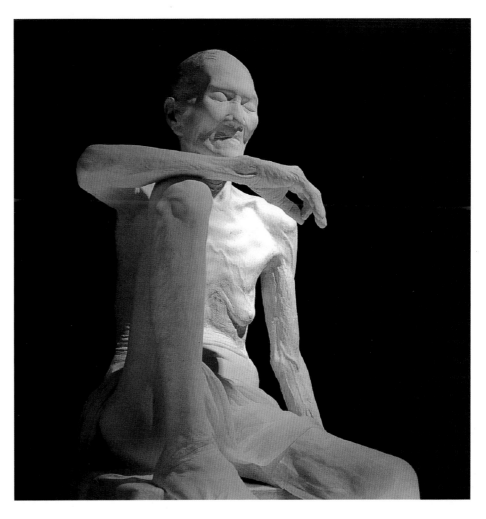

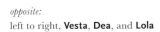

opposite:
left to right, **Vesta**, **Dea**, and **Lola**

above:
Dea, 1995
Cold-cast marble (life cast)
85 × 74 × 57 cm (33½ × 29⅛ × 22½ in.)
Courtesy of the artist

right:
Lola, 1995
Cold-cast marble (life cast)
160.5 × 84 × 77 cm (63⅛ × 33 × 30⅜ in.)
Courtesy of the artist

I Wayan Bendi

Indonesia

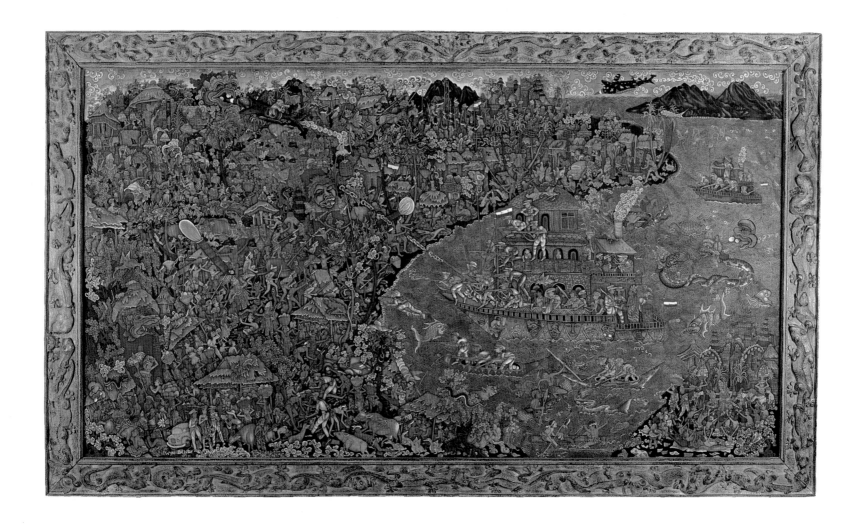

Revolution, 1991
Acrylic on canvas
146 × 266 cm (57½ × 104¾ in.), sight
Courtesy of the artist

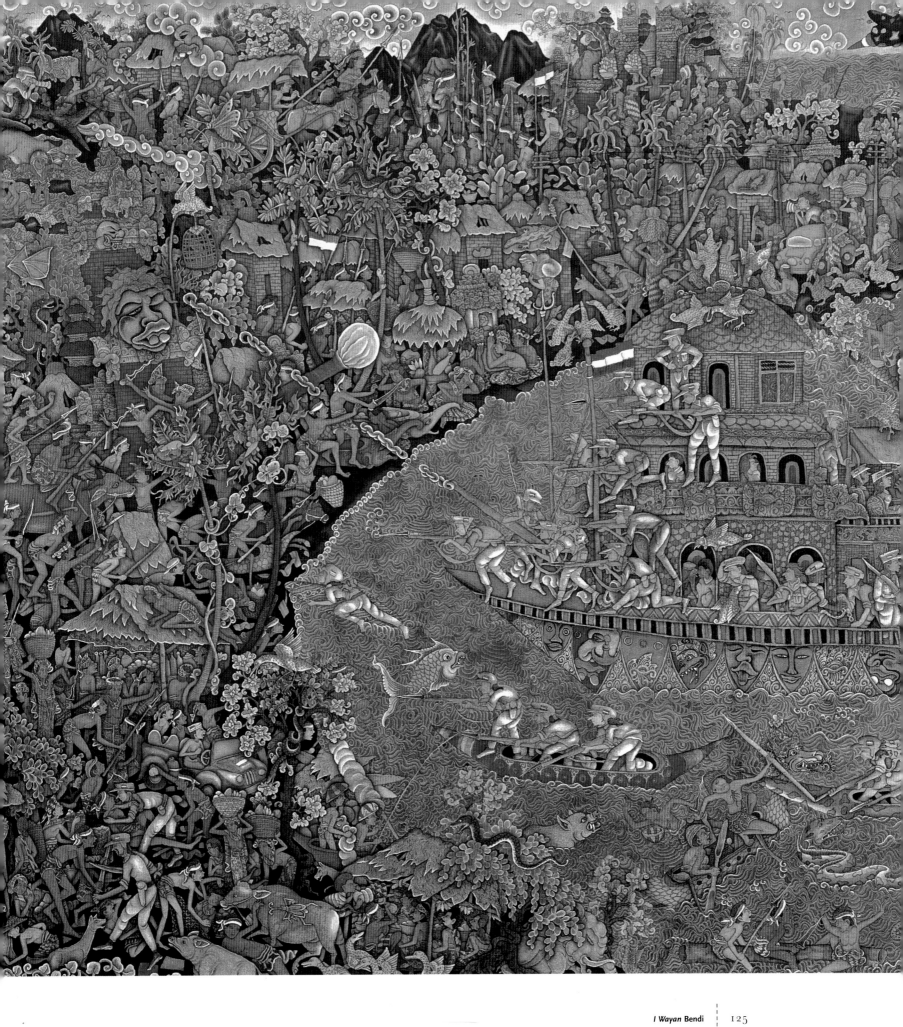

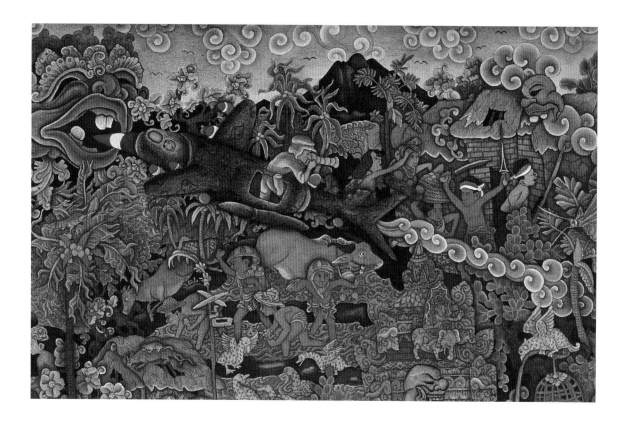

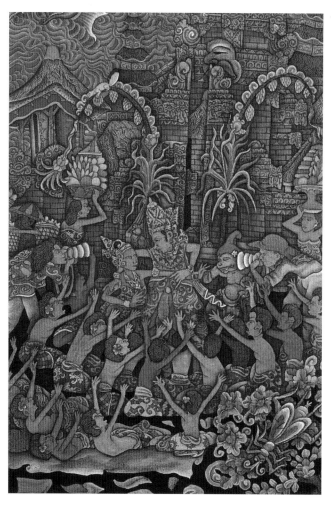

Details of **Revolution**

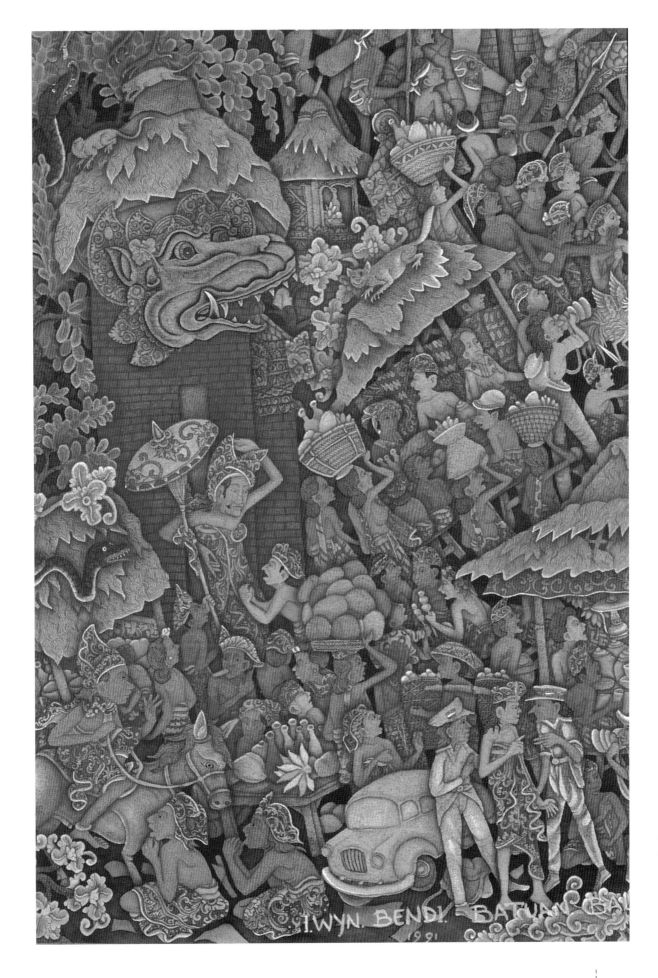

Montien Boonma

Thailand

perimeter:
Sala of the Mind, 1995–96
Steel, graphite, and tape recording
Four parts, each, 270 × 100 × 100 cm
(106 ¼ × 39 ⅜ × 39 ⅜ in.)
Courtesy of the artist

center:
Alokhayasan: Temple of Mind, 1995–96
(see pp. 130–31)

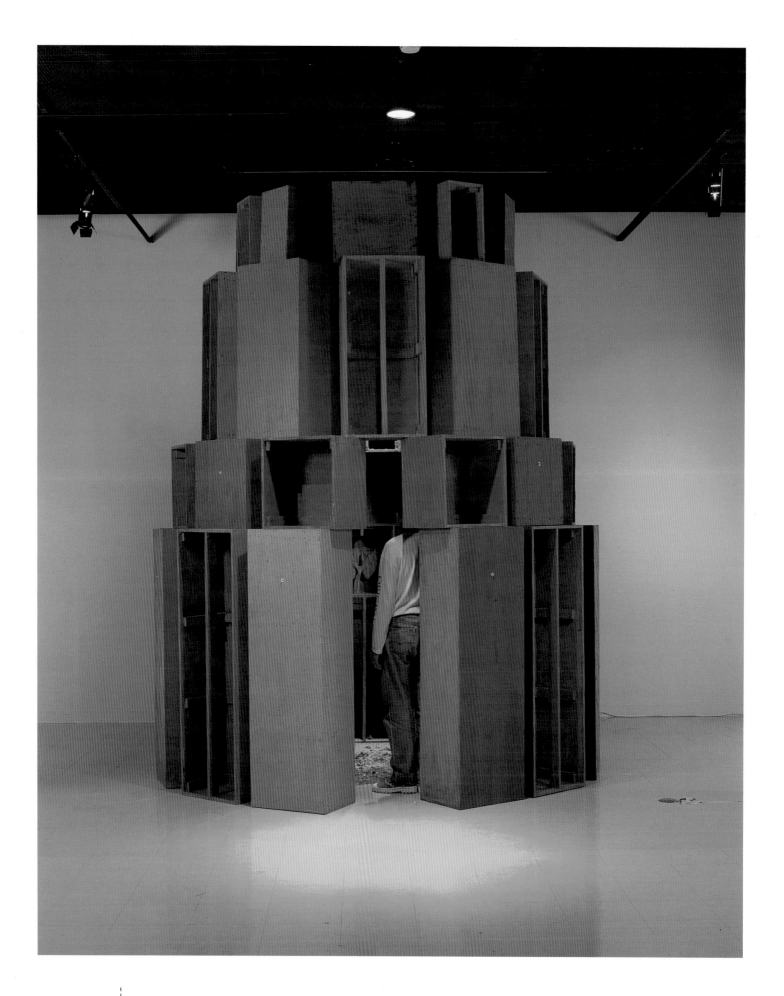

Montien Boonma

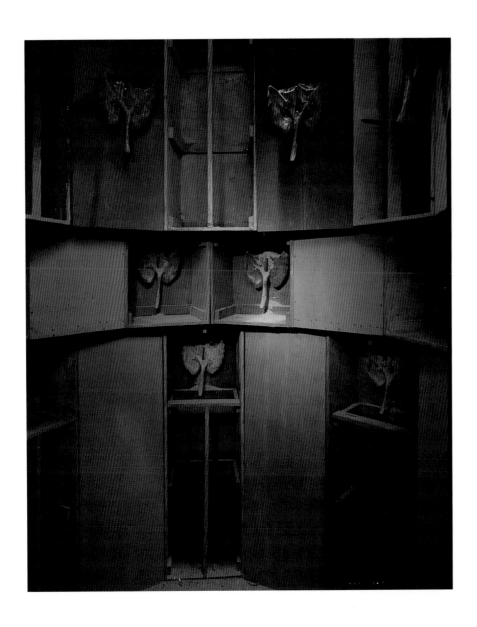

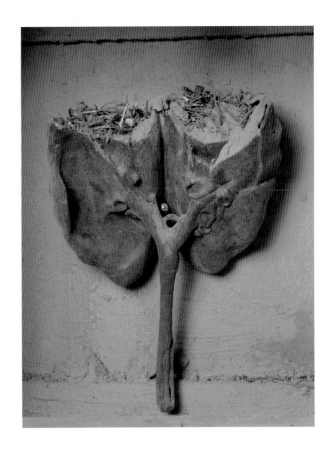

Alokhayasan: Temple of Mind, 1995–96
Installation with metal lungs, herbs, pigments,
and glue installed with herb boxes,
Chulalongkorn University, September 1995
Approx. 325 × 270 × 270 cm
(128 × 106 × 106 in.)
Courtesy of the artist

Imelda Cajipe-Endaya

Philippines

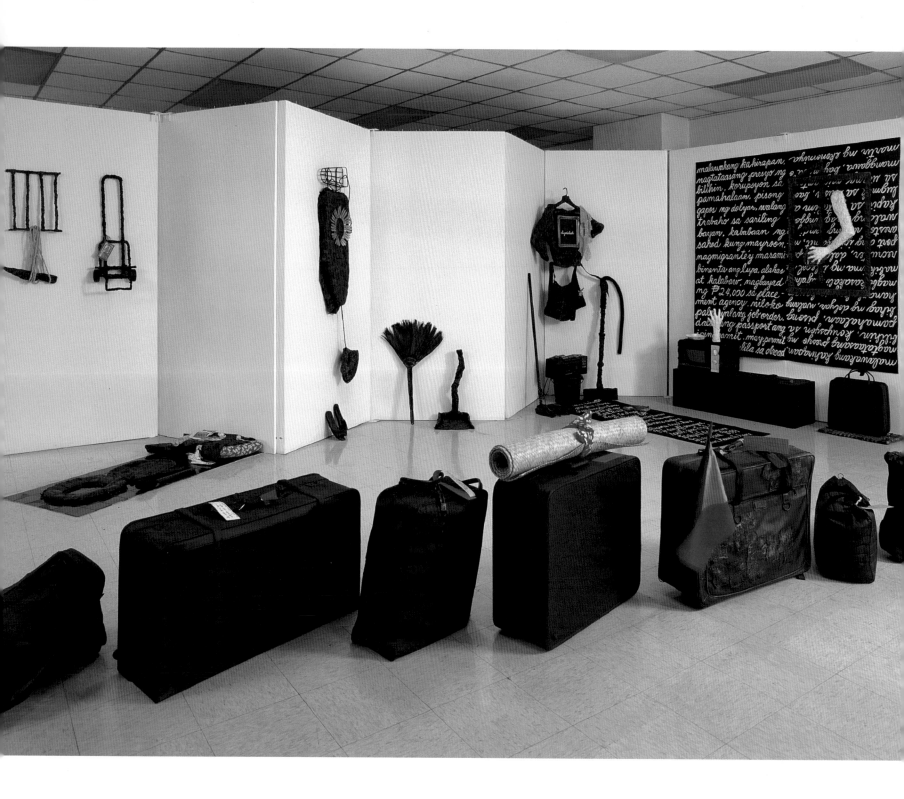

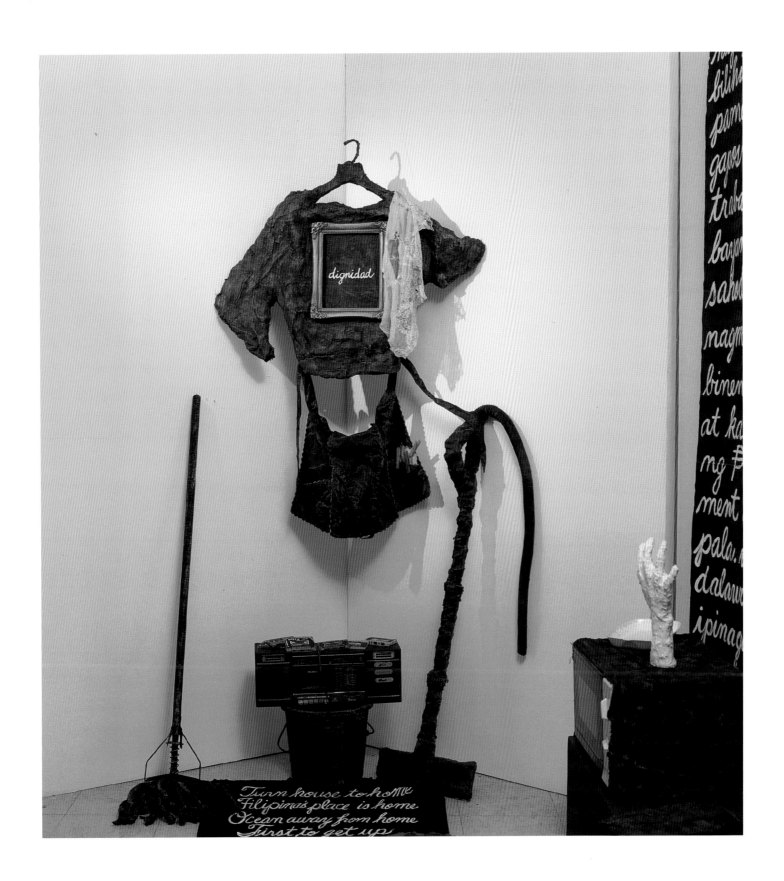

Filipina: DH, 1995
Installation with found objects, plaster-bonded
textiles, projected images, text, and sound
Approx. 300 × 500 × 300 cm (118 × 197 × 118 in.)
Courtesy of the artist

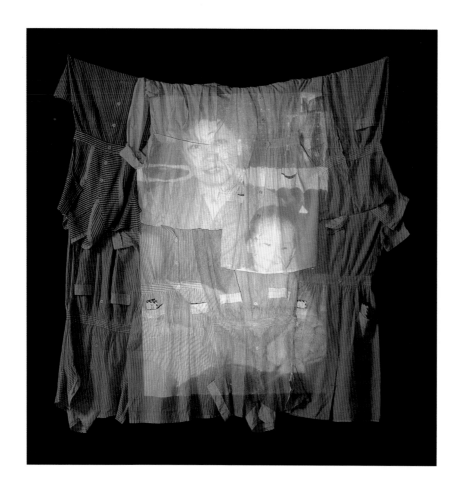

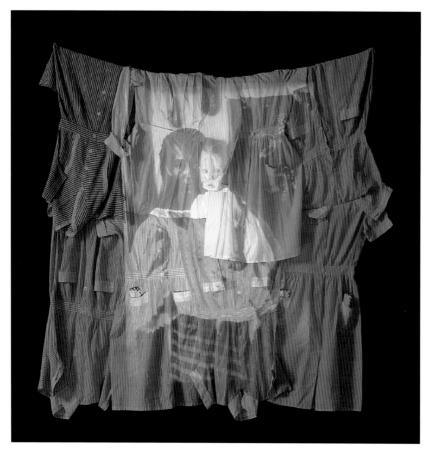

Details of **Filipina: DH**

Imelda Cajipe-Endaya

Cho *Duck Hyun*

Korea

A Memory of the Twentieth Century:
Gleg to the Uptake (details), 1993–95
Charcoal and graphite on canvas, wooden
boxes, and lights
Drawings, 160 × 160 cm and 91 × 91 cm
(63 × 63 in. and 35 ⅞ × 35 ⅞ in.)
Courtesy of the artist

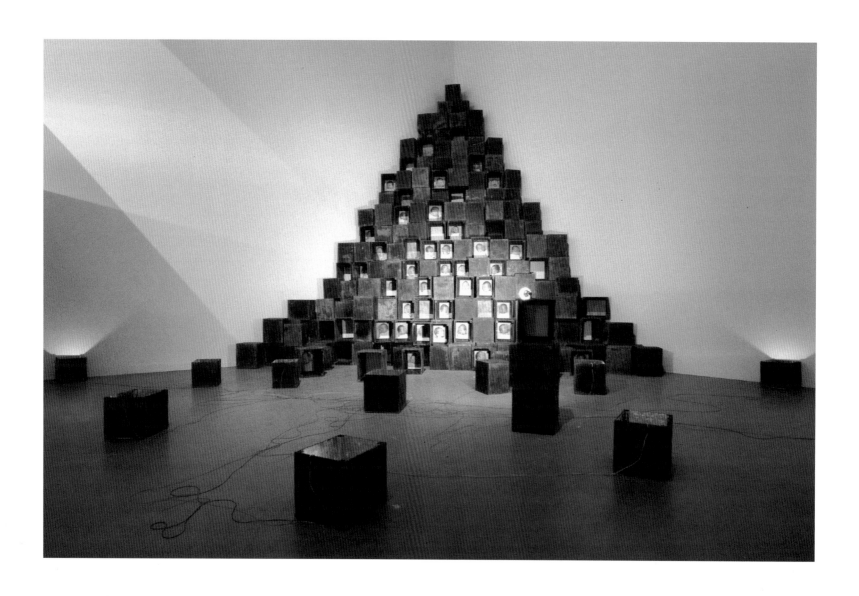

Accumulation, 1993–95, installation for the
Institute of Contemporary Art, University
of Pennsylvania, Philadelphia, 1995
Charcoal and graphite on canvas, wooden
boxes, and lights in steel structure
Approx. 838 × 838 × 243 cm
(330 × 330 × 96 in.)
Courtesy of the artist

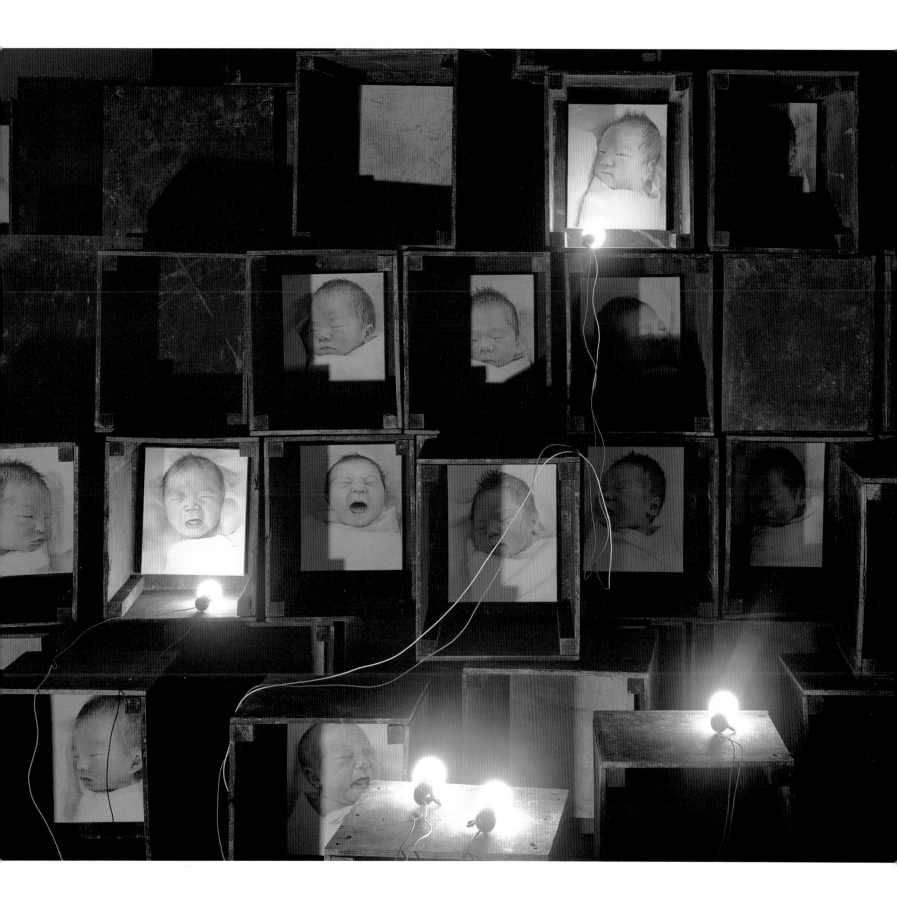

Choi *Jeong-Hwa*

Korea

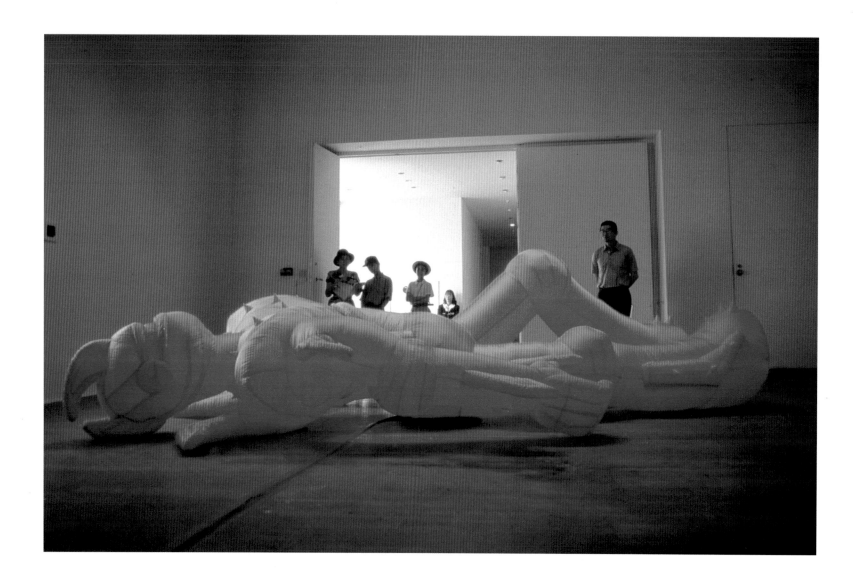

"About Being Irritated"—
The Death of a Robot, 1995
Fabric, air compressor, oil-pressure equipment,
movement timer, CD player with speakers
Approx. 700 × 200 × 500 cm
(275⅝ × 78¾ × 196⅞ in.)
Courtesy of the artist

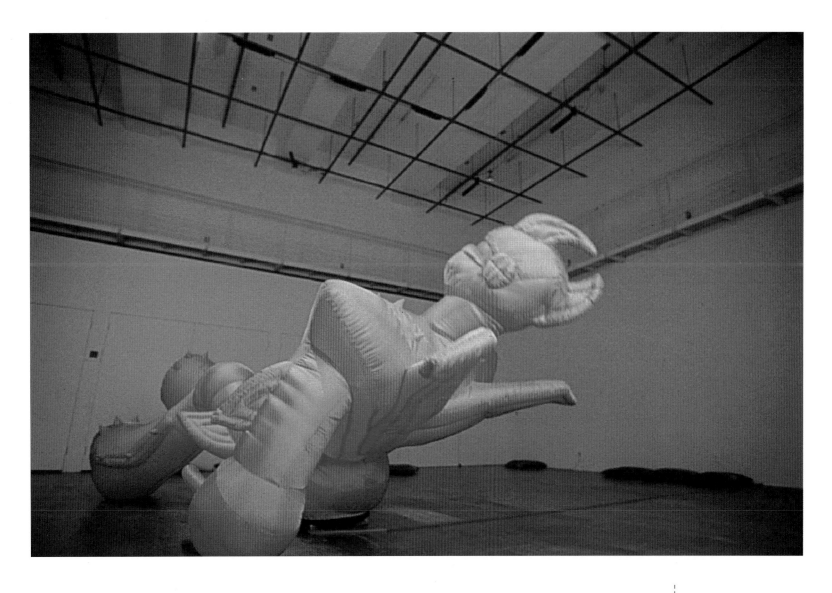

opposite:

Miss Korea, 1994, installed at
Seoul Sonje Museum site
Molded latex, lacquer table with
mother of pearl, and lights
47 × 82 × 64 cm (18½ × 32¼ × 25⅛ in.)
Courtesy of the artist

Plastic Happiness, 1995
Fabric, air compressor, wires,
movement timer, sensor
350 × 120 × 400 cm (137¾ × 47¼ × 157½ in.)
Courtesy of the artist

Dadang Christanto

Indonesia

Kekerasan I (Violence I), 1995
Terra-cotta, brick
300 × 300 × 300 cm (118⅛ × 118⅛ × 118⅛ in.)
Courtesy of the artist

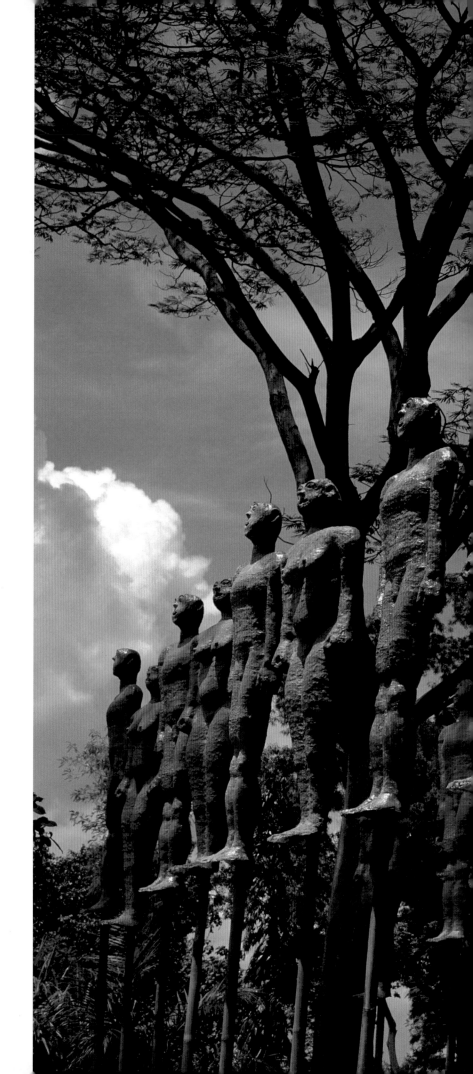

Untitled, 1995
Terra-cotta, bamboo
Height of each figure,
approx. 180 cm (71 in.)
Courtesy of the artist

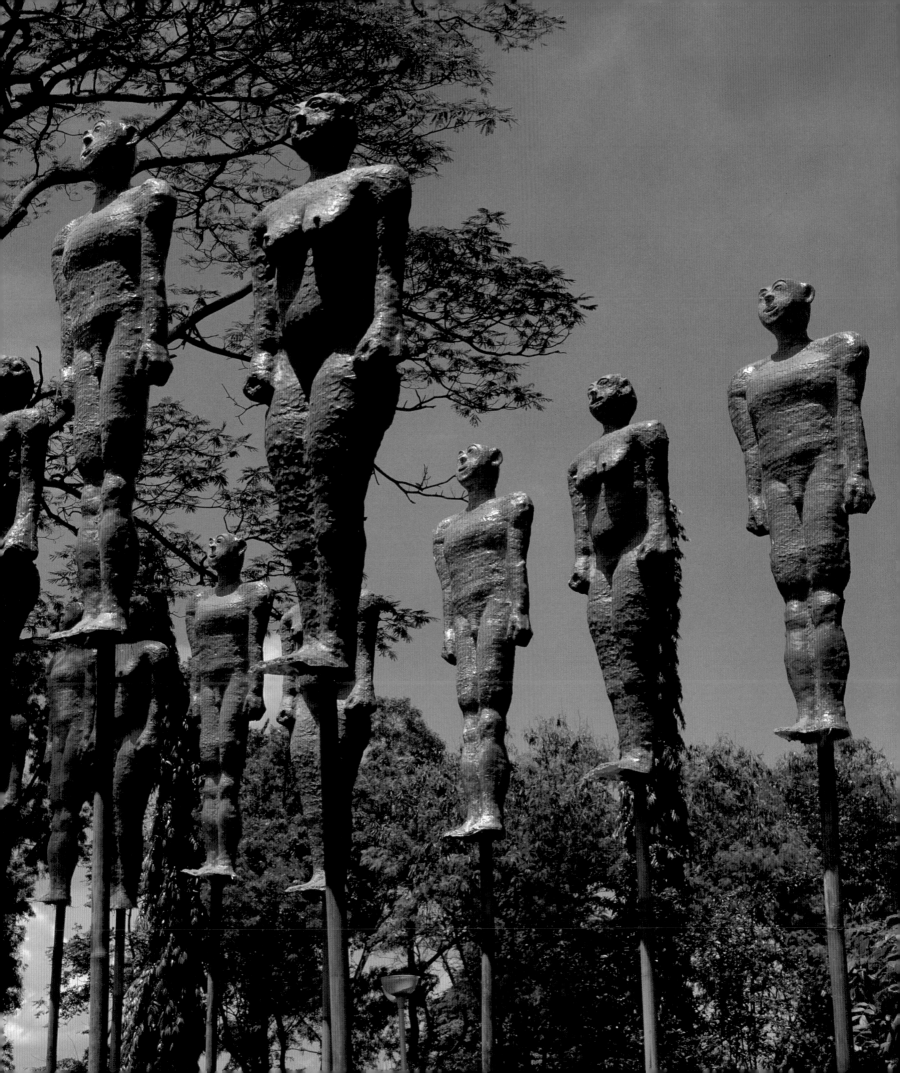

Heri Dono

Indonesia

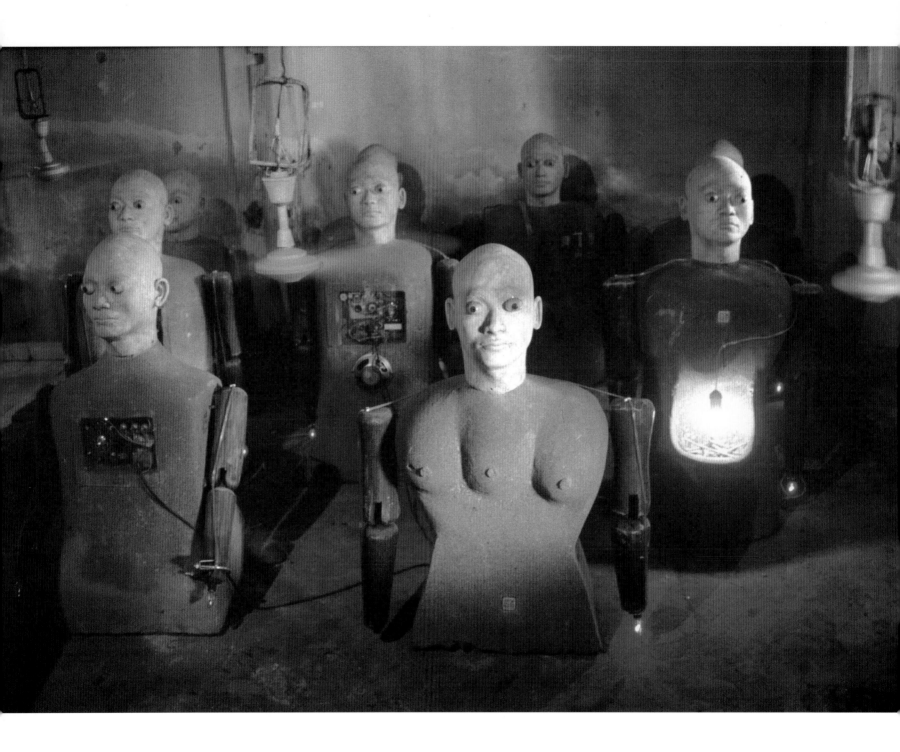

Ceremony of the Soul, 1995
Installation with stones, plastic, radios,
tape players, fans, wood, and fire
Approx. 500 × 500 × 100 cm (197 × 197 × 39 in.)
Courtesy of the artist

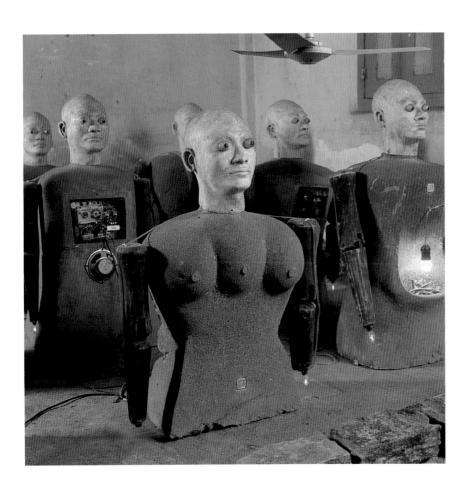

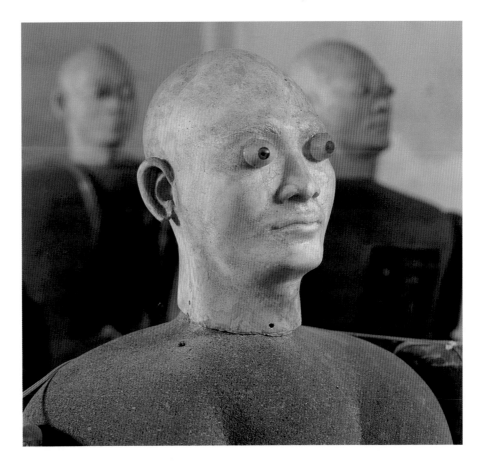

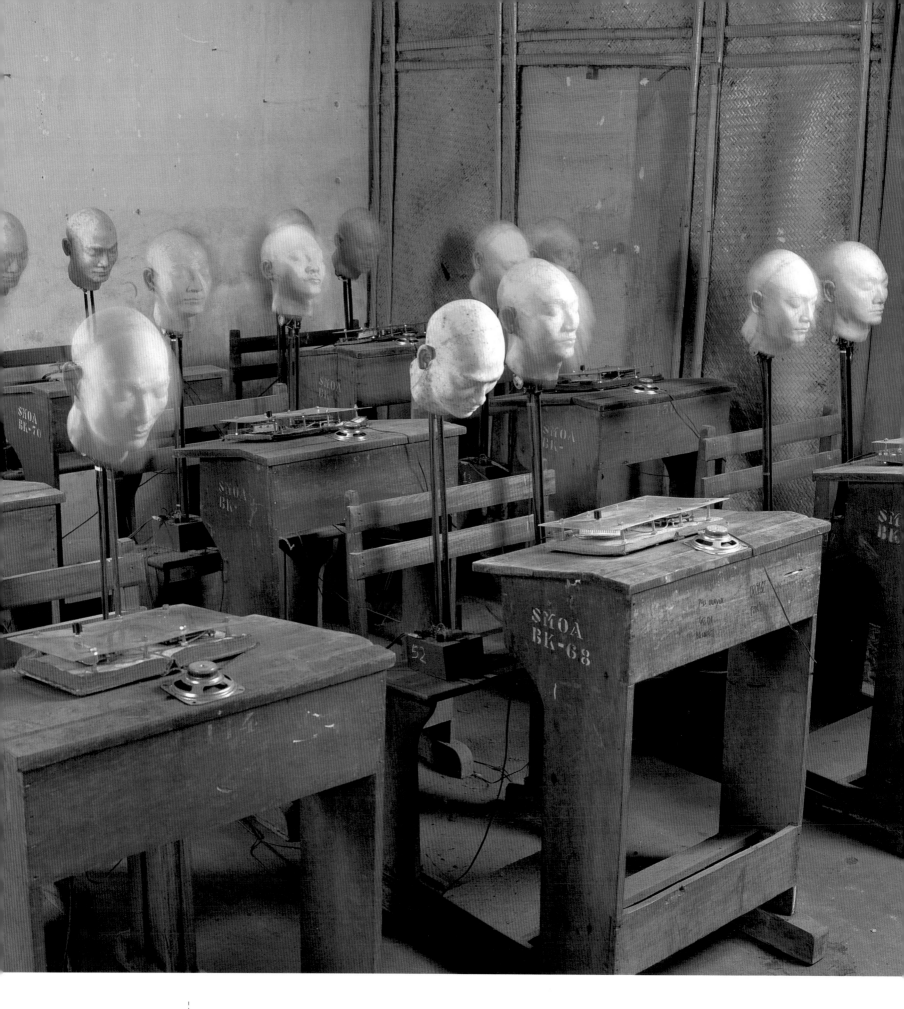

Heri Dono

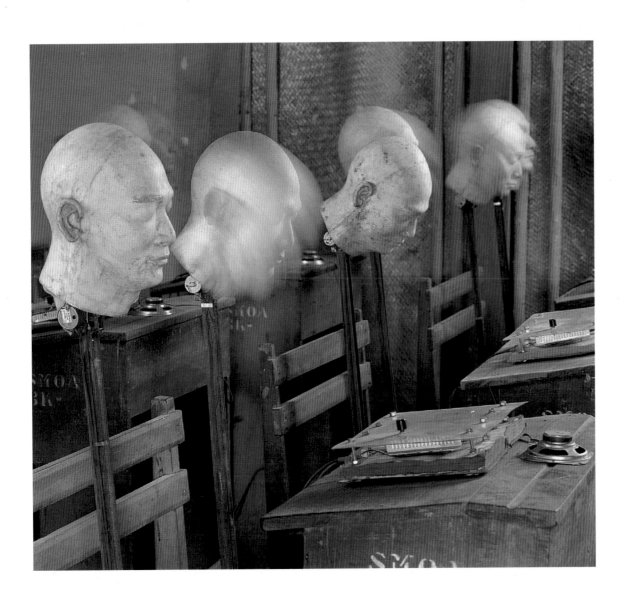

Fermentation of Mind, 1993–94
Installation with wooden school desks, books,
tape players, electronics, fiberglass, and metal
Approx. 600 × 600 × 100 cm
(236 × 236 × 39 in.)
Courtesy of the artist

Sheela Gowda

India

Work in progress, 1996
Installation with cow dung,
rangoli powder, and kum kum on paper
Dimensions variable
Courtesy of the artist

| *Sheela* Gowda

Untitled (details), 1992–93
Cow dung and gold leaf
Dimensions variable
Courtesy of the artist

FX Harsono

Indonesia

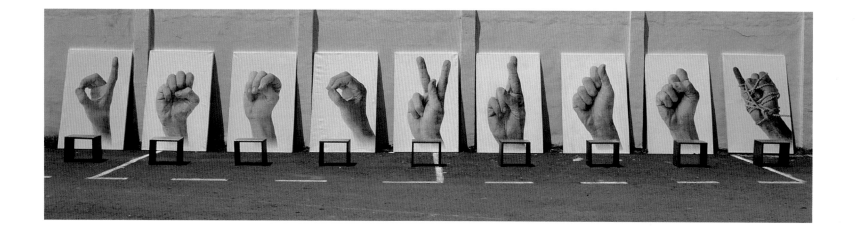

Voice Without a Voice/Sign, 1993–94
Screenprints on canvas, stools
100 × 1350 × 200 cm (39⅜ × 531½ × 78¾ in.);
each canvas, 180 × 120 cm (70⅞ × 47¼ in.)
Courtesy of the artist

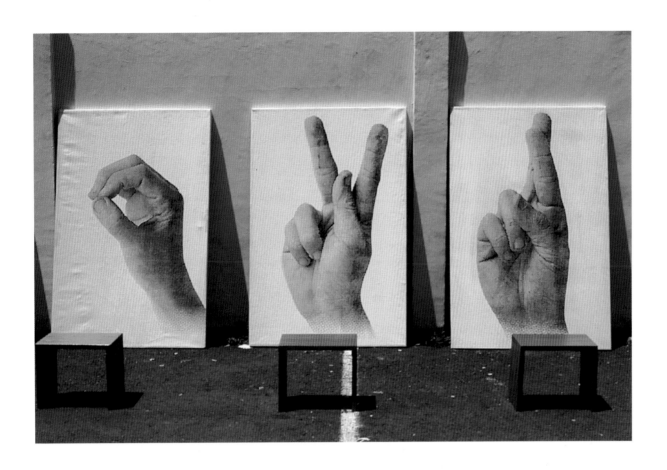

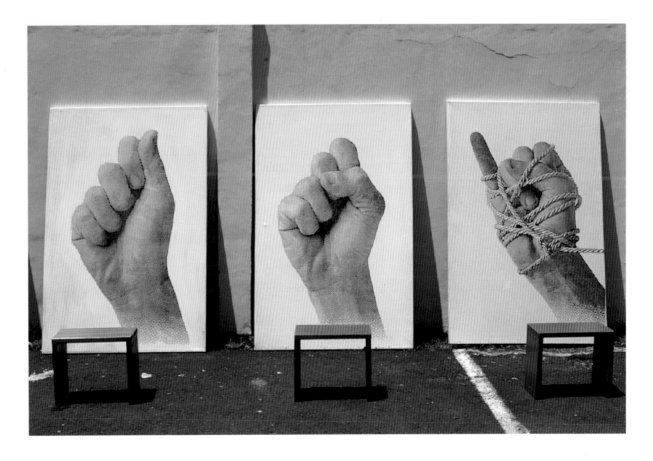

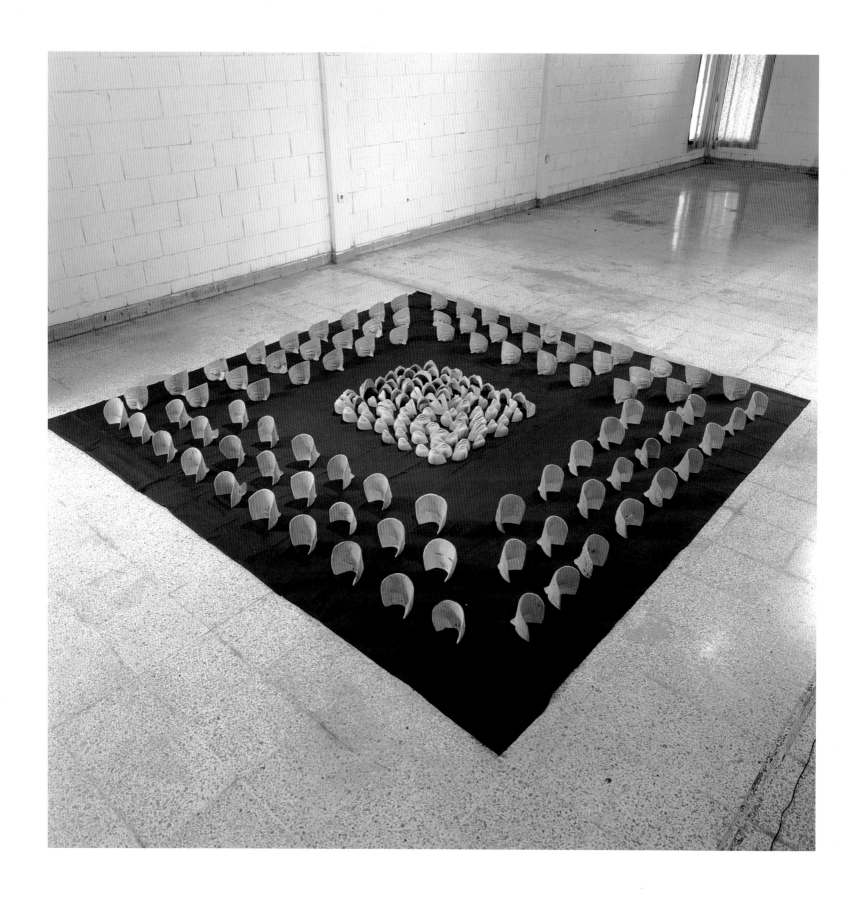

The Voices Are Controlled by the Powers, 1994
Wooden masks and cloth
30 × 350 × 350 cm (11 ⅞ × 137 ¾ × 137 ¾ in.)
Courtesy of the artist

| *FX Harsono*

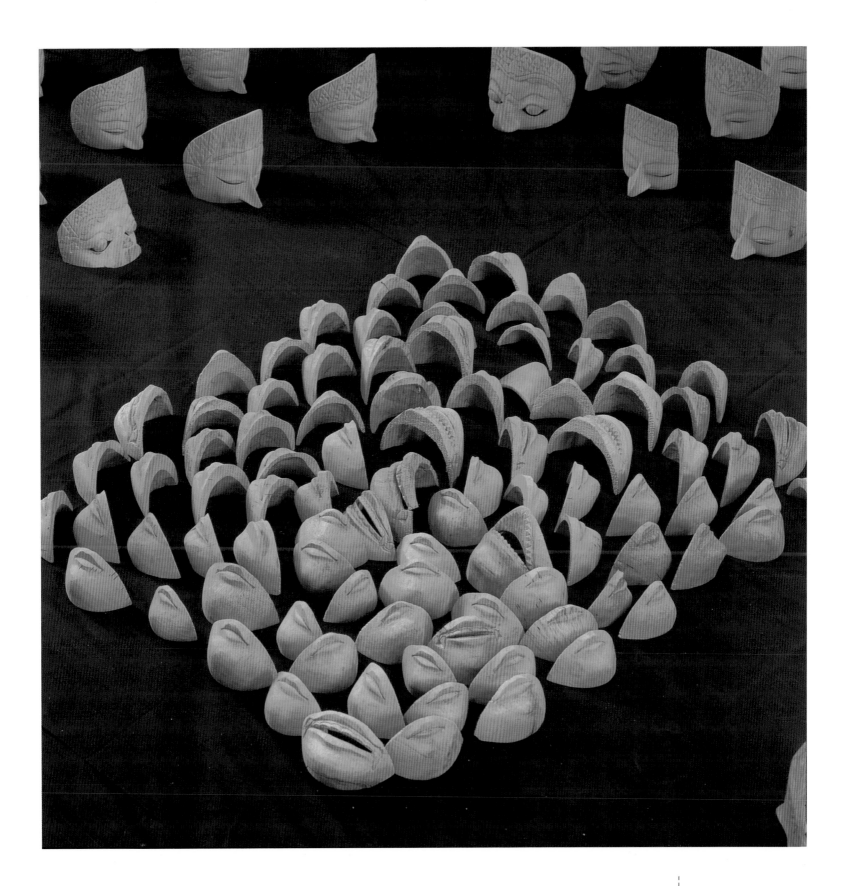

Bhupen Khakhar

India

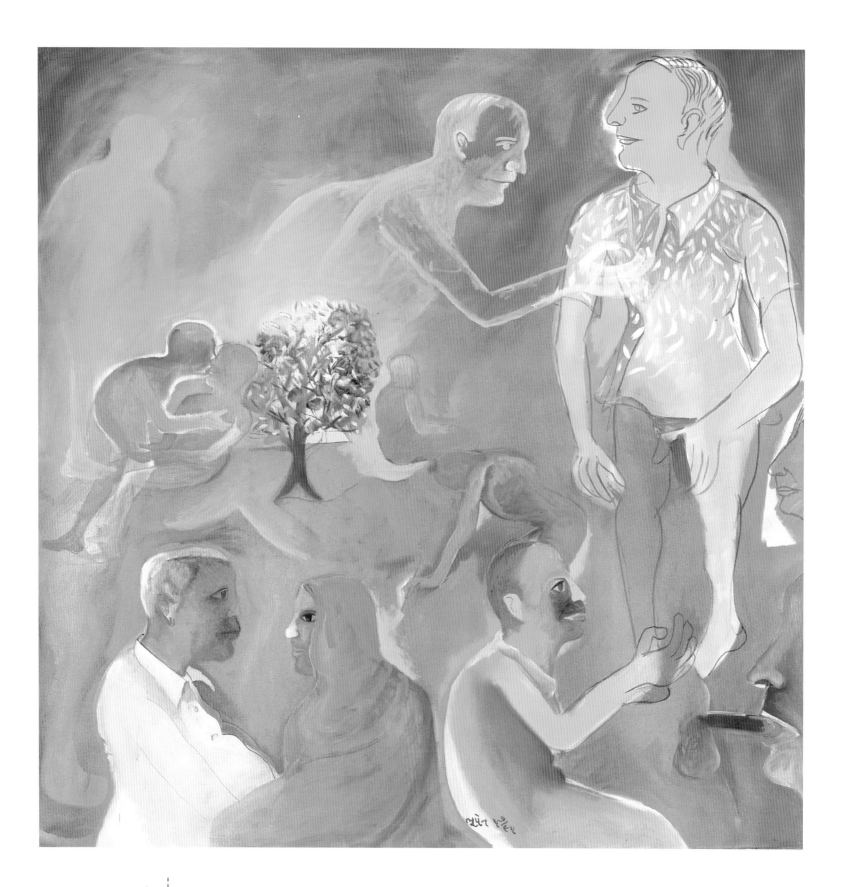

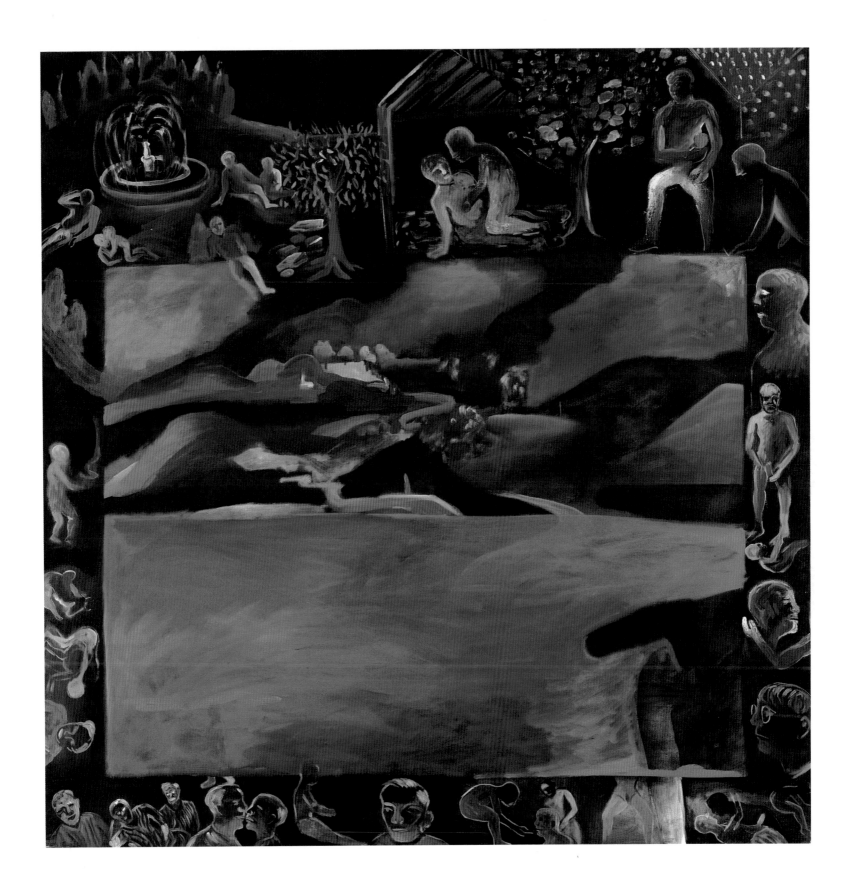

White Angel, 1995
Oil on canvas
175.3 × 175.3 cm (69 × 69 in.)
Courtesy of the artist and
Kapil Jariwala Gallery, London

Green Landscape, 1995
Oil on canvas
175.3 × 175.3 cm (69 × 69 in.)
Courtesy of the artist and
Kapil Jariwala Gallery, London

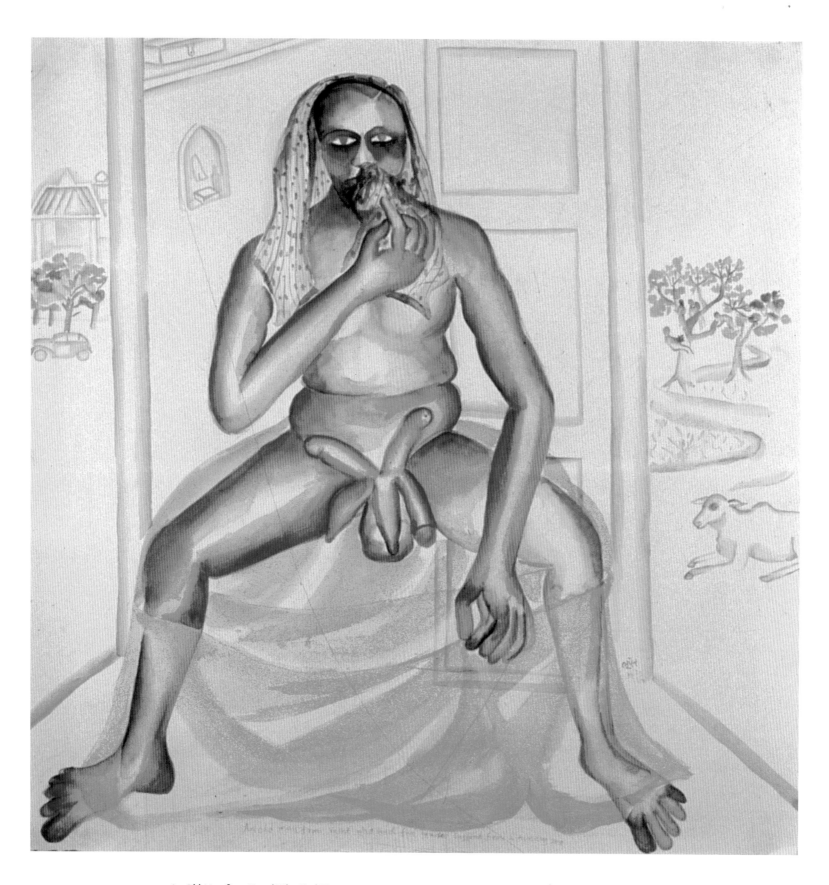

**An Old Man from Vasad Who Had Five
Penises Suffered from Runny Nose**, 1995
Watercolor on paper
110 × 110 cm (43¼ × 43¼ in.)
Courtesy of the artist

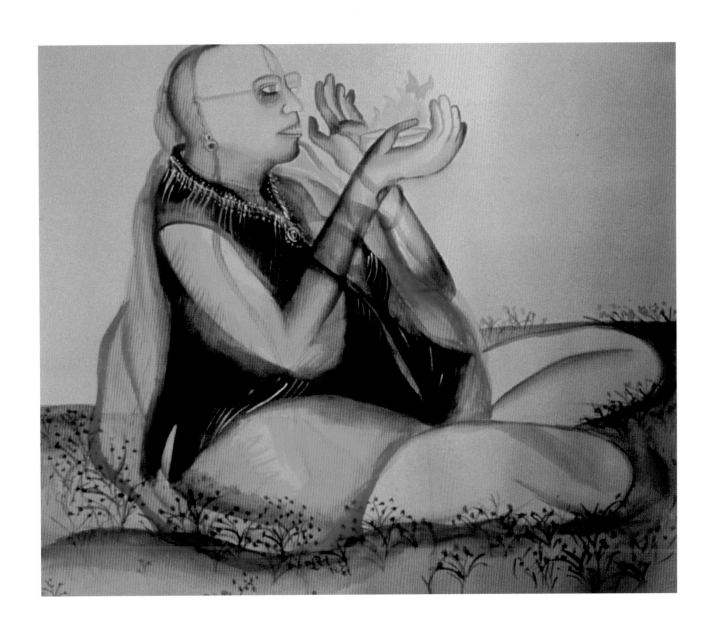

Sakhibhav, 1994
Watercolor on paper
110 × 110 cm (43¼ × 43¼ in.)
Courtesy of the artist

Kim *Ho-Suk*

Korea

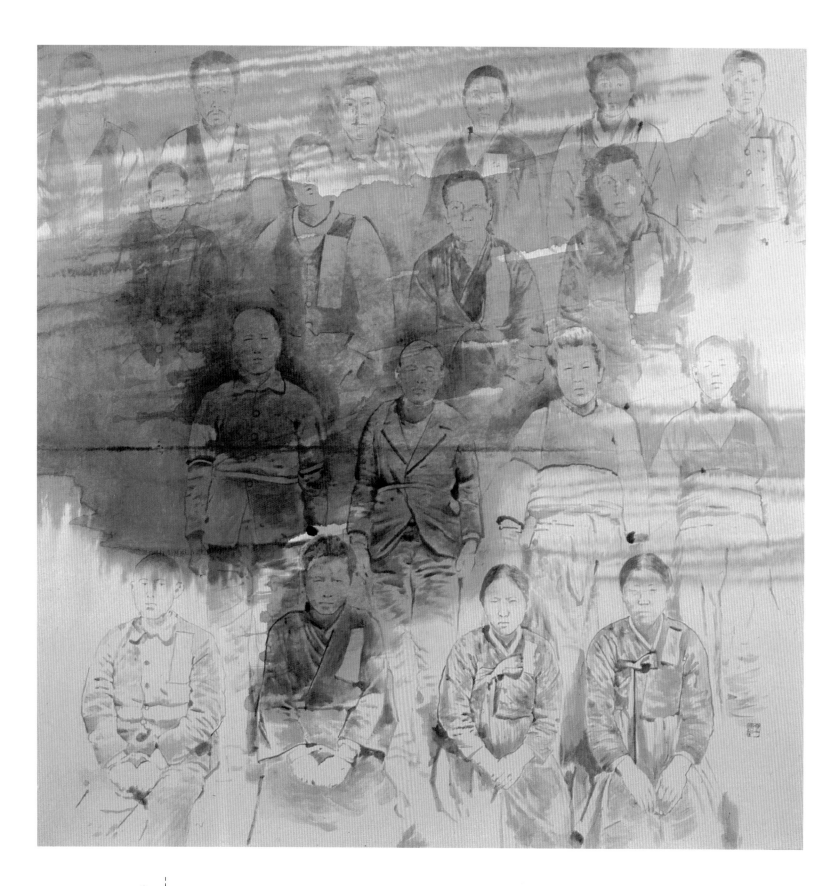

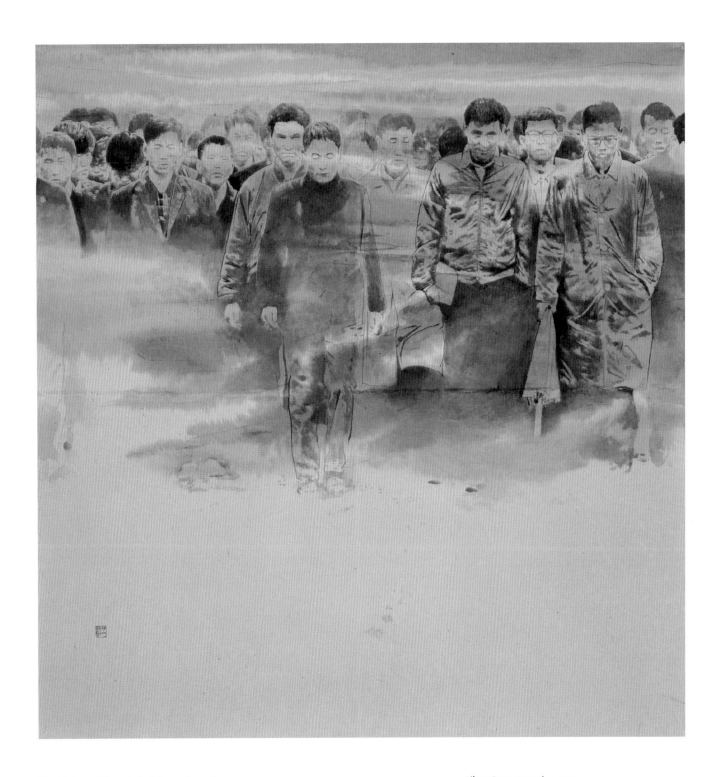

**The History of Korea's Resistance Against
Japanese Colonialism: Armed Uprising**, 1991
Ink on paper
183 × 183 cm (72 × 72 in.)
Courtesy of the artist

Silent Demonstration, 1992
Ink on paper
183 × 183 cm (72 × 72 in.)
Courtesy of the artist

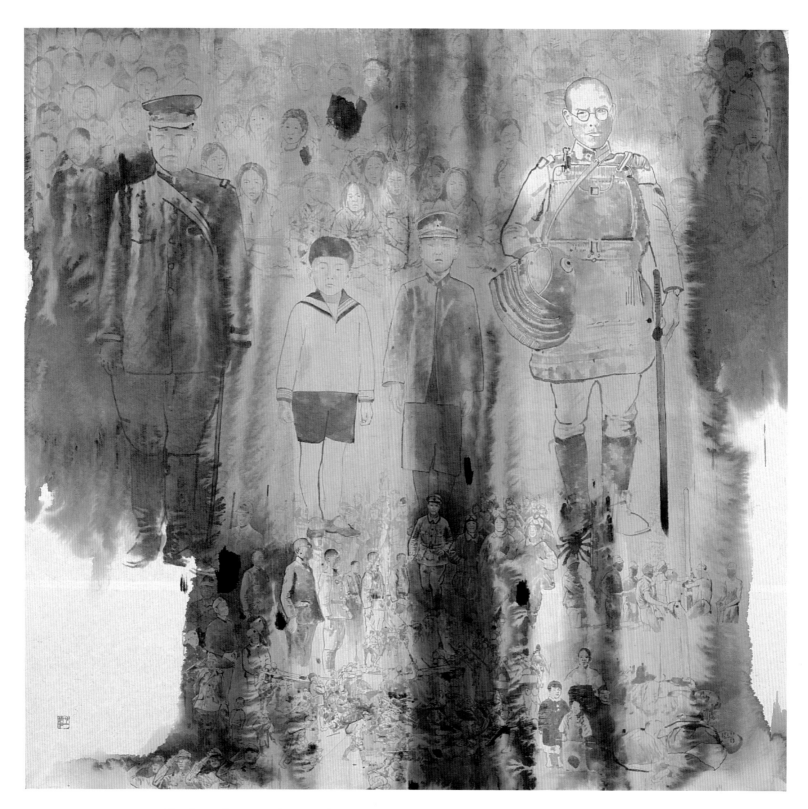

**The History of Korea's Resistance Against
Japanese Colonialism: The Period of
Japanization of Korean Culture**, 1990
Ink on paper
183 × 190 cm (72 × 74¾ in.)
Private collection, courtesy of Gana Art Gallery

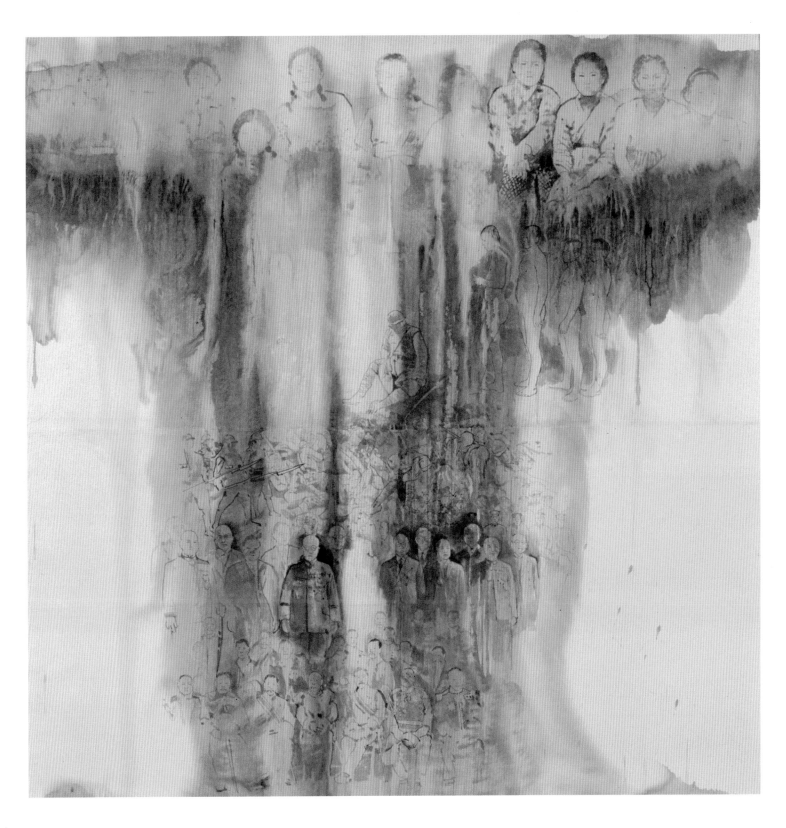

**The History of Korea's Resistance Against
Japanese Colonialism: Comfort Women**, 1990
Ink on paper
180 × 180 cm (70 ⅞ × 70 ⅞ in.)
Courtesy of the artist

Soo-Ja Kim

Korea

Deductive Object, 1994, installed in Yang
Dong Village, Kyungju, Korea
Used clothing, bedcover, and the artist
Dimensions variable
Courtesy of the artist

Deductive Object, 1996,
installed along a highway in Seoul
Used clothing
Dimensions variable
Courtesy of the artist

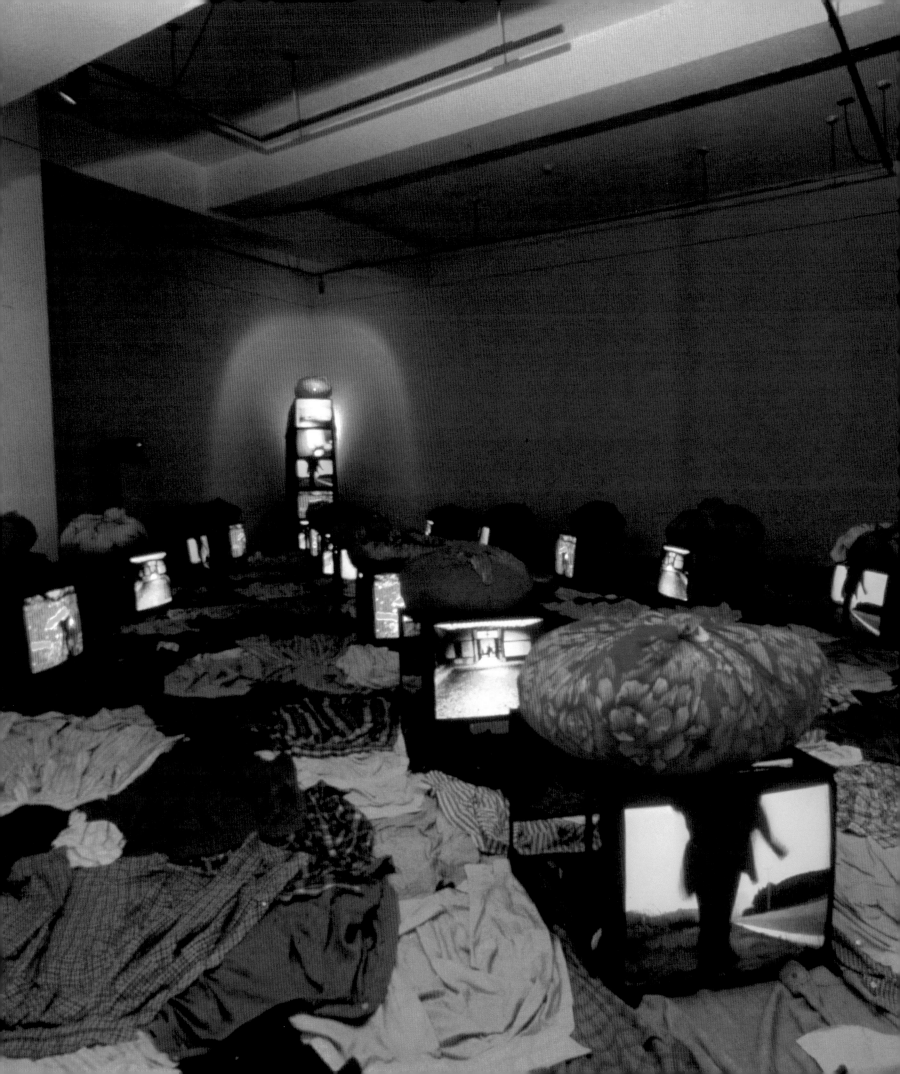

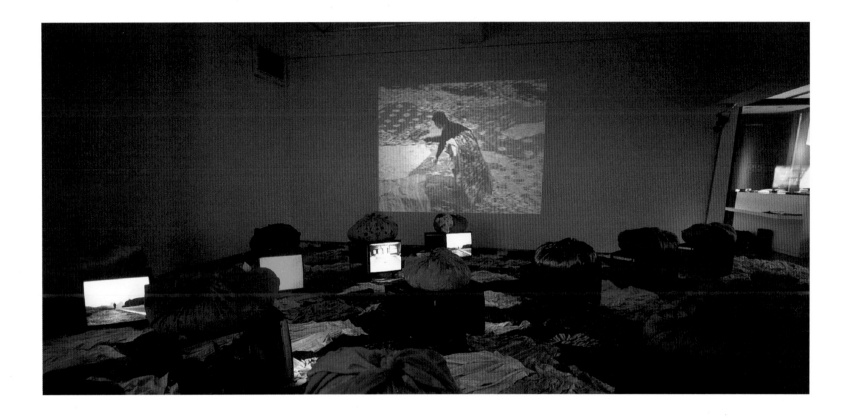

Sewing into Walking, 1994,
installed at Seomi Gallery, Seoul
Installation with used clothing, bedcover,
closed-circuit TV camera and monitor,
video projector, and CD player
Approx. 1200 × 1000 cm (473 × 394 in.)
Courtesy of the artist

Nalini Malani

India

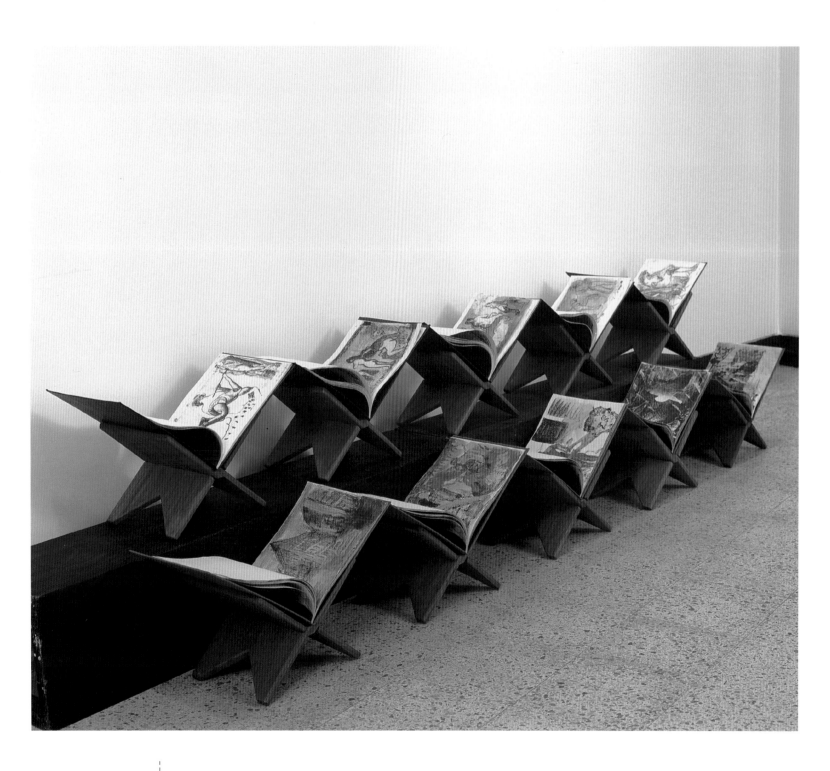

Hieroglyphs, Lohar Chawl, 1990–91
Five books, each with series of photocopied
collages on parchment and sunlit buff paper,
acrylic, watercolor, and ink; wooden stands
Each book, 23 × 28 × 2 cm (9 × 11 × 5 in.)
Courtesy of the artist

The Degas Suite, 1990–91
Five books, each with series of photocopied
monotypes on parchment and sunlit buff
paper, acrylic, watercolor, soft pastel, and ink;
wooden stands
Each book, 23 × 28 × 2 cm (9 × 11 × 5 in.)
Courtesy of the artist

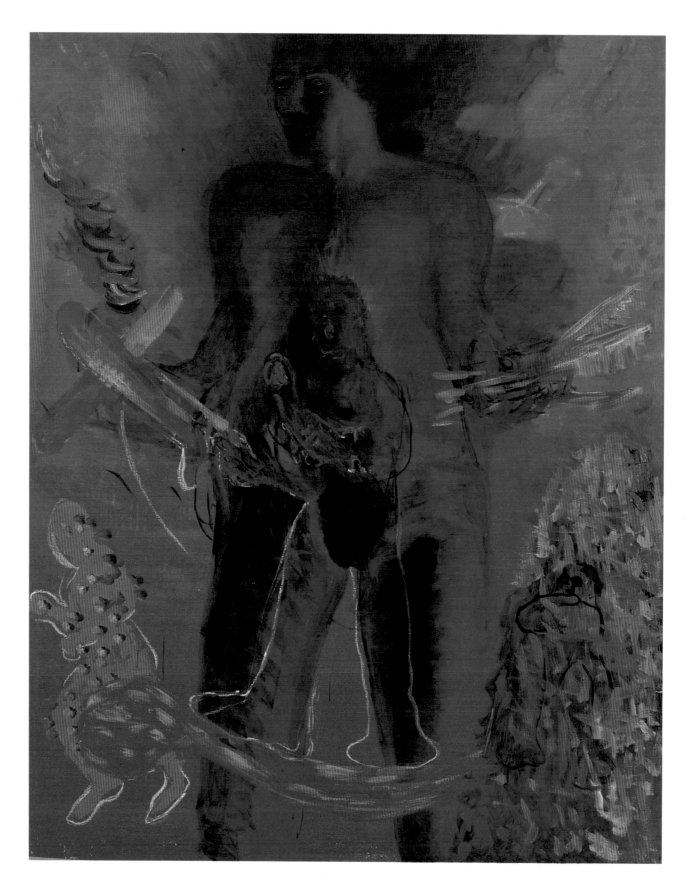

Mutant I, 1994
Acrylic, paintstick, and oil on canvas
152.4 × 121.9 cm (60 × 48 in.)
Courtesy of the artist

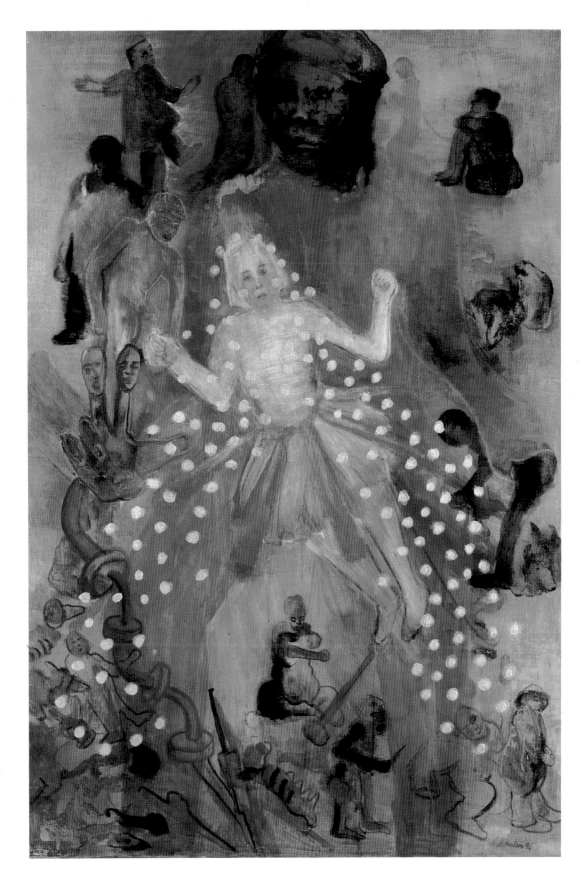

Mutant II, 1996
Acrylic and charcoal on canvas
152.4 × 111.7 cm (60 × 44 in.)
Chester and Davida Herwitz Collection

Kamol Phaosavasdi

Thailand

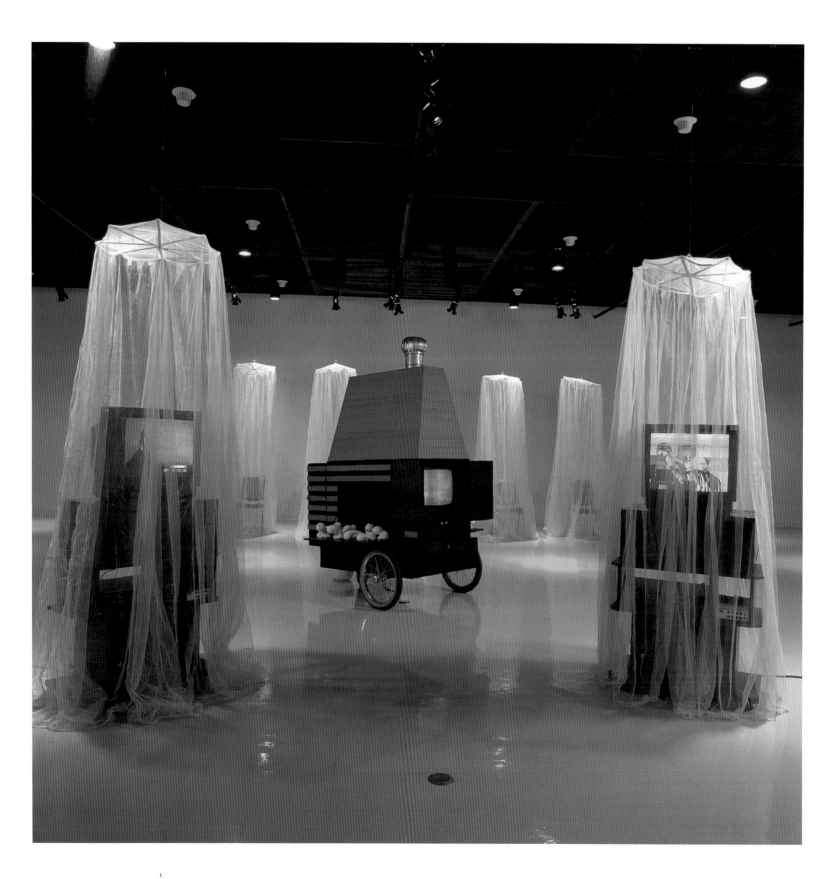

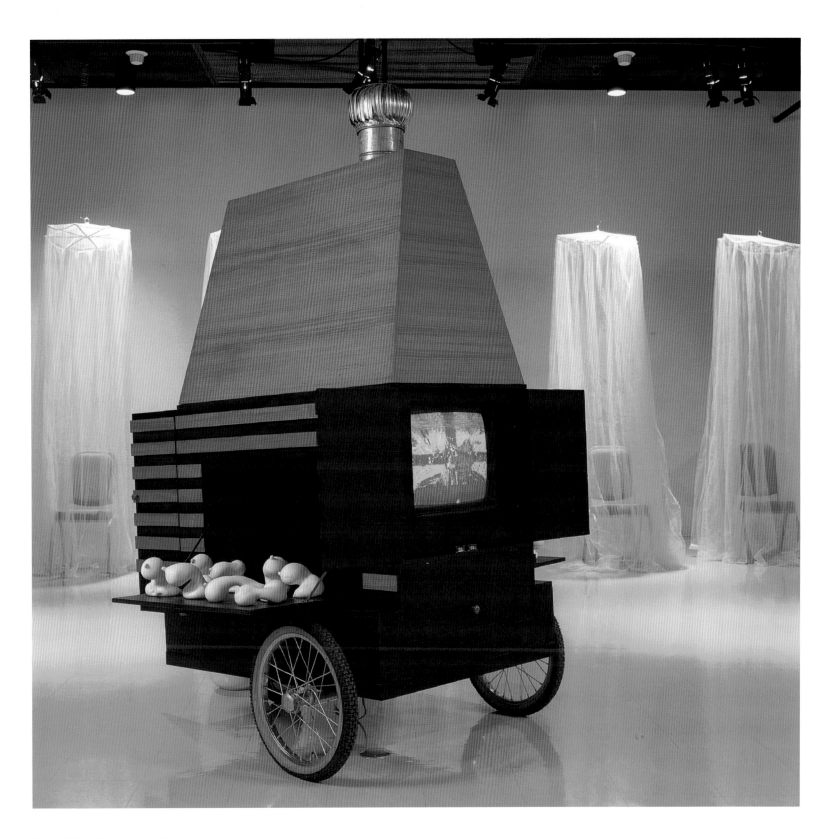

Mode of Moral Being, 1995–96
Installation with wooden trolley, mosquito
nets, video players, tape players, headphones,
plaster, rubber, stone, wood, photograph,
and photocopy
Approx. 250 × 500 × 600 cm
(99 × 197 × 236 in.)
Courtesy of the artist

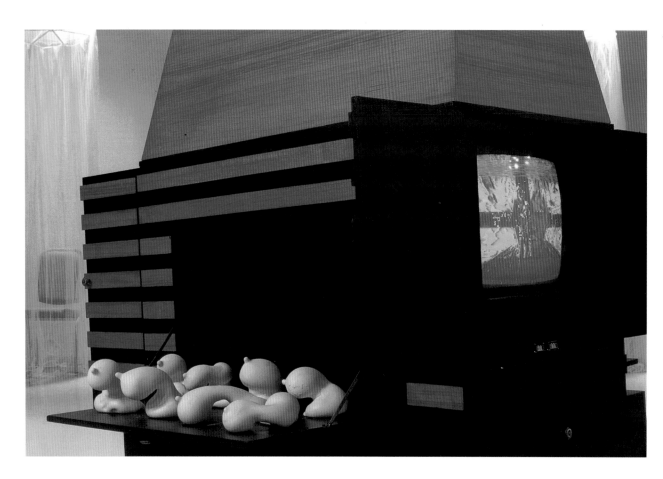

sample text:

Fines for Bar Hostesses

1. Late to work: 2 baht per minute
2. Taking off more than two days per month: 400 baht per day
3. No show on a Saturday, Sunday, or national holiday: 1,000 baht
4. Eating meals before or after allotted time: 50 baht
5. Fighting over customers: 300 baht
6. Failure to present health clinic check-up card on payday: No pay
 300 baht fine each violation if more than once a month
7. Missing quota for soft-drink sales to customers (60 per month): 50 baht per drink short
8. Must go with customers 4 times per month. 400 baht fine per time missed

Details of
Mode of Moral Being

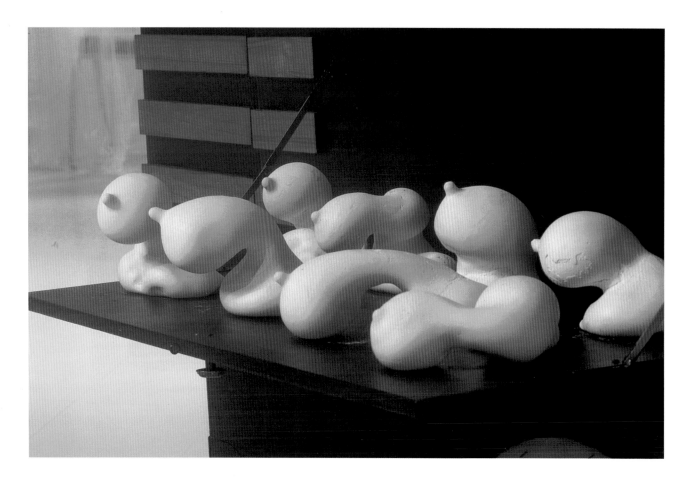

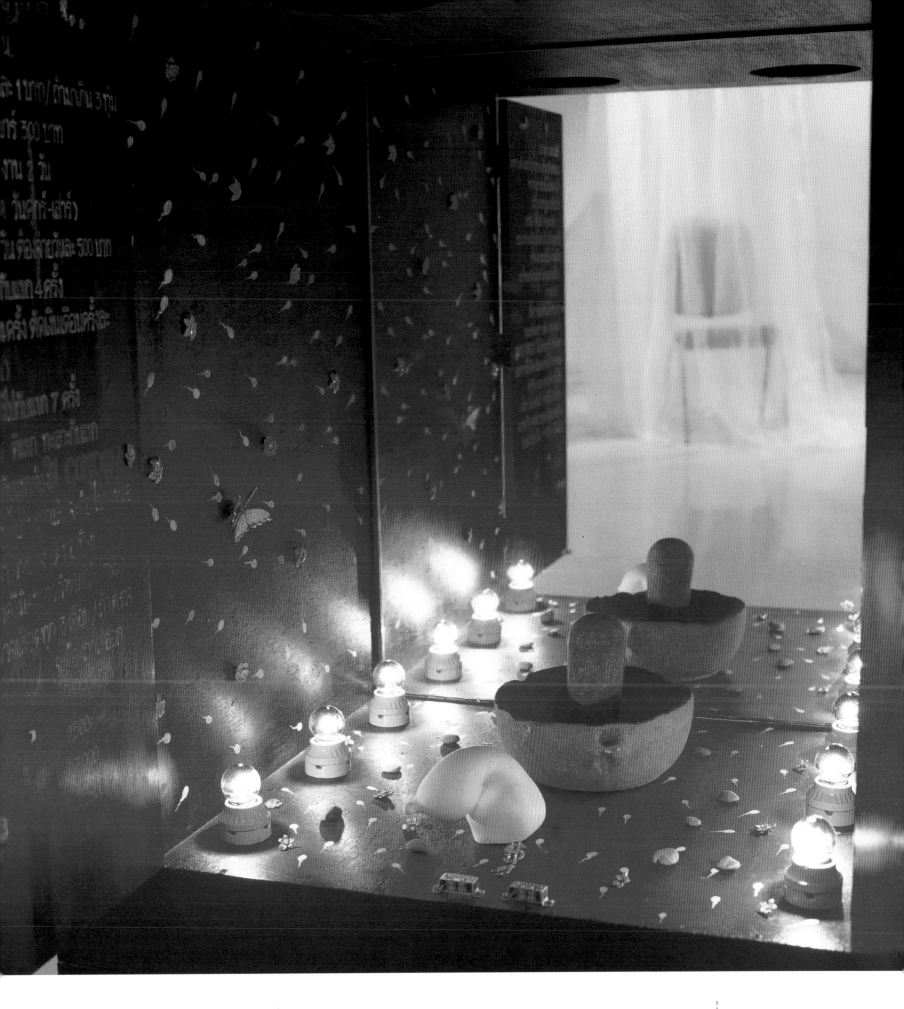

Chatchai Puipia

Thailand

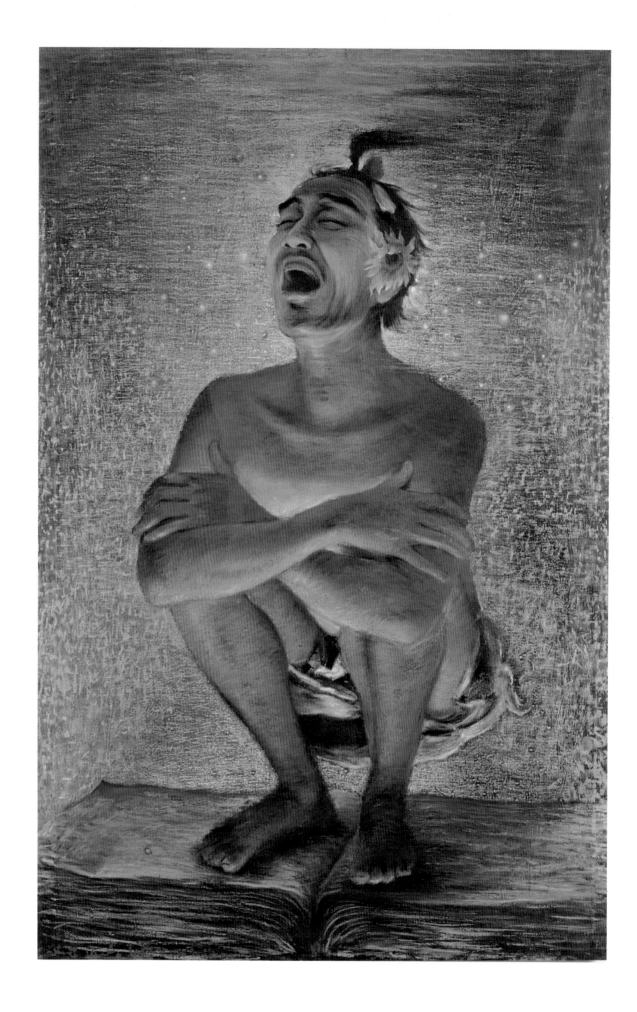

Mae Chow Woi!, 1994
Oil on canvas
150 × 110 cm (59 × 43¼ in.)
Private collection

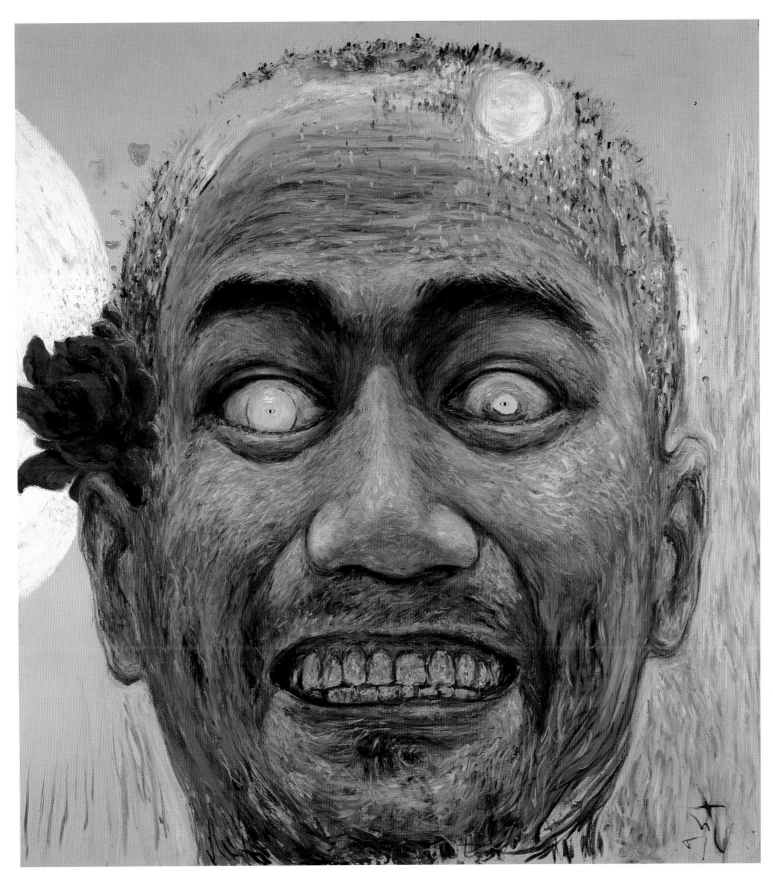

Siamese Smile, 1995
Oil on canvas
240 × 220 cm (94½ × 86⅝ in.)
Private collection

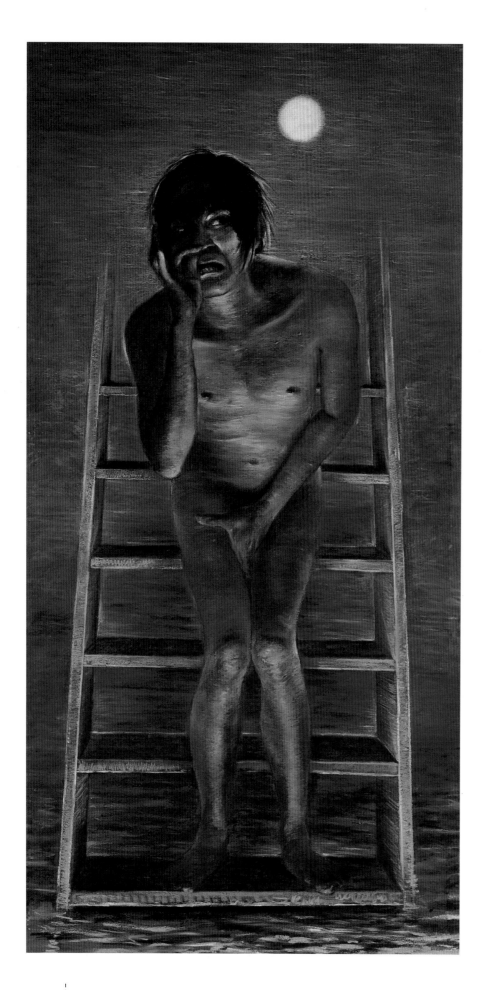

Something Smells Around Here, 1994
Oil on canvas
200 × 100 cm (78¾ × 39⅜ in.)
Courtesy of the artist

opposite:
Toe-Sucking Is Best, 1994
Oil, acrylic, pencil, and newspaper on canvas
200 × 180 cm (78¾ × 70⅞ in.)
Courtesy of the artist

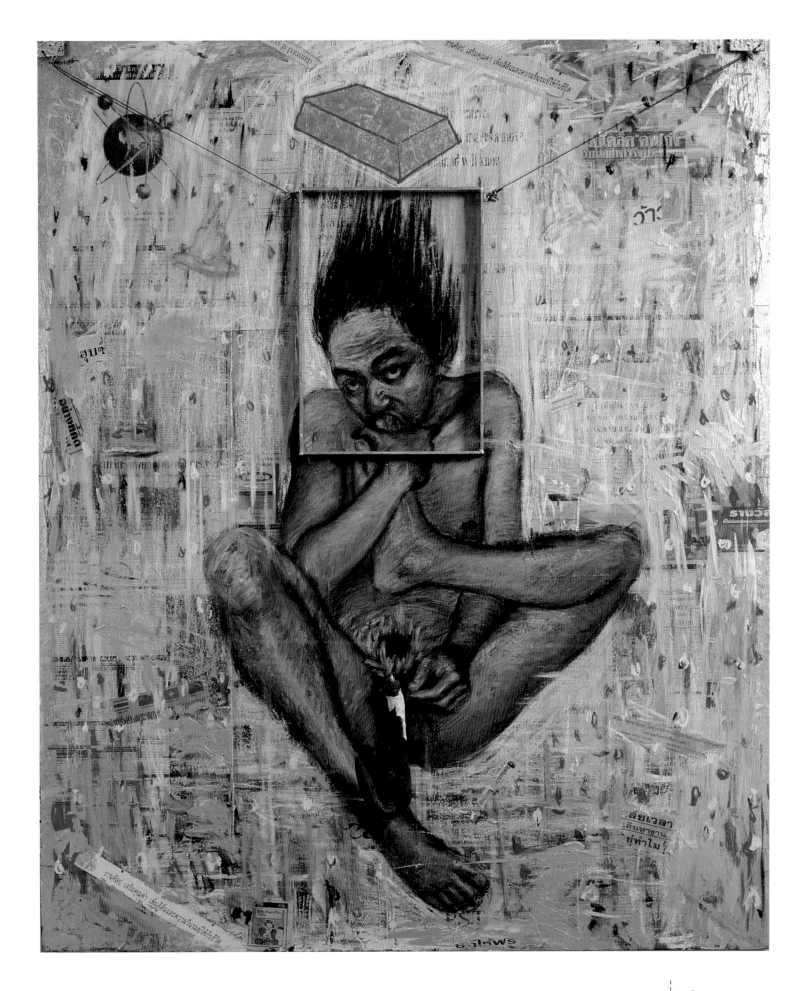

Araya Rasdjarmrearnsook

Thailand

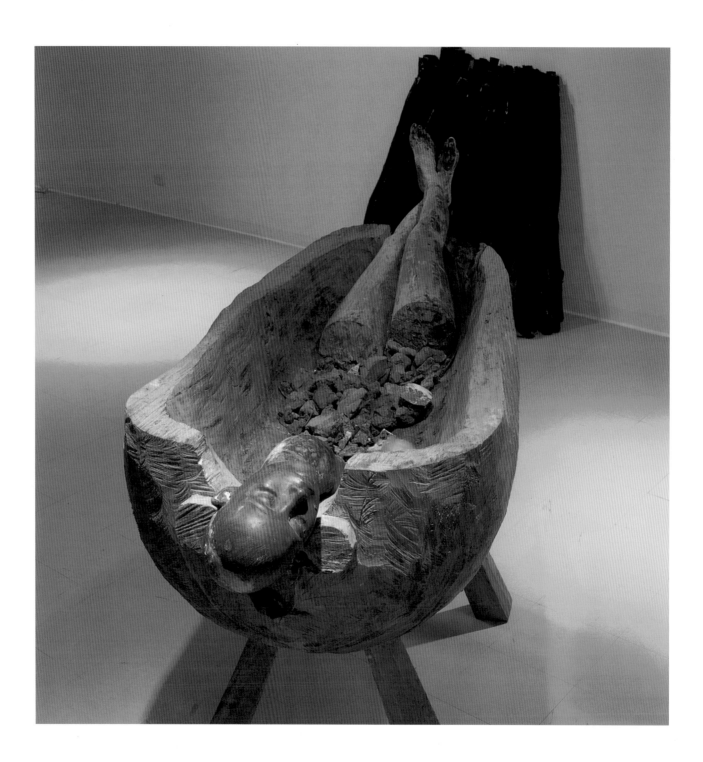

Buang (Trap), 1995
Installation with wood, metal plates, stone,
clay, and fiberglass
Approx. 500 × 800 × 450 cm
(197 × 315 × 177 in.)
Courtesy of the artist

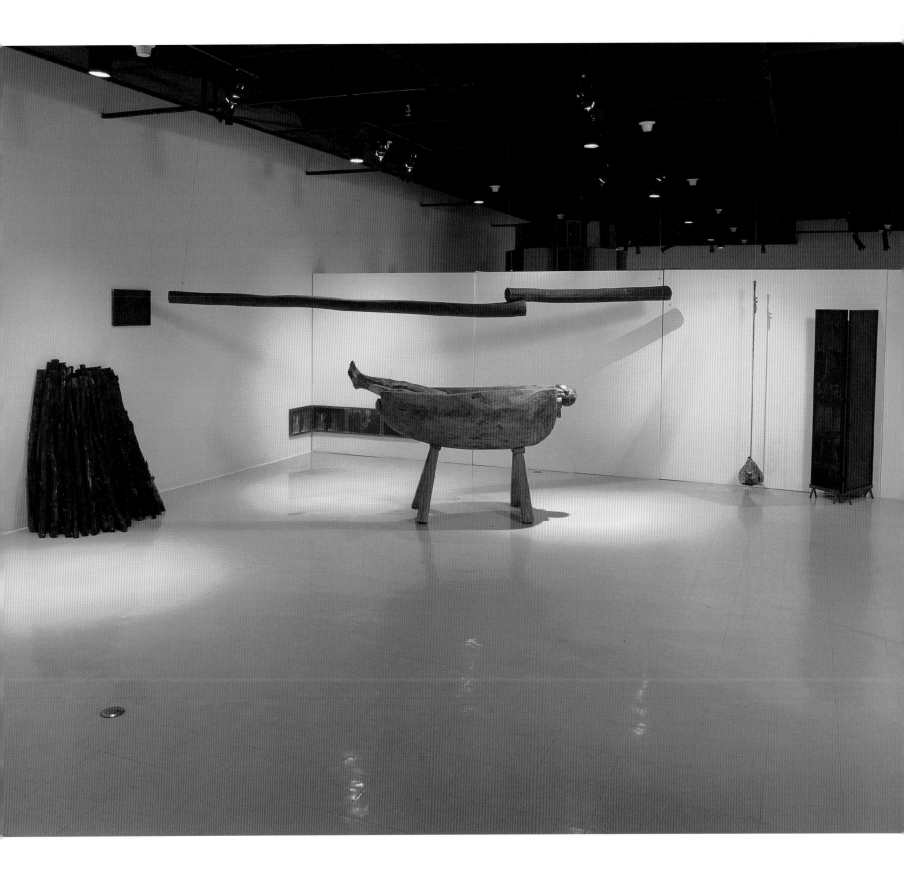

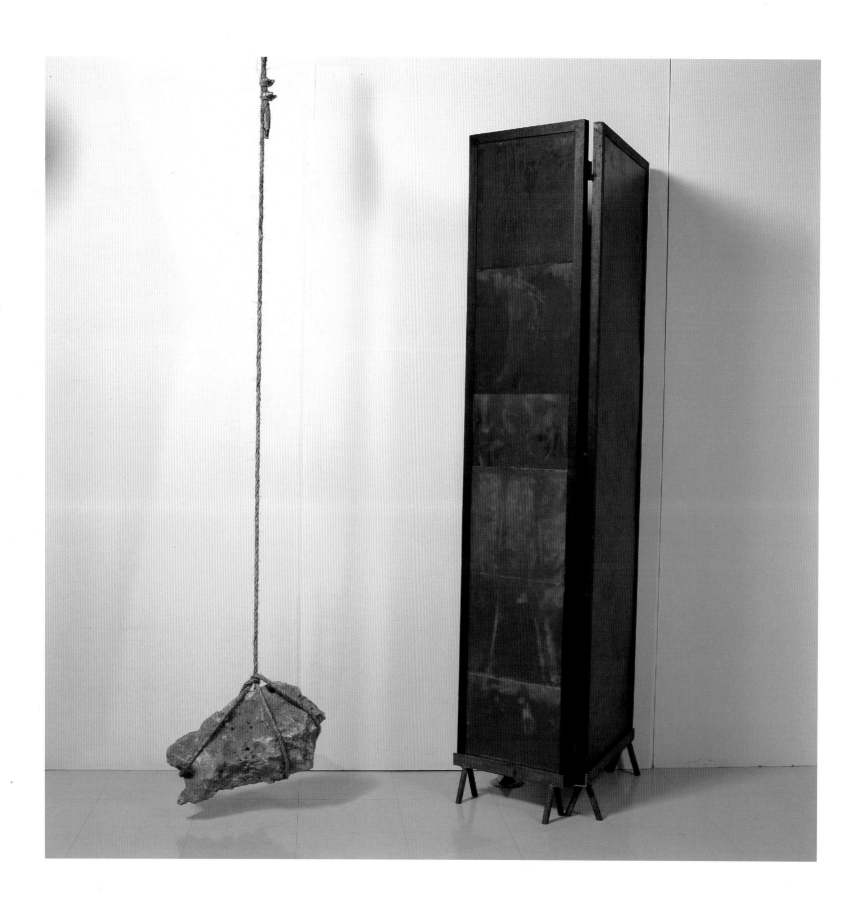

Details of **Buang** (Trap)

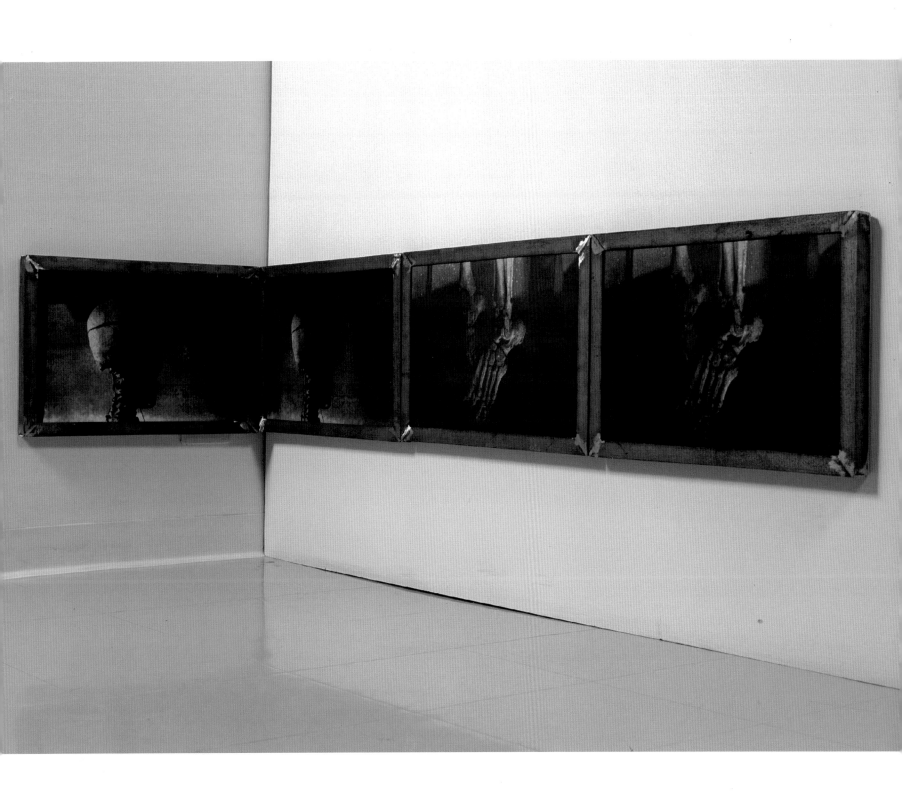

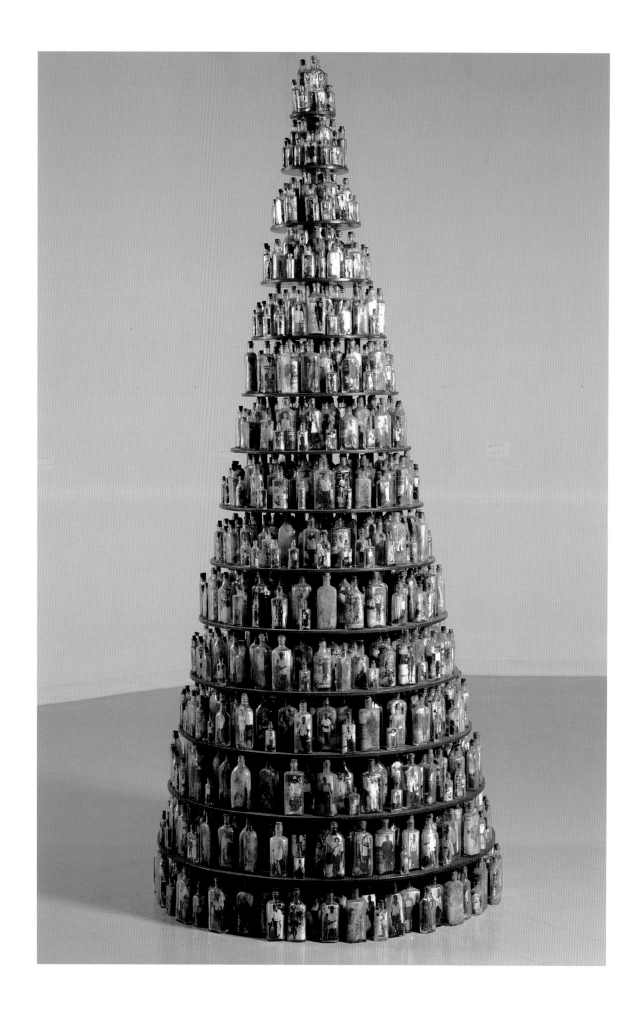

Navin Rawanchaikul

Thailand

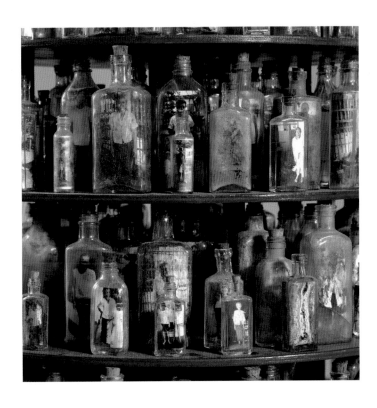

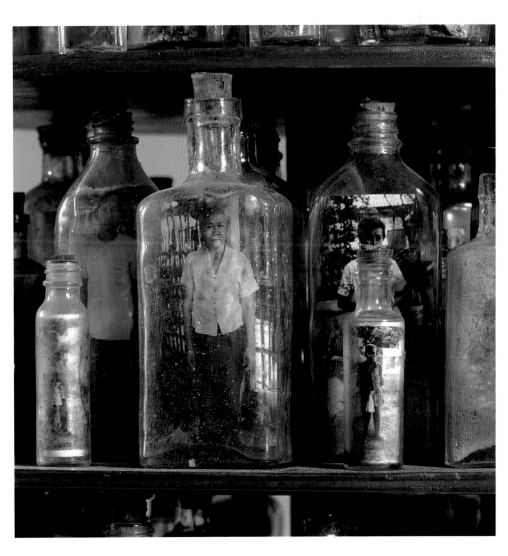

There Is No Voice, 1993
Photographs, glass bottles, cork, and wood
259 × 122 × 122 cm (102 × 48 × 48 in.)
Collection of Chulalongkorn University,
Bangkok

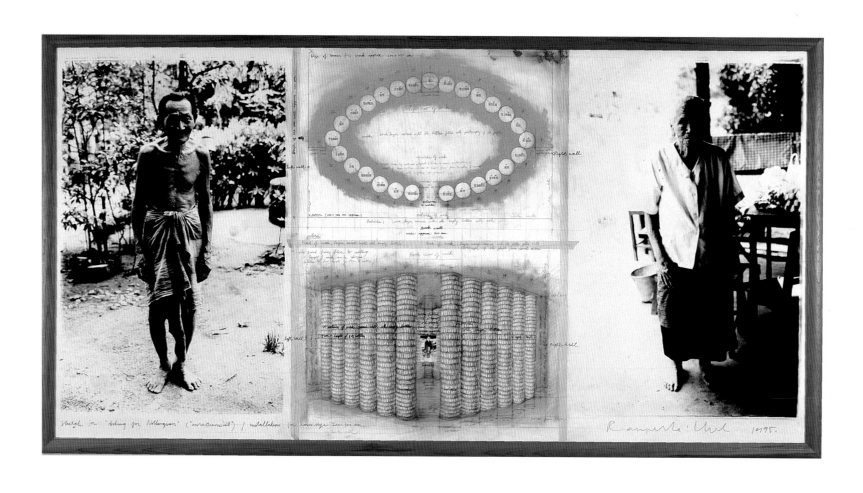

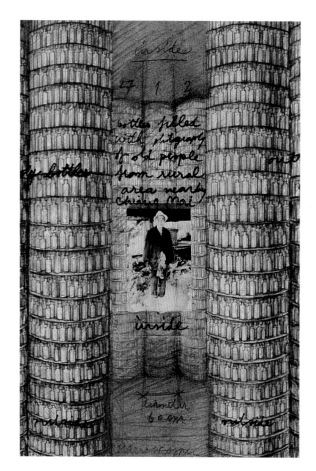

Sketch for **Asking for Nothingness**, 1995
Mixed media and photographs on paper
115 × 235 cm (45¼ × 92½ in.)
Courtesy of the artist

Navin Rawanchaikul

Documentation of **Fon Panya**, 1993
Display case containing book, bottle,
photograph, and walking cane; photographs
Case, 100 × 100 × 50 cm (39⅜ × 39⅜ × 19⅝
in.); photographs, 100 × 70 cm (39⅜ × 27½ in.)
Courtesy of the artist

Documentation of
Fon Panya and Dee Uraporn, 1993
Display case containing books, paper,
and bottles; photograph
Case, 100 × 100 × 50 cm (39⅜ × 39⅜ × 19⅝ in.);
photographs, 70 × 100 cm (27½ × 39⅜ in.)
Courtesy of the artist

Reamillo & Juliet

Philippines

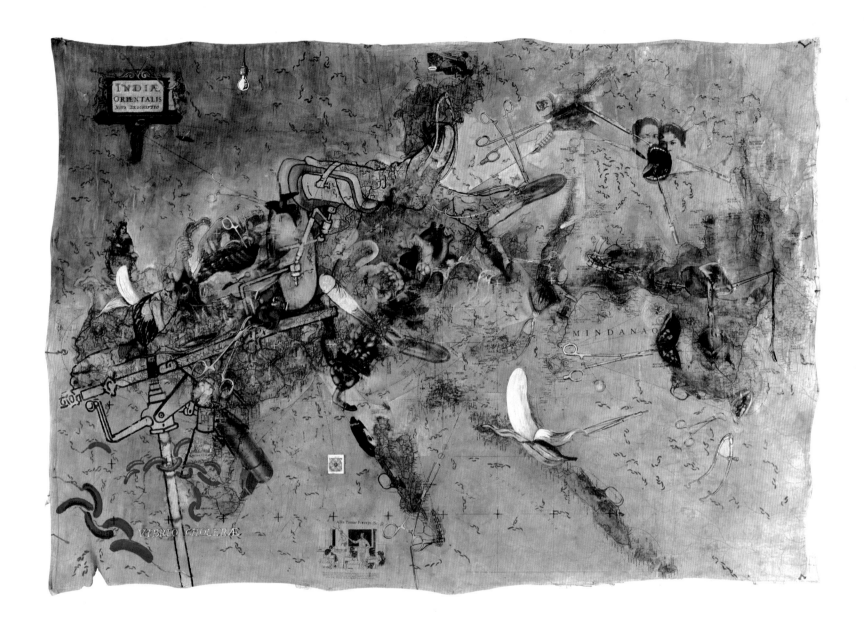

Kakainin ba nila ang mga saging?
(Will They Be Eating the Bananas?),
from "P. I. for Sale," 1995
Acrylic and oil on bedsheet and paper
158 × 236 cm (62¼ × 93 in.)
Courtesy of the artists

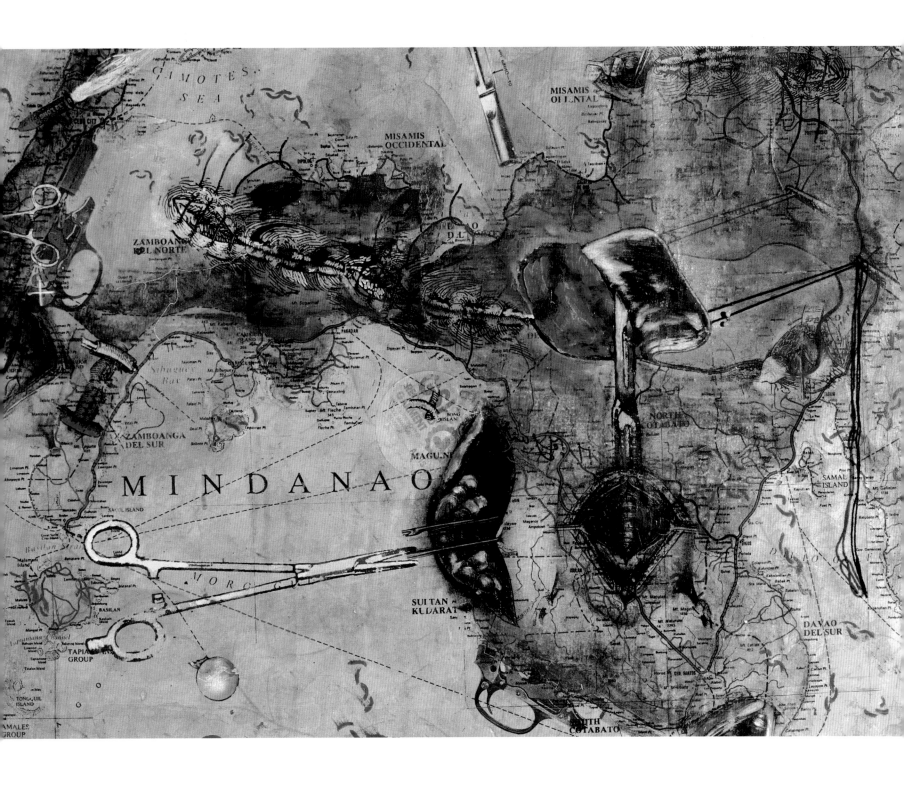

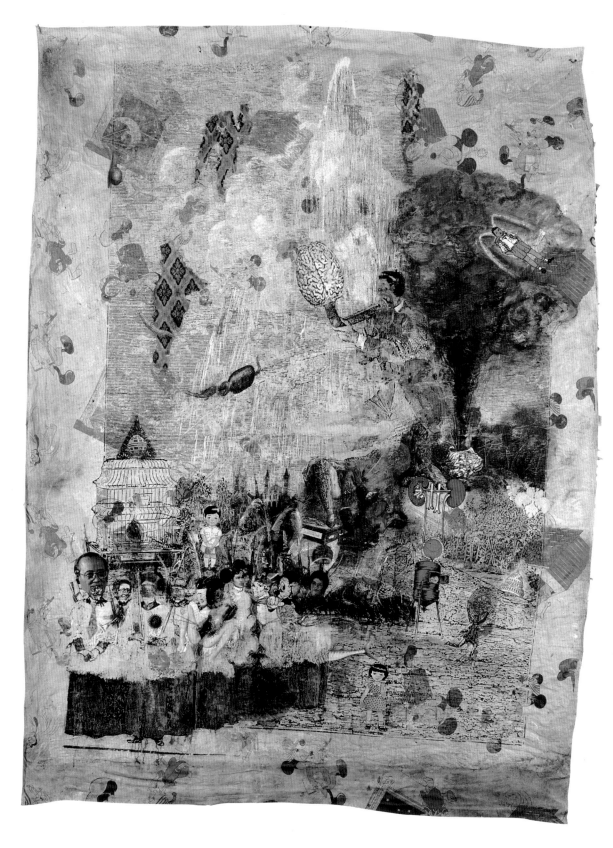

Bulag ang taong nakasalaming iyon
(Blind Is That Man with Glasses),
from "P. I. for Sale," 1995
Oil and acrylic on bedsheet and Bible
244 × 181 cm (96 × 71¼ in.)
Courtesy of the artists

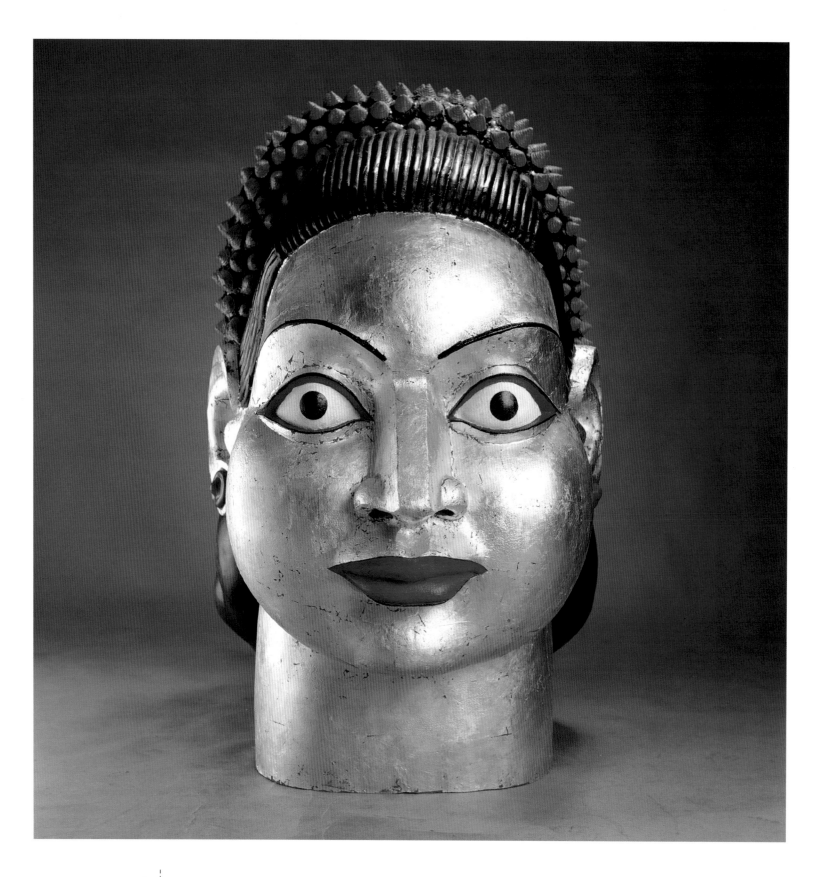

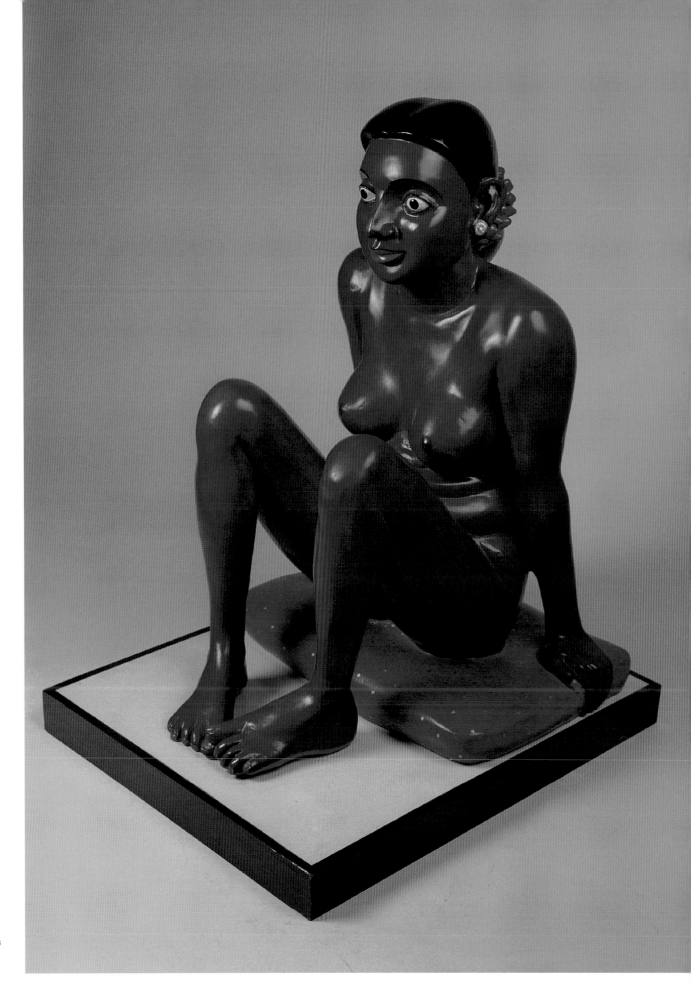

opposite:
Head IV, 1995
Gilded and painted
polyester-resin fiberglass
120 × 74 × 103 cm
(47¼ × 29⅛ × 40½ in.)
Courtesy of the artist

Sitting Woman '95, 1995
Painted polyester-resin fiberglass
95 × 61 × 76 cm (37 × 24 × 30 in.)
Courtesy of the artist

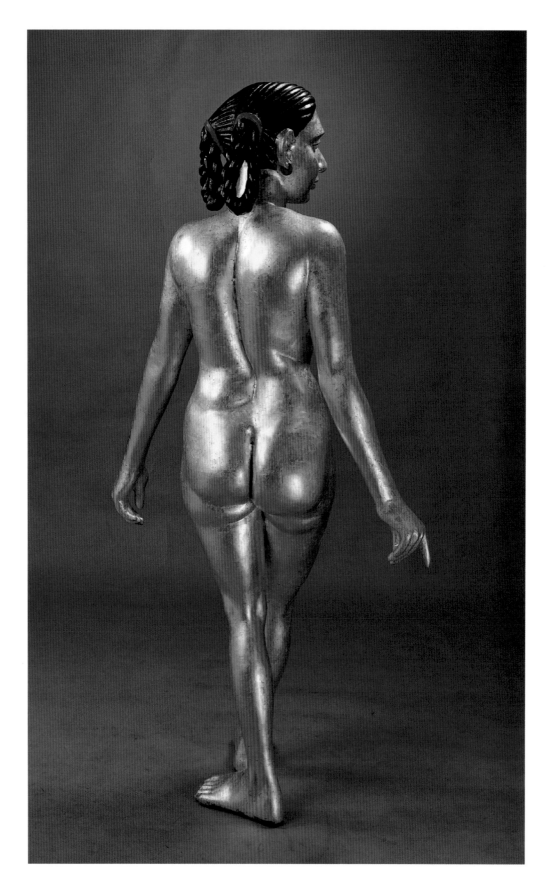

Woman '95, 1995
Gilded and painted polyester-resin fiberglass
166 × 84 × 60 cm (65 × 33 × 23⅝ in.)
Collection of Mrs. Padmini Reddy

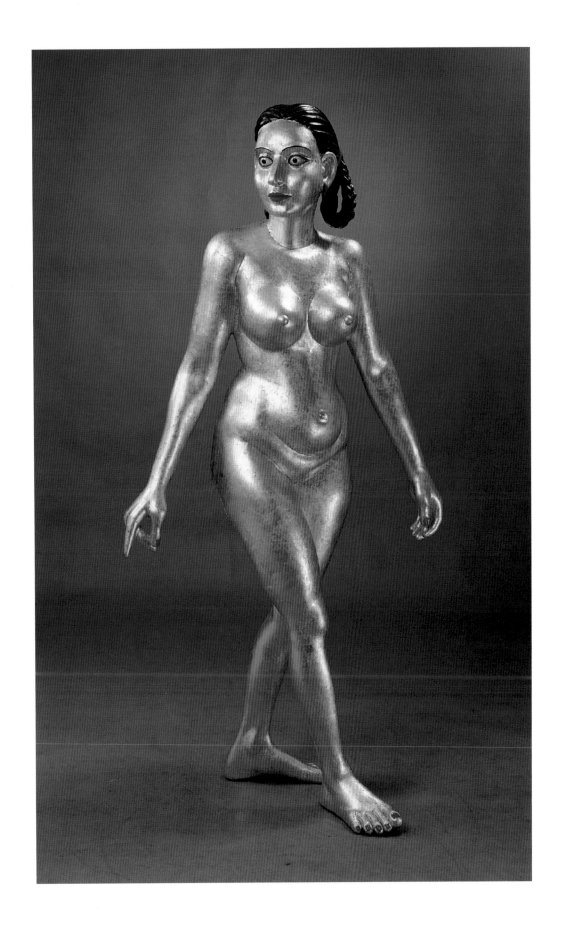

N. N. Rimzon

India

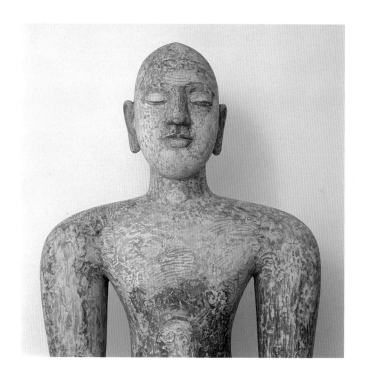

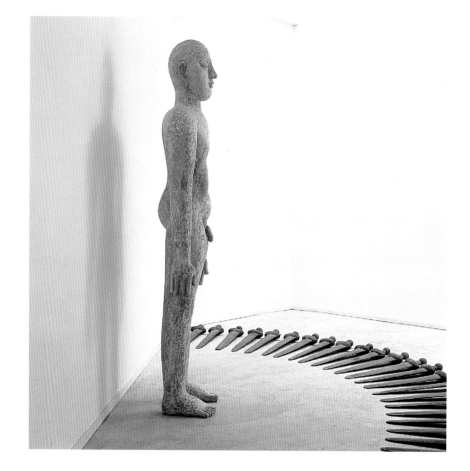

The Inner Voice, 1992
Resin fiberglass, marble dust, and cast iron
Height of figure, 207 cm (81½ in.);
diameter of half-circle, 456 cm (179½ in.);
each sword, 71.5 × 17 cm (28⅛ × 6⅝ in.)
Foundation for Indian Artists, Amsterdam

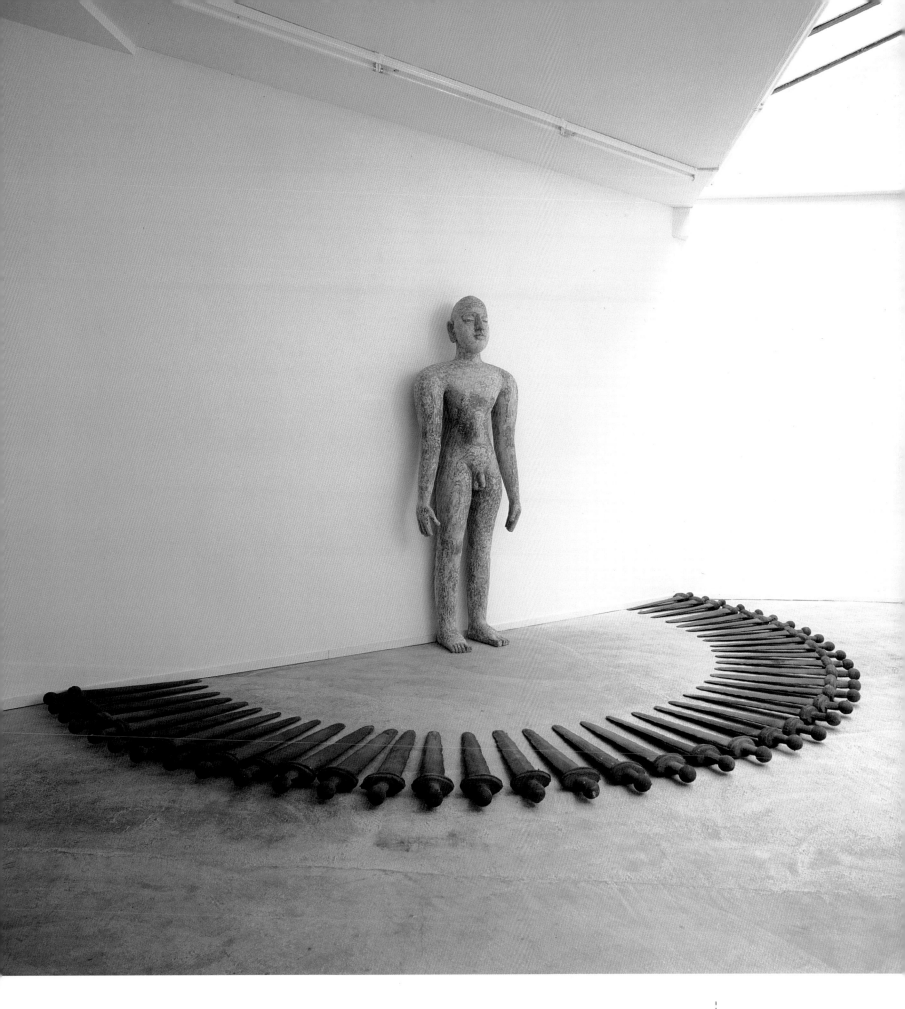

Sanggawa Group

Philippines

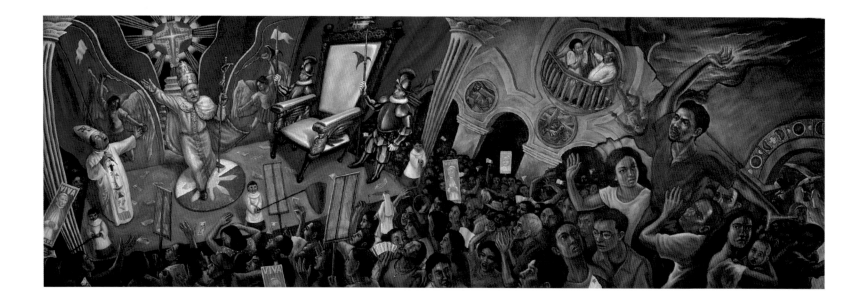

The Second Coming, 1995
Oil on canvas
203 × 607 cm (80 × 239 in.)
Courtesy of the artists

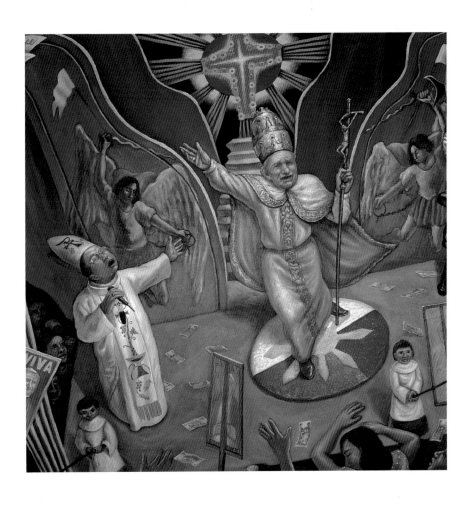

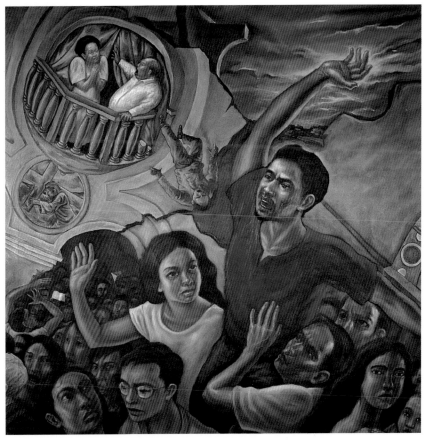

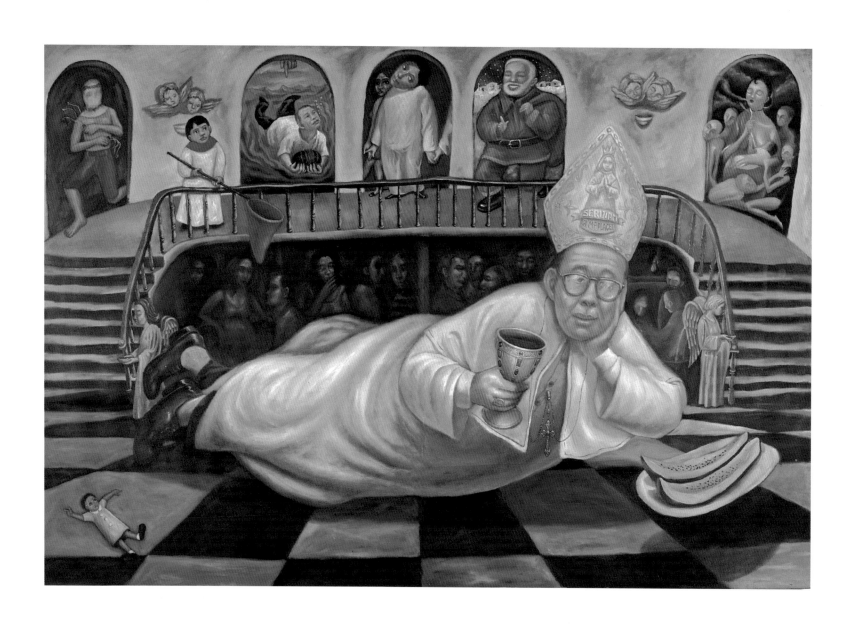

House of Sin, 1994
Oil on canvas
198 × 291 cm (78 × 114 ½ in.)
Courtesy of the artists

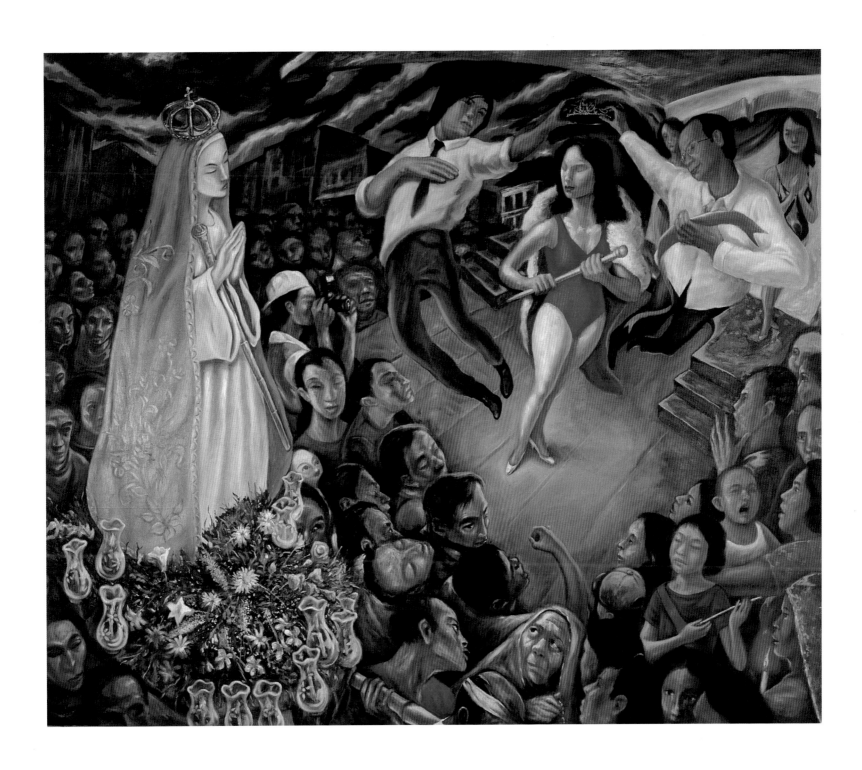

Salubong, 1994
Oil on canvas
252 × 300 cm (99¼ × 118⅛ in.)
Courtesy of the artists

Arpita Singh

India

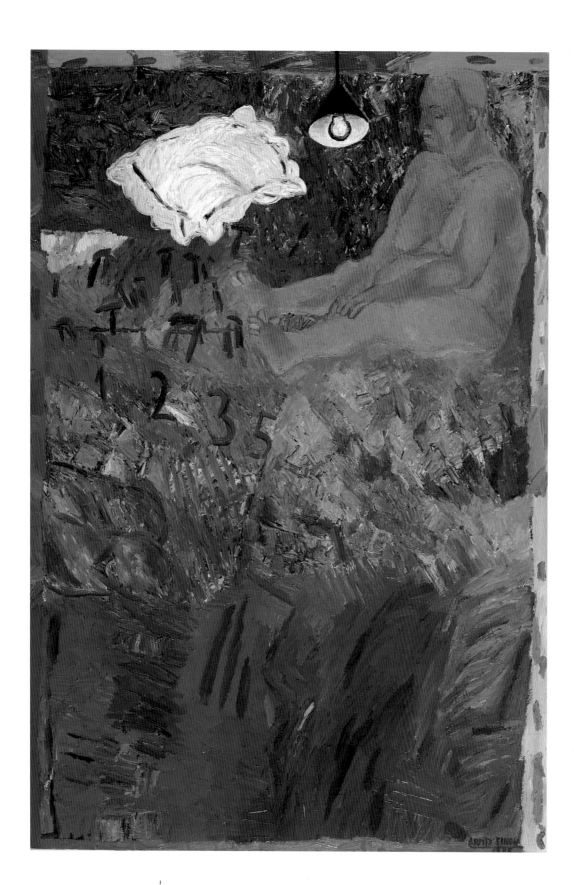

**Woman Sitting—
The Dissolving Body**, 1995
Oil on canvas
178 × 119 cm (70 × 46¾ in.)
Private collection

opposite:
Durga, 1993
Oil on canvas
76 × 61 cm (29⅞ × 24 in.)
Private collection

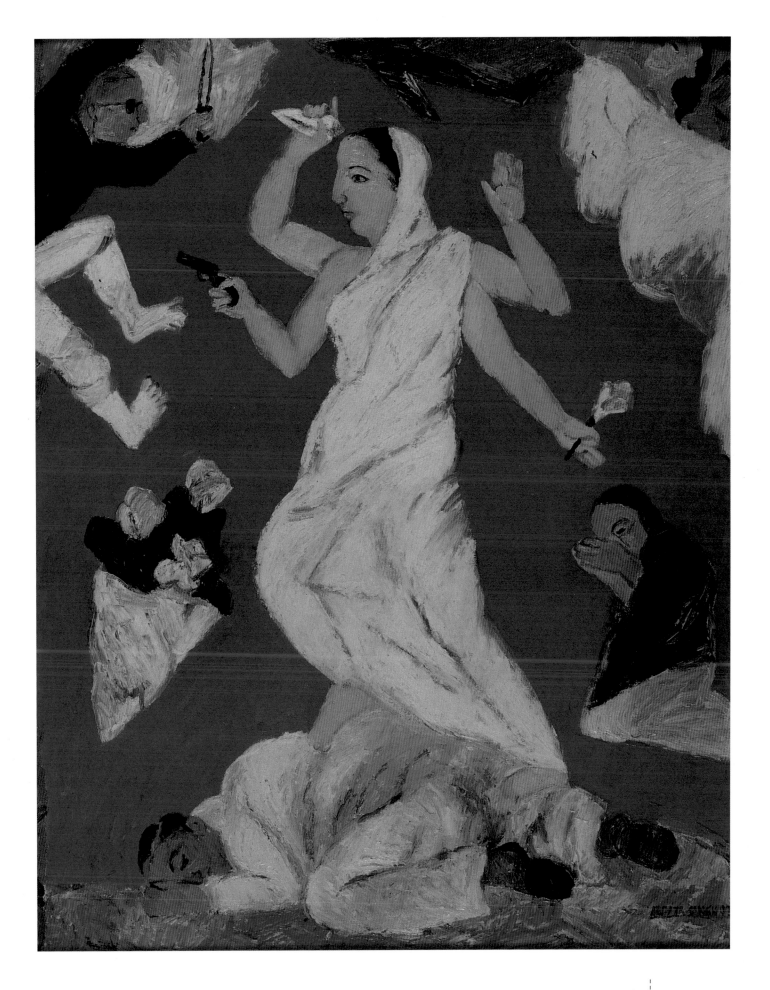

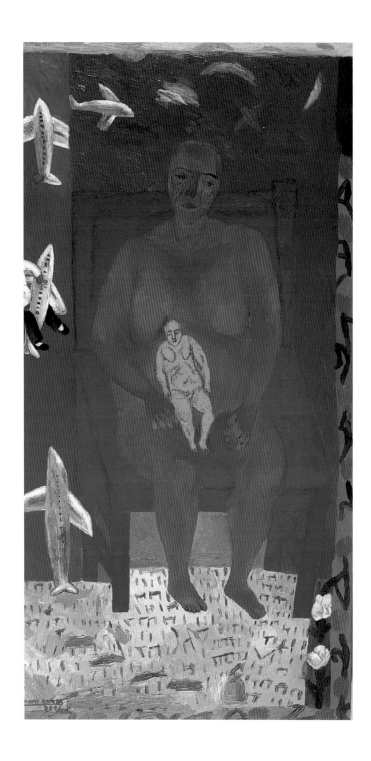

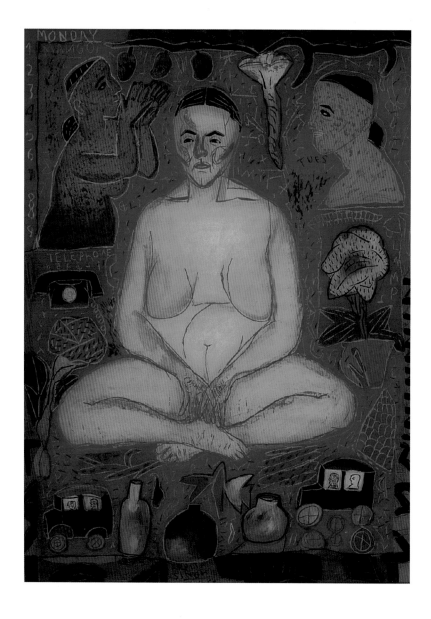

A Woman and a Woman, 1995
Oil on canvas
152.5 × 76 cm (60 × 29⅞ in.)
Private collection

right:
Red Feminine Tale, 1995
Acrylic on acrylic
38.5 × 25 cm (15⅛ × 9¾ in.)
Private collection

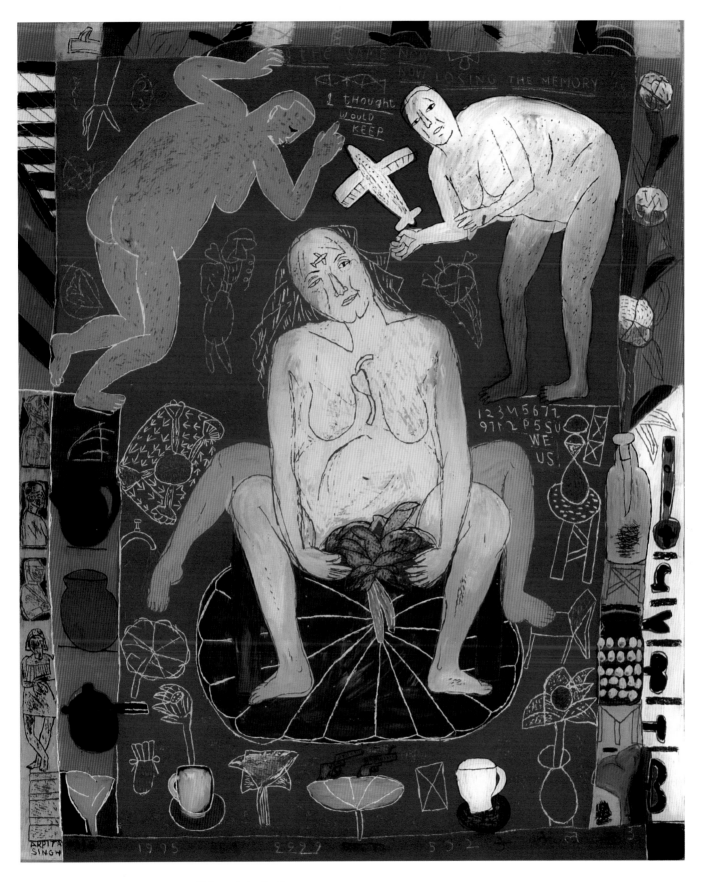

Girl on a Lotus Leaf, 1995
Acrylic on acrylic
61 × 50 cm (24 × 19⅝ in.)
Private collection

Jakapan Vilasineekul

Thailand

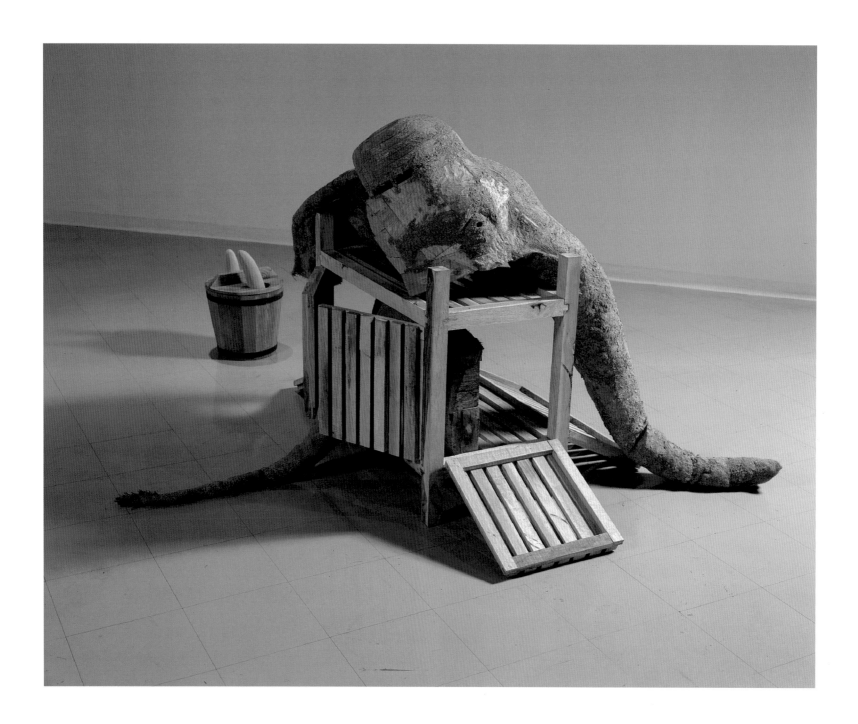

Chang Tai Thang Tua Auw Bai Bua Pid?
(Thailand, Can You Cover a Dead Elephant
with a Lotus Leaf?), 1993–94
Wood, sawdust, drawing, and hemp
110 × 200 × 160 cm (43⅜ × 78¾ × 63 in.)
Courtesy of the artist

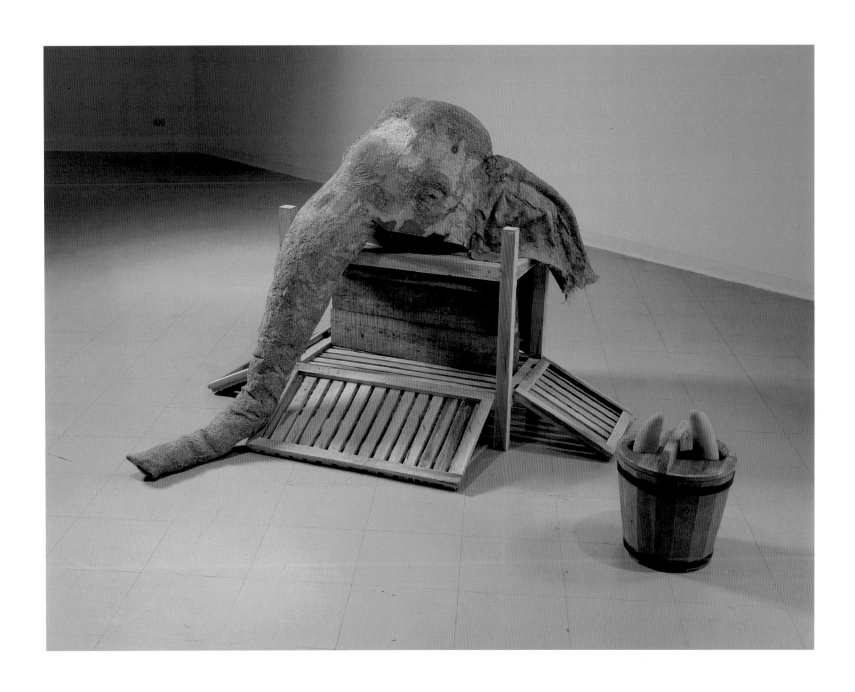

Yun *Suknam*

Korea

Day and Night, 1995
Installation with painted wooden figures,
plastic doll, chairs, and metal
Approx. 1000 × 1200 cm (394 × 473 in.)
Courtesy of the artist

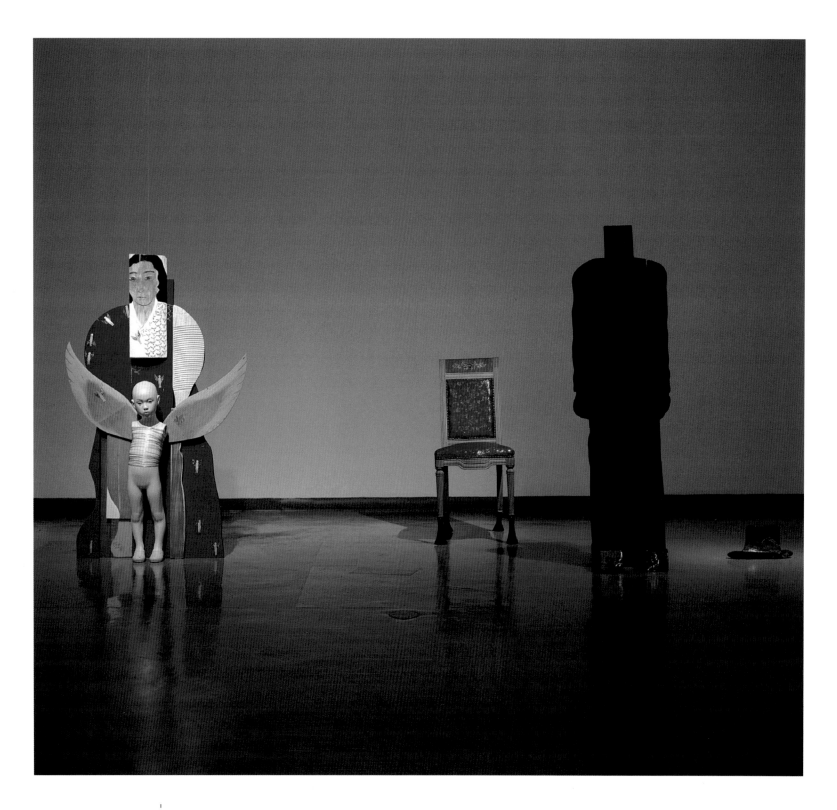

Nindityo Adipurnomo

Born in Semarang, Indonesia, 1961
Resides in Yogyakarta, Indonesia

Education

1981–88 Art Institute of Indonesia,
Yogyakarta

1986–87 State Academy of Fine Arts,
Amsterdam

Solo Exhibitions

1990 "Nindityo Adipurnomo, 1988–1990:
Protection, Liberation, Expression,"
Cemeti Gallery, Yogyakarta (catalogue)

1991 "The Floor Pattern," Foundation of
Fine Arts and ABN Bank, Amsterdam
"Spiritual Space," Cemeti Gallery,
Yogyakarta

1992 "The Floor Pattern," C-Line
Gallery, Jakarta
"Spiritual Space" (performance) Japan
Foundation, Jakarta (catalogue)

1993 "The Exotic of the Javanese
Burden," New Amsterdam Theater,
Amsterdam

1994 "The Exotic of the Javanese Burden"
(performance), Surakarta Art Council,
Surakarta, Indonesia

Group Exhibitions

1990 "Indonesian Modern Art,"
Municipal Gallery, Filderstadt,
Germany
"Intro-Extro Variform" (performance;
two-person exhibition), Cemeti Gallery,
Yogyakarta
"Modern Indonesian Art: Three
Generations of Tradition and Change,
1945–1990," Festival of Indonesia 1990,
Sewall Gallery, Rice University,
Houston (catalogue); traveled to San
Diego, Oakland, Seattle, and Honolulu

1991 "Nothing Is Everything, Everything
Is Nothing" (performance, two-person
exhibition), Tropenmuseum,
Amsterdam

"Sama-Sama," Centrum Beeldende Kunst
Oosterpoort, Groningen, the
Netherlands (catalogue); traveled to
Tilburg, the Netherlands; Yogyakarta;
and Jakarta
Vromans Gallery, Amsterdam

1992 7th Asian International Art
Exhibition, Gedung Merdeka, Bandung,
Indonesia (catalogue)

1993 Biennale IX, Taman Ismail Marzuki,
Jakarta (catalogue)
"Indonesian Modern Art," Oude Kerk,
Amsterdam (catalogue)
Cemeti Gallery, Yogyakarta

1994 Biennale VII, Yogyakarta (catalogue)

1995 "Asian Modernism: Diverse
Development in Indonesia, the
Philippines, and Thailand," Japan
Foundation Asia Center, Tokyo
(catalogue); traveled to Bangkok,
Manila, and Jakarta
"Orientasi," National Gallery,
Jakarta (catalogue)
"Unity in Diversity: Contemporary Art of
the Non-Aligned Countries," National
Gallery, Jakarta (catalogue)

1996 "Orientation," Stedelijk Museum
de Lakenhal, Leiden (catalogue)
2nd Asia-Pacific Triennial of
Contemporary Art, Queensland Art
Gallery, Brisbane (catalogue)

Public Collections

City of Amsterdam
City of Filderstadt, Germany
Dutch Embassy, Jakarta
Foundation of Fine Arts, Amsterdam
Lontar Foundation, Jakarta
National Museum of Modern Art,
Singapore
Sampoerna Group, Jakarta
Widayat Museum, Magelang, Indonesia
Zurich Assurance, Jakarta

Selected Bibliography

Acep Zam Zam Noor. "Abstraksi Gerak
Tari Srimpi." *Pikiran Rakyat* (October
1991).
Cohen, Margot. "Indonesia's Heirs of
Hair Heritage." *Asian Wall Street Journal*
(May 6–7, 1994).

Fadjri, R. "Orientasi Seni Rupa Dua
Negara." *Media Indonesia* (Aug. 27, 1995).
Mamannoor. "Kegelisahan Mencari
Identitas." *Kompas* (Sept. 29, 1991).
Masahiro Ushiroshoji. *Nishinippon Shinbun*
(May 20, 1994).
Ostenrik, Teguh. "Nindityo's Works Trace
Motions of Javanese Dance." *Jakarta Post*
(Mar. 27, 1992).
Owens, Linda. "Bienniale Takes Up
the Fight for Emerging Artists."
Asian Art News 4, no. 2 (1994).
Saint-Germain, Esther de Charon de.
"Orientation." *IIAS Newsletter*, no. 5
(Summer 1995).
Supangkat, Jim. "Menggali Estetika Jawa."
Tempo (Mar. 21, 1992).
Wright, Astri. "Young Painters Synthesize
Tradition and Modernism." *Jakarta Post*
(July 16, 1989).
———. "Two Artists, Two Bridges, One
World." *Jakarta Post* (May 21, 1990).
———. "Drinken Uit de Beker van
Traditie: Moderne Kunst in
Yogyakarta." *Museum Journal* (September
1993).
———. *Soul, Spirit, and Mountain:
Preoccupations of Contemporary Indonesian
Painters.* New York: Oxford University
Press, 1994.

Arahmaiani

Born in Bandung, Indonesia, 1961
Resides in Bandung, Indonesia

Education

1983 B.F.A., painting, Bandung Institute
of Technology

1985–86 Paddington Art School, Sydney

1991–92 Akademie voor Beeldende Kunst,
Enschede, the Netherlands

Solo Exhibitions

1980 *Accident I* (environmental installation),
Bandung

1983 *Independent Feast* (environmental
installation), Bandung

1992 *From Pieces to Become One — Homage to
Joseph Beuys* (installation), Enschede

1994 Drawing exhibition, Gallery Café
Cemara 6, Jakarta
"Sex, Religion, and Coca-Cola," Oncor
Studio, Jakarta

1995 *Coke Circle* (installation), Claremont
Art School, Perth, Australia

Solo Performances

1981 "Newspaper Man," Bandung

1982 "Black Bamboo and White Cloth,"
Bandung

1987 "My Dog Is Dead and Then He
Flew," Centre Cultural Français,
Bandung

1990 "Knocking the Door," Malioboro
Street, Yokyakarta

1994 "Intersection Flower," Lembah
UGM, Yogyakarta

1995 "Friday Sermon," Claremont Art
School, Perth

Group Exhibitions

1984 "Fibre Art and Design," Sydney
Textile Museum

1993 Biennale IX, Taman Ismail Marzuki,
Jakarta (catalogue)

1994 "5+5," Purna Budaya, Yogyakarta;
Erasmus Huis, Jakarta
Indonesia in Emergency Aid (installation),
Purna Budaya, Yokyakarta (catalogue)

1995 "Unity in Diversity: Contemporary
Art of the Non-Aligned Countries,"
National Gallery, Jakarta (catalogue)

1996 2nd Asia-Pacific Triennial of
Contemporary Art, Queensland Art
Gallery, Brisbane (catalogue)

Collaborative Projects

1985 "Kering" (theater work), Rumentang
Siang, Bandung

1989 "Off the Record" (musical work),
GKJ, Jakarta

1990 "Multi Media," Akademi Seni Tari
Indonesia, Bandung

Selected Bibliography

Arahmaiani. "From Ivory Tower to Control Tower." *Pikiran Rakyat* (Apr. 7, 1987).

_____. "In Need of Cultural Strategy." *Pikiran Rakyat* (Apr. 21, 1987).

_____. "The Green Book." *Horizon* (August 1992): 276–85.

_____. "Balance, Change, Continuity." *Surat Gorong-Gorong Budaya* 3, no. 4 (1994): 18–19.

"Arahmaiani: In Pursuit of Dialogue." *Media Budaya*, no. 1 (November 1994).

"Arahmaiani: `I Have Found Liberation.'" *Khazanah* (Feb. 3, 1995).

"Artist's Voice." *Asian Art News* 4, no. 2 (1994): 18.

"ARX Shocks: What Criteria for Success?" *Free Broadsheet* 24, no. 2 (1995): 18–19.

"Asia-Pacific Art Forum: Dialogue and Exploration." *Kompas* (April 1995).

Indonesia Business Weekly (Jan. 14, 1994): 17.

"Indonesia's Artist Pushed Beyond the Modern." *Jakarta Post* an. 13, 1994): 7.

"In the Shadow of Advertisement." *Kompas* (Sept. 11, 1994).

"Not a Black-and-White Process." *Indonesia Business Weekly* (Feb. 25, 1994): 21.

"The Restless One on the Crossroad." *Tempo* (Feb. 7, 1987): 61–62.

"Sex and Coca-Cola." *Indonesia Business Weekly* (Sept. 2, 1991): 20.

"Talk, Torque, and the Garden Knot?" *Artlink* 15, nos. 2–3 (1995): 9–10.

"Torque." *Art and Asia Pacific* 2, no. 4 (1995): 9.

Agnes Arellano

Born in Manila, the Philippines, 1949
Resides in Quezon City, the Philippines

Education

1971 B.A., psychology, University of the Philippines, Quezon City

1971–72 Studies in clinical psychology, Ateneo de Manila University

1976 Dégré Supérieure, French language and culture, Université de la Sorbonne, Paris

1979–83 Studies in sculpture, University of the Philippines, Quezon City

Solo Exhibitions

1990 "Myths of Creation and Destruction II: The Temple of the Sun God," Mitsubishi-Jisho Atrium, Fukuoka, Japan (catalogue)

1995 "A Posterior View of Apartheid," Crucible Gallery, Manila

Selected Group Exhibitions

1981 "Five Faces," Sining Kamalig at the Regent, Manila

1982 "Five and Other Faces," Manila Peninsula Gallery, Makati City

1983 "Six Artists," Museum of Philippine Art, Manila (catalogue)

1986 "Exchange: Berlin-Manila," Pinaglabanan Galleries, Manila (catalogue)

1988 "Exchange: Manila-Berlin," Raab Galerie, Berlin (catalogue)

"Fire and Death: A Labyrinth of Ritual Art," Pinaglabanan Galleries, Manila

"Thirteen Artists," Cultural Center of the Philippines (CCP), Manila (catalogue)

1989 "Sikat: Two Decades of Philippine Art," CCP, Manila

3rd Asian Art Show, Fukuoka Art Museum, Fukuoka (catalogue); traveled to Seoul and Yokohama

1991 "Iskultura: From Anito to Assemblage," Metropolitan Museum of Manila (catalogue)

1992 "Looking for the Tree of Life: A Journey to Asian Contemporary Art," Museum of Modern Art, Saitama, Japan (catalogue)

1993 4th Baguio Art Festival, Baguio Convention Center, Baguio, the Philippines

1994 "Asian Art Now," Hiroshima Museum of Contemporary Art

5th Bienal de la Habana, National Museum, Havana (catalogue)

1995 "Africus," Johannesburg Biennale (catalogue)

"Ako: Self-Portraits from 1800s to 1995," Metropolitan Museum of Manila

Honors and Awards

1988 Patnubay ng Sining at Kalinangan (Guardian of Art and Culture), City of Manila Award for the Visual Arts

Thirteen Artists Award, Cultural Center of the Philippines, Manila

1990 Outstanding Alumna, St. John's Academy, Manila

Selected Bibliography

Adams, Michael. "Naked Inscapes." *Business World* (Oct. 24–26, 1990).

Angara, Ana M. "Artists as They See Themselves." *Sunday Inquirer Magazine* (Aug. 27, 1995): 10–12.

Cajipe-Endaya, Imelda. "Images of Women: Questions We Ask Ourselves." *Artlink* 13, nos. 3–4 (1993): 89–90.

Enriquez, Marge. "This Exhibition Presents Burning Issues." *Business World* (May 26, 1988): 16.

Gatbonton, Juan T., ed. *Art Philippines.* Manila: Crucible Workshop, 1992, pp. 339–41.

Glanz, Alexandra. "Machwechsel in Manila." *Der Tagesspiegel* (July 8, 1988).

Guillermo, Alice. "Faces Young and New." *The Observer* (Manila) (Mar. 7, 1982): 30–31.

Kuhlbrodt, Detlef. "Virgin Killer: Manila-Berlin Exchange in Der Raab Galerie." *Taz Berlin (Die Tageszeitung)* (July 4, 1988): 17.

Labrador, Ana. "Beyond the Fringe." *Art and Asia Pacific* 2, no. 2 (1995): 84–97.

Lolarga, Elizabeth. "Inside Agnes Arellano." *Sunday Times Magazine* (Mar. 24, 1995): 6–8.

Poshyananda, Apinan. "First-Rate Art from the Third World." *Bangkok Post* (July 11, 1994).

Schafer, Annette. "Filipino Artists in the Raab Galerie: Experiences of Violence." *Volksblatt Kultur* (July 10, 1988): 7.

Shalala, Nancy. "Exhibit Opens New Windows onto Vibrant Contemporary Asian Art." *Japan Times* (July 19, 1992).

Sy, Mae Luna. "Agnes after the Sun God." *Philippine Graphic Magazine* (Nov. 26, 1991): 24–25.

Tiongson, Nicanor G. *Tuklas Sining: Essays on the Philippine Arts.* Manila: Cultural Center of the Philippines, 1991, pp. 324–25.

Ushiroshoji, Masahiro. "Fascinating Asian Art: Metaphor for the Universe in the Body of Woman." *Nishinippon Shinbun* (July 11, 1989).

_____. "An Asian Summer: Modern Art of Asia." *Fukuoka Style* 1 (1991): 96–107.

_____. "Philippine Contemporary Art and Narrative of Roberto Feleo and Others." *Ethno-Arts* 2, no. 2 (1992): 93–107.

Villa, Maricor T. de. "Agnes Arellano: Woman Sculptor." *Philippine Panorama* (May 8, 1983): 44–50.

Yuson, Alfred A. "Agnes of God and Goddesses." *Manila Times* (Sept. 16, 1990): 19.

I Wayan Bendi

Born in Desa Batuan, Gianyar, Bali, Indonesia, 1950
Resides in Desa Batuan, Gianyar, Bali, Indonesia

Education

Studied with his father, I Wayan Taweng, a traditional painter

Exhibitions

1980–84 Bali Arts Festival

1983 Taman Budaya, Denpasar, Bali (catalogue)

1985 2nd Asian Art Show, Fukuoka Art Museum, Fukuoka, Japan (catalogue)

1986 "Bali Arts Festival," Keio Department Store, Tokyo (catalogue)

1989 Taman Budaya, Denpasar

1990 "Modern Indonesian Art: Three Generations of Tradition and Change, 1945–1990," Festival of Indonesia 1990, Sewall Gallery, Rice University, Houston (catalogue); traveled to San Diego, Oakland, Seattle, and Honolulu

1991 "The Integrative Art of Modern Thailand," Lowie Museum of Anthropology, University of California, Berkeley (catalogue); traveled to Madison, Wisc.; Tempe, Ariz.; Seattle; and Santa Ana, Calif.

1992 Casa Luna, Ubud, Bali (catalogue)

1993 "Indonesian Modern Art," Oude Kerk, Amsterdam (catalogue)

1994 Jakarta International Fine Arts Exhibition 1994, Indonesia Fine Arts Foundation, Jakarta (catalogue)

1995 Regent Hotel/Indonesia Fine Arts Foundation, Jakarta (catalogue)

Honors and Awards

1991 Award from Indonesian government for work in "The Integrative Art of Modern Thailand," Berkeley

1992–93 Annual award of the Bali Provincial Government for work in "Indonesian Modern Art," Oude Kerk, Amsterdam

Public Collections

Agus Dharmawan, Jakarta
Fine Art Gallery, Agung Rai, Bali
Marine Messe, Fukuoka, Japan
Neka Museum, Ubud, Bali
Puri Lukisan, Ubud, Bali
Titiek Prabowo, Jakarta
Tossin Himawan, Jakarta
University of California, Berkeley

Selected Bibliography

Ketika Kata, Ketika Warna/In Words, In Colours. Jakarta: Yayasan Ananda, 1995.

Neka, Suteja. *The Development of Painting in Bali.* Translated by Garrett Kam. Ubud: Yayasan Dharma Seni Museum Neka, 1989.

Montien Boonma

Born in Bangkok, Thailand, 1953
Resides in Nonthaburee, Thailand

Education

1978 B.F.A., painting, Silpakorn University, Bangkok

1986–88 Studies in sculpture, École Nationale Supérieure des Beaux-Arts, Paris; Maîtrise Nationale en Arts Plastiques, University of Paris VIII

1989 M.F.A., painting, Silpakorn University, Bangkok

Solo Exhibitions

1989 "Story from the Farm," National Gallery, Bangkok (catalogue)

1990 "Form and Material," Visual Dhamma Gallery, Bangkok
"ThaiahT (Thai-Thai)," National Gallery, Bangkok (catalogue)

1991 "Aum," Visual Dhamma Gallery, Bangkok
"Montien Boonma: The Pagoda and Cosmos Drawn with Earth," Japan Foundation ASEAN Culture Center

Gallery, Tokyo/Mitsubishi-Jisho Atrium, Fukuoka, Japan (catalogue)

1992 "Arte Amazonas," Goethe-Institut, Bangkok

1993 "Works 1991–1993," National Gallery, Bangkok (catalogue)

1994 "Marks of Mind," Silom Art Space, Bangkok

1996 "Container 96: Art Across Oceans," City of Copenhagen

Group Exhibitions

1990 "The Readymade Boomerang," 8th Biennale of Sydney, Art Gallery of New South Wales (catalogue)
"Von der Natur in der Kunst," Wiener Festwochen, Messepalast, Vienna (catalogue)

1991 "The Integrative Art of Modern Thailand," Lowie Museum of Anthropology, University of California, Berkeley (catalogue); traveled to Madison, Wisc.; Tempe, Ariz.; Seattle; and Santa Ana, Calif.

1992 "Arte Amazonas," Museu de Arte Moderna, Rio de Janeiro (catalogue); traveled to Brasilia and Berlin
"New Art from Southeast Asia 1992," Tokyo Metropolitan Art Space (catalogue); traveled to Fukuoka, Hiroshima, and Osaka

1993 1st Asia-Pacific Triennial of Contemporary Art, Queensland Art Gallery, Brisbane (catalogue)
"Prospect '93: An International Exhibition of Contemporary Art," Frankfurt Kunstverein and Schirn Kunsthalle, Frankfurt (catalogue)
"Thai-Australian Cultural Space," National Gallery, Bangkok (catalogue); traveled to Chiang Mai and Sydney

1994 "Adelaide Installations," 1994 Adelaide Biennial of Australian Art, Art Gallery of South Australia, Adelaide (catalogue)
"Faret Tachikawa," project for Tachikawa Prefecture, Art Front Gallery, Tokyo (catalogue)

1995 "Asian Modernism: Diverse Development in Indonesia, the Philippines, and Thailand," Japan Foundation Asia Center, Tokyo (catalogue); traveled to Bangkok, Manila, and Jakarta

"Content/Sense" (two-person exhibition), National Gallery, Bangkok (catalogue)
4th International Istanbul Biennial, Nejat F. Eczacibasi Art Museum/Istanbul Foundation for Culture and Arts (catalogue)
Signboard Project, Fukuoka
"Thai Tensions," Art Center, Chulalongkorn University, Bangkok (catalogue)

1996 "Container '96: Art Across Oceans," City of Copenhagen

Public Collections

Art Gallery of New South Wales, Sydney
Fukuoka Art Museum, Fukuoka, Japan
National Gallery of Australia, Canberra
Olympiade of Art, Olympic Sculpture Park, Seoul
Queensland Art Gallery, Brisbane
Tachikawa Prefecture, Tokyo

Selected Bibliography

Hoskin, John. "Where to Go?" *Artlink* 13, nos. 3–4 (1993): 25–29.

Madoff, Steven Henry. "Pacific Rim: An Art World Blooms." *Art News* 91, no. 6 (1992): 94–95.

Schlagheck, Irma. "Im Hirn wurzolt ein Baumchen Ausstellungen." *Art* (May 1990): 118–21.

Wongchirachai, Albert Paravi. "Montien Boonma." *Art and Asia Pacific* 2, no. 3 (1993): 74–81.

Imelda Cajipe-Endaya

Born in Manila, the Philippines, 1949
Resides in Manila, the Philippines

Education

1970 B.F.A., University of the Philippines, Quezon City

1975–76 Studies in art history and criticism, University of the Philippines, Quezon City

Solo Exhibitions

1969 "Paintings," Delaney Hall, University of the Philippines, Quezon City

1975 "Pintig: Prints and Monoprints," Quad Gallery, Manila

1977 "*Forefathers* and Other Serigraphs," Citibank Center, Manila

1979 "*Mga Ninuno* (Ancestors) and Other Musings on Philippine History," ABC Galleries, Manila (catalogue)

1981 "Paintings: *Woman and Windows*," City Gallery, Manila

1983 "*May Bukas Pa, Inay* (Mother, There's Tomorrow) and Other Mixed Media," Hiraya Gallery, Manila

1985 "*Hulagpos* (Set Free) and Other Mixed Media," Hiraya Gallery, Manila

1988 "*Lupa Sa Aming Altar* (Land Upon My Altar) and Other Mixed Media," Cultural Center of the Philippines (CCP), Manila

1990 "*Inang Lupa* (Mother Earth) and Other Collages," Hiraya Gallery, Manila

1992 "Obando Sketches," Hiraya Gallery, Manila

1995 "Filipina: DH," National Commission on Culture and Arts Gallery, Manila

Selected Group Exhibitions

1980 "Okir: The Epiphany of Philippine Graphic Art," Royal Festival Hall, London (catalogue)

1981 "Philippine Prints," Art East/Art West, Hong Kong

1985 "Grafik der Philipinen," Bayerische Versicherungskammer, Munich (catalogue)

1986 "Art at the Crossroads," CCP, Manila

1987 "Creación Femenina en el Mundo Hispánico," Art Gallery, University of Puerto Rico, Mayaguez

1988 "Arte Hispano-Americano y Filipino," Galleria Espiral, San Juan, Puerto Rico

1989 "Signed, Sealed, and Delivered," Performance Space Gallery, Sydney and ARX '89, Perth (catalogue)

1990 "Mail Order Bride" (installation), Powerhouse Museum, Sydney

1991 "Third World and Beyond," Galleria Civica di Arte Contemporanea, Marsala, Italy (catalogue)

1992 "Ang Babae (The Woman)," KASIBULAN Foundation and CCP, Manila
"The Boundary Rider," 9th Biennale of Sydney, Art Gallery of New South Wales (catalogue)

1993 "Filipina: Migranteng Mangga-
gawa," KASIBULAN Foundation
and CCP, Manila

1st Asia-Pacific Triennial of Contemporary
Art, Queensland Art Gallery, Brisbane
(catalogue)

1994 "Taka at Takaan ng Paete (Moulds
and Papier-Mâché of Paete)," CCP,
Manila

1995 "Asian Modernism: Diverse
Development in Indonesia, the
Philippines, and Thailand," Japan
Foundation Asia Center, Tokyo (cata-
logue); traveled to Bangkok, Manila,
and Jakarta

1996 "Memories of Overdevelopment,"
University of California, Irvine

Honors and Awards

1972 First Prize, National Printmaking
Competition, Philippine Association
of Printmakers

1979 Gold Medal (Printmaking), Annual
Competition, Art Association of the
Philippines

1980 Critics' Choice, Ma-Yi Art
Associates, Manila

1990 First Gawad CCP Para Sa Sining
Biswal (Award for Visual Arts), Cultural
Center of the Philippines, Manila

1995 Special Award, Outstanding
Installation, Cheju Biennale, Cheju,
Korea

Public Collections

Ateneo de Manila University
Cultural Center of the Philippines, Manila
National Museum of Modern Art,
Singapore
National Museum of the Philippines,
Manila

Selected Bibliography

"Artist's Voice." *Asian Art News* 3, no. 5
(1993).
Benesa, Leonidas V. *The Printmakers.*
Manila: BNFI, 1975.
Collins, Kate. "Looking East: A Feminist
View." *Courier Mail* (Brisbane) (Sept. 24,
1993).
Ewington, Julie. "Feminism, Art, and
Advocacy in the Philippines." *Artlink* 12
(Autumn 1994).
Gatbonton, Juan T., ed. *Art Philippines.*
Manila: Crucible Workshop, 1992.

Guillermo, Alice. "Endaya's Winds
of Change." *The Observer* (Manila)
(Dec. 13, 1981).
_____. *Social Realism in the Philippines.*
Quezon City: Asphodel Books, 1987.
Javelosa, Jeannie. "Contemporary
Indigenous Statements." *Artlink* 13,
nos. 3–4 (1993).
Labrador, Ana. "Beyond the Fringe."
Art and Asia Pacific 2, no. 2 (1995): 84–97.
Pilar, Santiago. "How Very Filipino."
Philippine Star (Sept. 18, 1990).
Salanga, Alfredo Navarro. *Imelda Cajipe
Endaya.* Manila: ASEAN Institute of
Art, 1984.
Torres, Emmanuel. "Internationality."
Art and Asia Pacific 1, no. 1 (1993).

Cho *Duck Hyun*

Born in Hoengsong, Korea, 1957
Resides in Seoul, Korea

Education

1984 B.F.A., painting, Seoul National
University

1987 M.F.A., painting, Seoul National
University

Solo Exhibitions

1988 "Cho Duck Hyun, 1983–1988,"
Gallery Hyundai, Seoul

1990 "Cho Duck Hyun, 1988–1990,"
Seoul Arts Center
"Did East Meet West?," Gallery ROHO,
Berlin

1991 "A Memory of the 20th Century I,"
Seoul Arts Center

1992 "The History of Korean Women,"
Gallery Meegun, Seoul
"A Memory of the 20th Century II,"
National Museum of Contemporary
Art, Seoul

1993 "L.A. International," Dorothy
Goldeen Gallery, Santa Monica, Calif.
"Wall, Boxes, and ...," Kukje Gallery,
Seoul

1994 "New Wind of Asia," Sogetsu Art
Museum, Tokyo

1995 "Boxes," Dorothy Goldeen Gallery,
Santa Monica, Calif.

"Cho Duck-Hyun," Institute of
Contemporary Art, University of
Pennsylvania, Philadelphia (catalogue)

Selected Group Exhibitions

1987 "Artists of Today," Kwanhoon
Gallery, Seoul

1988 "Inaugural Exhibition by Artists Cho
Duck-Hyun, Park Soon-Ok, and Kang
Sung-Won," Indeco Gallery, Seoul
"Late Modernism Show," Trade Center,
Gallery Hyundai, Seoul

1989 "Contemporary Korean Art," Total
Museum of Contemporary Art, Seoul
Korean Young Artists Biennale, National
Museum of Contemporary Art, Seoul

1990 "The Contemporary Korean Art
Presentiment of the Twenty-First
Century," Total Museum of
Contemporary Art, Seoul
"Divinity-Art-Sex," Yeil Gallery, Seoul

1991 Festival International de la Peinture
de Cagnes, Cagnes-sur-Mer, France
"Horizon of Art at the Turning Point,"
Kumho Museum of Art, Seoul
"Informel après Informel," Chosun Ilbo
Museum, Seoul
"Peinture Coréenne Moderne," Fondation
Vasarely, Annet-sur-Marne, France
20th Anniversary Exhibition, Chosun
Gallery, Seoul

1992 "Art and Photography," Seoul
Arts Center
"Korean Contemporary Paintings,"
Artcore Annex, Los Angeles

1993 1st Asia-Pacific Triennial of
Contemporary Art, Queensland Art
Gallery, Brisbane (catalogue)
"Recollection and Union of the Korean
People," Batanggol Gallery, Seoul
"Recycling through Art," Taejon Expo,
Recycling Art Pavilion, Taejon, Korea

1994 "From the Antipodes," São Paulo
Biennale
"Realism as an Attitude," 4th Asian Art
Show, Fukuoka Art Museum, Fukuoka,
Japan (catalogue); traveled to Hakone,
Akita, and Tokyo
"Reconciliation and Union of the Korean
People II," Galleria Museum, Seoul

1995 "Circulating Currents: Japanese-
Korean Contemporary Art," Aichi
Prefecture Museum of Art/Nagoya
City Museum of Art, Nagoya, Japan
(catalogue)
"Front D.M.Z.," Sangmumdang Gallery,
Seoul
"Information and Reality: Korean
Contemporary Art," Fruitmarket
Gallery, Edinburgh (catalogue)
"Korean Contemporary Paintings,"
Chinese Museum, Beijing
"The Tiger's Tail: Fifteen Korean
Contemporary Artists for Venice '95,"
15th Venice Biennale (catalogue);
traveled to Seoul
"Total Art Awards Show," Total Museum
of Contemporary Art, Seoul

Honors and Awards

1989 Special Prize, Grand Art Exhibition
of Korea

1990 Grand Prize, Dong-A Art Festival

1991 Special Prize, Total Museum of
Contemporary Art, Seoul

Selected Bibliography

Cunahan, Christine O. "Blown in from
Korea." *Asahi Evening News* (Sept. 15,
1994).
Heartney, Eleanor. "Report from Korea."
Art in America (July 1993).
Hornik, Susan. "South Korea: A High-
Risk Tightrope Act." *Art News* (Summer
1992).
Kandel, Susan. "Photographic Memories
of Duck Hyun Cho." *Los Angeles Times*
(Mar. 11, 1993).
Kim Hee-Sun. "Cold Gaze, Firm
Plasticity." *Wolgan Misool* (May 1990).
Kim Sung. "Artist Paints the Parade of
History with Old Black-and-White
Photography." *Elle* (September 1993).
Kim Tae-Ik. "Cho Duck Hyun's Seventh
Solo Show." *Chosun Ilbo* (Apr. 20, 1992).
Levin, Kim. "Report from Seoul." *Sculpture*
(November–December 1992).
Oh Byung-Wook. "The History of Korean
Women Reilluminating Modern
History." *Wolgan Misool* (May 1992).
Seo Sung-Rok. "Opposition and
Reconciliation: Meaning of
Multistructure." *Wolgan Misool*
(April 1991).
Yoon Chul-Kyu. "São Paulo Biennale:
The Boom of Korean Art." *Joong-Ahng
Ilbo* (July 22, 1994).

Choi *Jeong-Hwa*

Born in Pusan, Korea, 1961
Resides in Seoul, Korea

Education

1987 B.F.A., Hong-Ik University, Seoul

Selected Group Exhibitions

1987 "Museum," Kwanhoon Gallery, Seoul

1988 "After Modernism," National Museum of Contemporary Art, Seoul
"Contemporary Korean Art in the '80s," National Museum of Contemporary Art, Seoul
"The Phase of Korean Art in the '80s," Hangang Gallery, Seoul
"Present Images," Gallery Hyundai, Seoul

1990 "Mixed Media," Kumho Museum of Art, Seoul
"New Images and Structures," Woong Gallery, Seoul

1991 "Made in Korea," Sonamoo Gallery, Seoul
"Shock of Hangul," Sejong Cultural Center, Seoul

1992 "Art and Philosophy," Seoul Arts Center
"Bio-Installation," Space Ozone, Seoul
"Diet," Sagak Gallery, Seoul
"Floating Gallery," Warehouse, Tokyo

1993 "Across the Pacific," Queens Museum of Art, Flushing, N.Y. (catalogue)
"Photography Today in Seoul," Walker Hill Art Center, Seoul
"Plastic Spring," Dukwon Gallery, Seoul

1994 "Dish Washing," Kumho Museum of Art, Seoul
"Horizon of Korean Photography," Gongpyong Art Center, Seoul
"Realism as an Attitude," 4th Asian Art Show, Fukuoka Art Museum, Fukuoka, Japan (catalogue); traveled to Hakone, Akita, and Tokyo
"View of the Next Generation," Seoul Arts Center

1995 "Territory of Mind: Korean Art of the 1990s," Contemporary Art Gallery, Art Tower, Mito, Japan
"Visions of Happiness," Japan Foundation ASEAN Cultural Center, Tokyo (catalogue)
World Artists Festival, Fukuoka

1996 2nd Asia-Pacific Triennial of Contemporary Art, Queensland Art Gallery, Brisbane (catalogue)

Honors and Awards

1986 First Prize, Joong-Ahng Daily News Art Competition

1987 Grand Prize, Joong-Ahng Daily News Art Competition

Public Collections

Fukuoka Art Museum, Fukuoka, Japan
Sonje Museum of Contemporary Art, Seoul

Selected Bibliography

Ahn Sang-Soo and Choi Jeong-Hwa. "Interview." *Bogosuh Bogosuh* 6 (July 1991): 80–89.
Erimi. "Visions of Happiness." *Brutus* (March 1995): 15.
Gaori. "Question of Worth." *Korean Culture* (August 1995): 64.
Hansen, Dana Friis. "Choi Jeong-Hwa." *Flash Art* (February 1995): 85.
Kang Hye-Kyung, Jung Bang-I, and Choi Jeong-Hwa. "Dial Tone from the Unknown." *Art Education* (May 1995): 188–92.
Kim Chang-Seob. "Territory of Mind." *Asiana* (September 1995): 64–69.
Kim Hyun-Do. "Silence and Screaming." *Art World* (February 1992): 60–63.
_____. "Between the Winter of Creation and the Summer of Criticism." *Munhak Jungshin* (March 1994): 165.
_____. "Waiting for Cold Noodles." *Munhak Jungshin* (July 1994): 7–10.
_____. "Shadow Menu." *Gana Art* (May–June 1995): 54.
Kim Joo-Yun. "Korea: Dadaism." *Architectural Review* (September 1995): 86–90.
Kim Tae-Ik. "Heated Rebellion." *Chosun Ilbo* (July 1995).
Kuroda, Raiji. "Contemporary Asian Art—Inside and Out." *Art Express* 6 (Spring 1995): 32–42.
Lee, James B. "Choi Jeong-Hwa." *Asian Art News* (January–February 1995).
Lee Young-Ook. "Kitsch Art, Our Culture." *Art and Culture* (October 1992): 22–25.
_____. "Choi Jeong-Hwa: Fragmentary Afterthoughts." *Munhak Jungshin* (April 1994): 61–63.
Park Shin-Ae. "Change of Impressions: Rebellion Towards High-Class Art." *Art Monthly* (July 1992): 119–25.
Speaking of Image. Seoul: Munae Madang, 1995, pp. 177–205, 223–34.
Takiguchi, Noriko. "Choi Jeong-Hwa." *Tokyojin* (May 1995): 165.

Dadang Christanto

Born in Tegal, Central Java, Indonesia, 1947
Resides in Yogyakarta, Indonesia

Education

1975–79 Indonesia Institute of the Arts, Yogyakarta

1986 B.F.A., painting, Indonesia Institute of the Arts, Yogyakarta

Solo Exhibitions

1991 "Contemporary Indonesian Artist," University of South Australia Art Museum, Adelaide/Victoria College of the Arts, Melbourne (catalogue)

1992 "I Am Human Being"/"Earth Man in Tenjin," City of Fukuoka, Japan (performance)

1993 "For Those Who Have Been Killed" (performance), Queensland Art Gallery, Brisbane

1995 "Terracotta or the Case of Land," Bentara Budaya Gallery, Yogyakarta

1996 *1001 Earth Humans* (installation), Marina Beach, Jakarta

Group Exhibitions

1992 Museum City Project '92, Fukuoka
"New Art from Southeast Asia 1992," Tokyo Metropolitan Art Space (catalogue); traveled to Fukuoka, Hiroshima, and Osaka

1993 Biennale IX, Taman Ismail Marzuki, Jakarta (catalogue)
1st Asia-Pacific Triennial of Contemporary Art, Queensland Art Gallery, Brisbane (catalogue)

1994 5th Bienal de la Habana, National Museum, Havana (catalogue)
"Nur Gora Rupa," Taman Budaya Surakarta, Solo, Indonesia
"Realism as an Attitude," 4th Asian Art Show, Fukuoka Art Museum, Fukuoka (catalogue); traveled to Hakone, Akita, and Tokyo

1995 "Asian Peace Art, War, and Art 1995," Osaka International Peace Center, Osaka, Japan
"Osaka Triennial 1995: Sculpture," Dome Exhibition Hall, Osaka

Public Collections

Fukuoka Art Museum, Fukuoka, Japan
Queensland Art Gallery, Brisbane
Widayat Museum, Magelang, Indonesia

Selected Bibliography

Bakarudin. "Manusia Tanah Yang Kritis." *Tiras Magazine* (July 13, 1995): 78.
Dudley, Jenni. "Considering the Issues: An Installation of Work by Dadang Christanto, Contemporary Indonesian Artist." *Artlink* 11, no. 3 (1991): 56–58.
Dwi Marianto, Martinus. "Metafora Gerabah Dadang Christanto." *Kompas* (July 9, 1995).
Fadjri, R. "Kekerasan Dalam Instalasi Keramik." *Forum Keadilan* (July 17, 1995).
_____. "Pameran Pembangunan Dadang Christanto." *Media Indonesia* (June 1995).
Fakih, Mansour. "Karya Seni dan Transformasi Sosial." *Media Indonesia* (June 1995).
Megaw, Vincent. "Visual Art: Indonesian Art with a Message." *The Advertiser* (August 1991): 16.
Radok, Stephanie. "Different Demons." *Adelaide Review* (September 1991).
Ward, Peter. "Out of Batik, into the Real World." *Entertainment and the Arts* (Aug. 26, 1991).
Westwood, Matthew. "Suffering Souls Soar in Asia-Pacific Showpiece." *The Australian* (Sept. 16, 1993): 6.
Wright, Astri. "Resistance and Memory in the Visual Field." *Jakarta Post* (July 9, 1995).

Heri Dono

Born in Jakarta, Indonesia, 1960
Resides in Yogyakarta, Indonesia

Education

1980–87 Indonesia Institute of the Arts, Yogyakarta

1987–88 Studied Wayang Kulit with Sukasman

1990–91 International Artist Exchange Program, Basel

Selected Solo Exhibitions

1988 Cemeti Gallery, Yogyakarta
Mitra Budaya Indonesia Gallery, Jakarta

1991 "Unknown Dimensions," Museum für Völkerkunde, Basel

1993 "Heri Dono: The Chair," Canberra Contemporary Art Space

1996 "Blooming in Arms," Museum of Modern Art, Oxford, (catalogue)

Selected Performances

1988 "Wayang Legenda" (shadow play), Seni Sono Gallery, Yogyakarta

1989 "Wayang Imaginative," Mendut Temple, Central Java

1991 "Destructive Images," Seni Sono Gallery, Yogyakarta
"Wayang Top," International Cultural Camp, Desa Apuan, Tabanan, Bali

1994 "Kuda Binal," Centre for Contemporary Art, Darwin, Australia

Selected Group Exhibitions

1982 "Art on the Environment," Parangtritis Beach, Yogyakarta

1984 4th Biennale of Indonesian Young Artists, Taman Ismail Marzuki, Jakarta

1986 5th Biennale of Indonesian Young Artists, Taman Ismail Marzuki, Jakarta
"Experimental Music and Visual Art," Seni Sono Gallery, Yogyakarta

1987 Cultural Center of the Philippines, Manila

1988 "Hendendaagse Indonesische Kunst," Volkenkundig Museum Nusantara, Delft, the Netherlands

1990 "Modern Indonesian Art: Three Generations of Tradition and Change, 1945–1990," Festival of Indonesia 1990, Sewall Gallery, Rice University, Houston (catalogue); traveled to San Diego, Oakland, Seattle, and Honolulu

1991 "Sama-Sama," Centrum Beeldende Kunst Oosterpoort, Groningen, the Netherlands (catalogue); traveled to Tilburg, the Netherlands; Yogyakarta; and Jakarta
"Wayang: From Gods to Bart Simpson," University of British Columbia, Vancouver

1992 "New Art from Southeast Asia 1992," Tokyo Metropolitan Art Space (catalogue); traveled to Fukuoka, Hiroshima, and Osaka

1993 1st Asia-Pacific Triennial of Contemporary Art, Queensland Art Gallery, Brisbane (catalogue)
"Indonesian Modern Art," Oude Kerk, Amsterdam (catalogue)
International Festival of Puppetry, Taman Budaya, Yogyakarta

1994 "Adelaide Installations," 1994 Adelaide Biennial of Australian Art, Art Gallery of South Australia, Adelaide (catalogue)
Jakarta International Fine Arts Exhibition 1994, Indonesia Fine Arts Foundation, Jakarta (catalogue)
"Realism as an Attitude," 4th Asian Art Show, Fukuoka Art Museum, Fukuoka, Japan (catalogue); traveled to Hakone, Akita, and Tokyo

1995 "Beyond the Border," 1st Kwangju Biennale 1995, Kwangju, Korea (catalogue)
"Unity in Diversity: Contemporary Art of the Non-Aligned Countries," National Gallery, Jakarta (catalogue)
"Visions of Happiness," Japan Foundation ASEAN Cultural Center, Tokyo (catalogue)

1996 "Modernity and Beyond," National Museum of Modern Art, Singapore (catalogue)
"Orientation," Stedelijk Museum de Lakenhal, Leiden (catalogue)

Honors and Awards

1981/85 Best Painting, Indonesia Institute of the Arts, Yogyakarta

1989 Young Indonesian Artists, L'Alliance Française and Bandung Institute of Technology

1992 I Gusti Nyoman Lempad Prize, Sanggar Dewata Indonesia, Yogyakarta

Public Collections

artoteek den haag, The Hague
Cemeti Gallery, Yogyakarta
Fukuoka Art Museum, Fukuoka, Japan
Indonesia Institute of the Arts, Yogyakarta
Museum für Völkerkunde, Basel, Switzerland
National Museum of Modern Art, Singapore
Queensland Art Gallery, Brisbane

Selected Bibliography

"Alternative Approaches for Artistic Expression." *Brisbane Review* (Sept. 16, 1993).
Daniswara, Ugeng T. "Kartunal, Lukisan-Lukisan Heri Dono." *Laras* 46 (October 1992).
Dwi Marianto, Martinus. "The Experimental Artist Heri Dono from Yogyakarta and His `Visual Art' Religion." *Art Monthly Australia* (October 1993): 21–24.
Supangkat, Jim. "Indonesia Report: A Different Modern Art." *Art and Asia Pacific* (September 1993): 20–24.
Waldmann, Thomas. "Eine Figurenwelt mit indonesischen Wurzeln." *Basler Zeitung* (Jan. 17, 1991).
Wright, Astri. "Dono Tries to Expand the Use of `Wayang' Puppets." *Jakarta Post* (Oct. 6, 1988).
Wright, Astri. *Soul, Spirit, and Mountain: Preoccupations of Contemporary Indonesian Painters.* New York: Oxford University Press, 1994.

Sheela Gowda

Born in Bhadravati, Karnataka, India, 1957
Resides in Bangalore, India

Education

1979 Diploma, painting, Ken School of Art, Bangalore

1979–80 Studies in painting, Maharaja Sayajirao University, Baroda

1982 Post-diploma, painting, Visvabharati University, Santiniketan, West Bengal

1986 M.F.A., Royal College of Art, London

Solo Exhibitions

1987 Venkatappa Art Gallery, Bangalore

1989 Gallery 7, Bombay (catalogue)

1993 "Anatomy of Sacrilege," Gallery Chemould, Bombay (catalogue)
Venkatappa Art Gallery, Bangalore

Selected Group Exhibitions

1981 Annual Exhibition, Karnataka Lalit Kala Akademi, Bangalore

1982 Annual Exhibition, Karnataka Lalit Kala Akademi, Bangalore

1984 National Exhibition of Art, Lalit Kala Akademi, New Delhi (catalogue)

1985 Annual Exhibition, Karnataka Lalit Kala Akademi, Bangalore

1986 Degree Show, Royal College of Art, London (catalogue)

1987 Gallery 7, Bombay (two-person exhibition, catalogue)

1988 2nd Biennale, Bharat Bhavan, Bhopal (catalogue)

1989 "Timeless Art," Victoria Terminus, Bombay (catalogue)

1994 "Tangente," Schaffhausen, Switzerland
"Africus," Johannesburg Biennale (catalogue)
"Art and Nature," Buddha Jayanti Park, New Delhi
"Immaterial-Material," Bangalore (catalogue)

Honors and Awards

1984 Inlaks Foundation Scholarship

1985 Karnataka Lalit Kala Akademi Award

Selected Bibliography

Jakimowicz-Karle, Marta. "About Things Sensual and Violent." *India Magazine* (May 1993): 64–72.
Nair, Janaki. *Economic Times* (Bombay-Bangalore) (Apr. 12, 1993): 6.
Sahani, Roshan. *Sunday Times of India* (July 25, 1993): 5.

FX Harsono

Born in Blitar, East Java, Indonesia, 1948
Resides in Jakarta, Indonesia

Education

1969–74 Indonesia Institute of the Arts, Yogyakarta

1987–91 Jakarta Art Institute, Jakarta

Solo Exhibitions

1988 Jakarta Art Institute Gallery

1994 "Suará (Voice)," National Art Gallery, Gambir, Jakarta

Selected Group Exhibitions

1973 "Kelompok Lima Pelukis Muda Yogyakarta," Solo, Indonesia

1974 All-Indonesia Painting Exhibition I,
 Taman Ismail Marzuki, Jakarta
Balai Budaya, Jakarta
PPIA, Surabaya, Indonesia

1975 "Concept: New Art Movement I,"
 Taman Ismail Marzuki, Jakarta

1976 "New Art Movement," Balai
 Budaya, Jakarta

1977 "New Art Movement II," Taman
 Ismail Marzuki, Jakarta

1979 "New Art Movement III," Taman
 Ismail Marzuki, Jakarta

1982 "Art on the Environment,"
 Parangtritis Beach, Yogyakarta

1985 "Process '85," Galeri Seni Rupa
 Ancol, Jakarta

1986 Purna Budaya, Yogyakarta

1987 "Proyek I: Pasar Raya Dunia
 Fantasi," Taman Ismail Marzuki,
 Jakarta

1992 Artist Regional Exchange (ARX 3),
 Perth Institute of Contemporary Art,
 Perth, Australia

1993 1st Asia-Pacific Triennial of
 Contemporary Art, Queensland Art
 Gallery, Brisbane (catalogue)
4th Baguio Art Festival, Baguio
 Convention Center, Baguio, the
 Philippines

1994 Biennial of Contemporary Art,
 Taman Ismail Marzuki, Jakarta

1995 "Asian Modernism: Diverse
 Development in Indonesia, the
 Philippines, and Thailand," Japan
 Foundation Asia Center, Tokyo
 (catalogue); traveled to Bangkok,
 Manila, and Jakarta

Public Collections
Queensland Art Gallery, Brisbane

Bhupen Khakhar

Born in Bombay, India, 1934
Resides in Baroda, India

Education
1954 B.A., Bombay University

1956 B.C., Bombay University

1964 M.A., art criticism, Maharaja
 Sayajirao University, Baroda

Selected Solo Exhibitions
1965 Jehangir Art Gallery, Bombay

1970 Kunika Chemould Art Centre,
 New Delhi

1972 Black Partridge Gallery, New Delhi

1979 Anthony Stokes Gallery, London
Hester von Royen Gallery, London

1981 Gallery Chemould, Bombay

1982 Urja Art Gallery, Baroda

1983 Contemporary Art Gallery,
 Ahmedabad, India
Gallery Chemould, Bombay
Knoedler Gallery, London (catalogue)

1985 Gallery Chemould, Bombay and
 New Delhi
Hutheesingh Visual Arts Centre,
 Ahmedabad

1986 Gallery Vatari, Tokyo

1989 Gallery Chemould, Bombay

1990 Gallery Chemould, Bombay

1992 Galerie Schoo, Foundation for
 Indian Artists, Amsterdam

1993 Gallery Chemould, Bombay

1995 Kapil Jariwala Gallery, London
 (catalogue)

Selected Group Exhibitions
1982 "Six Indian Painters," Tate Gallery,
 London (catalogue)

1986 "Contemporary Indian Artists,"
 Centre Georges Pompidou, Paris
 (catalogue)

1989 "India Contemporary Art," World
 Trade Center, Amsterdam

1992 Documenta IX, Kassel, Germany
 (catalogue)

1994 "Indian Songs," Perth, Australia
 (catalogue)

1995 "100 Years of Indian Art," National
 Gallery of Art, New Delhi (catalogue)

Honors and Awards
1984 Padmashree, Government of India,
 New Delhi

1986 Asian Cultural Council Fellowship
 in New York

Public Collections
British Museum, London
Chester Herwitz Trust, Worcester, Mass.
Museum of Modern Art, New York
National Gallery of Modern Art,
 New Delhi
National Gallery of Modern Art, Sydney
Victoria and Albert Museum, London

Selected Bibliography
Boin, Louki. "Schilder Bhupen Khakhar."
 Avenue (July 1992).
Desai, Mahendra. *A Man Labelled Bhupen
 Khakhar Branded as Painter.* Bombay:
 Identity People, 1983.
Festival of India (film). London: ITV, 1982.
 Features an interview with Khakhar.
Figures of Thought (film). 1989. Directed by
 Arun Khopkar and featuring Bhupen
 Khakhar, Nalini Malani, and Vivan
 Sundaram.
Hyman, Timothy. "New Figuration in
 India: The Baroda School and Bhupen
 Khakhar." *Art International*, no. 10 (1990):
 60–64.
Lost Portrait (film). London: BBC, 1984.
Messages from Bhupen Khakhar (film).
 London: Arts Council of Great Britain,
 1982.

Kim *Ho-Suk*

Born in Chongup, Korea, 1957
Resides in Seoul, Korea

Education
1981 B.F.A., Hong-Ik University, Seoul

1987 M.F.A., Hong-Ik University, Seoul

Selected Solo Exhibitions
1986 "Traditional Ink Painting,"
 Kwanhoon Gallery, Seoul

1988 Ondara Gallery, Jeonju, Korea

1989 Kwanhoon Gallery, Seoul

1991 Gana Art Gallery, Seoul

1993 Samto Gallery, Seoul

1995 "Traditional Ink Portraiture," Seoul
 Arts Center

Selected Group Exhibitions
1981 "Young Artists," National Museum
 of Contemporary Art, Seoul

1983 "The Best Korean Artists in Eastern
 and Western Style Paintings: An
 Invitational Exhibition," Lotte Gallery,
 Seoul

1986 "Korean Contemporary Ink
 Paintings: The Crossing of Eastern
 and Western Consciousness," Korean
 Culture Center, Paris

1987 "Korean Contemporary Ink and
 Color Paintings," Gallery Korea,
 New York

1988/89 "Contemporary Korean
 Paintings," Ho-Am Art Museum,
 Yongin, Korea

1990 "Deliberation of a Young Artist,"
 National Museum of Contemporary
 Art, Seoul
"Korean Arts: The Current Status," Seoul
 Arts Center

1992 "Spirit of the Tradition: A Search
 for Korean Spirit," Sunam Gallery,
 Seoul

1993 "Across the Pacific," Queens
 Museum of Art, Flushing, N.Y.
 (catalogue)
"Korean Art: An Opening Sanctuary of
 Its Visual Expression," Gallery Grace,
 Seoul
"Working Exhibition of DMZ Art and
 Culture Movement," Municipal
 Museum of Art, Seoul

1994 "Fifteen Years of Minjoong Art,"
 National Museum of Contemporary
 Art, Seoul
"The Recovery of Traditional Ink
 Paintings," Gongpyong Art Center,
 Seoul
"600 Years of Seoul: The Change of
 Scenery," Seoul Arts Center
"27 Korean Contemporary Artists,"
 World Gallery, Pusan, Korea

1995 "The Future of Korean Art," Nara
 Gallery, Seoul
Korean Contemporary Art Festival,
 Magyar Nemzeti Galeria, Budapest

Honors and Awards
1979 Award, 2nd Joong-Ahng Grand Art
 Exhibition, National Museum of
 Contemporary Art, Seoul

1980 Award, 7th Hankook Fine Art
 Exhibition, National Museum of
 Contemporary Art, Seoul

Special Prize, 3rd Joong-Ahng Grand Art
Exhibition, National Museum of
Contemporary Art, Seoul

Public Collections
Ho-Am Art Museum, Yongin, Korea
National Museum of Contemporary Art,
Seoul

Selected Bibliography
Cotter, Holland. "Korean Art Building the
Linkage with the West." *New York Times*
(Dec. 10, 1993).
Kim Eun-Jung. "The Beauty of Formative
Art Expressed in Ink." *Traditional Culture*
(May 1986).
Kim Hee-Sun. "The Artist Who Carries
History on His Shoulder." *Wolgan Misool*
(May 1989): 137–39.
Kim Ho-Suk. "My Hobby: A Penniless
Journey on Foot." *Joong-Ahng Ilbo*
(Apr. 4, 1990).
_____. "An Attempt to Modernize
Traditional Ink Painting Shackled in a
Frame." *Hankuk Ilbo* (June 29, 1993).
_____. "Chosun's Six Best Traditional
Portraits." *Hanna Bank* (Winter 1995):
20–23.
_____. "A Memoir on the Birthplace of
My Art." In *Dreaming Portrait*. Seoul:
Toso Publisher, 1995, pp. 150–78.
Lee Joo-Hyun. "A Trace of Painful
History Blooms in Ink Paintings."
Hankyorae Ilbo (Dec. 7, 1990).
_____. "Searching for a New Direction
in Minjoong Art." *Hankyorae Ilbo*
(May 30, 1993).
Lee Sun-Min. "The Highest Peak in
Confucianism and Buddhism: A
Crossing on a Canvas." *Chosun Ilbo*
(Dec. 13, 1995).
Lee Tae-Ho. "The Historical Portrait with
the Best Traditional Ink Painting Skill."
Wolgan Misool (February 1990): 33.
*The Recovery of Korea: Searching for the
Portrait of Our Generation*, KBS1-TV,
July 14, 1994.
TV Gallery: Portrait, Expression of Life,
EBS-TV, 16 May 1993.
Yoon Chul-Kyu. "Kim Ho-Suk's Solo
Exhibition of Portraits." *Joong-Ahn Ilbo*
(Sept. 25, 1991).

Soo-Ja Kim
Born in Taegu, Korea, 1957
Resides in Seoul, Korea

Education
1980 B.F.A., painting, Hong-Ik University,
Seoul

1984 M.F.A., painting, Hong-Ik
University, Seoul

1984–85 Ecole Nationale Supérieure des
Beaux-Arts, Paris

Solo Exhibitions
1988 Gallery Hyundai, Seoul (catalogue)

1989 On Gallery, Osaka, Japan

1991 Gallery Hyundai, Seoul (catalogue)

1992 Hankook Gallery, Seoul (catalogue)

1994 "Sewing into Walking" (video
performance), Seomi Gallery, Seoul
(catalogue)

Selected Group Exhibitions
1979 "Breath Show" (two-person
exhibition), Growrich Gallery, Seoul
(catalogue)

1983 International Drawing Exhibition,
Seoul Arts Center (catalogue)

1984 Korean Contemporary Art Festival,
Municipal Museum, Taipei, Taiwan
(catalogue)

1985 French Government Scholarship
Exhibition, Galerie Bernanos, Paris

1987 8th International "Impact" Art
Festival, Municipal Museum, Kyoto
(catalogue)

1988 '88 Korean Contemporary Art
Festival, National Museum of
Contemporary Art, Seoul (catalogue)

1989 International Contemporary Art
Festival, Municipal Museum, Berlin
Young Artists Festival, Trade Center/
Hyundai Museum, Seoul (catalogue)

1990 "Impact 3 '90," Galerie Humanité,
Tokyo (catalogue)

1991 "Korean Contemporary Art,"
Sun Jae Museum, Kyongju, Korea
(catalogue)
"Ten Contemporary Korean Women
Artists," National Museum of Women
in the Arts, Washington, D.C./ Seoul
Arts Center (catalogue)

1992 "Artists from Korea," Tenri Gallery,
New York
"Triangle Artists' Show," Lorraine Kessler
Gallery, New York

1990 "In Their Own Image," P.S. 1,
New York (catalogue)
"Open Studio," Clocktower Gallery,
New York
"Semblances," Ise Art Foundation,
New York (catalogue)
"Trade Routes," New Museum of
Contemporary Art, New York
(catalogue)

1994 "Ecole de Seoul," Kwanhoon
Gallery, Seoul (catalogue)
"Women: The Difference and the Power,"
Hankook Gallery, Seoul (catalogue)

1995 "Beyond the Border," 1st Kwangju
Biennale 1995, Kwangju, Korea
(catalogue)
"Circulating Currents: Japanese-Korean
Contemporary Art," Aichi Prefecture
Museum of Art/Nagoya City Museum
of Art, Nagoya, Japan (catalogue)
"Division of Labor: Women's Work in
Contemporary Art," Bronx Museum
of the Arts, New York (catalogue);
traveled to Los Angeles
"Information and Reality: Korean
Contemporary Art," Fruitmarket
Gallery, Edinburgh (catalogue)
Korean Women Artists Festival 1995,
Municipal Museum of Art, Seoul
(catalogue)
6th Triennale Kleinplastik, Süd-West L.B.,
Stuttgart (catalogue)
XVI Biennale Internationale del Bronzetto
e della Piccola Scultura, Palazzo della
Ragione, Padua (catalogue)
"The Tiger's Tail: Fifteen Korean
Contemporary Artists for Venice '95,"
15th Venice Biennale (catalogue);
traveled to Seoul

1996 Akira Ikeda Gallery, Tokyo (two-
person exhibition, catalogue)
"Home/Salon," Clocktower Gallery,
New York

Honors and Awards
1991 Grant from Song-Un Culture
Foundation

1992 11th Suk-Nam Fine Art Prize

1992–93 Korean Culture and Arts
Foundation Fellowship

Public Collections
National Museum of Contemporary Art,
Seoul
National Museum of Women in the Arts,
Washington, D.C.

Selected Bibliography
Anson, Libby. "Division of Labor." *Art
Monthly* (April 1995): 32–33.
Haye, Christian. "Asiana, Transculture,
Tiger's Tail." *Frieze* 24 (September–
October 1995): 66–67.
Hornik, Susan. "South Korea: A High-
Risk Tightrope." *Art News* (Summer
1992).
Kozlova, Natalia. "Stranger to Myself."
Russian-American Daily News (New York)
(July 16, 1993).
Levin, Kim. "Report from Seoul."
Sculpture (November–December 1992).
Ryberg, Barbara. "The Art of Soo-Ja
Kim." *Arirang* (Spring 1993).
Yoon Jin-Sup. "Is the Art Gambling?"
Art Monthly (January 1995).
Yo Jae-Kil. "Formative Characteristics
Shown in Soo-Ja Kim's *Sewing* and
Deductive Object Works." *Art Vivant* 21
(1994).

Nalini Malani
Born in Karachi, India, 1946
Resides in Bombay, India

Education
1964–67 Studio, Bhulabhai Memorial
Institute, Bombay

1969 Diploma, fine arts, Sir J. J. School
of Art, Bombay

Solo Exhibitions
1980 Art Heritage, New Delhi (catalogue)

1982 Pundole Art Gallery, Bombay
(catalogue)

1983 Contemporary Art Gallery,
Ahmedabad, India

1984 Pundole Art Gallery, Bombay
(catalogue)

1986 Pundole Art Gallery, Bombay
(catalogue)

1990 "Under the Skin," Gallery 7,
Bombay (catalogue)

1991 "Hieroglyphs," Gallery Chemould/Jehangir Art Gallery, Bombay (catalogue)

1992 "Hieroglyphs," Sakshi Gallery, Madras and Bangalore
LTG Gallery, New Delhi
"Site-Specific," Gallery Chemould, Bombay

1995 "Bloodlines," Gallery Chemould, Bombay

Videos
1992 "City of Desires," screened at "Africus," Johannesburg Biennale (catalogue)

1994 "Medeamaterial," screened at "Africus," Johannesburg Biennale (catalogue)

1995 "Memory: Record/Erase"

Selected Group Exhibitions
1974 Rabindra Bhavan, New Delhi

1976 Festival of Perth, Australia

1977 Festival International de la Peinture de Cagnes, Cagnes-sur-Mer, France
"Pictorial Space," Lalit Kala Akademi, New Delhi

1979 "Three Artists," Lalit Kala Parishad, Bhopal

1980 "Place for People," Jehangir Art Gallery, Bombay/ Rabindra Bhavan, New Delhi

1982 "Contemporary Indian Art," Festival of India 1982, Royal Academy of Arts, London (catalogue)
"Myth and Reality," Museum of Modern Art, Oxford

1985 "Les Artistes Étrangères en France," Festival of India, Centre National des Arts Plastiques, Paris

1987 "Coups de Coeur," Halle de l'Ile, Geneva (catalogue)
2nd Bienal de la Habana, National Museum, Havana (catalogue)
Smith Galleries, London

1988 "Through the Looking Glass," Bharat Bhavan, Bhopal (catalogue); traveled to Bangalore and New Delhi

1989 "Artist Alert," Lalit Kala Galleries, New Delhi (catalogue)
"Timeless Art," Victoria Terminus, Bombay (catalogue)

1991 "Artists Against Communalism," Safdar Hashmi Memorial Trust, New Delhi (catalogue)

1992 "Journeys within Landscapes," Jehangir Gallery, Bombay

1993 "A Critical Difference: Contemporary Art from India," Chapter Arts Centre, Cardiff, Wales (catalogue); traveled through United Kingdom
"India Songs: Multiple Streams in Contemporary Indian Art," Art Gallery of New South Wales, Sydney (catalogue); traveled in Australia
"Still Life," Sakshi Gallery, Bombay

1994 "Parallel Perception," Sakshi Gallery, Bombay

Collaborative Projects
1985 1st XAL Human Growth Workshop, Goa, India

1988 "The Sculpted Image," Festival of India, Nehru Centre, Bombay (catalogue)

1993 Installation/performance with Alaknanda Samarth, Max Mueller Bhavan, Bombay

Honors and Awards
1970–72 French Government Scholarship for Fine Arts, Paris

1984–87 Government of India Junior Fellowship

1989 Fund for Artists Colonies, Residency Fellowship at Fine Arts Work Center, Provincetown, Mass.
United States Information Service Fellowship

1989–91 Government of India Senior Fellowship

Selected Bibliography
Figures of Thought (film). 1989. Directed by Arun Khopkar and featuring Bhupen Khakhar, Nalini Malani, and Vivan Sundaram.
Kapoor, Kamila. "Missives from the Streets: The Art of Nalini Malani." *Art and Asia Pacific* 2, no. 1 (1995): 41–51.
One World Art. Geneva: UNESCO, 1992. Film series by Lutz Mahler-Wien.

Kamol Phaosavasdi
Born in Phitsanulok, Thailand, 1958
Resides in Bangkok, Thailand

Education
1981 B.S., art education, Chulalongkorn University, Bangkok

1984 M.F.A., intermedia, Otis/Parsons Art Institute, Los Angeles

Solo Exhibitions
1984 "Not My Performance in 72 Steps," Otis/Parsons Art Institute, Los Angeles

1985 "Song for the Dead Art Exhibition" (performance), Bhirasri Institute of Modern Art, Bangkok

1991 "Collaboration with Yesterday and the Day Before," National Gallery, Bangkok

1994 "Water Project," Silom Art Space, Bangkok

Solo Performances
1983 "Disconnected A+B," Otis/Parsons Art Institute, Los Angeles

1984 "Kill Canvas," Otis/Parsons Art Institute, Los Angeles

1985 "How to Teach Art to Bangkok Cock," Bhirasri Institute of Modern Art, Bangkok
"Last Dream: No Art at All," Silpakorn University Art Gallery, Bangkok

1992 "Earth Treatment," Silpakorn University Art Gallery, Bangkok

1994 "Blue Circulation," Chulalongkorn University, Bangkok
"Give Me a Glass of Water," Silom Art Space, Bangkok

Selected Group Exhibitions
1985 2nd Asian Art Show, Fukuoka Art Museum, Fukuoka, Japan (catalogue)

1986 "Thai Reflections on American Experiences," Bhirasri Institute of Modern Art, Bangkok (catalogue)

1992 Artist Regional Exchange (ARX 3), Perth Institute of Contemporary Art, Perth, Australia
"The Boundary Rider," 9th Biennale of Sydney, Art Gallery of New South Wales (catalogue)
Kamol and Vichoke Exhibition, Silpakorn University Art Gallery, Bangkok (two-person exhibition)

"Mobile," Museum City Project '92, Tenjin and Fukuoka, Japan

1993 1st Asia-Pacific Triennial of Contemporary Art, Queensland Art Gallery, Brisbane (catalogue)
"Thai-Australian Cultural Space," National Gallery, Bangkok (catalogue); traveled to Chiang Mai and Sydney

1994 "Water Collaboration" (two-person exhibition), Chulalongkorn University, Bangkok

1995 "Content/Sense" (two-person exhibition), National Gallery, Bangkok
"Thai Tensions," Art Center, Chulalongkorn University, Bangkok (catalogue)

Honors and Awards
1981 Bronze Medal (Sculpture), National Art Exhibition, Bangkok

1982 Award, Contemporary Art Exhibition, Thai Farmers Bank, Bangkok
Silver Medal (Sculpture), National Art Exhibition, Bangkok

Public Collections
Chulalongkorn University, Bangkok
Cultural Center of the Philippines, Manila
Silpakorn University Art Gallery, Bangkok

Chatchai Puipia
Born in Mahasarakam, Thailand, 1964
Resides in Bangkok, Thailand

Education
1988 B.F.A., painting, Silpakorn University, Bangkok

Solo Exhibitions
1993 Hymn of Fire, Silom Art Space, Bangkok (catalogue)

1994 "Take Me Somewhere, Tell Me Something," Dialogue Gallery, Bangkok (catalogue)

1995 "Siamese Smile," Japan Cultural Center, Bangkok (catalogue)

Selected Group Exhibitions
1985 2nd Exhibition of Contemporary Art by Young Artists, Silpakorn University Art Gallery, Bangkok (catalogue)

1986 32nd National Exhibition of Art, Silpakorn University Art Gallery, Bangkok (catalogue)

1987 33rd National Exhibition of Art, Silpakorn University Art Gallery, Bangkok (catalogue)

1988 34th National Exhibition of Art, Silpakorn University Art Gallery, Bangkok (catalogue)

"Five Young Artists of the Year 1988," Silpakorn University Art Gallery, Bangkok (catalogue)

1989 35th National Exhibition of Art, Silpakorn University Art Gallery, Bangkok (catalogue)

13th Bualuang Art Exhibition, Bangkok (catalogue)

"Four Experimental Artists," Silpakorn University Art Gallery, Bangkok (catalogue)

"Les Peintres Thailandais Traditionnels et Contemporains," Espace Pierre Cardin, Paris (catalogue)

1990 36th National Exhibition of Art, Silpakorn University Art Gallery, Bangkok (catalogue)

Contemporary Art Exhibition, National Gallery/Thai Farmers Bank, Bangkok (catalogue)

"Two Men: Two Insights," Landmark Plaza, Bangkok

1991 "Art and Environment," Silpakorn University Art Gallery, Bangkok (catalogue)

"Recent Works by Chatchai Puipia and Pinaree Sanpitak," National Gallery, Bangkok (catalogue)

1992 "New Art from Southeast Asia 1992," Tokyo Metropolitan Art Space; traveled to Fukuoka, Hiroshima, and Osaka (catalogue)

"Small Works by 56 Thai Artists," Silom Art Space, Bangkok (catalogue)

1993 Contemporary Art Exhibition, National Gallery/Thai Farmers Bank, Bangkok (catalogue)

1995 "Visions of Happiness," Japan Foundation ASEAN Cultural Center, Tokyo (catalogue)

"Thai Tensions," Art Center, Chulalong-korn University, Bangkok (catalogue)

Honors and Awards

1988 Grand Prize (Painting), Contemporary Art Exhibition, Bangkok

Silver Medal (Painting), 34th National Exhibition of Art, Bangkok

Silver Medal (Painting), 12th Bualuang Art Exhibition, Bangkok

Young Artist of the Year, Silpakorn University, Bangkok

1989 1st Prize, Thai Toshiba Groups Art Competition

Silver Medal (Painting), 35th National Exhibition of Art, Bangkok

Silver Medal (Painting), 13th Bualuang Art Exhibition, Bangkok

1992 United States Information Service and Mid-America Arts Alliance Fellowship, Headlands Center for the Arts, San Francisco

1995 Artist-in-Residence, Art Tower, Mito, Japan Foundation Fellowship

Public Collections

Chulalongkorn University, Bangkok

Silpakorn University Art Gallery, Bangkok

Thai Farmers Bank, Bangkok

Araya Rasdjarmrearnsook
Born in Trad, Thailand, 1957
Resides in Chiang Mai, Thailand

Education

1980 B.F.A., graphic art, Silpakorn University, Bangkok

1986 M.F.A., graphic art, Silpakorn University, Bangkok

1990 Diploma, Hochschule für Bildende Künste, Brunswick, Germany

1994 Meisterschüler, Hochschule für Bildende Künste, Brunswick, Germany

Solo Exhibitions

1987 Goethe-Institut, Bangkok

National Gallery, Bangkok

1990 Atelier Forsthaus, Gifhorn, Germany

Vereins- und Westbank, Hannover, Germany

1991 Atelier Forsthaus, Gifhorn, Germany

1992 National Gallery, Bangkok

1994 National Gallery, Bangkok

1995 National Gallery, Bangkok

Selected Group Exhibitions

1979 26th National Exhibition of Art, Silpakorn University Art Gallery, Bangkok (catalogues)

1980 27th National Exhibition of Art, Silpakorn University Art Gallery, Bangkok (catalogue)

"Thai Graphic Art," L'Alliance Française, Bangkok

Contemporary Art Exhibition, National Gallery/Thai Farmers Bank, Bangkok (catalogue)

1981 28th National Exhibition of Art, Silpakorn University Art Gallery, Bangkok (catalogue)

Contemporary Art Exhibition, National Gallery/Thai Farmers Bank, Bangkok (catalogue)

14th International Exhibition of Graphic Art, Moderna Galerija, Ljubljana, Yugoslavia (catalogue)

2nd ASEAN Exhibition of Painting and Photography, Ministry of Human Settlements of the Philippines, Manila; traveled to Singapore, Kuala Lumpur, Jakarta, and Bangkok (catalogue)

1982 "Art in Thailand since 1932," Thai Khadi Research Institute, Thammasat University, Bangkok (catalogue)

"Bangkok Bicentennial Art Exhibition," Memorial Art Gallery, University of Rochester, Rochester, N.Y. (catalogue)

Contemporary Art Exhibition, National Gallery/Thai Farmers Bank, Bangkok (catalogue)

1983 15th International Biennial Exhibition of Graphic Art, Moderna Galerija, Ljubljana, Yugoslavia (catalogue)

1984 8th Bualuang Painting Competition, Bangkok (catalogue)

"Paper Work Group," Silpakorn University Art Gallery, Bangkok

10th Independents Exhibition of Prints, Kanagawa Prefectural Community Hall Gallery, Yokohama, Japan (catalogue)

10th International Print Biennial, Muzeum Narodowe, Krakow, Poland (catalogue)

1985 2nd Asian Art Show, Fukuoka Art Museum, Fukuoka, Japan (catalogue)

2nd International Biennial Print Exhibit, Taipei Fine Arts Museum, Taipei, Taiwan (catalogue)

16th Yokosuka Peace Exhibition of Art, Yokosuka, Japan

1986 "Contemporary Drawing," Silpakorn University Art Gallery, Bangkok

'86 Seoul Contemporary Asian Art Show, National Museum of Contemporary Art, Seoul (catalogue)

1987 "Landscape," Masterpiece Art Gallery, Bangkok

"Thai Women Artists," Amarin Art Gallery, Bangkok

Contemporary Art Exhibition, National Gallery/Thai Farmers Bank, Bangkok (catalogue)

1990 "Culture and Destruction in South-East Asia," City of Nuremburg, Germany

International Exhibition of Graphic Art '92, Kunstverein zu Frechen, Frechen, Germany (catalogue)

Contemporary Art Exhibition, National Gallery/Thai Farmers Bank, Bangkok (catalogue)

1992 "The New Path," National Convention Center, Bangkok

2nd International Women's Exhibition, International Women's Group and Silpakorn University, Bangkok

"Thai Contemporary Art," Thai Farmers Bank, Bangkok

"Through Her Eyes," Dialogue Gallery, Bangkok

1993 "Art and Environment II," National Gallery, Bangkok

1st Asia-Pacific Triennial of Contemporary Art, Queensland Art Gallery, Brisbane (catalogue)

20th International Exhibition of Graphic Art, Moderna Galerija, Ljubljana, Yugoslavia (catalogue)

1995 "Africus," Johannesburg Biennale (catalogue)

"Art and Environment III," National Gallery, Bangkok

"Thai Tensions," Art Center, Chulalong-korn University, Bangkok (catalogue)

"Visions of Happiness," Japan Foundation ASEAN Cultural Center, Tokyo (catalogue)

Honors and Awards

1980 1st Prize (Graphic Art), 26th National Exhibition of Art, Bangkok

Award, Contemporary Art Exhibition, Bangkok

1981 2nd Prize (Graphic Art), 27th National Exhibition of Art, Bangkok

1985 2nd Prize (Graphic Art), 31st National Exhibition of Art, Bangkok

1987 3rd Prize (Graphic Art), 33rd National Exhibition of Art, Bangkok

1990 Award, Contemporary Art Exhibition, Bangkok

Navin Rawanchaikul

Born in Chiang Mai, Thailand, 1971
Resides in Chiang Mai, Thailand

Education
1994 B.F.A., painting, Chaing Mai University

Solo Exhibitions
1994 "There Is No Voice," USIS Library, Bangkok (catalogue)

1995 "The Zero Space Which Is Not Empty," Art Forum Gallery, Bangkok

Selected Group Exhibitions
1991 8th Exhibition of Contemporary Art by Young Artists, Silpakorn University Art Gallery, Bangkok (catalogue)
"Modern Drawings by the POSTLINE Group," Silpakorn University Art Gallery, Bangkok
17th International Biennial Exhibition of Prints, Sapporo Museum of Modern Art, Hokkaido, Japan (catalogue)
37th National Exhibition of Art, Silpakorn University Art Gallery, Bangkok (catalogue)

1992 "Artists' Books: Books as Art," Goethe-Institut, Bangkok
"Chiang Mai Social Installation," 1st Art and Culture Festival: Temples and Cemeteries, Chiang Mai
14th Contemporary Art Exhibition, National Gallery/Thai Farmers Bank, Bangkok (catalogue)
"Melancholic Trance," Visual Dhamma Gallery, Bangkok
9th Exhibition of Contemporary Art by Young Artists, Silpakorn University Art Gallery, Bangkok (catalogue)
38th National Exhibition of Art, Silpakorn University Art Gallery, Bangkok (catalogue)

1993 "Art and Environment II," National Gallery, Bangkok
"Chiang Mai Social Installation," 2nd Art and Culture Festival, Chiang Mai
"Magic Set II," National Gallery, Bangkok
"Social Contract: New Art from Chiang Mai," Visual Dhamma Gallery, Bangkok

1994 "Critical Stream," Thammasat University, Bangkok
"Realism as an Attitude," 4th Asian Art Show, Fukuoka Art Museum, Fukuoka, Japan (catalogue); traveled to Hakone, Akita, and Tokyo
"Rebirth of Things," Ideal Art Gallery, Bangkok
Thailand Cultural Center, Bangkok

1995 "Art and Environment III," National Gallery, Bangkok
"Chiang Mai Social Installation," 3rd Art and Culture Festival, Chiang Mai
"Substanceaboutnonsubstance" (two-person exhibition), Goethe-Institut, Bangkok
"Thai Tensions," Art Center, Chulalongkorn University, Bangkok (catalogue)

Collaborative Projects
1994 "Please Donate Your Ideas for Dispirit Artistic Research," by Navin Rawanchaikul in collaboration with 3,000 Chiang Mai residents, Art Forum Gallery, Bangkok
"Navin Production Company Limited," Chiang Mai

1995 "Navin Driving School," Chiang Mai
"Navin Gallery Bangkok," Chiang Mai

Public Collections
Chulalongkorn University, Bangkok

Reamillo & Juliet

Alwin Reamillo born 1964, Manila, the Philippines
Juliet Lea born 1966, Stroud, U.K.
Both presently reside in Perth, Australia

Education
Alwin Reamillo
1981–85 College of Fine Arts, University of the Philippines, Quezon City

Juliet Lea
1984–85 University of Western Australia, Nedlands

1987 B.F.A., sculpture, Curtin University, Bentley, Australia

1991 M.F.A., University of Tasmania, Hobart

Collaborative Installations
1993 *B. Lipunan 2000*, 4th Baguio Art Festival, Baguio Convention Center, Baguio, the Philippines
Black Hole, Manila Film Center
Virus, Philippine-Thai-Australian Artists Exchange, Concrete House, Bangkok

1994 *Cancer Site*, National Cancer Week Art Exhibition, Lung Center of the Philippines, Quezon City
Tres Personas Non Grata, "Thirteen Artists," Cultural Center of the Philippines, Manila (catalogue)

1995 "30th `Artists Today' Exhibition, Asia-Pacific Universe: Contemporary Art from Australia, Canada, China, India, Japan, Philippines," Yokohama Citizen's Gallery, Yokohama, Japan (catalogue)
Tres Personas Non Grata, "Visions of Happiness," Japan Foundation ASEAN Cultural Center, Tokyo (catalogue)
Tres Personas Non Grata, "TransCulture," 15th Venice Biennale (catalogue)

Selected Bibliography
Apisuk, Chumpon. "The Concrete House." *Art and Asia Pacific* 2, no. 3 (1995).
Espiritu, Talitha. "House of Horrors." *Sunday Chronicle* (Nov. 14, 1993).
Ewington, Julie. "Cross Currents: Salubungang Agos." *Art and Asia Pacific* 1, no. 3 (1994).
Jacobs, Mike. "Messages of Misery, Visions of Happiness." *Daily Yomiuri* (Mar. 3, 1995).
Lasschuyt, Helga. "The Venice Biennale Game." *Asian Art News* 5, no. 5 (1995).
Lolarga, Elizabeth. "Juliet, Alwin, and This Crazy Little Thing Called Art." *Mirror Weekly* (Nov. 28, 1994).
Medina, Francine. "Reamillo Not for Sale." *Today* (Aug. 24, 1994).
Tatehata, Akira. "Statements on Grim Modernity." *Asahi Evening News* (Mar. 2, 1995).
Templado, Louis. "Don't Worry, Be Happy for a Price." *Japan Times* (Mar. 11, 1995).

Ravinder G. Reddy

Born in Suryapet, Andhra Pradesh, India, 1956
Resides in Vishakhapatnam, Andhra Pradesh, India

Education
1980 B.F.A., sculpture, Maharaja Sayajirao University, Baroda

1982 M.F.A., creative sculpture, Maharaja Sayajirao University, Baroda

1983 Diploma, art and design, Goldsmith College of Arts, University of London

1984 Short Course Certificate, ceramics, Royal College of Art, London

Solo Exhibitions
1981 "Sculpture in Fibreglass," Art Heritage, New Delhi (catalogue)

1982 Contemporary Art Gallery, Ahmedabad, India
"Sculpture in Fibreglass," Jehangir Art Gallery, Bombay (catalogue)

1989 Hutheesingh Visual Arts Centre, Ahmedabad
Max Mueller Bhavan, Hyderabad (catalogue)

1990 Centre for Contemporary Art, New Delhi (catalogue)

1991 "Painted Sculptures and Reliefs, 1989–91," Sakshi Gallery, Madras

1992 "Painted Sculptures and Reliefs, 1989–91," Sakshi Gallery, Bangalore (catalogue)

Group Exhibitions
1983 "Indian Sculpture Today," Jehangir Art Gallery, Bombay (catalogue)

1988 2nd Biennale, Bharat Bhavan, Bhopal (catalogue)

1989 "Artist Alert," Lalit Kala Galleries, New Delhi (catalogue)
Bombay Art Society Centenary Invitees Show, Jehangir Art Gallery, Bombay (catalogue)
"Timeless Art," Victoria Terminus, Bombay (catalogue)

1990 "Art Trends in South India," Regional Centre, Lalita Kala Akademi, Madras
"Kanoria Centre for Arts Group Show," Jehangir Art Gallery, Bombay

"Small Sculptures from India," Indian Council for Cultural Relations, New Delhi

3rd Biennale, Bharat Bhavan, Bhopal (catalogue)

1992 "Heads," Sakshi Gallery, Bombay (catalogue)

1993 "A Critical Difference: Contemporary Art from India," Chapter Arts Centre, Cardiff, Wales (catalogue); traveled through United Kingdom

"India Songs: Multiple Streams in Contemporary Indian Art," Art Gallery of New South Wales, Sydney (catalogue); traveled in Australia

1995 "Portraits," Sakshi Gallery, Bombay

"Sculpture '95," Gallery Espace, Lalit Kala Galleries, New Delhi (catalogue)

Honors and Awards

1980 Award, Gujarat State Lalit Kala Akademi, Ahmedabad

National Akademi Award, National Exhibition of Art, Lalit Kala Akademi, New Delhi

Sanskriti Award in Arts, Sanskriti Prathisthan, New Delhi

1991–93 Junior Fellowship, Department of Culture, Government of India, New Delhi

1995–97 Senior Fellowship, Department of Culture, Government of India, New Delhi

Public Collections

Deutsche Bank, Bombay

National Gallery of Modern Art, New Delhi

National Lalit Kala Akademi, New Delhi

Times of India, New Delhi

Victoria and Albert Museum, London

Selected Bibliography

Bazaar Magazine (London) 23 (1992): 2.

Chatterji, Ram. *Indian Sculpture Today.* Bombay: Jehangir Art Gallery, 1983.

David, Esther. "Reddy Tries New Tack in Sculpture." *Times of India* (Ahmedabad) (Sept. 27, 1982).

Doctor, Geeta. "Monumental Sculpture." *Indian Express* (Madras) (Dec. 6, 1991).

Gangopadhyan, Sumati. "The Ascetic Art of Reddy: Organic and Erotic Aspects." *Indian Express* (Ahmedabad) (Dec. 6, 1991).

Jakimowicz-Karle, Marta. "Awkward Aspirations in Sensuality." *Deccan Herald* (Bangalore) (Apr. 1, 1992).

Kent, Sarah. "Worlds Apart." *Time Out* (London) (June 1993).

Mahadevan, Uma. "Women of Wisdom." *Indian Express* (Bangalore) (Apr. 10, 1992).

"New and Explorative Works." *Hindustan Times Weekly* (New Delhi) (December 1981).

Ranjitha, B. "Inspired by Hoary Past." *Times of India* (Bangalore) (Apr. 1, 1992).

Reddy, Ravinder G. "A New Sculptural Tradition." *Events and Comments* (Hyderabad) (July 16–30, 1980).

Shahani, Roshan. "Heads Tell Tales." *Sunday Times of India* (July 4, 1993).

N. N. Rimzon

Born in Kakkoor, Kerala, India, 1957

Resides in New Delhi, India

Education

1982 B.F.A., sculpture, College of Fine Arts, Trivandum, India

1984–87 Studies in sculpture, Maharaja Sayajirao University, Baroda

1989 M.F.A. with Distinction, Royal College of Arts, London

Solo Exhibitions

1991 "Recent Sculpture and Drawings," Art Heritage, New Delhi (catalogue)

1993 "Sculpture and Drawings," Art Heritage, New Delhi (catalogue)

1994 "N. N. Rimzon," Galerie Schoo, Foundation for Indian Artists, Amsterdam

Selected Group Exhibitions

1985 Hutheesingh Visual Arts Centre, Ahmedabad, India

"Seven Young Sculptors," Rabindra Bhavan, New Delhi (catalogue)

1986 Gallery 7, Bombay (two-person exhibition)

6th Triennale India, Lalit Kala Akademi, New Delhi (catalogue)

1987 "Six Contemporary Artists from India," Centre d'Art Contemporain, Geneva (catalogue)

1988 "Revelations Black II," Gillion Art Gallery, Manchester

"The Sculpted Image," Festival of India, Nehru Centre, Bombay (catalogue)

1989 "40th Anniversary of the Universal Declaration of Human Rights: Works on Paper," Geneva

1991 4th Bienal de la Habana, National Museum, Havana (catalogue)

1992 "Artists for Cuba," National Committee for Solidarity with Cuba, LTG Gallery, New Delhi

1993 "A Critical Difference: Contemporary Art from India," Chapter Arts Centre, Cardiff, Wales (catalogue); traveled through United Kingdom

"Inbetween," 14th Venice Biennale (catalogue)

"India Songs: Multiple Streams in Contemporary Indian Art," Art Gallery of New South Wales, Sydney (catalogue); traveled in Australia

"Prospect '93: An International Exhibition of Contemporary Art," Frankfurt Kunstverein and Schirn Kunsthalle, Frankfurt (catalogue)

"Trends and Images," Centre of International Modern Art, Calcutta (catalogue)

1994 "Art for Children's Sake," Mobile Creches, Indian Habitat Centre, New Delhi (catalogue)

Deutsche Bank Collection, Bombay (catalogue)

"One Hundred Years: From the National Gallery of Modern Art Collection," National Gallery of Modern Art, New Delhi (catalogue)

1995 "Art and Nature," Buddha Jayanti Park, New Delhi

"The Other Self," National Gallery of Modern Art, New Delhi/Stedelijk Museum, Amsterdam (catalogue)

"Recent Trends in Contemporary Indian Art," Vadehra Gallery, New Delhi (catalogue)

"Sculpture '95," Gallery Espace, Lalit Kala Galleries, New Delhi (catalogue)

Honors and Awards

1984 Senior Fellowship, Ministry of Human Resource Development, Government of India, New Delhi

1985 Navdeep Award, Ahmedabad, India

1992 Research Grant, Lalit Kala Akademi, New Delhi

Sanskriti Award, New Delhi

Public Collections

Art Gallery of New South Wales, Sydney

Lalit Kala Akademi, Trissur, Kerala, India

National Gallery of Modern Art, New Delhi

Panjab University Museum, Chandighar

Royal College of Art, London

Schoo Foundation for Indian Artists, Amsterdam

Selected Bibliography

Bhushan, Rasna. "This Conundrum: The Sculpture of N. N. Rimzon." *India Magazine* (October 1991).

Kapur, Geeta. "One Hundred Years from the National Gallery of Modern Art Collection: Working Notes." *Art and Asia Pacific* 2, no. 1 (November 1995): 82–86.

_____. "When Was Modernism in Indian Art?" *Arts and Ideas* (March 1995).

Lynn, Victoria. "Between the Pot and the Sword: The Art of N. N. Rimzon." *ARTAsiaPacific* 3, no. 2 (1996): 86–89.

Panikkar, Shivaji, and Ansuhuman Dasgupta. "The Transitional Modern: Figuring the Post-Modern in Indian Art." *Lalit Kala Contemporary* 41 (1995).

Rimzon, N. N. "The Artist as Exile: A Note by the Sculptor." *Art Heritage* 10 (1991): 20–21.

_____. "The Thing Itself." *Arts and Ideas* (June 1995).

Sanggawa Group

Sanggawa was founded in late December 1994 by the Manila-based visual artists Elmer Borlongan, Karen Flores, Mark Justiniani, Joy Mallari, and Federico Sievert as a collective which will work in unison for visual idioms that relate to Philippine society, its history, politics, and various idiosyncracies. Although Sanggawa has been active as a group only since January 1995, its members have worked together on various public murals and other art projects since 1988.

Selected Activities

1991 *Hope in Struggle*, mural by Mark Justiniani, Elmer Borlongan, Karen Flores, Anthony Palomo, Ferdinand Montemayor, and Sister Yolly Lunod, donated to the Prelature of Infanta, Quezon Province

Payaso, Salingpusa mural for Baguio Convention Center, 3rd Baguio Art Festival, Baguio, the Philippines

Salingpusa lightning mural commissioned by the Social Work Department, Miriam College, Quezon City

Untitled, Salingpusa lightning mural for the Coco Jam Concert, 3rd Baguio Art Festival, Baguio

Untitled, mural by Mark Justiniani, Elmer Borlongan, and Karen Flores, donated to Quezon National High School, Iyam, Lucena City

1992 *Bayview*, Salingpusa lightning mural for Save Manila Bay Art Protest, Cultural Center of the Philippines, Manila

Goddess of Manila Bay, Salingpusa lightning mural for Save Manila Bay Streetfest

Save Manila Bay, ad project by Mark Justiniani, Karen Flores, and Elmer Borlongan, commissioned by Tourist Belt Businessmen's Association and presented in the *Philippine Daily Enquirer* and *Philippine Star*

1993 *Pusoy*, mural dedicated to Filipina migrant workers by Elmer Borlongan, Mark Justiniani, Karen Flores, Emmanuel Garibay, Mikel Parial, and Federico Sievert, Cultural Center of the Philippines, Manila

1994 *Maria*, church icon by Mark Justiniani, Emmanuel Garibay, Karen Flores, Joy Mallari, Elmer Borlongan, and Ferdinand Montemayor, requested by the Prelature of Infanta, Quezon Province, now owned by the nuns of Augustinian Missionaries of the Philippines

Prusisyon, mural by Mark Justiniani, Emmanuel Garibay, and Karen Flores, for National Cancer Week, exhibited at the Lung Center of the Philippines, Quezon City

1995 *Getting Into the Out*, outdoor mural by Sanggawa, University of New South Wales, Kensington, Australia

Kasal sa Hatinggabi, by Sanggawa for the 1995 Mayfest rites at Grand Heights, Antipolo, donated to the Antipolo Foundation for Arts, Culture, and Ecology

Luksong-Tinik, fundraising exhibition of artworks and photographs to commemorate the U.N. Declaration on the Rights of the Child, presented by UNICEF, Kamalayan Development Foundation, and Sanggawa in cooperation with the Phil-American Life Insurance Company, Philamlife Building, Manila

Vox Populi, Vox Dei, seven murals by Sanggawa, Ray Hughes Gallery, Sydney

Vox Populi, Vox Dei: Mga Gawang Editoryal, six collaborative murals by Sanggawa (with the participation of Emmanuel Garibay, Mikel Parial, Anthony Palomo, and Jeho Bitancor), Shangri-la Plaza Mall, EDSA, Mandaluyong City, Metro Manila

Arpita Singh

Born in West Bengal, 1937
Resides in New Delhi, India

Education

1954–59 School of Art, Delhi Polytechnic, Delhi

Solo Exhibitions

1972 Kunika Chemould Art Centre, New Delhi

1975 Dhoomimal Art Centre, New Delhi

1976 Pundole Art Gallery, Bombay

1978 Art Heritage, New Delhi

1982 Art Heritage, New Delhi

1985 Art Heritage, New Delhi

1987 Gallery 7, Bombay

1990 Gallery 7, Bombay

1991 Art Heritage, New Delhi

1992 Centre for Contemporary Art, New Delhi

1993 Galerie Schoo, Foundation for Indian Artists, Amsterdam

1995 Centre of International Modern Art, Calcutta (catalogue)

Selected Group Exhibitions

1963 "In Memory of Sailoz Mukherjee," Kunika Chemould Art Centre, New Delhi

1969 "Art Today," Kunika Chemould Art Centre, New Delhi

1972 "25 Years of Indian Art," Lalit Kala Akademi, New Delhi
"Two Painters," Gallery Chemould, Bombay

1974 Rabindra Bhavan, New Delhi

1975 3rd Triennale India, Lalit Kala Akademi, New Delhi (catalogue)

1977 "Pictorial Space," Lalit Kala Akademi, New Delhi

1981 All-India Drawing Exhibition, Lalit Kala Akademi, Chandigarh

1982 "Contemporary Indian Art," Festival of India 1982, Royal Academy of Arts, London (catalogue)
5th Triennale India, Lalit Kala Akademi, New Delhi (catalogue)

1984 Inaugural exhibition, Bharat Bhavan, Bhopal
Indo-Greek Cultural Festival, Delphi, Athens
"Three Painters," Cymroza Gallery, Bombay

1986 Centre Georges Pompidou, Paris (catalogue)
1st Biennale, Bharat Bhavan, Bhopal

1987 "Coups de Coeur," Halle de l'Ile, Geneva (catalogue)
2nd Bienal de la Habana, National Museum, Havana (catalogue)

1988 "Through the Looking Glass," Bharat Bhavan, Bhopal (catalogue); traveled to Bangalore and New Delhi
"Water Colour by Four Painters," Jehangir Art Gallery, Bombay

1989 "Artist Alert," Lalit Kala Galleries, New Delhi (catalogue)
"Timeless Art," Times of India Exhibition, Bombay

1990 Habiart Gallery, Habitat Centre, New Delhi
"Nine Indian Contemporaries," Centre for Contemporary Art, New Delhi

1992 "The Subjective Eye," Sakshi Gallery, Bombay

1993 "Indian Encounters," The Gallery, Madras; traveled to London
"India Songs: Multiple Streams in Contemporary Indian Art," Art Gallery of New South Wales, Sydney (catalogue); traveled in Australia
"Trends and Images," Centre of International Modern Art, Calcutta

1994 "Art for Children's Sake," Mobile Creches, Indian Habitat Centre, New Delhi (catalogue)

Honors and Awards

1981 All-India Drawing Exhibition, Chandigarh

1987 Algeria Biennale

1991 Parishad Samman, Sahitya-Kala Parishad, New Delhi

1992 All-India Drawing Exhibition, Chandigarh

Public Collections

Chandigarh Museum, Chandigarh
Chester Herwitz Trust, Worcester, Mass.
Lalit Kala Akademi, New Delhi
National Gallery of Modern Art, New Delhi
Punjab University Museum, Chandigarh
Roopankar Museum, Bharat Bhavan, Bhopal
Times of India, New Delhi
Victoria and Albert Museum, London

Jakapan Vilasineekul

Born in Bangkok, Thailand, 1964
Resides in Bangkok, Thailand

Education

1982 Certificate, College of Fine Arts, Bangkok

1987 B.F.A., sculpture, Silpakorn University, Bangkok

1993 Diplom Bidhauerei, Staatliche Akademie der Bildenden Künste, Karlsruhe, Germany

1993–94 Meisterschüler, Staatliche Akademie der Bildenden Künste, Karlsruhe, Germany

Solo Exhibitions

1994 Silpakorn University Art Gallery, Bangkok (catalogue)

Selected Group Exhibitions

1983 29th National Exhibition of Art, Silpakorn University Art Gallery, Bangkok (catalogue)

1984 1st Exhibition of Contemporary Art by Young Artists, Silpakorn University Art Gallery, Bangkok (catalogue)
2nd ASEAN Youth Painting Workshop and Exhibition, MARA Institute of Technology, Shah Alam, Malaysia (catalogue)

1985 2nd Exhibition of Contemporary Art by Young Artists, Silpakorn University Art Gallery, Bangkok (catalogue)
3rd Sculpture Exhibition by Thai Sculpture Association, Silpakorn University Art Gallery, Bangkok (catalogue)

1986 3rd Exhibition of Contemporary Art by Young Artists, Silpakorn University Art Gallery, Bangkok (catalogue)
32nd National Exhibition of Art, Silpakorn University Art Gallery, Bangkok (catalogue)

1987 33rd National Exhibition of Art, Silpakorn University Art Gallery, Bangkok (catalogue)

1988 "Five Young Artists of the Year 1988," Silpakorn University Art Gallery, Bangkok (catalogue)

1990 "Jakapan Vilasineekul and Surasi Kusolwong," Goethe-Institut, Bangkok (catalogue)

1993 "Jakapan Vilasineekul and Frank Maier," Silpakorn University Art Gallery, Bangkok

1994 "2537 Art Exhibition," School of Fine and Applied Arts, Bangkok University/Office of the National Culture Commission (catalogue)

1995 "Thai Tensions," Art Center, Chulalongkorn University, Bangkok (catalogue)

Honors and Awards

1984 Thai representative, 2nd ASEAN Youth Painting Workshop and Exhibition, Malaysia

1985 National Youth Bureau commission, sculpture installation, Lumpini Park, Bangkok

1986 2nd Prize, 3rd Exhibition of Contemporary Art by Young Artists, Bangkok
3rd Prize (Sculpture), 32nd National Exhibition of Art, Bangkok

1987 3rd Prize (Sculpture), 33rd National Exhibition of Art, Bangkok

1988 Young Artist of the Year 1988 (Sculptor), Silpakorn University Art Gallery, Bangkok

1990–94 King's Scholarship, Konrad-Adenauer Foundation for study in Germany

Public Collections

Phet Osathanukroh
Silpakorn University Art Gallery, Bangkok
Thai Danu Bank, Bangkok
Thai Farmers Bank, Bangkok

Selected Bibliography

Apichatkriengkrai, Vichit. "Artist and Art." *Art Record in Thailand* (December 1995): 15–21.
Kunavichayanont, Sutee. "Song Moom Thi Tag Tang: Jakapan Vilasineekul, V.S. Vasant Sittiket" (Two Different Views: Jakapan Vilasineekul and V. S. Vasant Sittiket). *Korawik* (April 1995): 191–95.
Milindasuta, Sansern. "Malang Poh, Tao, Ngoo" (Dragonfly, Turtle, Snake). *Na Ka* 11 (January 1995): 84–85.
Praphatthong, Pholawat. "Wattu Kab Tua Ton" (Materials and Self). *City Life* (February 1995): 56–59.
Sève, Carole. "Donner du sens à la matière." *Le Gavroche* (October 1995): 27.
Suphanimitr, Phisanu. "Ya Khom An Ngod Ngam Kong Jakapan Vilasineekul" (Bittersweet Medicine of Jakapan Vilasineekul). *Praew* 16 (February 1995): 162–65.

- - - - - - - - - - - - - - - - -

Yun *Suknam*

Born in Manchuria, China, 1937
Resides in Seoul, Korea

Education

1959–60 Studies in English literature, Sungkyunkwan University, Seoul

1983–84 Pratt Institute and Art Students League, New York

Solo Exhibitions

1982 Fine Art Center, Seoul

1993 "The Eyes of Mother," Kumho Museum of Art, Seoul

1996 Johyun Gallery, Pusan, Korea
Kamakura Gallery, Tokyo

Selected Group Exhibitions

1985 "October Group Show," Kwanhoon Gallery, Seoul

1986 "From Half to One," Min Art Gallery, Seoul

1987 "Women and Reality," Min Art Gallery, Seoul

1988 "Cross Encounter of Liberated Women Poets and Painters," Min Art Gallery, Seoul

1992 "Women and Reality," Min Art Gallery, Seoul

1993 "Across the Pacific," Queens Museum of Art, Flushing, N.Y. (catalogue)
"Open Show," Youngduk Gallery, Seoul
"Peak of Contemporary Korean Art," Min Art Gallery, Seoul
"Re-Open Show," Koart Gallery, Seoul

1994 Centennial Commemoration of the Donghak Revolution, Seoul Arts Center
"Fifteen Years of Minjoong Art," National Museum of Contemporary Art, Seoul
"Technology, Environment, and Information," Expo Deajon, Korea
"Women: The Difference and the Power," Hankook Gallery, Seoul (catalogue)

1995 "Exhibition of Primitivism 1995," Moran Open-Air Museum, Masuk, Korea
"Korea: 100 Self-Portraits from Yi Dynasty to Contemporary," Musée de Seoul
"Korean Art '95: Quality, Quantity, Sensation," National Museum of Contemporary Art, Seoul
"Korean Modern Art," Art Museum of Peking, Beijing
"Korean Sculpture Now," Jongro Gallery, Seoul
Korean Women Artists Festival 1995, Municipal Museum of Art, Seoul (catalogue)
"A Mirror on Our Times," Dong-A Gallery, Seoul

"The Road of Self-Respect," Kumho Museum of Art, Seoul
"Seeds Exhibition," Sonje Museum of Contemporary Art, Seoul
6th Triennale Kleinplastik, Süd-West L.B., Stuttgart (catalogue)
"The Tiger's Tail: Fifteen Korean Contemporary Artists for Venice '95," 15th Venice Biennale (catalogue); traveled to Seoul
"Where We Are: 1945–1995," Seoul Arts Center
"Woman, History," Garam Gallery, Pusan, Korea

Public Collections

National Museum of Contemporary Art, Seoul

Selected Bibliography

"Change in Feminist Art." *Joong-Ahng Ilbo* (June 7, 1993).
"The Eyes of the Mother." *Chosun Ilbo* (June 7, 1993).
"For Women, for Art, for Wholeness." *Pine Hill* (Summer 1993): 16.
"The History of Women through Motherhood." *Dong-A Ilbo* (June 9, 1993).
"New Structure of Feminist Art." *Women's News* (June 11, 1993).
"On Yun Suknam." *Gana Art* (July–August 1994): 26.
The Portraits of 20th-Century Korea. Seoul: Jeawon Publishing Company, 1994.
"Sculpture for Motherhood." *Sisa Journal* 189 (1993): 84.
"Self-Portraits of Korea." *Hankyorae Ilbo* (July 21, 1993).
"The Story of Half World That Carved on Wood." *Wolgan Misool* (June 1993): 166–68.
"The True Nature of Mother That Deeply Touched on Body." *Gana Art* (July–August 1993): 26.

[INDIA]

1947–48
India establishes its independence; the country is partitioned into India and Pakistan. Massive communal riots break out with bloodshed on both sides of the border.

1947
Binode Behari Mukherjee completes his one-hundred-foot-long fresco *Medieval Hindi Saints* in Hindi Bhavan, in Tagore's Viswa-Bharati University at Santiniketan, Bengal.

Francis Newton Souza forms the Progressive Artists' Group (PAG) in Bombay, with S.H. Raza, M.F. Husain, Ara, Gade, and Bakre. PAG is later very influential in the formulation of Indian modernist art. It expands to incorporate the best Bombay artists, including Akbar Padamsee,Tyeb Mehta, Krishen Khanna.

1948
Gandhi is assassinated by a Hindu fanatic.

1949–50
After their exhibition in 1949, members of the original PAG (including F.N. Souza and S.H. Raza) travel to London and Paris. Several other Indian artists (Ram Kumar and Krishna Reddy, among them) also travel to Europe in the 1950s to study and live abroad.

1950
Maharaja Sayajirao University in Baroda, Gujarat, inaugurates the Faculty of Fine Arts, which plays a seminal role in the pedagogy and integral vision of contemporary Indian art.

1952–55
Satish Gujral obtains a scholarship for an apprenticeship with David Alfaro Siqueiros in Mexico. He returns with an even more politicized program for his Partition-based iconography.

1954
The Government of India establishes the National Gallery of Modern Art (NGMA) in New Delhi. It also institutes a centralized arts council, the Lalit Kala Akademi (LKA), to propagate contemporary Indian art.

1955
M.F. Husain paints a twenty-foot work titled *Zameen* (Land), an emblematic statement in modernist terms of home and belonging.

1956
Ramkinker Baij, the legendary figure from pre-Independence Bengal, creates a monumental cement sculpture, *Mill Call*, in the compound of Kala Bhavan at Santiniketan.

1955–59
Successive waves of Indian artists travel to study in Europe, including France, Britain, Poland, Yugoslavia, and Italy. Connections with the international art world are established through (mostly) state sponsorship of Indian artists in several biennales, notably at São Paulo.

1959–62
After gaining a strong reputation in the London art scene, F.N. Souza is frequently written about as a leading Third World artist.

1960–62
The United States enters the context of Indian art when Biren De returns from a Fulbright scholarship in 1960. From 1962 until at least 1972, many Indian artists also receive fellowships from the Rockefeller Fund, through their representative Porter McCray. Among those taking residencies abroad are V.S. Gaitonde, Akbar Padamsee, Krishen Khanna, K.G. Subramanyan, Paritosh Sen, Ram Kumar, and Tyeb Mehta.

1963
The twelve-member Group 1980, which includes J. Swaminathan, Jeram Patel, Ambadas, Himmat Shah, Gulammohammed Sheikh, and Jyoti Bhatt, exhibits in Delhi. Its anarchist manifesto, written by communist-turned-painter Swaminathan, marks a crucial intervention. The work itself, however, indicates an aesthetic disjuncture. Nehru inaugurates the exhibition and Octavio Paz writes the catalogue introduction.

1965
Bhupen Khakhar, using popular and kitsch sources, emerges as the new factor in Indian art. In the coming decades, he uses an ironic iconography and "naive" language to subvert the modernist canons that had been adapted for a national modern art since the 1950s.

The exhibition "Art Now in India," organized by American-born, London-based critic George Butcher, is shown at the Commonwealth Arts Festival in England. It focuses on emerging avant-garde artists in India. The catalogue texts are written by Butcher, Philip Rawson, and J. Swaminathan and refer to popular art forms, iconic images, and the sense of the numinous in Indian art.

1966
A major show of Tantra art is organized at the Hayward Gallery in London by the Arts Council of Britain in collaboration with Ajit Mukherjee. This exhibition confirms the international interest in the more subversive aspects of Indian philosophy and aesthetics.

K.C.S. Paniker, eminent artist-teacher and founding member of the Progressive Artists' Association of Madras, launches an artists' village complex in Cholamandal, near Madras. It provides living and studio space for artisans making commercially viable crafts. The collective signals an alternative to mainstream art practices and later becomes a venue for local-global transaction through residencies with international participants.

1967
"Two Decades of American Painting," a major traveling exhibition from the Museum of Modern Art is shown in Delhi. Critic Clement Greenberg participates in seminars associated with the exhibition.

1968–78
The LKA inaugurates Triennale India, one of the earliest Asian initiatives in international art and a major event for a decade. India hosts important international artists, critics, and avant-garde works with American participants, for example, sculptors Louise Nevelson, Eva Hesse, and Carl Andre, and critic Harold Rosenberg.

1971
L.P. Sihare, an art historian trained at New York's Institute of Fine Arts, becomes director of the National Gallery of Modern Art and introduces a new level of professionalism for curators, as well as an ambitious exhibition program (including major retrospectives of the work of Auguste Rodin, Paul Klee, and Henry Moore).

1971–74
An all-India Artists' Protest movement against the bureaucratic mismanagement of the Lalit Kala Akademi briefly raises artists' consciousness. It achieves participation by artists in policy matters through an electoral roll, then regresses into a populist forum.

1975
Garhi Studios are set up by the LKA in Delhi; this provides low-cost studios for artists.

1980
After experimenting with multimedia sculpture, Satish Gujral turns to architecture and designs a vast complex for the Belgian Embassy in Delhi.

K.G. Subramanyan returns to teach at his alma mater, Santiniketan, after nearly thirty years on the faculty of Baroda. Through his curriculum, he emphasizes pluralistic and polyvalent artistic practices that incorporate traditional artisanal skills. The new head of the painting department in Baroda is Gulammohammed Sheikh, who establishes ties to the "School of London" by inviting such artists and critics as Howard Hodgkin, Peter de Francia, Ken Kiff, John Davies, and Timothy Hyman.

1981

A group of six artists (Bhupen Khakhar, Gulammohammed Sheikh, Jogen Chowdhury, Vivan Sundaram, Nalini Malani, and Sudhir Patwardhan) stage the exhibition "Place for People" in Baroda. This key exhibition stakes out a polemical position based on a figurative-narrative art that emphasizes the politics of the local, regional, and national as a ground for cultural difference and subjectivity.

1982

India launches the first of a series of Festivals of India in Britain. This one features three exhibitions of contemporary Indian art: at the Tate Gallery are Jamini Roy, Rabindranath Tagore, and Amrita Sher-Gil; at the Museum of Modern Art in Oxford are M.F. Husain, K.G. Subramanyan, and Bhupen Khakhar; and at the Royal Academy of Arts in London is a large group exhibition. These shows have a strong impact on the international reception of Indian art.

The Bharat Bhavan is inaugurated in Bhopal. This autonomous, state-sponsored institution, under the directorship of the artist J. Swaminathan, is distinguished for its twin museums of contemporary tribal and urban art. The institution becomes a flourishing source of cultural experimentation before a right-wing provincial government scuttles the project in 1990.

1982–83

The National Gallery of Modern Art organizes a major show of Indian art for the Hirshhorn Museum in Washington, and tours an exhibition of neo-Tantra art to major venues in Germany.

1985

The exhibition "Seven Young Sculptors," which includes N.N. Rimzon, K.P. Krishnakumar, and Pushpamala N., establishes the credentials of the younger avant-garde in Indian art.

1985–86

As part of the Festival of India in France, the Centre Georges Pompidou organizes a series of exhibitions of the artists Sheikh, Viswanadhan, Khakhar, Patwardhan, and Arpita Singh.

1987

The Festival of India in the United States facilitates several exhibitions of contemporary art. The Grey Art Gallery in New York and the Phillips Collection in Washington show selections from the large Herwitz Collection of Indian art.

1987–89

A group of four women artists—Nalini Malani, Arpita Singh, Nilima Sheikh, and Madhvi Parekh—exhibit throughout India, making a point about the strength of an informal women's collective.

A movement called the Radical Painters' and Sculptors' Association is formed in Kerala under the leadership of K.P. Krishnakumar. They issue manifestoes that adhere to an extreme left political stance; they seek alternative contexts for practice and pedagogy for the artist in society, and they challenge the capitulation of Indian artists to bourgeois patrons and the market.

1988–89

Both Christies' and Sotheby's auction houses enter the contemporary Indian art market. India moves toward a more consumer-oriented economy; commercial rates multiply twenty times after 1989.

1989

France sends an exhibition of modern European masters, "Birth Life of Modernity," to the National Gallery of Modern Art in New Delhi.

After the political murder of Safdar Hashmi, a young communist theater activist, protesters form a politically alert, cultural action organization called SAH-MAT. Through multi-arts solidarity programs titled "Artists Against Communalism," the movement becomes a broad artists' front against authoritarian and fundamentalist forces in India.

1992

Bhupen Khakhar is invited to participate in Documenta IX at Kassel, Germany.

1993–96

Several carefully curated exhibitions of Indian art take place in Australia, England, France, South Africa, and the United States. These exhibitions are collaborations between the Indian state, international museums, and independent agencies, and they replace the anonymous official representation of Indian art. Individual Indian artists begin to be invited to international exhibitions.

1994

An exhibition titled "Hundred Years: From the NGMA Collection," organized by Geeta Kapur for the National Gallery of Modern Art, attempts to reconfigure Indian art by seeking alternative views of Indian modernism.

1995

A major exhibition of contemporary French art, titled "Thresholds," is shown at the National Gallery of Modern Art.

1996

A new branch of the National Gallery of Modern Art opens in Bombay.

[INDONESIA]

1946

Painter S. Soedjojono founds the group Seniman Muda Indonesia (Young Indonesian Artists), or SIM, in Yogyakarta. The group is based on his strong opposition to Dutch colonial influences on Indonesian art practices. As early as the 1930s, Soedjojono had denounced Basuki Abdullah and other Indonesian painters who participated in Dutch colonial art societies and who accepted the Dutch view that art was meant to serve the elite class. He feels that art should be based on nationalism and the struggle for an independent Indonesia; this is the basis of Indonesian modern art.

1947

Influenced by Soedjojono's principles, modern art in Indonesia takes on a distinctly political cast. Factions begin to develop in SIM. Hendra Gunawan leaves to found Pelukis Rakyat (People's Painters), an even more leftist organization. In Surabaya, followers of Soedjojono, led by the painter Sularko, set up an organization called Pelangi (The Rainbow) which encourages Indonesian artistic expression.

The Dutch colonial government (which had ignored Indonesia's declaration of independence issued August 17, 1945) establishes a training course for art teachers at the Bandung Institute of Technology. There, the Dutch painter Ries Mulder promotes modern art. Several Indonesian painters participate, including Syafei Soemardja (as a lecturer) and Ahmad Sadali (as a student).

1948

Led by Barli, Hendra's friends in Bandung set up an organization called Jiva Mukti (The Good Soul) that stresses the importance of art education. Several artists who had been trained under the colonial system become instructors for this group, including Sasmitawinata, Sadali, and Mochtar Apin.

Affandi, another prominent artist, breaks away from SIM and founds Gabungan Pelukis Indonesia (Indonesian Painters Association), a group dedicated to establishing the professional status of artists in

Indonesia. This group becomes influential in Jakarta after the young painters Oesman Effendi and Zaini join.

1950

Following the Dutch acknowledgment of Indonesian independence in 1949, the extension course for art teachers is transferred to Indonesia University in Jakarta.

Katamsi, an art teacher, founds the Akademi Seni Rupa Indonesia (Indonesian Academy of the Visual Arts), or ASRI, in Yogyakarta, based on Soedjojono's principles and art theories. Many prominent artists teach at ASRI, including Hendra, Affandi, and Trubus.

Leftist writers in Jakarta form the Lembaga Kebudayaan Rakyat (Institute of People's Culture), known as LEKRA.

1950–56

Outside the art academies, political influences in art practice continue. Pelukis Rakyat becomes very influential because of its affiliation with the Communist Party. Many organizations oppose the dominance of Pelukis Rakyat; chief among these opponents is the Badan Musyawarah Kebudayaan Nasional (National Culture Forming Body), a large cultural organization formed in 1956 and affiliated with the Nationalist Party.

1956

An important seminar of cultural issues is organized by Gajah Mada University in Yogyakarta. Artists from all factions participate, but the discussion on art is dominated by Rusnadi and Trisno Soemardjo. They argue for artistic idealism and stress the importance of developing an Indonesian art history.

1956–60

Despite the open discussions at the Yogyakarta seminar, art continues to be dominated by the Communist Party. Communist monuments are built in the big cities and artists are involved in creating large paintings for propaganda. In 1959, President Sukarno issues the Political Manifesto, which states that politics should be the ultimate purpose of all efforts. Nevertheless, as an art collector himself, Sukarno continues to patronize nonleftist artists.

1963

Artists, poets, and intellectuals issue the Manifest Kebudayaan (Cultural Manifesto), which denounces LEKRA, opposes the political rule of the Communist Party, and demands freedom of expression.

1964

Sukarno denounces the Cultural Manifesto as counterrevolutionary. All activities based on the Cultural Manifesto are banned and artists who demand freedom are intimidated by leftist groups.

1965

An alleged Communist coup fails and brings swift reprisals by the military. Leftist groups, including the Communist Party and LEKRA, are dissolved and many opposition leaders are killed or imprisoned. Hendra Gunawan, Djoko Pekik, Batar Lubis, and other artists are incarcerated; Trubus is shot. The new government, called The New Order, concentrates on economic development and multinational investment. After years of being a virtually closed society, Indonesia becomes totally open for international influences.

1968

Taman Ismail Marzuki Art Center (TIM), a publicly funded performance center and art academy, is established in Jakarta. There, Indonesian artists have complete artistic freedom for the first time.

1971

At the "Group 18 Exhibit" at TIM, artists from the Bandung Institute of Technology exhibit modernist works. Achmad Sadali and his followers present abstract paintings.

Mochtar Apin issues a statement proclaiming that art is a universal phenomenon, that it does not have boundaries, and that it is not related to national identity.

1972

The Jakarta Art Council establishes the Jakarta National Painting Biennial, which stresses the equal importance of artistic avant-gardism and national cultural identity.

1973

Sculptor G. Sidharta organizes the "Exhibition of Contemporary Sculptures" at TIM. This is the first time the term "contemporary" is used in a major Indonesian art exhibition.

The artist/poet Danarto exhibits the first conceptual art installation in Jakarta. The work, an installation of empty canvases, is severely criticized.

1974

In a speech at TIM, art historian Dr. Soedjoko attacks the activities of the art center, sharply reprimanding artists for acting superior to other people. He criticizes the principle of art for art's sake and complains that modern art has displaced the more traditional arts of the Indonesian public.

"Exhibit 74" is staged in Jakarta by artists of the Bandung School, including Jim Supangkat, Nini Saleh, Peni Hoegeng, and Tine Karnaya. Supangkat and Saleh show installations using readymades. The exhibition is heavily criticized.

Artists of Yogya School, including FX Harsono, Nanik Mirna, and Bonyong B. Munni Ardhi, exhibit their installations of geometric paintings in Jakarta.

At the 2nd Jakarta National Biennial of Painting, many younger artists criticize the top five prizes, all awarded to decorative paintings. The protesters issue the Desember Hitam (Black December) Manifesto, which is signed by D.A. Peransi, Hardi, Siti Adyati, FX Harsono, and Nanik Mirna, among others. They challenge the view that the decorative style represents Indonesian national identity.

1975

As the controversy around the Biennial continues, Soedjoko, one of the judges, issues a response which states that many of the works by younger artists were hard to consider as serious artworks.

In reaction to Soedjoko's statement, young artists from Bandung and Yogyakarta form Gerakan Seni Rupa Baru Indonesia (Indonesian New Art Movement). This group, which includes Supangkat, Hardi, Adyati, Mirna, Harsono, and Ardhi, challenges the identification of "seni rupa" (visual art) with traditional "fine art."

1976

The New Art Movement organizes "Conceptual Exhibition" at Cultural Hall in Jakarta; this collaborative work consists of remarks and graffiti (texts, drawing, caricature, diagrams) on the walls of the exhibition space. The group proclaims its opposition to modernism, avant-gardism, universalism, and a search for a national identity.

1977

The New Art Movement organizes its second exhibition, "Gerakan Seni Rupa Baru II" (New Art Movement II), at TIM. Younger artists from Bandung and Yogyakarta join the group, including Dede Eri Supria.

Several artists from the New Art Movement, including Bonyong B. Munni Ardhi, Dede Eri Supria, and Gendut Ryanto, found another group under the name "Kepribadian Apa?" (What Is an Identity?). Their exhibition in Yogyakarta includes photorealist paintings and other works that incorporate popular symbols.

1978

The Jakarta Art Council establishes a biennial for young Indonesian painters. The first exhibition shows the strong influence of the New Art Movement; nearly all the works shown are installations.

1979

At "Gerakan Seni Rupa Baru III" (New Art Movement III), Sulistiarso organizes a happening that causes a disturbance at the Art Center. Police come and inspect the exhibition. They seize Hardi's self-portrait *The President of Indonesia in 2001*, which is perceived as political criticism. Hardi is jailed for several days.

In addition to conflicts over its exhibition, internal strife among members (particularly between Hardi and Supangkat over expansion of the group) leads to the breakup of the Indonesian New Art Movement.

1983

Art critic Sanento Yuliman seeks to reevaluate the term "seni rupa" by focusing on the high art/low art dichotomy. In Indonesia, he argues, "low art" is not mass culture but the traditional art of indigenous peoples, produced with modest technology and local materials.

1987

Yuliman and many artists once involved in the New Art Movement (Supangkat, Adyati, Harsono, and Ryanto among others) organize "Pasaraya, Dunia Fantasi" (Fantasy World in the Supermarket) at TIM. The large collaborative installation tries to advance the critical discourse around high art/low art issues.

1991

The exhibition "Modern Indonesian Art: Three Generations of Tradition and Change, 1945–1990," organized as part of the Festival of Indonesia in the United States, is rejected by American museums and galleries.

1992

Installation artist Dadang Christanto organizes a counter-biennial to coincide with the 1992 Yogyakarta Biennale of Painting. Included in the counter-biennial are installations, performances, and environmental works in several public spaces in Yogyakarta.

Moelyono's installation "Pameran untuk Marsinah" (Exhibit for Marsinah), a memorial to a female labor activist who had been mysteriously killed, is closed by the police in Surabaya.

The 9th Jakarta Biennial, curated by Jim Supangkat, becomes the 9th Jakarta Biennial of Contemporary Art and focuses on art of the 1980s. For the first time, installation art is featured in a major exhibition. Nearly all Indonesian installation artists participate. The Biennial provokes considerable debate and controversy over installation art, postmodernism, and contemporary art in general.

1994

The Yogyakarta Biennial of Painting follows the model of the Jakarta Biennial and focuses on contemporary art. While continuing the Yogyakarta tradition of exhibiting painting, this Biennial also exhibits installations and outdoor sculptures.

Political activists in Surakarta (near Yogyakarta) organize an experimental art festival at the Surakarta Cultural Center. Installation and performance are featured along with experimental music, dance, and theater. The media claims that contemporary art encourages anarchy and anti-art tendencies.

1995

The exhibition "Contemporary Art of The Non-Aligned Countries 1995," including work by artists from thirty-five non-aligned countries, is held in Jakarta. Debates over this exhibition emphasize the controversial status of contemporary art.

1996

At Ancol Bay, a recreation area in Jakarta, Dadang Christanto creates a huge outdoor art installation consisting of 1,000 life-size statues embedded in the beach. According to the artist, the figures represent the people of the grass-roots, who have been backed into a corner by fast-track economic development.

[PHILIPPINES]

1884

Expatriate Filipino painter Juan Luna is awarded a gold medal at the Madrid Exposition for the large-scale work *Spoliarium*, an allegory of the Philippine condition under Spanish colonization; another expatriate, Felix Resurrecion Hidalgo, wins a silver medal. The two artists are part of a group of middle-class Filipino intellectuals living in Europe who seek reforms in the colony from Spain (the group includes Dr. José Rizal, whose novels and execution in Manila in 1886 inflame revolutionary fervor).

1884–98

The struggle for Philippine independence: the revolutionary war against Spain culminates in the declaration of Philippine independence on June 12, 1898 and the Congress that promulgates the first constitutional democracy in Asia on January 23, 1899. The Philippines is sold by Spain to the United States for $20 million in the Treaty of Paris, signed on December 10, 1898.

1889–1901

Many Filipino revolutionaries do not accept the Treaty of Paris, and the Philippine-American War rages; the United States establishes a civil government in the Philippines in 1901 and consolidates colonial holdings.

1928

Painter Victorio Edades, after studies in the United States, holds a one-person exhibition at the Philippine Columbian Club, heralding the arrival of what is to be called Philippine modernism. Around this time, selected Filipinos are sent to the United States for study under government subsidy.

1930s

Idyllic Philippine pastorales are popularized by the so-called Amorsolo school, led by the painter Fernando Amorsolo, who heads the University of the Philippines School of Fine Arts; Toribio Herrera, Irineo Miranda, Dominador Castaneda, and Jorge Pineda are associated with this artistic stream. Guillermo Tolentino is considered the premier practicing sculptor, articulating heroic subject matter with a neoclassical monumentality.

1935

The Commonwealth of the Philippines is established under the U.S. and promoted as a preparatory stage for full independence.

The University of the Phillipines is the hub of intellectual and artistic activity and research into Filipiniana material while employing modern artistic and popular media.

1942–45

The Philippines are occupied by Japanese military forces. Despite widespread suffering, artists continue working; after the war, some are accused of "collaboration" with the Japanese propaganda machinery.

1946

On July 4, the United States confirms the independence of the Republic of the Philippines; Manuel Roxas y Acuna is president.

1948

The Art Association of the Philippines (AAP) is established, led by Purita Kalaw Ledesma. The AAP will become the premier visual arts organization in the Philippines.

1950

A School of Fine Arts is established at the Philippine Women's University.

1951

The Philippine Art Gallery (PAG), owned and managed by Lydia Villanueva-Arguilla, is opened, inaugurating the gallery-based market in the visual arts.

1953

Carlos Francisco's mural *Five Hundred Years of Philippine History*, executed in wood by Paete artists, is shown at the Manila International Fair.

1950s

The group "Thirteen Moderns" is founded by Edades, Carlos V. Francisco, Hernando Ocampo, Galo Ocampo, Vicente Manansala, Cesar Legaspi, Anita Magsaysay-Ho, Diosdado Lorenzo, José Pardo, Demetrio Diego, Ricarte Puruganan, Bonifacio Cristobal, and Amadeo Manalad. Later members include Romeo Tabuena, Ramon Estrella, Cenon Rivera, Constancio Bernardo, José Joya, Jesus Ayco, Lee Aguinaldo, Manuel Rodriguez, and Nena Saguil. While devoted to the international mainstream,

most members experiment with and overtly seek "Filipinism."

1955
The "moderns" (following Edades's lead) take all the awards in the competition sponsored by the AAP, precipitating a walk-out of the conservatives (following the Amorsolo school). Art criticism flourishes, beginning with commentaries by Leonides Benesa, Ricardo Demetillo, E. Aguilar Cruz, and Galo Ocampo. Filipino-Spanish painter (and resident of Spain) Fernando Zobel exerts substantial influence on the younger generation of abstract artists.

1958
Guillermo Tolentino paints *Oblation* for the University of the Philippines.

1960
The impact of American Abstract Expressionism is manifest in the painting of Lee Aguinaldo, Arturo Luz, José Joya, and Constancio Bernardo, and in sculpture by Napoleon Abueva, Solomon Saprid, and Virginia Ty Navarro. Hernando Ocampo, Abdulmari Imao, and J. Elizalde Navarro specifically seek an abstract idiom that will convey a Filipino sensibility. An expressionist bent is visually articulated, variously, by Ang Kiukok, Danilo Dalena, Jaime de Guzman, and Onib Olmedo. Expatriate artists, such as the Paris-based painter Nena Saguil and the Brittany-based Macario Vitalis, exert minimal influence on developments in the Philippines. Art criticism is practiced by Benesa, Emmanuel Torres, Alfred Roces, and later, Rodolfo Paras Perez (also a printmaker and painter).

1962
The Philippine Association of Printmakers is founded by Manuel Rodriguez, Sr.

In a period of great capitalist expansion, the Philippines enjoys the highest per capita income and growth rate in Southeast Asia.

1964
Carlos Francisco paints his mural *History of Manila* in the Katipunan Hall of the Manila City Hall.

1968
Araceli Dans and Brenda Fajardo establish the Philippine Art Educators Association.

1969
The Cultural Center of the Philippines (CCP) is established under the patronage of Imelda Marcos. The CCP immediately becomes the "center" of internationalist ambitions in the arts. David Cortez Medalla, kinetic art pioneer and enfant terrible of the Philippines visual arts, leads a rally protesting the CCP.

1971
The political art group Nagkakaisang Progresibong Artista at Arkitekto (United Progressive Artists and Architects) is founded.

1972
President Ferdinand Marcos declares martial law, ostensibly to combat terrorism; thousands are killed by government troops.

Ben Cabrera's exhibition "Larawan" (Portrait) is based on nineteenth-century photographs.

1975
Developments in abstraction continue in the work of Romulo Olazo, Mars Galang, Ben Maramag, Justin Nuyda, Lao Lianben, Augusto Albor, Glen Bautista, Nestor Vinluan, Philip Victor, and Phyllis Zaballero. Abstract sculpture is represented by Edgardo Castrillo, Imelda Pilapil, Lamberto Hechanova, and Ramon Orlina.

Many artists continue to work in a figurative mode: the works of Mario Parial, Angelito Antonio, Benedicto Cabrera (Bencab), Antonio Austria, Norma Belleza, Edgar Doctor, and Alfredo Liongoren demonstrate the tenacious popularity of this idiom.

The art market enjoys robust growth, thanks to extensive tourism-related construction. Luz Gallery, considered the premier gallery, specializes in artists pursuing modern trajectories.

Under the directorship of Roberto Chabet and then Raymundo Albano, the CCP Art Museum draws artists interested in Minimalism, Conceptual Art, installation, and performance art, including Alan Rivera, Lazaro Soriano, Yolando Laudico, Liwayway Recapping Co., Joe Bautista, Fernando Modesto, Judy Freya Sibayan, Hugo Bartolome, Genara Banzon, and later, June Yee and Virginia Dandan.

An alternative experimental art space is provided by the privately owned Sining Kamalig. Printmaking becomes a significant medium for expressing a wide variety of ideological positions; practitioners include Manuel Rodriguez, Sr. and Jr., Rodolfo Samonte, Beana Lee, Virgilio Aviado, Nonon Padilla, Brenda Fajardo, and Paris-based Ofelia Gelvezon-Tequi.

1976
An earthquake hits Mindanao, killing over 8,000 people.

The Kaisahan social realist group is founded; members include Pablo Baens Santos, Renato Habulan, Edgar Talusan Fernandez, Antipas Delotavo, Jose Tence Ruiz, Al Manrique, and Imelda Cajipe-Endaya. Widespread disaffection with the Marcos dictatorship polarizes visual artists into two camps: those branded as seduced by art-for-art's sake attitudes and those who seek political engagement through their work. Alice Guillermo becomes a prominent critical voice.

1980
The opening of the privately owned Pinaglabanan Galleries occasions support for artists interested in continuing work within modernism. A second group of installation and performance artists, as well as young painters, coalesces around this gallery, including Santiago Bose, Roberto Villanueva, Agnes Arellano, Cesare and Jean Marie Syjuco, Edson Armente, R.M. de Leon, and Dan Raralio.

The AAP continues to identify and support new talents in the visual arts, as do Hiraya Gallery and Finale Art File, both commercial galleries.

1983
Exiled opposition leader Benigno Aquino is assassinated on his return to the Philippines; his death unites opponents of Marcos.

Santiago Bose exhibits his installation *Pasyon and Rebolusyon* (Passion and Revolution), made of indigenous and organic material.

1985
Julie Lluch makes *Si Picasso at Ako* (Picasso and Me), one of her first feminist sculptures.

1986
A revolt against the dictatorship results in the ouster of President Marcos, the abolition of the constitution, and the succession of Corazon Aquino as president. The collapse of the Marcos regime blurs the ideological terrain for artists, with many finding common ground in a search for "indigeneity."

Black Artists in Asia (BAA) is established at Negros Occidental in the Visayas by Charlie Co, Nunelucio Alvarado, and Norberto Roldan.

1987
Establishment of the Baguio Arts Guild (BAG).

1989
A failed military coup against the Aquino government signals growing disenchantment with her rule.

1991
An earthquake strikes Luzon, killing over 1,600 people.

1992
General Fidel Ramos is elected president, succeeding Aquino.

[SOUTH KOREA]

1945

Korea is liberated from the colonial rule of imperial Japan. The United States and the Soviet Union agree to divide Korea along the 38th Parallel; the U.S. occupies the South and the USSR the North. This division provokes an ideological battle between factions of the left and right within South Korea.

The Korean art community is also divided politically. The Chosun Artists Association is formed as the central organization for right-wing artists; it opposes the involvement of art in politics and encourages the construction of a nationalist art on the basis of the traditional and indigenous aesthetics of the Korean people. The same year, the Chosun Proletariat Art Federation is formed; this group represents extreme left artists, who advocate a politics of resistance and politically engaged art.

1947

The group Shinsashilpa is formed by early abstract artists. Through its exhibitions, this group presents a version of progressive art and modernist aesthetics in an art community driven by right-versus-left politics. Shinsashilpa is recognized as the beginning of abstraction in Korea. The founding members are Kim Whanki, Yoo Young-Kuk, Lee Joong-Sup, Chang Ucchin, and Baek Young-Soo.

1949

Following the end of U.S. occupation in the South, the Korean government inaugurates an annual juried exhibition, known as Kuk'jun (National Art Exhibition). This exhibition continues until 1979, making it the longest surviving art institution in modern art history. It provides a way to institutionalize a conservative academism and figurative art in the mainstream and to officially sanction apolitical art and artists of the right.

1950–53

The Korean War.

1957

The Hyundai Mee'hyup group is formed by young artists who are among the first generation educated at art colleges in Korea, rather than in Japan. Although short-lived, this group is historically important as the first to reject conservative figurative art and present abstraction as an alternative. This group is a forerunner of the Informel movement.

1963

Many of the Informel Group artists (including Kim Chong-Hak, Kim Chang-Yeul, Park Seo-Bo, Youn Myeung-Ro, Chung Chang-Sup, Ha Chong-Hyun, and Choi Man-Rin) are invited to participate in the São Paulo and Paris biennales, the first time Korean artists have participated in major overseas exhibitions.

1967

The Korean Young Artists Coalition is formed, uniting the artists' groups Origin, Mu'dongin, and Shinjun'dongin. This coalition signals an emerging generation of young artists that oppose the overt expressionism and individualism of the Informel Group. Working with various mediums and found objects (and rejecting Informel-style abstraction), the coalition artists make work that is characterized as neo-Dada, geometric abstraction, or assemblage.

Korea's first happening, "Happening with a Plastic Umbrella and Candlelight," takes place. It is followed by numerous happenings and performances in the late 1960s. Art terms such as "event," "happening," "land art," and "process art" gain general usage.

1969

The formation of various artists groups, including AG (Korean Avant-garde Association), followed by ST (1970), Shin'chae'jae (1970), and Espirit (1972), creates a momentum for experimental art and avant-garde activities.

A number of art students form the short-lived Hyunshil-dong'in Group, which is significant for later alternative and political art practices. In their manifesto, the group identifies the failings of mainstream and modernist art practices and specifies an artistic and political program for socially relevant art that would build on the national identity of the Korean people.

1972

The annual Independent exhibition begins. This show is open to all artists; there is no screening process. It becomes a dynamic showcase for new, experimental art. It is followed by the Seoul Biennale (1974), the Ecole de Seoul (1975), and other large-scale art exhibitions that provide various venues as well as support for new and different art activities.

1975

The Tokyo exhibition "The Korean Artists: 5 Variations on White" initiates the discourse on monochrome painting, the most influential Korean art movement of the 1970s. Influenced by the art of Lee U-fan and Mono-ha of Japan, monochrome painting revived age-old discourses of spirituality and traditional aesthetics for Korean modern art.

1979

The group Reality & Utterance is formed. It consists of twelve artists and art critics and is to become one of the central forces in the antimodernist aesthetics and prodemocracy politics of the Minjoong art movement of the 1980s.

1980

In the aftermath of the assassination of President Park Chung-Hee and a coup d'état by the military, demonstrations in the provincial capital of Kwangju are suppressed by an army division that kills an unknown number of civilians. General Chun Doo-Hwan is sworn in as president.

1984

Minjoong artists organize exhibitions at various venues throughout the country. These shows establish a solidarity among the members of the movement, presenting a powerful front against the establishment and modernist aesthetics. Between the poles of Minjoong and establishment art are many younger, nonaligned artists; their exhibitions, such as "Metavox," "nan'ji'do," "logos & pathos," and "TARA," are a breeding ground for diverse and experimental art. Nonaligned artists counter the confrontational force of the Minjoong camp by staging an exhibition that brings together 500 artists who oppose the formalism of modernism but are unengaged politically.

1985

Aggressive grass-roots activities and political critique from the Minjoong art movement leads to a crackdown by the authorities. An exhibition titled "The 1985 Power Exhibition" is targeted as problematic for exhibiting a painting that represents a scene of labor-union activities. Police close the show and confiscate twenty-six artworks, causing anger and aggression from the Minjoong art movement.

Yu'mee'yun, a branch within the Minjoong art movement that brings together various smaller organizations of women artists, is formed. The members include Choi Kyung-Sook, Kim Jin-Sook, and Yun Suknam. In 1987, the group organizes the exhibition "Women and Reality," the first feminist art exhibition in Korea.

1987

The group Museum is formed by Ko Nak-Bum, Noh Kyung-Aeh, Lee Bul, Choi Jeong-Hwa, and Hong Sung-Min. Other groups, such as Sub-club, Coffee-Coke, Golden Apple, and New Kids in Seoul, comprise a new, postmodern generation of Korean artists. Born in the 1960s and raised during the rapid modernization of Korea, these artists come together as a generation with a distinct identity. They quote from the mass-marketed consumer culture and their visual tastes are attuned to advertising, television, and technology.

1988

Seoul hosts the 24th Summer Olympic Games, which provide a boost for international exchange in the visual arts. Various large-scale exhibition programs and symposia are staged, bringing together artists and critics from around the world.

1990

The Sonje Museum of Contemporary Art opens in the provincial city of Kyungju. This museum is financed by the Daewoo Corporation and represents the new role of corporations and the private sector in patronizing contemporary art and sponsoring public art museums. These corporate-run art museums, which have become major organizers of important exhibitions of Korean and international contemporary art, include the Ssangyong-affiliated Sung-kok Art Museum (which opened in 1995), the Kumho Art Museum (scheduled to open in 1996), and the Ho-Am Art Gallery, financed by the Samsung Corporation (scheduled to open in 1999).

1995

Korea celebrates fifty years of independence from the colonial rule of Imperial Japan.

Two events signal the globalization of Korean contemporary art: the inauguration of the Korean pavilion at the Venice Biennale and the first Kwangju Biennale. Individual Korean artists, such as Jheon Soo-Cheon, Choi Jae-Eun, Cho Duck Hyun, and Yeuk Kun-Byung also receive increasing attention overseas, participating in major biennales and exhibitions.

The Korean government makes the controversial decision to tear down the National Museum building in Seoul, formerly the headquarters of the governor general of the Japanese Occupation forces and a reminder of that dark history. The spire atop the dome of the building is removed before debate halts further demolition.

[THAILAND]

1946

King Ananda Mahidol is assassinated. King Bhumibol Adulyadej (Rama IX) assumes the throne.

1947

A military coup d'état overthrows the leftist premier Pridi Phanomyang.

1948

Luang Phibun Songkhram becomes prime minister of Thailand, serving until 1957.

A major exhibition of contemporary Thai art is staged in London, including works by Fua Hariphitak, Khien Yimsiri, and Paitun Muangsomboon.

1954

Chalood Nimsamer is the first student to graduate from Silpakorn University (founded in 1943; formerly the School of Fine Arts); later studies at the Academy of Fine Arts, Rome. Sawasdi Tantisuk also attends the Academy of Fine Arts in 1956 and Tawee Nandakhwang, follows in 1960.

1957

Pibul Songgram is overthrown as premier in a coup led by Sarit Thanarat; Thanom Kittakachorn is named premier in 1958.

Marxist critic Jit Phumisak publishes *Sinlapa phua chiwit* (Art for Life) and *Sinlapa phua prachachon* (Art for the People).

1958

Sarit Thanarat establishes martial law; political parties are banned and military absolutism reigns in Thailand until his death in 1963.

1960

Sawasdi Tantisuk becomes director of the Chang Silpa School of Fine Arts.

Indonesian painter Raden Basoeki Abdullah begins to paint portraits of King Bhumibol and Queen Sirikit.

1961

Princess Chumbhot opens the Young Artists Exhibition at Bangkok Art Center, signaling court approval of modern art.

1962

Silpa Bhirasri (born Corrado Feroci), one of the most important modern Thai artists, dies.

Inson Wongsam goes to study at the Ecole Nationale Supérieure des Arts Decoratifs, Paris.

1963

Thanom Kittikachorn returns to power as prime minister, supporting the U.S. military buildup in Vietnam.

A contemporary Thai art exhibition is held at the Alpine Club in London.

King Bhumibol is painted by Piriya Krairiksh in Chitra La Da Palace; King Bhumibol and Queen Sirikit preside over the opening of Piriya Krairiksh's art exhibition at the Siam Society.

Damrong Wong-upparaj attends the Slade School in London.

1964

Thawan Duchanee goes to study at the Rijksakademie voor Beeldende Kunste, Amsterdam.

1966

The Contemporary Artists Group is formed, led by Damrong Wong-upparaj; the group includes Pira Pathanapiradej, Pratuang Emjaroen, and Tang Chang.

The John D. Rockefeller 3rd (JDR3) Foundation gives fellowships for Thai artists to study in the United States.

1968

Damrong Wong-upparaj attends the University of Pennsylvania.

1969

Kamol Tassananchalee goes to study at the Otis Institute in Los Angeles.

1970–71

Paiboon Suwannakudt paints his first set of murals for the Montien Hotel in Bangkok.

1971

Thanom seizes full power in a bloodless coup; political unrest and Communist guerrilla attacks mount.

Pratuang Emjaroen founds the Dharma Group.

Thawan Duchanee's paintings are slashed by angry Buddhist students, who see them as sacrilegious.

1962

TISCO (Thai Investment and Securities) begins to collect and exhibit contemporary Thai art.

1973

The military dictatorship is overthrown by popular demonstrations; a brief democratic interregnum follows.

Pratuang Emjaroen and Chang Se Tang exhibit works commemorating battles between students and the military.

Chalood Nimsamer tries to expel eleven teachers from Silpakorn University for ideological differences.

1974

Bhirasri Institute of Modern Art is established with the support of Princess Chumbhot; it closes after her death in 1988.

Artists' Front of Thailand is formed, led by Kamchorn Soongpongsri, advocating the political "art for life" line developed by critic Jit Phumisak in the 1950s.

The Bualuang Painting Contest is organized by Bangkok Bank.

1975

Seni Pramoj becomes prime minister for five days, replaced by Kukrit Pramoj.

Billboard exhibitions are staged to commemorate political events.

1976

A military junta seizes power following political crisis and rioting by students; martial law is declared. Violence by the military leads to the slaughter of students and civilians.

Thanin Kraivixien becomes prime minister, overseeing authoritarian government ruled by the military.

1977

A coup by military advisers replaces Thanin with General Kriangsak Chomanan.

The National Gallery of Art is established in Bangkok.

A department of Thai Art opens at Silpakorn University.

1978

The Lanna Group exhibition is held in Chiang Mai.

1979
A contemporary art competition is organized by Thai Farmers Bank.

Artists' Front stages the first Open Art Exhibition with unlimited entries.

1980
Kriangsak resigns as prime minister and is replaced by General Prem Tinsulanonda, head of the military advisory council.

The "Asian Art Show" is held at the Fukuoka Art Museum, Japan.

Kamol Tassananchalee and Chavalit Sermprungsuk have solo shows at the National Art Gallery.

1981
Failed military coup.

The Visual Dhamma Gallery opens with a show by Angkarn Kalayanapongsa.

The White Group is founded.

1982
The Bangkok bicentennial is celebrated.

Golden Brush Art Contest is held.

Thammasat University sponsors an exhibition and conference on "Art in Thailand since 1932."

1983
A Faculty of Fine and Applied Arts is established at Chulalongkorn University. Later the same year, a Faculty of Fine Arts opens at Chiang Mai University.

Yanawitya Kunchaethong goes to study at Aichi Prefectural Arts University, Nagoya.

1984
Chalermchai Kositpipat, Panya Vijinthanasarn, and assistants begin to paint vast neo-Buddhist murals at Wat Buddhapadipa, Wimbledon, England.

Vasan Sitthiket publishes a Neo-Dada manifesto.

1985
Failed military coup.

A national artist award is established.

1986
Montien Boonma goes to study sculpture at the Ecole Nationale Supérieure des Beaux Arts, Paris.

A Faculty of Fine Arts opens at Rangsit University.

Petroleum Oil of Thailand sponsors an art contest.

The exhibition "Thai Reflections on American Experiences" is organized by the United States Information Agency (USIA).

1987
Border clash with Laotian troops as regional tensions mount.

1988
General Chatichai Choonhavan, leader of the Chart Thai party, becomes prime minister.

Bhirasri Institute of Modern Art closes.

Chumpol Apisuk exhibits at ARX (Artist Exchange), Perth.

1989
An art contest is organized by Toshiba (Thailand).

The exhibition "Inspiration from Japan" is organized by Japan Foundation.

1990
Thammasak Booncherd and Pinaree Sanpitak exhibit at ARX2, Perth.

Thwan Duchanee's solo show opens at Fukuoka Art Museum.

Araya Rasdjarmrearnsook goes to study at Hochschule für Bildende Kunste, Brunswick, Germany.

1991
A military coup d'état ends the trend toward democracy; businessman Anand Panyarachun becomes interim prime minister but General Suchinda Kraprayoon effectively rules the government.

HR Princess Sirindhorn's thirty-sixth anniversary is celebrated.

Queen Sirikit National Convention Centre opens.

The exhibition "The Integrative Art of Modern Thailand" tours the United States.

1992
Suchinda Kraprayoon is appointed prime minister. A mass demonstration in Bangkok turns into a four-day May riot with troops firing on civilians and over fifty killed. In September, Chuan Leekpai is elected prime minister.

Queen Sirikit's sixtieth birthday is celebrated.

The first Chiang Mai Social Installation is held in Chiang Mai.

CON-tempus, the Bangkok Art Center, opens.

Kamol Phaosavasdi and Vichoke Mukdamanee exhibit in ARX3, Perth.

The exhibition "The New Art from Southeast Asia" opens in Japan.

A roundtable discussion on contemporary art in Asia is held at the Asia Society, New York.

1993
Vasan Sitthiket, Kamol Phaosavasdi, and Kamin Lertchaiprasert exhibit in the Sydney Biennale.

Rirkrit Triravanija is selected for the "Aperto" section of the Venice Biennale.

Vasan Sitthiket, Kamol Phaosavasdi, Montien Boonma, Araya Rasdjarm-rearnsook, Apichai Piromrak, and Prasong Luemuang exhibit in the First Asia-Pacific Triennial, Brisbane.

1994
A symposium on the "Local/Global" is organized by the Asia Society at the National Centre of Performing Arts, Bombay.

Montien Boonma and Kamin Lertchaiprasert exhibit in the Havana Biennale.

Boonma creates a permanent work at Faret Tachikawa, Japan.

The exhibition "Thai-Australian Cultural Space" opens at the Art Gallery of New South Wales, Sydney.

1995
Death of the Princess Mother.

Banharn Silpa-acha is elected prime minister.

Rirkrit Triravanija exhibits in the Whitney Biennial.

Sansern Milindasuta and Triravanija exhibit in the Kwangju Biennale.

Tawatchai Puntusawasdi wins first prize at the Osaka Triennale.

Montien Boonma exhibits in the Istanbul Biennale.

Another Chiang Mai Social Installation is organized.

The exhibition "Thai Tensions" shows at the Art Gallery, Chulalongkorn University.

1996
Royal cremation of the Princess Mother.

Celebration of King Bhumibol's golden jubilee on the throne.

Navin Rawanchaikul exhibits in "Conversation" in Atlanta.

Araya Rasdjarmrearnsook exhibits in the Sydney Biennale.

Jakapan Vilasineekul, Kamin Lertchaiprasert, Navin Rawanchaikul, Chatchai Puipia, and Yupha Changkoon exhibit in the Second Asia-Pacific Triennial, Brisbane.

An exhibition on five decades of contemporary Thai art opens at the Queen Sirikit National Convention Centre, Bangkok.

— Chronologies compiled by country-essay authors

Bibliography

General

ART AsiaPacific (Sydney), 1993–current.

Asian Modernism: Diverse Development in Indonesia, the Philippines, and Thailand. Tokyo: The Japan Foundation Asia Center, 1995.

Clark, John, ed. *Modernity in Asian Art.* The University of Sydney East Asian Series no. 7. Sydney: Wild Peony, 1993.

Dobbs-Higginson, Michael. *Asia Pacific: Its Role in the New World Disorder.* London: Mandarin, 1993.

Ewington, Julie. "Five Elements: An Abbreviated Account of Installation Art in South-East Asia." In *Art and Asia Pacific,* 2, no. 1. (1995): 84–87.

Journal of Art and Ideas (Delhi), 1988–current.

Poshyananda, Apinan. "Asian Art in the Posthegemonic World." In *The Potential of Asian Thought.* Tokyo: The Japan Foundation ASEAN Cultural Center, 1994.

Sabapathy, T.K., ed. *Modernity and Beyond: Themes in Southeast Asian Art.* Singapore: National Heritage Board, 1996.

Turner, Caroline, ed. *Tradition and Change.* Brisbane: University of Queensland, 1993.

"Unity in Diversity in International Art." Conference proceedings. Jakarta, Indonesia, April 29–30, 1995, Non-Aligned Countries Organization.

Van Fenema, Joyce, ed. *Southeast Asian Art Today.* Singapore: Roeder Publications, 1996.

India

Archer, W.G. *India and Modern Art.* London: George Allen and Unwin, 1959.

Clark, John. *Modern Indian Art: Some Literature and Problematics.* RIAP, Occasional Paper no. 26. Sydney: The University of Sydney, 1994.

Contemporary Indian Art: From the Chester and Davida Herwitz Family Collection. Texts by Gieve Patel, Thomas W. Sokolowski, and Daniel A. Herwitz. New York: Grey Art Gallery and Study Center, New York University, 1985.

Guha-Thakurta, Tapati. *The Making of a New "Indian" Art: Artists, Aesthetics, and Nationalism in Bengal 1850–1920.* Cambridge: Cambridge University Press, 1992.

India Songs: Multiple Streams in Contemporary Indian Art. Texts by V. Lynn, M.G. Singh, M. Bawa, H. Shah. Sydney: Art Gallery of New South Wales, 1993.

Kapur, Geeta. *Contemporary Indian Artists: M.F. Husain, Bhupen Khakhar, Akbar Padamsee, F.N. Souza, Ram Kumar, J. Swaminathan.* Delhi: Vikas Publishers, 1978.

_____. *When was Modernism: Essays on Contemporary Cultural Practice in India.* New Delhi: Tulika, forthcoming 1996.

Mitter, Partha. *Art and Nationalism in Colonial India 1850–1922: Occidental Orientations.* Cambridge: Cambridge University Press, 1994.

Sen, Geeti. *Image and Imagination: Five Contemporary Artists in India.* Ahmedabad: Mapin, 1996.

Sheikh, Gulammohammed, ed. *Art in Baroda.* Delhi: Tulika, forthcoming 1996.

Indonesia

Contemporary Indonesian Art. Jakarta: Taman Ismail Marzuki Art Center, 1995.

Fischer, Joseph, ed. *Modern Indonesian Art: Three Generations of Tradition and Change, 1945–1990.* New York and Jakarta: Festival of Indonesia, 1990.

Holt, Claire. *Art in Indonesia.* Ithaca: Cornell University Press, 1967.

Supangkat, Jim. "The Emergence of Indonesian Modernism and Its Background." *Asian Modernism: Diverse Development in Indonesia, the Philippines, and Thailand.* Tokyo: The Japan Foundation Asia Center, 1995, pp. 204–13.

_____. "Indonesia Report: A Different Modern Art." *Art and Asia Pacific,* sample issue (September 1993): 20–24.

Triennale Jakarta 1986. Pameran dan Kompetisi Seni Patung Kontemporer Indonesia. Jakarta: Dewan Kesenian, 1986.

Wright, Astri. *Soul, Spirit, and Mountain: Preoccupations of Contemporary Indonesian Painters.* Kuala Lumpur: Oxford University Press, 1994.

South Korea

Across the Pacific: Contemporary Korean and Korean American Art. New York: Queens Museum of Art, 1993.

Korean Minjoong Arts: 1980–1994. Seoul: National Museum of Contemporary Art, Korea, 1994.

Man, Yul, and Choi Tae, eds. *Minjoong Misul 15 Nyun* (Fifteen Years of Minjoong Art). Seoul: Sal'm'kwa Kkum, 1994.

Oh, KwangSu. *Hanguk Hyundai Misulsa* (History of Korean Modern Art). Seoul: Yul'hwa dang. 1992.

Rebellion of Space: Korean Avant-Garde Since 1967. Seoul: Seoul Metropolitan Art Museum, 1995.

Suh, Sung-Rok, *Hankuk'ui Hyundai Misul* (Modern Art in Korea) Seoul: Mun'ye Chul'pan-sa, 1994.

Territory of Mind: Korean Art of 1990s. Tokyo: Contemporary Art Gallery, Art Tower Mito, 1995.

The Tiger's Tail: 15 Korean Contemporary Artists for Venice '95. Seoul: National Museum of Contemporary Art, Korea, 1995.

Philippines

Albano, Raymundo R. "Developmental Art of the Philippines." *Philippine Art Supplement* 2, no. 4 (1981): 15-19.

Benesa, Leonidas. "The Winds of Philippine Art." *Panorama*, November 1957.

Casal, Gabriel et al. *The People and Art of the Philippines*. Los Angeles: Museum of Cultural History, University of California, Los Angeles, 1981.

Coseteng, Alice M.L., ed. *Philippine Modern Art and its Critics*. Manila: UNESCO National Commission of the Philippines, 1972.

Guillermo, Alice. "The Development of Philippine Art." In *Tradition and Change: Contemporary Art of Asia and the Pacific*, ed. Caroline Turner. Brisbane: University of Queensland Press, 1993, pp. 72–82.

Kalaw-Ledesma, Purita, and Guerrero Amadis Ma. *The Struggle for Philippine Art*. Quezon City: Vera-Reyes, 1974.

100 Years of Philippine Painting. Pasadena, Calif.: Pacific Asia Museum, 1984.

Pastor-Roces, Marian. "The Outer Limits of Discourse: Art into Text, Philippines." In *Shift: Critical Strategies Forum Papers,* ed. Nicolas Tsoutas. Brisbane: Institute of Modern Art, 1992, pp. 79–98.

Tiongson, Nicanor G., ed. *Tuklas Sining: Essays on the Philippine Arts*. Manila: Sentrong Pangkultura ng Pilipinas, 1991.

Thailand

Art and Asia Pacific, Thailand issue, 3, no. 3 (1995).

Hoskin, John. *Ten Contemporary Thai Artists: The Spirit of Siam in Modern Art*. Bangkok: Graphis, 1984.

Krairiksh, Piriya. *Art in Thailand Since 1932*. Thai Khadi Research Institute: Thammasat University, 1982.

Pawlin, Alfred. *Dhamma Vision*. Bangkok: Visual Dhamma, 1984.

Phillips, Herbert. *The Integrative Art of Modern Thailand*. Berkeley: University of California, 1992.

Poshyananda, Apinan. *Modern Art in Thailand*. Singapore: Oxford University Press, 1992.

_____. *Western-style Painting and Sculpture in the Royal Thai Court*, vols. 1–2. Bangkok: Bureau of the Royal Household, 1993.

Reynolds, Craig, ed. *National Identity and Its Defenders: Thailand, 1939–1989*. Monash Papers on Southeast Asia no. 25. Melbourne: Monash University, 1991.

Rodboon, Somporn. "Thai Contemporary Installation." *Art Monthly* (Australia) no. 72 (August 1994).

Silpakorn University, *Contemporary Art in Thailand*. Bangkok: Silpakorn University, 1968.

Index of Illustrations

Contributors

Apinan Poshyananda is associate professor and associate dean for research and foreign affairs on the Faculty of Fine and Applied Arts at Chulalongkorn University, Bangkok. He has been a curator or juror for international exhibitions in Sydney, Brisbane, Perth, Johannesburg, Osaka, Sapporo, Jakarta, and Istanbul and has written many articles. Dr. Poshyananda is author of *Modern Art in Thailand: 19th and 20th Centuries* (1992).

Thomas McEvilley is a New York–based critic and theorist of contemporary art. He has published numerous monographs and two anthologies of essays: *Art and Discontent: Theory at the Millennium* (1991) and *Art and Otherness: Crisis of Cultural Identity* (1992).

Geeta Kapur writes on contemporary Indian art. An anthology of essays, *When Was Modernism: Contemporary Cultural Practice in India*, is forthcoming. Ms. Kapur, holder of a fellowship at the Indian Council for Historical Research, lives in New Delhi.

Jim Supangkat is a critic and artist who lives in Jakarta. A catalogue essayist and curator or judge for many contemporary Indonesian art shows seen abroad, he is a leading theorist in the definition of a contemporary art for Indonesia in a global context.

Marian Pastor Roces is a prolific writer, curator, and cultural projects administrator. She is based in Manila, and her many activities include the establishment of museums. Ms. Pastor Roces's most recent book is *Sinaunang Habi: Philippine Ancestral Weave* (1991).

Jae-Ryung Roe is an art historian and curator specializing in contemporary Korean art. She has studied and worked in Korea, Sweden, and North America, receiving her Ph.D. from the Institute of Fine Arts at New York University.

Colophon

Project Director: Joseph N. Newland
Design: Bethany Johns Design, New York
Editor: Brian Wallis
Publication Associate: Merantine Hens-Nolan
Composition: Chelsea Arts Inc., New York, and
 Bethany Johns Design
Print production: The Actualizers, New York
Printed and bound by Everbest Printing Co. Ltd., Hong Kong

Photograph Credits

Photographs courtesy of the artists or essay authors
unless otherwise noted.

Rajan Babu, Hyderabad, 12, 31, 196–99
Henni van Beek, 30 (2), 200–1
Stephen Briggs, 175
Centre of International Modern Art, Calcutta, 206–9
Robert Frith, Acorn Photo Agency, 192–95
Gallery Hyundai, Seoul, 97 (4)
Lynton Gardiner, 30 (1)
Gurumurthi T. Hegde, 47 (33), 152–53
Ju Myung-Duk, 168–69
Kapil Jariwala Gallery, London, 160–61
Kim Woo-Il, 143
Andrew Meintjes, 154–55
Otto E. Nelson, 34 (9)
Ravi Pasricha, Delhi, 62 (4), 63 (5)
Apinan Poshyananda, 2–4, 6, 30 (3), 36 (12), 42 (21), 46 (30),
47 (32), 148
Prakash Rao, 42 (22), 172–74
Singapore Art Museum, 112–13
Manit Sriwanichpoom, cover, 8, 32 (7), 33, 34 (10), 38 (16), 39,
40 (18, 19), 42 (23), 43 (25), 44, 45 (28), 48 (35), 116, 118–35, 144–47,
149–51, 156–59, 176–79, 181–90, 202–5, 210–11
Vivan Sundaram, Delhi, 61 (1), 62 (3)